MW00608182

150 BEST OF THE BEST APARTMENT IDEAS

150 BEST OF THE BEST APARTMENT IDEAS

FRANCESC ZAMORA MOLA

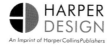

HARPER
DESIGN

An Imprint of HarperCollins Publishers

150 BEST OF THE BEST APARTMENT IDEAS
Copyright © 2020 by LOFT Publications

All rights reserved. No part of this book may be used or reproduced in any manner whatsoever
without written permission, except in the case of brief quotations embodied in critical articles and reviews.
For information, address Harper Design, 195 Broadway, New York, NY 10007.

HarperCollins books may be purchased for educational, business, or sales promotional use.
For information, please email the Special Markets Department at SPsales@harpercollins.com.

First published in 2021 by
Harper Design
An Imprint of HarperCollins*Publishers*
195 Broadway
New York, NY 10007
Tel.: (212) 207-7000
Fax: (855) 746-6023
harperdesign@harpercollins.com
www.hc.com

Distributed throughout the world by
HarperCollins*Publishers*
195 Broadway
New York, NY 10007

Editorial coordinator: Claudia Martínez Alonso
Art director: Mireia Casanovas Soley
Editor and texts: Francesc Zamora Mola
Layout: Cristina Simó Perales

ISBN 978-0-06-301887-7

Library of Congress Control Number: 2020034262

Printed in Malaysia
First printing, 2021

CONTENTS

INTRODUCTION

This book explores the design ideas of apartment living through a varied selection of projects. The examples range from blank canvases and simple upgrades of fixtures, finishes, and furnishings for a fresher look to major renovations improving the layout, creating better circulation, making better use of space, and maximizing natural lighting and views. Some designs breathe new life into apartments with historical value, upgrading the structure to contemporary living standards while highlighting original architectural features such as steel windows, fireplaces, tin ceilings, moldings, and hardwood floors. At the opposite end of the design spectrum, high-rise buildings meet high design. These different ways of approaching apartment design offer creative solutions for everyone's taste and budget. At the same time, they all address a common aspect: they all embody the spirit of city living.

A large section of the urban population lives in apartments. The existing built fabric is complemented with new construction, trying to keep up with an increasing demand for housing. The city attracts singles, young families, empty nesters downsizing from their large home, and retirees. This opens the doors to the adaptation of existing spaces for contemporary living and the exploration of new and efficient design ideas.

People move to the city because they are interested in the amenities that urban living has to offer: access to public transit and proximity to schools, public spaces, culture, shops, restaurants, and workplaces. Apartments—like any other type of living space—

are not disconnected from the activity outside their walls. To a lesser or greater degree, a part of their character expresses the rhythm, energy, and vitality of city living. The city's influence creates living spaces that are multifunctional and can accommodate private life and entertainment. Open plans are a good example of this effect, reflecting the complexities of city life.

The city inspires and allows one to immerse oneself in the vibrant urban environment. The views and the skyline have a great aesthetic impact. With open layouts and generous fenestration, not only are the different spaces of the home connected but the entire home is also linked, on a greater scale, to the urban landscape outside.

Cities are an extraordinary mix of architectural highlights from different eras, offering incredible backdrops for inspiring interiors. The exposed ceilings and weathered brick walls ooze with elements of industrial flair. Prewar buildings, with their high ceilings, herringbone wood floors, wood-burning fireplaces, and decorative moldings, bring glamour to a new home, and for the ultimate city living experience, upscale condominiums and high-rise apartments offer all the modern conveniences one could imagine.

Apartments are all about living in the city, and they offer a unique experience that is intrinsically linked to a particular lifestyle, one that embraces communities, social interaction, and the vibrant energy that only a city can offer.

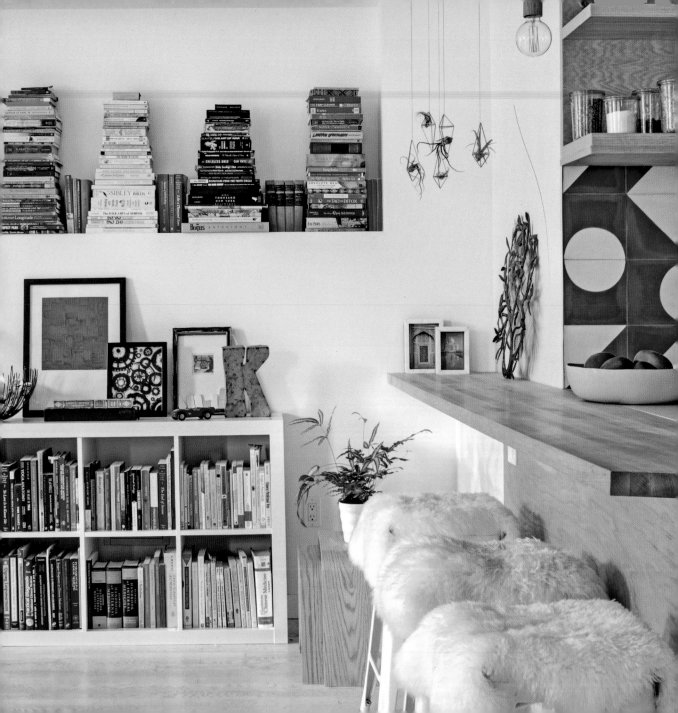

This apartment has beautiful views of Prospect Park, but the room configuration failed to take full advantage of this selling point. The new design collects shared spaces together and allows for flexible uses. BAAO Architects focused on spatial exploration and material practices that adapt to the evolving relationships between inhabitants and the built environment. The design is completed with a material palette of white combined with white oak and pops of color that keeps the rooms light and airy; bleached white floors tie them together and reflect light.

Prospect Park Apartment

900 sq ft

Brooklyn, New York, United States

BAAO Architects

Photographs © Francis Dzikowski/OTTO

001

Location and orientation are key factors that influence the configuration of interior spaces. They are part of a design strategy aimed at maximizing the effectiveness of natural lighting and taking advantage of the views.

Floor plan

A. Entry hall E. Kid's bedroom
B. Kitchen F. Bathroom
C. Dining area G. Media room
D. Living area H. Bedroom

The kitchen is centrally positioned, with visual connections toward the living and dining areas in one direction and the media room in another direction. While the kitchen doesn't have windows, it does receive natural lighting from the adjacent spaces.

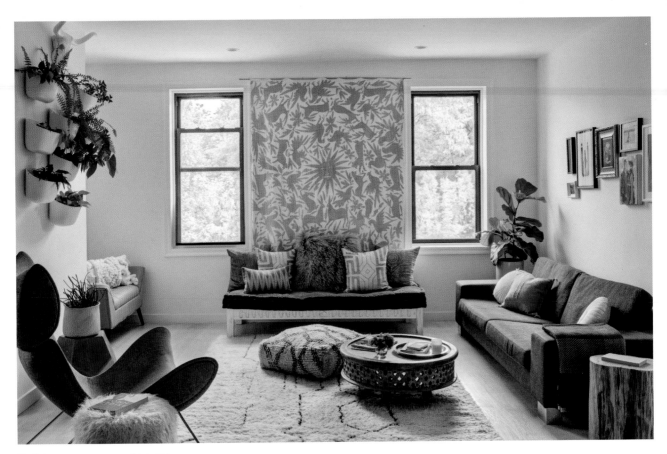

The living spaces were consolidated into a single large open room overlooking the park with a flexible living/dining space that could be cleared of furniture to allow for yoga sessions led by the owner of the apartment.

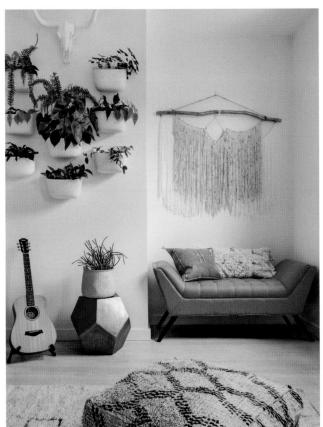

002

Using neutral colors and minimizing the use of partitions and doors create a layout that is as open as possible, with spaces that feel airy and spacious.

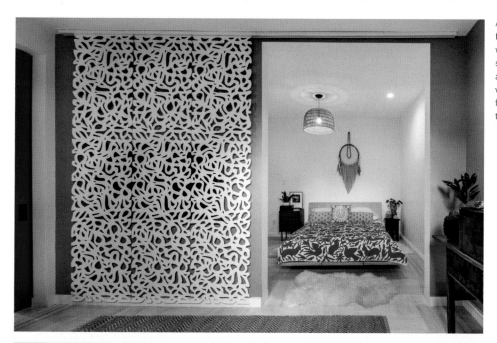

A barn door separates the master suite from the living spaces. The master suite was expanded into a room of layered spaces to create a small media room and a more secluded sleeping space. An open wood screen separates the sleeping space from the media room and conceals the television when it's not in use.

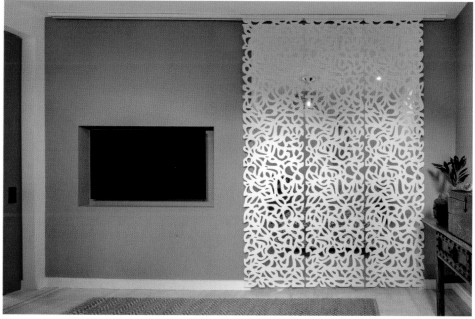

With windows on two walls, the kid's bedroom has panoramic views of the park and abundant natural lighting.

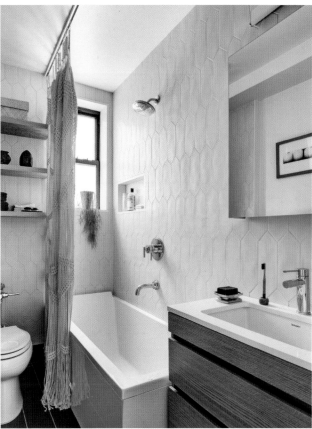

003

In small bathrooms, limit the use of materials and patterns in favor of a simple and understated scheme that makes it feel bright and soothing.

After several partial renovations over the years, this flat had a dark and busy 1990s feel. To accommodate new owners, it needed a transformation. The mandate was to create a new flexible space within a tight floor plan for the owners, who work from home. The aim was to reconfigure the layout, brighten the space, and restore some of the original features. Atelier SUWA created a central living space, which became a bridge between the sleeping quarters (located on the street side) and the home office (garden side). During the design process, Atelier SUWA worked closely with its clients to create a simple and warm environment with a curated selection of furniture and objects for their new home.

Hutchison Flat

1,150 sq ft
Montreal, Quebec, Canada

Atelier SUWA

Photographs © Élène Levasseur

Before renovation floor plan

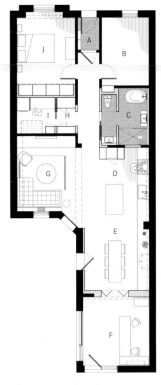

After renovation floor plan

A. Entry
B. Nursery
C. Bathroom
D. Kitchen
E. Dining area
F. Office
G. Living area
H. Closet
I. Laundry room
J. Bedroom

The central space—kitchen, and dining
and living areas—is structured by a long
marble counter, which accentuates the
linearity of the flat and consolidates
storage along one wall. Also, the
architects placed storage and a laundry
room opposing a powder room and
bathroom along the corridor, the least
bright section of the flat.

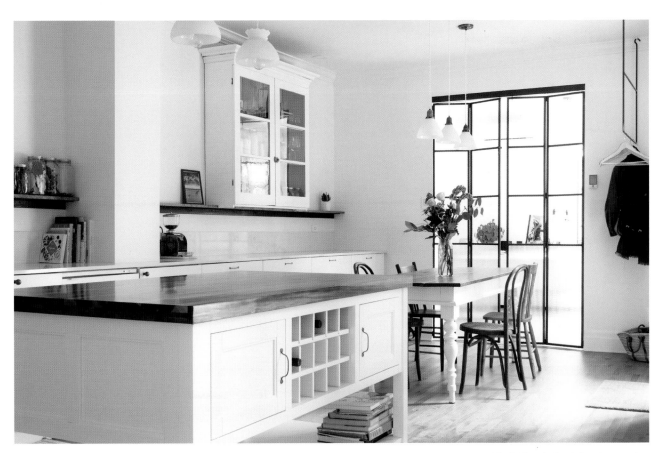

The folding steel and glass door creates fluidity between the workspace and the living areas while adding a second source of natural lighting to brighten up the center of the flat.

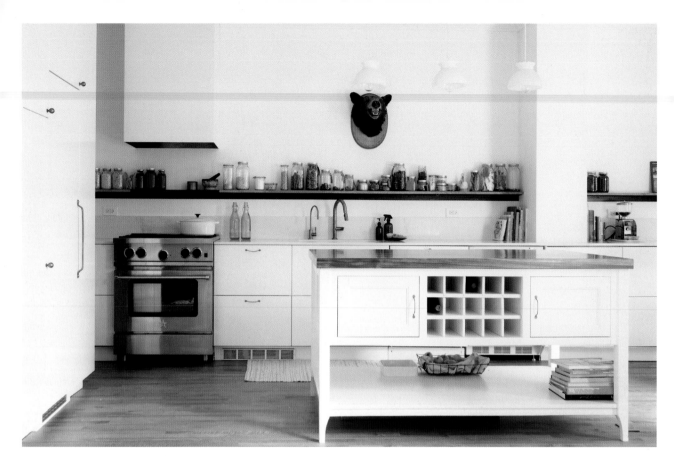

004

A combination of closed and open storage offers the right balance between order and visual appeal. While closed storage keeps the home neat and tidy, open storage offers the opportunity to display favorite pieces and provides easy access to the items used most often.

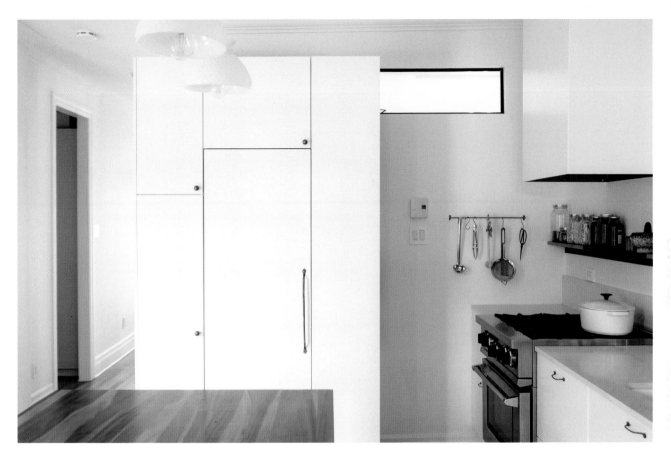

005

Built-in cabinets maximize storage and integrate seamlessly with the overall space design.

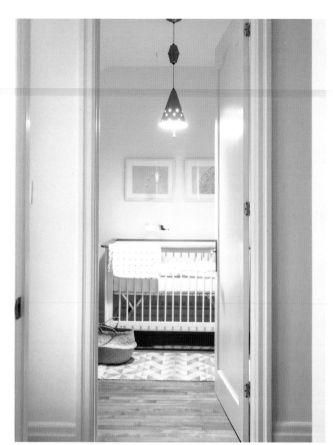
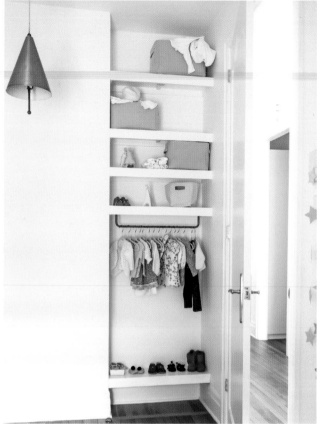

006

The design of small living spaces focuses on optimizing the use of space and providing storage solutions that bring organization, functionality, and spatial integrity to the home.

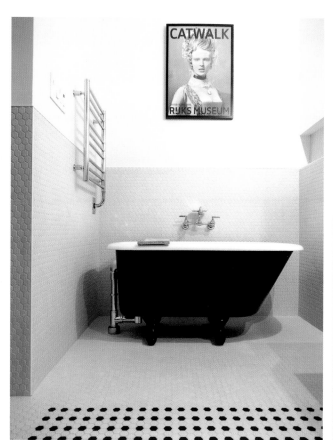

Special attention was paid to textures, motifs, and finishes to achieve an overall composition that speaks of the age of the building while staying current and fresh. Durable and classic materials were used and mixed with contemporary design and Victorian details. The goal was to create a timeless space that will age gracefully.

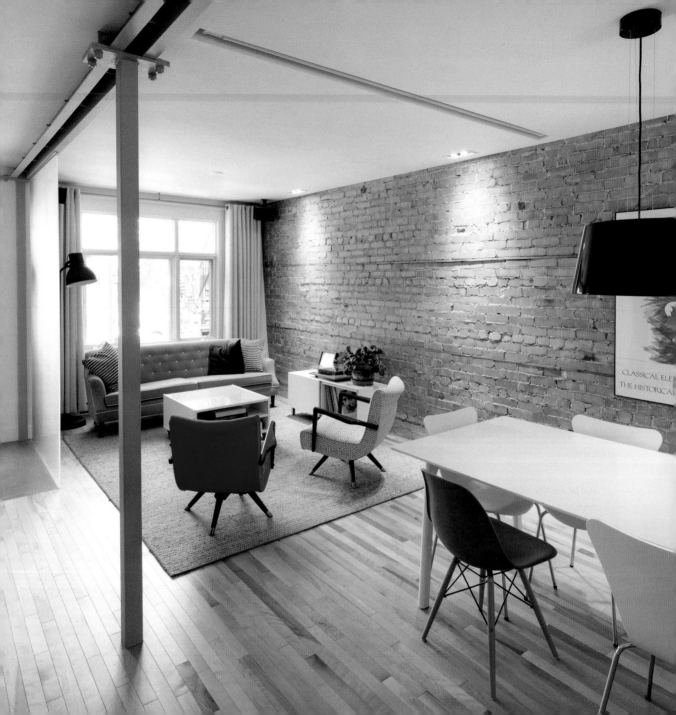

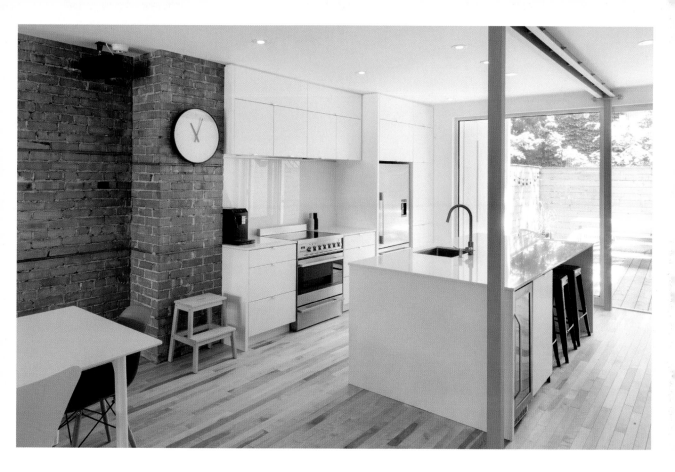

The project is a complete overhaul of a ground-floor apartment in a building dating back to 1924. The clients, a young family, wanted their new home to be airy, bright, and functional. The coherence of the new layout, the meticulous detailing, and the creation of a new outdoor area provide the family with a comfortable and private living environment in the heart of Quebec City. The demolition work revealed original surfaces such as a brick wall and a wood board–clad wall. They were integrated into the new design, creating focal points instead of being hidden behind new finishes. Similarly, some original architectural features such as door trims were maintained, giving a nod to the neighborhood's colonial character.

De Bougainville

895 sq ft

Quebec City, Quebec, Canada

Bourgeois / Lechasseur Architectes

Photographs © Adrien Williams

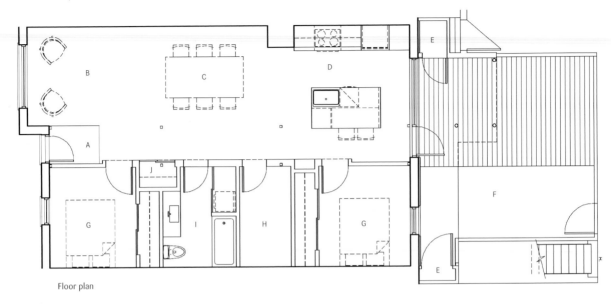

Floor plan

A. Entry
B. Living area
C. Dining area
D. Kitchen
E. Storage

F. Rear patio
G. Bedroom
H. Sewing room
I. Bathroom
J. Closet

The existing space was opened up to create ample spaces, including living areas that span the entire depth of the building's footprint. The rear facade was also opened up, connecting the interior spaces to a new, partially covered patio, ideal for outdoor dining.

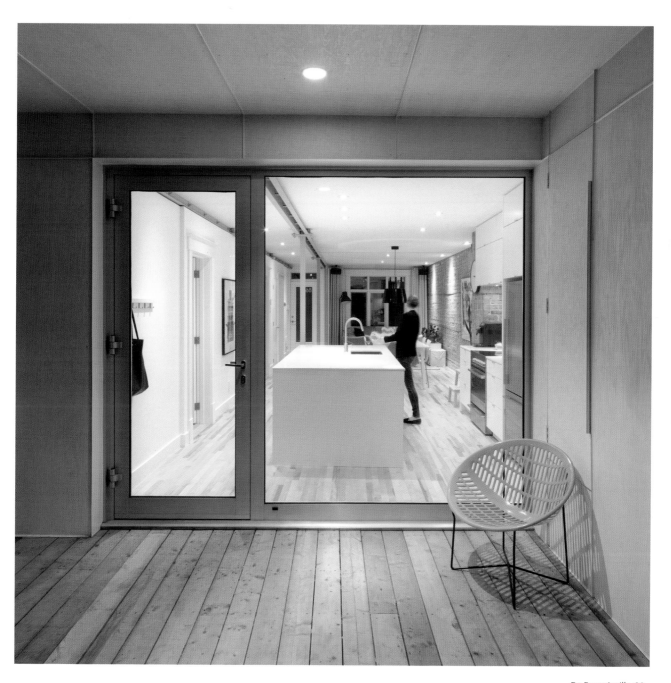

The kitchen design is simple and functional. The glossy white MDF and quartz countertops offer an understated presence, softly reflecting the light while allowing the brick wall and wood flooring to stand out and bring comfortable warmth.

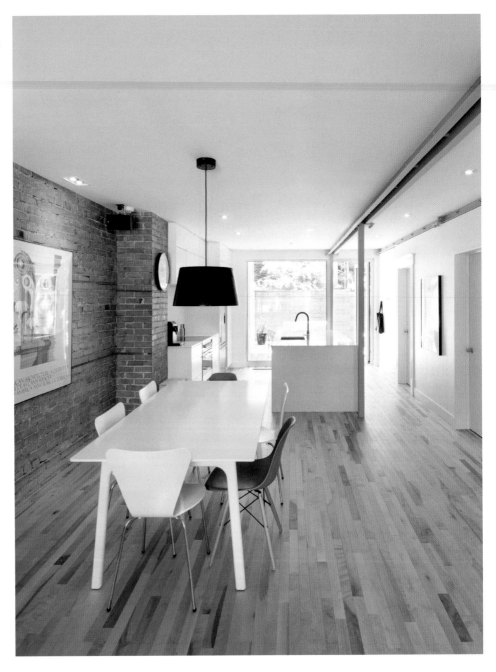

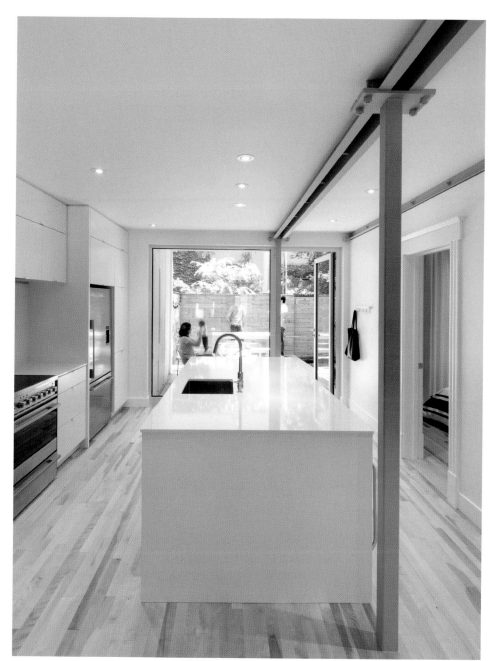

007

Structural elements such as steel columns and beams are widely used to open up spaces. When left exposed, they provide spaces with a modern and industrial appeal that harmonizes with sleek finishes such as polished concrete and glass, and rough, natural surfaces like stone, brick, and wood.

De Bougainville **31**

The demolition work also revealed
existing wood wall boards, which were
reused to create an accent wall in the
bedrooms, adding a warm touch.

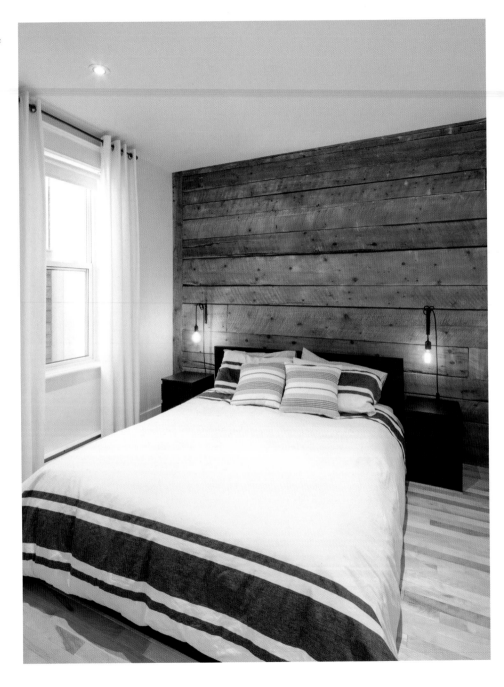

The salvaged wood boards were also reused to create a feature wall in the bathroom in contrast with the large, high-gloss white ceramic tiles covering the other three walls and the micro-cement flooring. The combination of materials gives the small bathroom a peaceful, timeless feel.

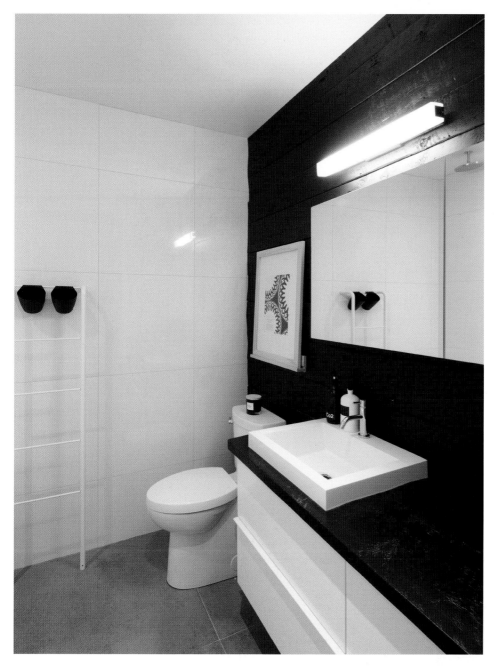

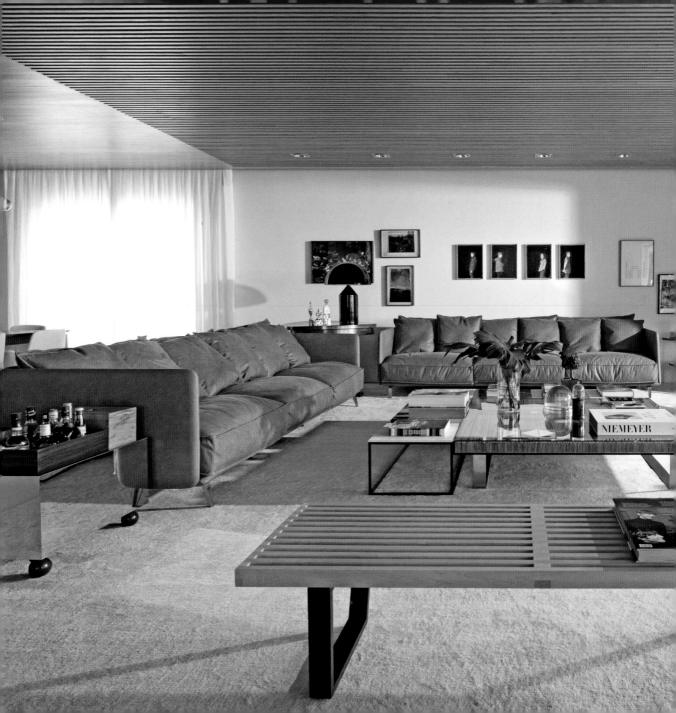

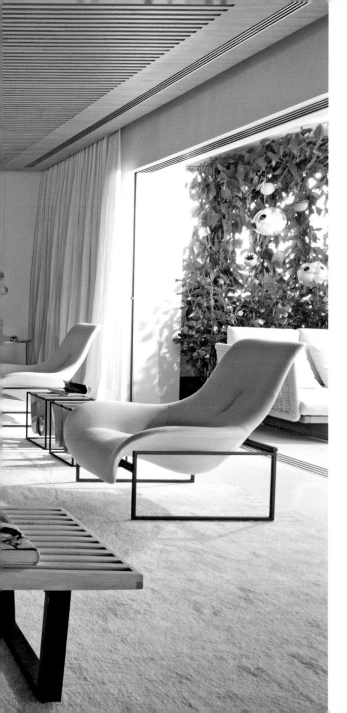

AQH Apartment

5,380 sq ft
São Paulo, Brazil

Coletivo Arquitetos

Photographs © Rui Teixeira

The AQH project presented the challenge of transforming a neoclassical apartment into a contemporary living space. The apartment was rethought to include spaces in tune with modern lifestyles and the taste of the new residents, a young couple with a passion for art and nature. The basic premise of the project was "living with art and garden," an idea reflected in the spaces, which feature both natural elements and design pieces. The owners' particular appreciation for spheres was used as inspiration for the selection of furnishings, light fixtures, and artwork. The many artists whose works are on display include Alex Katz, Vik Muniz, Abraham Palatinik, Ernesto Neto, Janaina Tschäpe, Leda Catunda, Nazareno, Alex Prager, and Ron Galella.

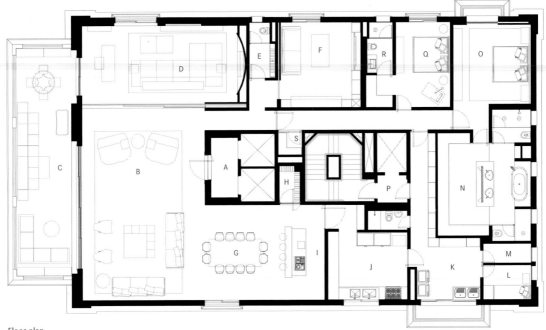

Floor plan

A. Entrance hall
B. Living area
C. Terrace
D. Home theater
E. Water closet

F. Office
G. Dining area
H. Cellar
I. Gourmet kitchen
J. Kitchen

K. Laundry room
L. Staff bedroom
M. Pantry
N. Master bathroom
O. Master bedroom

P. Service entrance
Q. Bedroom
R. Bathroom
S. Linen storage

Walls were knocked down, and the
interior was completely reorganized
to provide greater integration and
flow between spaces. Only two of the
original bedrooms were kept.

Used as non-permanent partitions, sliding panels can be designed to merge with the surrounding interior partitions. They offer flexible use of space, transforming both atmosphere and spatial perception.

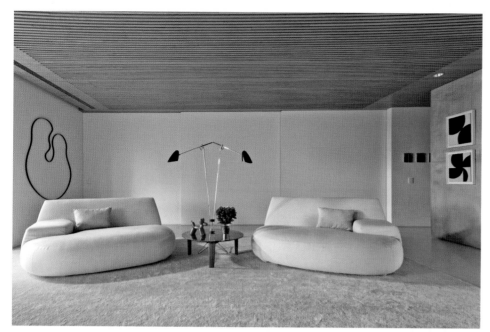

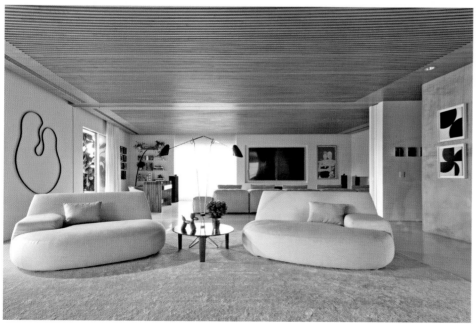

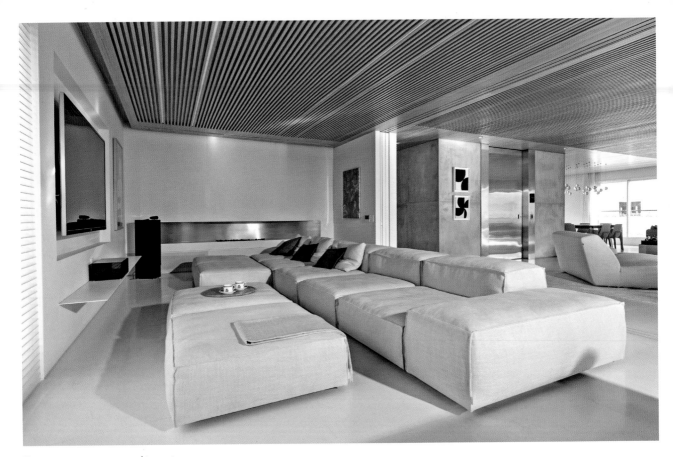

The concrete core was exposed to create
a showcase for a rotating selection of
artworks. Because the pieces hang from
steel cables, they can be easily changed
or moved.

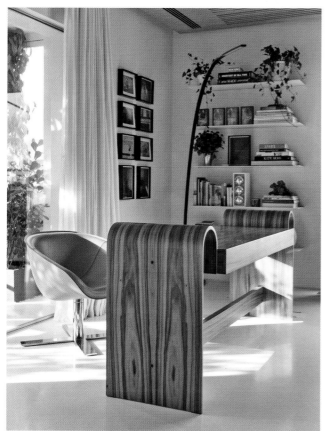
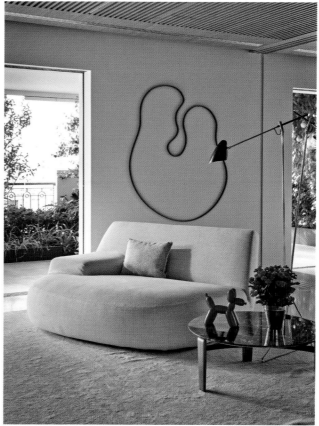

009

Furnishings, decorative accessories, and artwork can showcase personal aesthetics, tastefully expressing interests and reflecting one's personality.

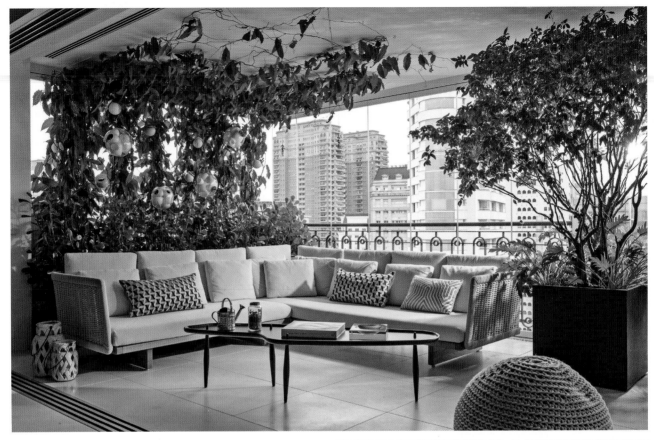

A balcony garden with fruit trees gives
the apartment the warmth and appeal
of a house and creates a buffer between
the living spaces and the city skyline.

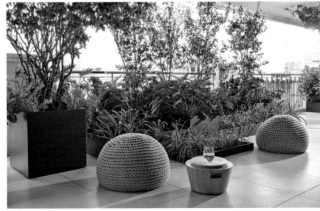

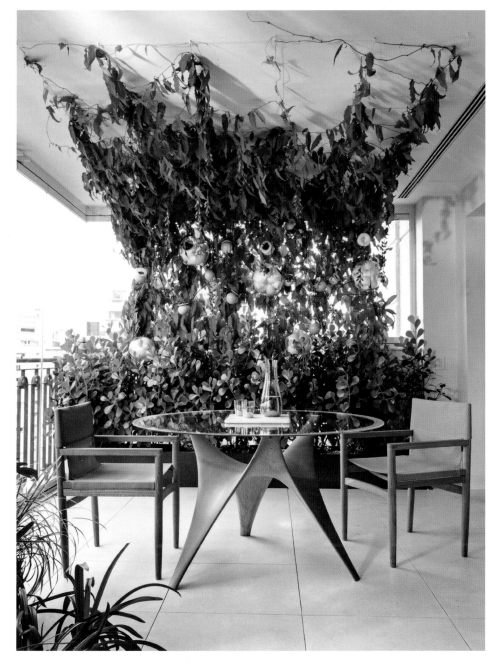

Balconies and terraces offer a gentle connection to urban environments. Ideal for entertaining and relaxing, they are an extension of interior living and dining spaces.

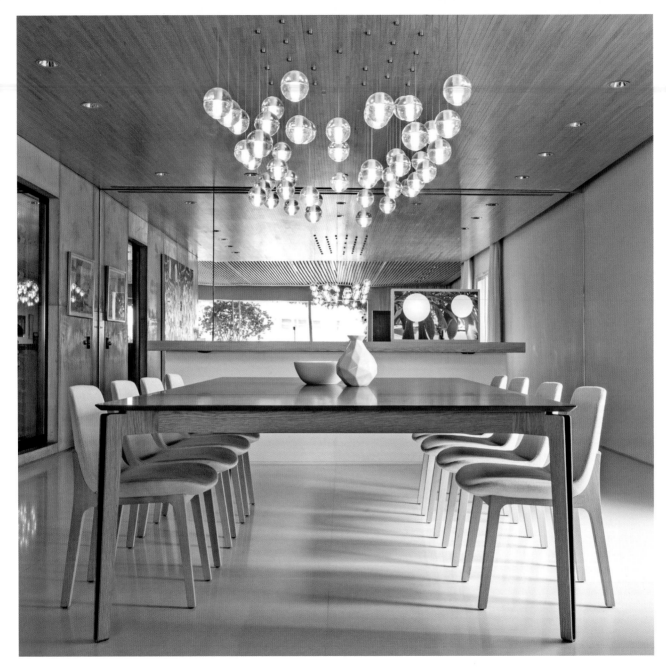

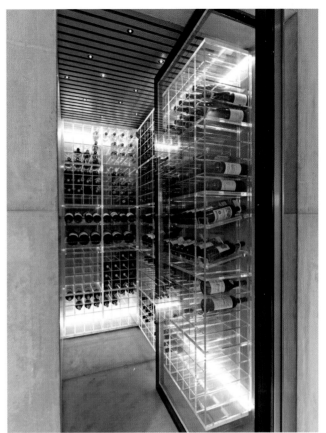

An opening in the concrete structure leads to a wine cellar with clear acrylic walls, making the wine a striking centerpiece.

Bathrooms and powder rooms have evolved from being strictly utilitarian to becoming rooms that offer limitless design opportunities. Materials, color, and lighting lend to design exploration and the creation of artful spaces.

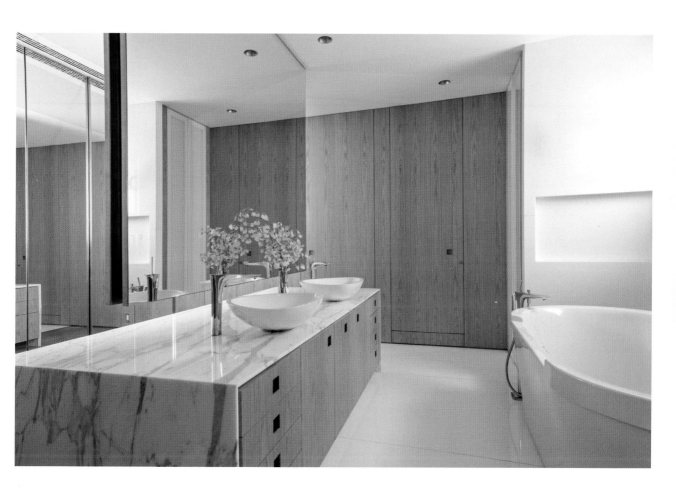

West Chelsea Apartment

520 sq ft

New York, New York,
United States

**BoND/Noam Dvir and
Daniel Rauchwerger**

Photographs © Eric Petschek

A dark and divided interior in West Chelsea was transformed into a bright, loftlike space. The apartment, whose layout is typical of that of many prewar apartments in New York City, occupies the third floor of a small 1910 apartment building. In its original layout, before BoND's intervention, the apartment was divided into three distinct sections: a living room, a bedroom, and a closed-off corridor connecting the two. The architects removed the partitions to create one continuous space, celebrating the apartment's elongated proportions. The renovation uses custom design details combined with off-the-shelf products. The fireplace, for example, is an original—and functioning—fixture of the apartment. Its brick core is wrapped by a cut-and-folded stainless steel sheet that gives the living room a contemporary edge.

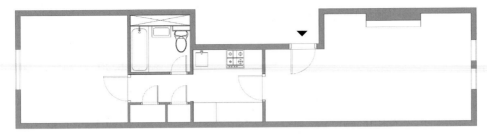

Before renovation floor plan

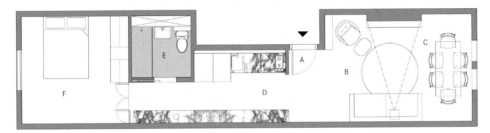

After renovation floor plan

A. Entry D. Kitchen
B. Living area E. Bathroom
C. Dining area F. Bedroom

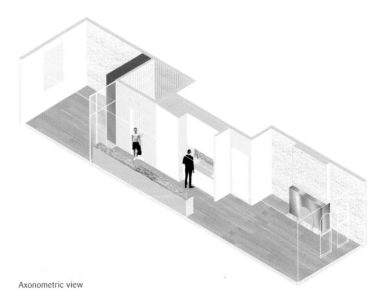

Axonometric view

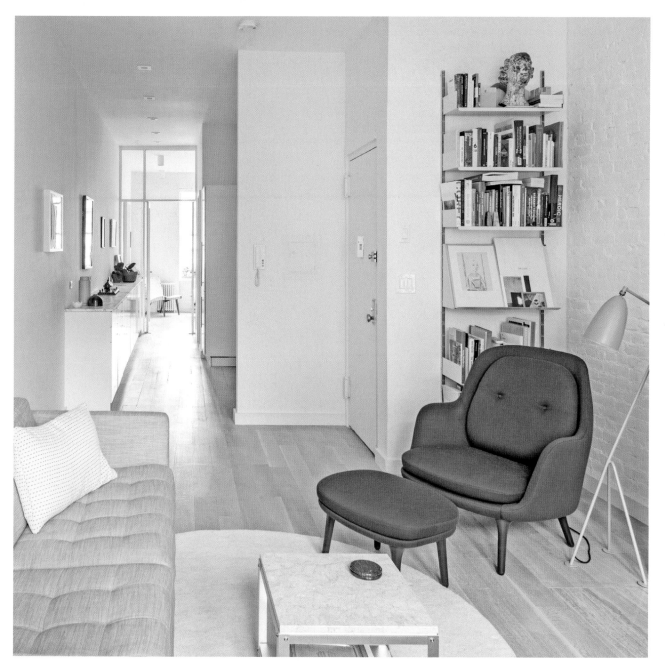

The linearity of the floor plan is enhanced by a series of inset lighting fixtures that extend from the kitchen into the bedroom, and a wood floor pattern that highlights the length rather than the width of the space.

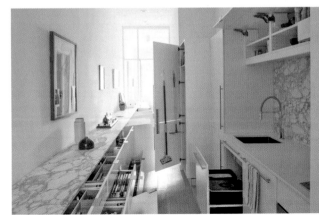

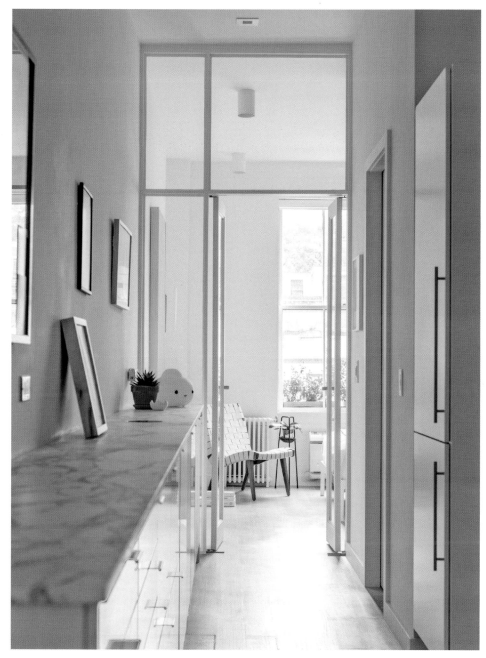

The renovation created a clear distinction between the western wall where the apartment's utilities, services, and hardware are located and the eastern wall, which was left blank to provide room for art display.

012

Storage is essential in the remodeling market. While the design of closets is an art and science of its own, efficient use of the available space is a top priority.

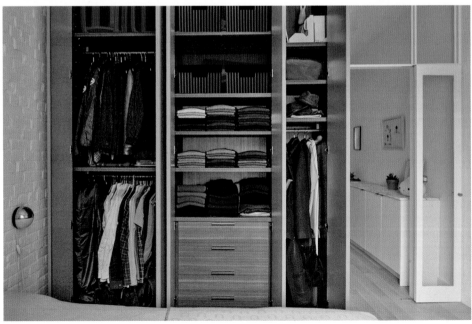

A neutral color and material scheme ensures a timeless design that ages well. It can act as a foundation where details can change to provide the overall design with subtle variations.

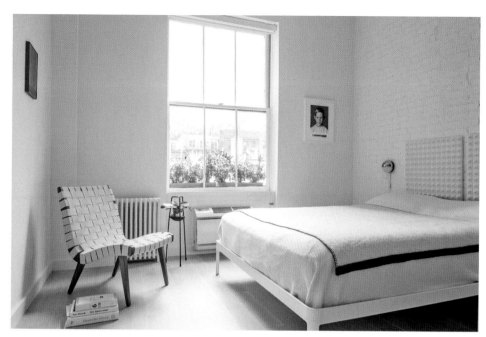

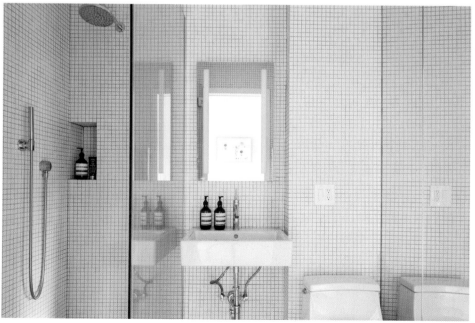

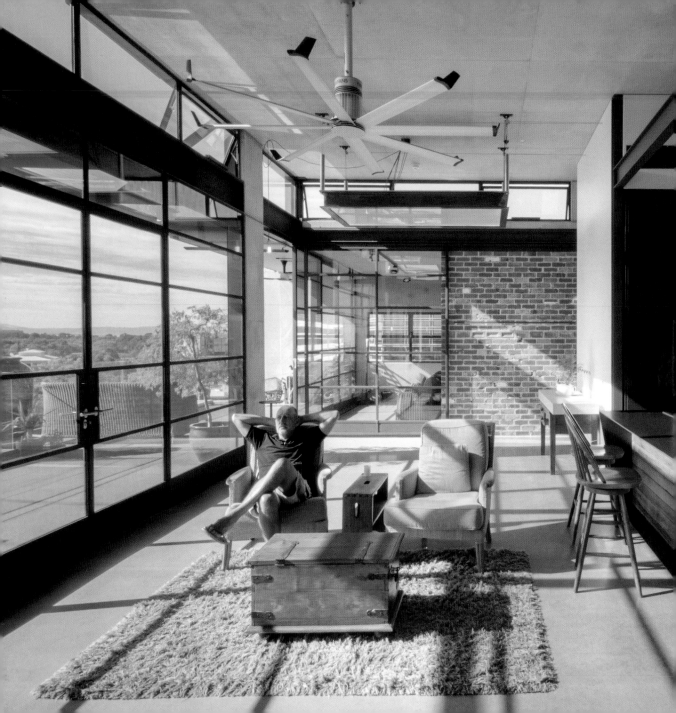

TJ House

1,755 sq ft

Canberra, Australian Capital
Territory, Australia

Ben Walker Architects

Photographs © Lightstudies

The project comprised the furnishing and equipment of a
residential apartment in a new building in one of Canberra's
busiest precincts with wonderful eastern views across the
suburbs of Ainslie and Braddon and to the Parliament House
to the south. Each room captures a view of a major Canberra
landmark, providing a great sense of being within the capital.
The project was a team effort between clients and builder,
joiner, architect, and carpenters. The clients' clear vision for the
character of the space led to the detailing and material choice.
Rooms are divided more by joinery elements than by traditional
walls, allowing most of the apartment to read as a single space,
which retains a great sense of volume and light. The elements
defining rooms include recycled timber joinery units, recycled
brick and steel walls, and sliding glass panels.

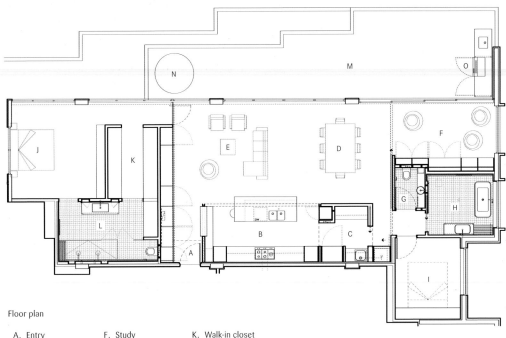

Floor plan

A. Entry
B. Kitchen
C. Laundry/Pantry
D. Dining area
E. Living area
F. Study
G. Powder room
H. Bathroom
I. Guest bedroom
J. Bedroom
K. Walk-in closet
L. Ensuite
M. Balcony
N. Spa
O. Outdoor kitchen

Rooms are designed as flexible spaces.
The study has a large steel and glass
sliding door that can be used to open or
close that space from the main living
area, for instance.

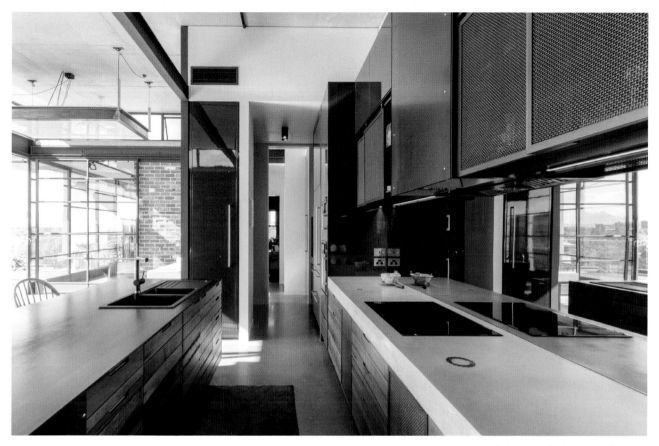

The kitchen is the focal point of the apartment—it is in the center of the layout and has visual connections to the other primary living zones, and out to the east towards Mount Ainslie.

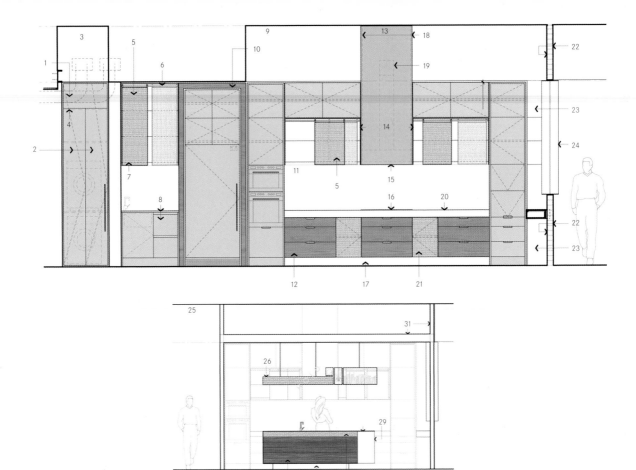

Kitchen elevations

1. Zone above cabinets for reticulation of ducting
2. Bifold joinery doors
3. Plasterboard bulkhead over cabinets only
4. Top of cabinets behind bifold doors
5. Sliding steel mesh screens in 20 x 6 mm thick flat steel frame
6. 2 of 20 x 6 mm thick steel bar runners for rolling tracks
7. Steel plate shelves in steel box surround
8. Painted top sides and drawer/cabinet fronts
9. Concrete beam
10. Solid timber surround

11. Mirror backsplash
12. Solid timber drawer fronts
13. 4 mm thick steel plate cover
14. Steel plate box with steel plate shelves
15. Range hood behind steel plate cover
16. Cooktop
17. Recessed kick
18. 25 x 25 mm steel angle range cover
19. Duct range hood to outside through concrete beam
20. Concrete bench
21. Steel mesh cabinet fronts in 32 x 6 mm thick flat steel frame

22. Face of brickwork
23. Mirror on the wall
24. Steel plate surround
25. Plasterboard wall
26. Steel mesh light box
27. Solid timber fronts. Timber to continue around north face of bench
28. Recessed mirror kick
29. Steel plate to top, sides, and bottom
30. Steel mesh cover, continuous T5 light behind. Mesh to continue around north face of bench
31. Steel beams and columns

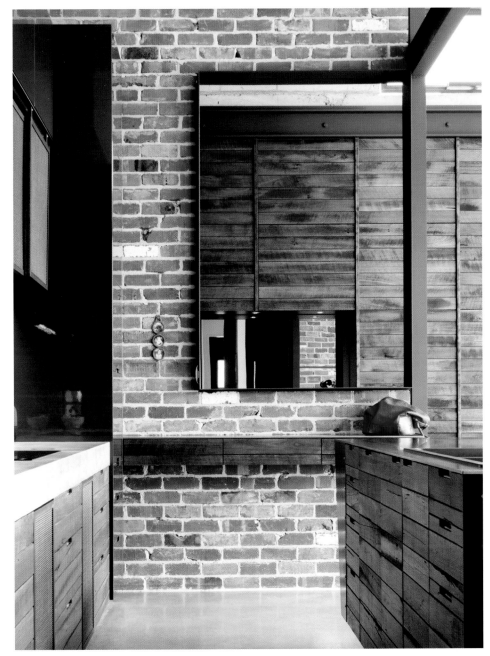

The apartment has an industrial character reminiscent of the old workshops common throughout Braddon in years gone by. The steel plate, concrete, glass, recycled brick, and timber combine to give a contemporary and distinct character. A high level of precision and craftsmanship is evident in all elements.

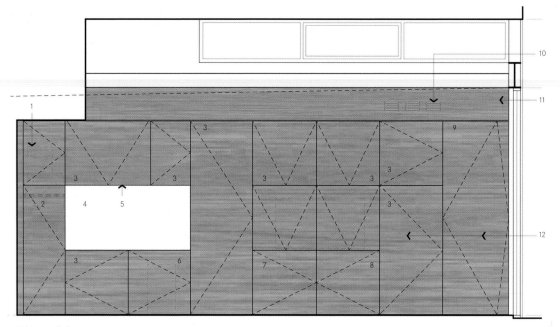

Cabinet wall elevation

1. Water meter and gas valve in cabinet
2. Coat
3. Storage
4. Mirror
5. LED strip light in recess pelmet above mirror
6. Manifold
7. Visual
8. Audio
9. Pivot door
10. Routed slots for A/C outlet, black mesh behind slots
11. Timber joinery to continue up in front of the concrete beam
12. Horizontal timber boards across joinery unit

The mix of materials used provides a rich and interesting visual quality, offering a sense of discovery as one moves between rooms and sees a different material used as a wall, joinery element, or screen.

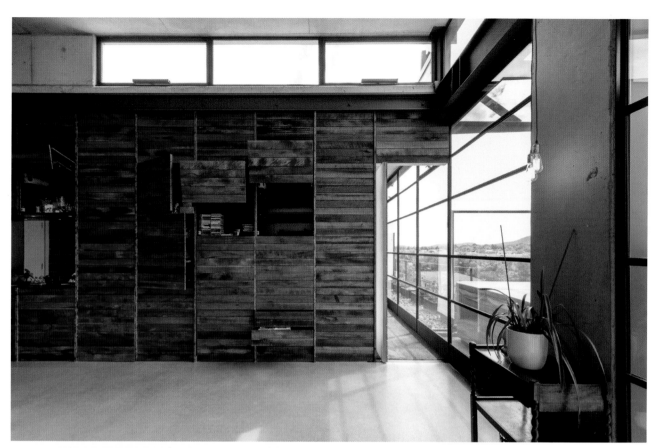

014

Built-in cabinetry works well as room divider and is a creative alternative to conventional walls. It offers plenty of design opportunities to satisfy functional needs while adapting to the desired design aesthetics. It can combine bookcases, closed cabinets, and even pass-through openings that add depth to the rooms.

No room is more suitable for a specific design aesthetic than another, whether it's a living room, a kitchen, or a bathroom. However, each might require a different approach to the use of materials.

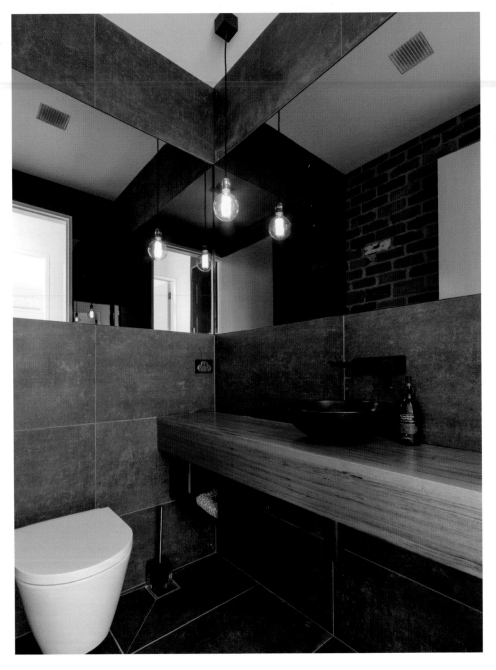

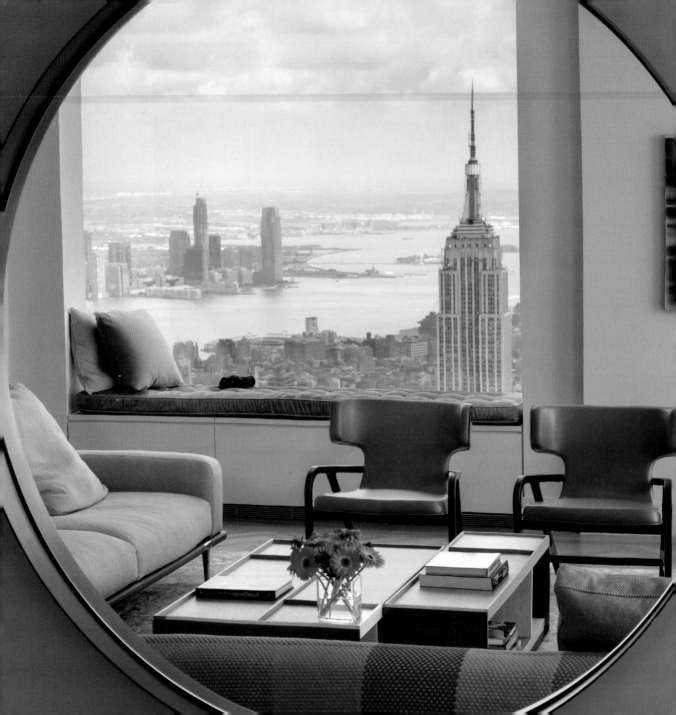

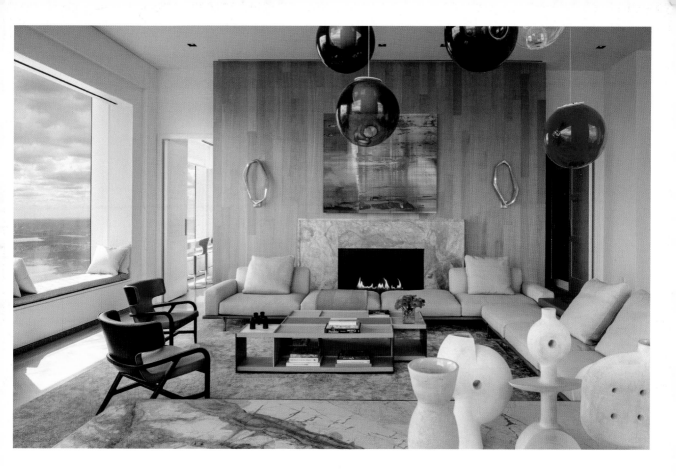

This apartment is on one of the highest floors of what is considered the tallest residential tower in the western hemisphere and has some of the most amazing views of Manhattan. Designed by John Beckmann and his design firm Axis Mundi, the apartment celebrates city living and sophistication while articulating an energetic sense of place. Known for its glamorous low-slung aesthetic, Axis Mundi took on the challenge to design the residence for an American client with a family of four living in China. The design highlights an important art collection including works of Cy Twombly, Gerhard Richter, Suzan Frecon, Vik Muniz, and Lisette Schumacher, among others.

432 Park Avenue

4,000 sq ft
New York, New York,
United States

Axis Mundi Design

Photographs © Durston Saylor

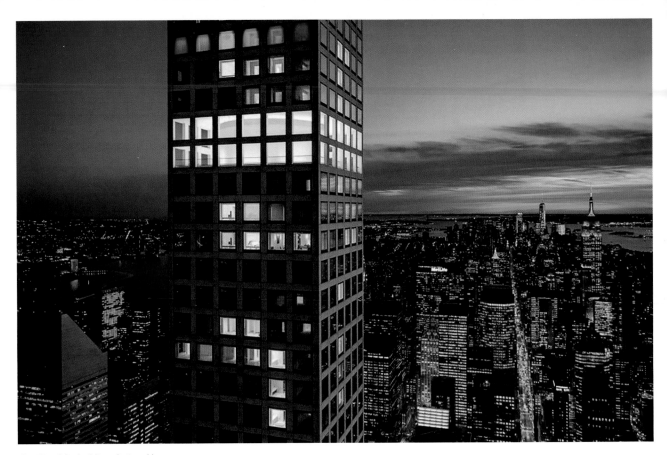

The skin of the building, designed by
architect Rafael Viñoly, is treated with an
LED lighting system that changes colors.
The client can control the system from
the street with their iPhone.

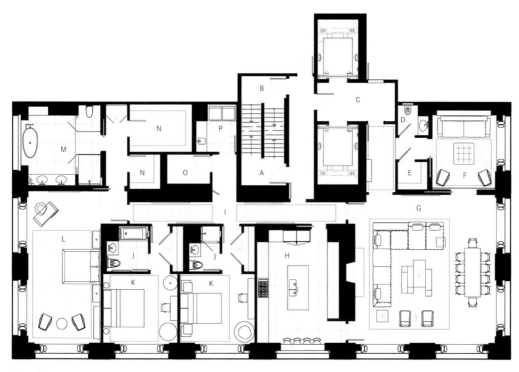

Floor plan

A. Staircase A
B. Staircase B
C. Elevator lobby
D. Powder room
E. Closet
F. Library

G. Living and
 dining area
H. Kitchen
I. Gallery
J. Bathroom
K. Bedroom

L. Master bedroom
M. Master bathroom
N. Walk-in closet
O. Storage
P. Laundry room

Bright and airy, the dining room features a Bocci "28 Chandelier" above an intricate marble and brass "Stealth" table by Henge. In the main living room, a sectional from Poltrona Frau and armchairs in saddle leather by Antonio Citterio for B&B Italia around a coffee table designed by Vincent Van Duysen, create a perfect space for entertaining. In contrast with the airy feel of the living and dining areas, the library exudes a sensuous atmosphere, featuring custom-designed bookshelves in burnished brass and walnut.

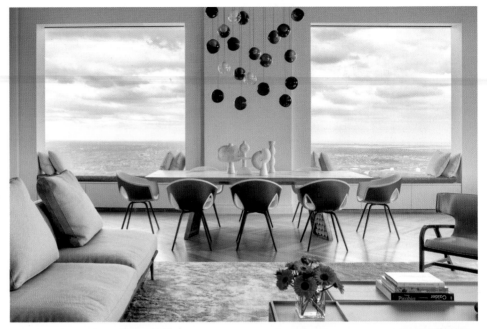

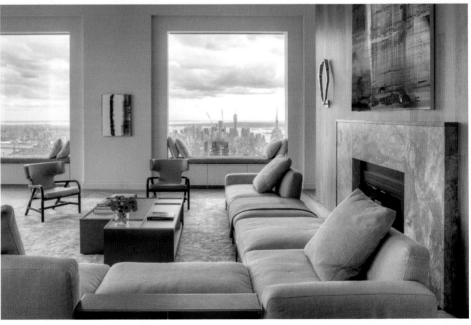

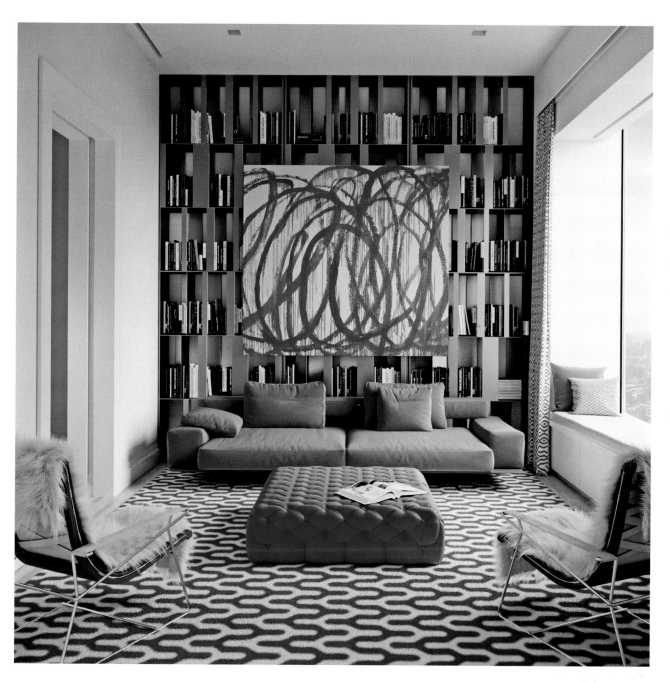

016

The studio focuses on the rich vocabulary of the design and materials, incorporating concepts and technologies that create stimulating forms of expression that fill spaces with character.

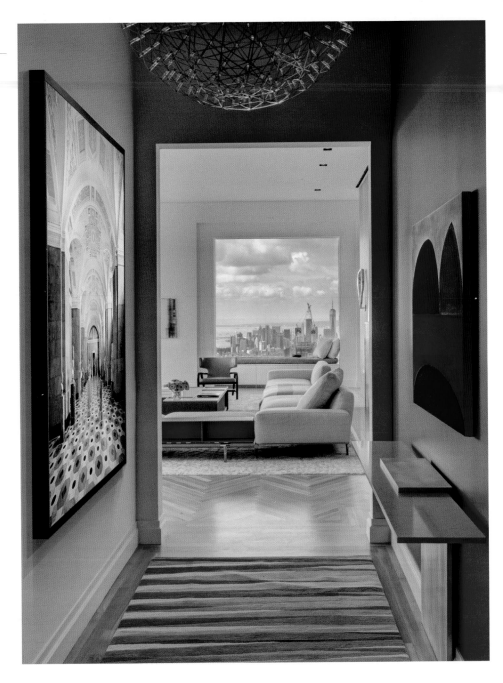

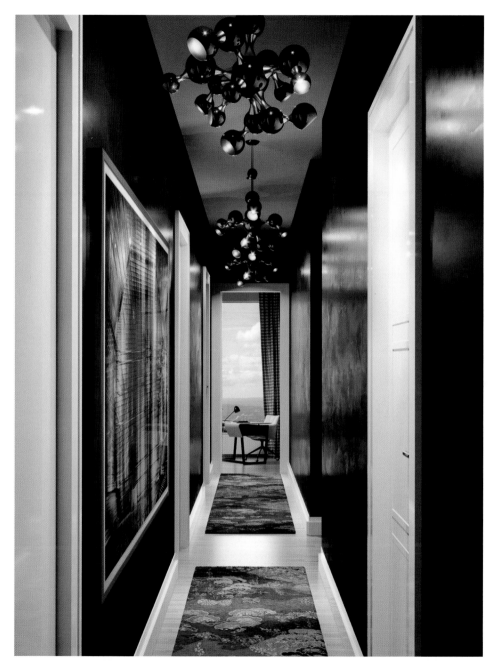

Axis Mundi made the gallery dark by finishing the walls in a smoked lacquered plaster with hints of mica, which add sparkle and glitter.

The kitchen accentuates the gray marble flooring and all-white color palette, which is broken only by some light wood and marble details. A dramatic pendant in hand-burnished brass, "Tubular Horizontal," designed by Henge, hovers above the kitchen island, while a floating marble counter spans the window opening.

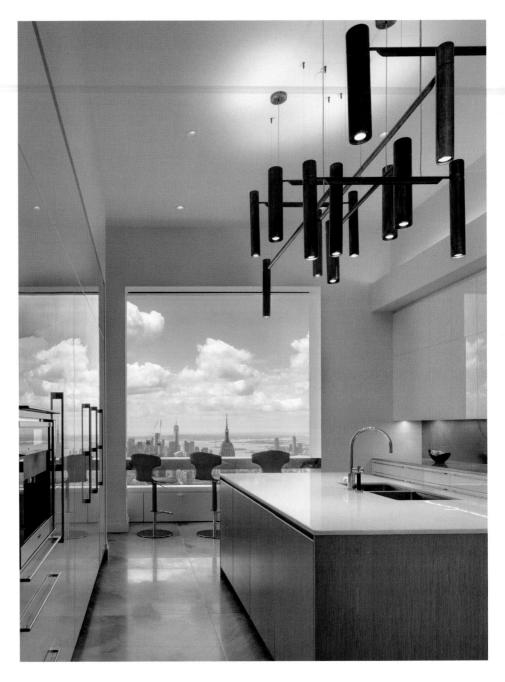

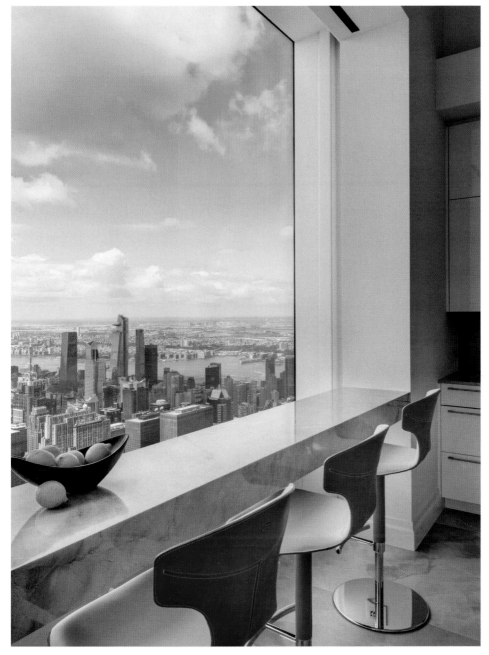

Views are an integral part of an architecture and interior design project. They can guide the layout of rooms so residents can enjoy the ever-changing urban skyline.

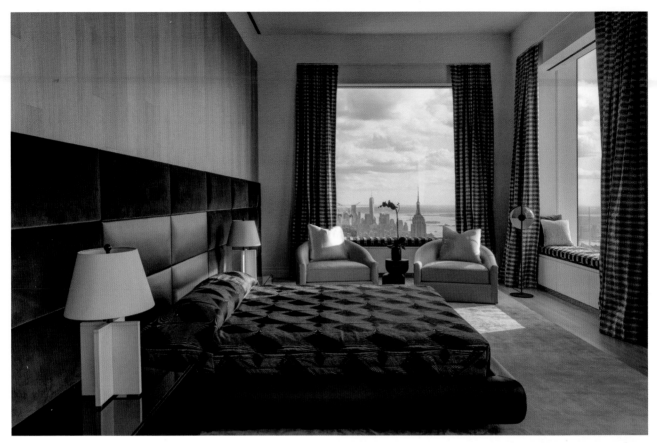

The master bedroom features a wall-length headboard system in leather and velvet panels from Poliform. Dupré-Lafon lounge chairs in a buttery leather on a custom golden silk carpet by Joseph Carini and a pair of parchment bedside lamps by Jean-Michel Frank complete the design.

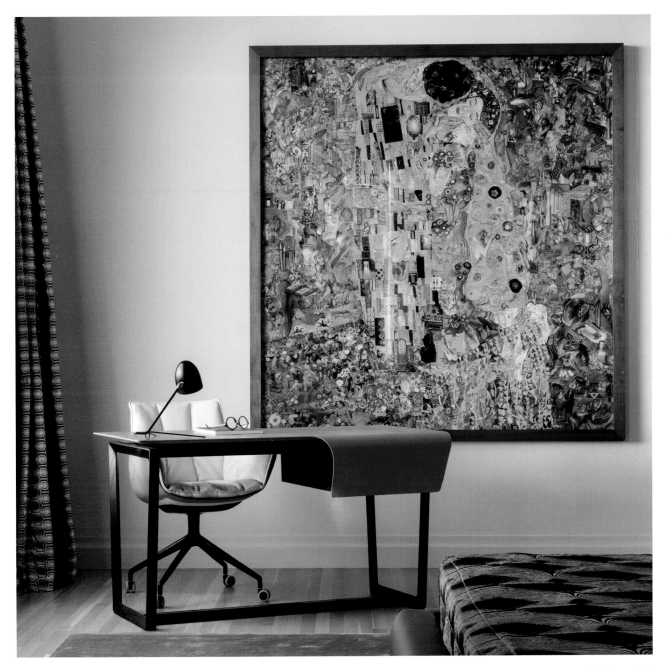

018

Clean architectural details paired with bold statement furnishings and materials provide any room with character, reflecting the tastes and personality of the owners.

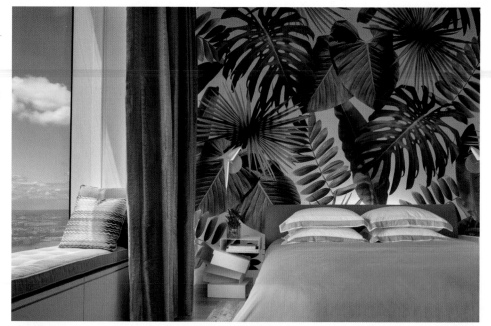

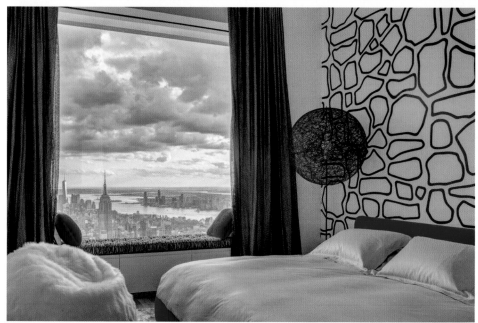

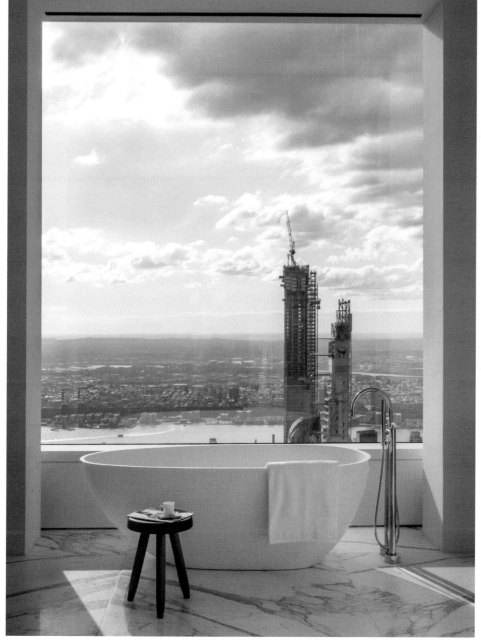

Picture windows are the perfect frame for extraordinary views, bringing the outdoors into the home as a living artwork.

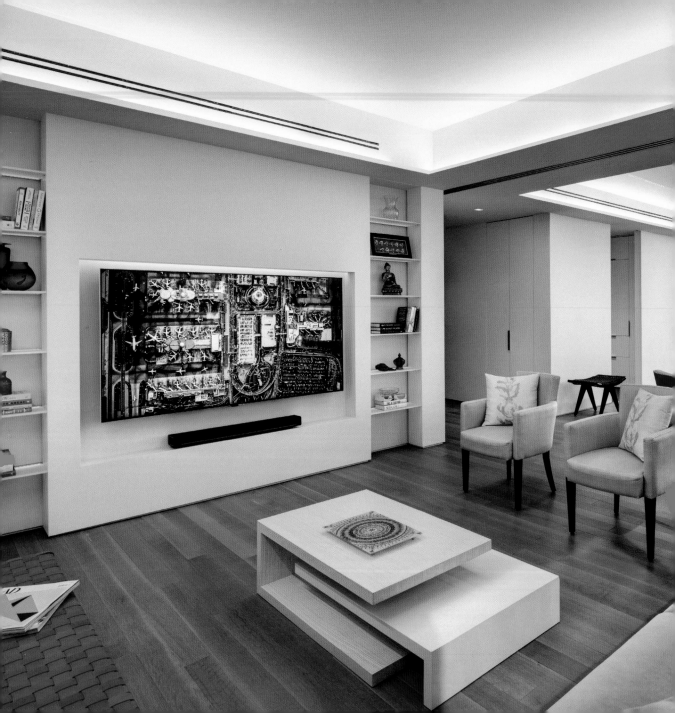

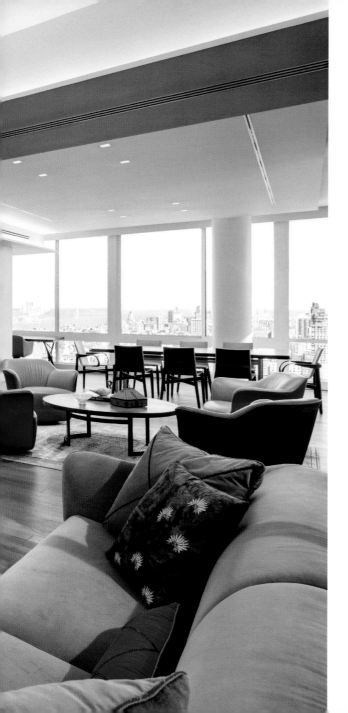

Lincoln Square Alteration

1,600 sq ft

New York, New York,
United States

Lilian H. Weinreich Architects

Photographs © Francis
Dzikowski Photography

This high-rise apartment occupies a corner site with mesmerizing, panoramic views of the city, park, and river. It is in New York's Lincoln Square neighborhood on the Upper West Side in a prominent and prestigious postwar high-rise condo building. The clients, an international couple who have lived in many locations around the world, envisioned a living environment designed according to feng shui principles. Their commitment to feng shui influenced the selection of the apartment and also informed the alteration program for the two-bedroom, three-full-bath unit. Feng shui design dictated the orientation and functional layout of the apartment to harmonize with spiritual forces: the yin and yang and the flow of energies (chi) that have positive and negative effects.

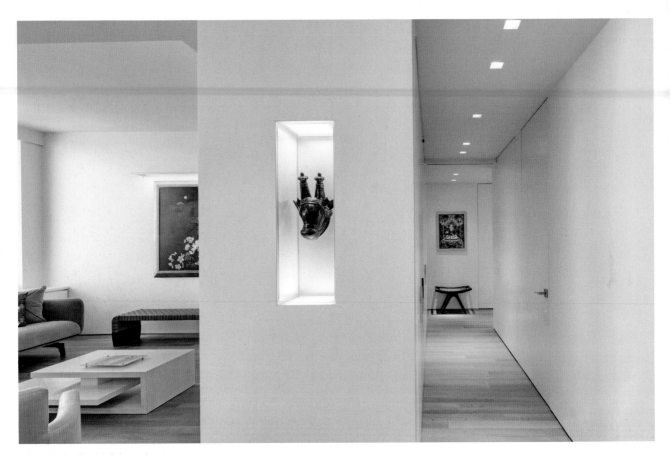

In line with the client's beliefs, a welcoming mask floats in a northeast-facing, lit niche at the central axis of the apartment to protect the occupants from evil spirits.

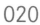

The den area can be separated from the main living/dining areas and serve as a guest bedroom with a series of three interlocked translucent sliding panels that span twenty-six feet. When not needed, the panels stack neatly and unobtrusively at the entry.

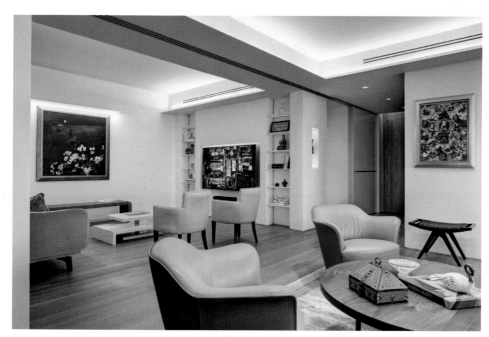

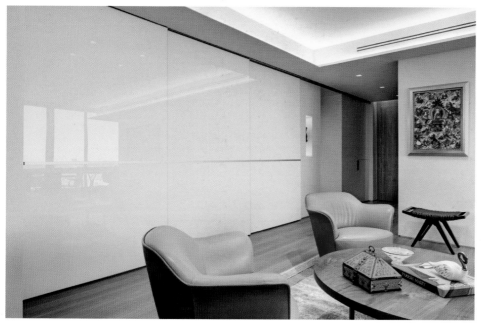

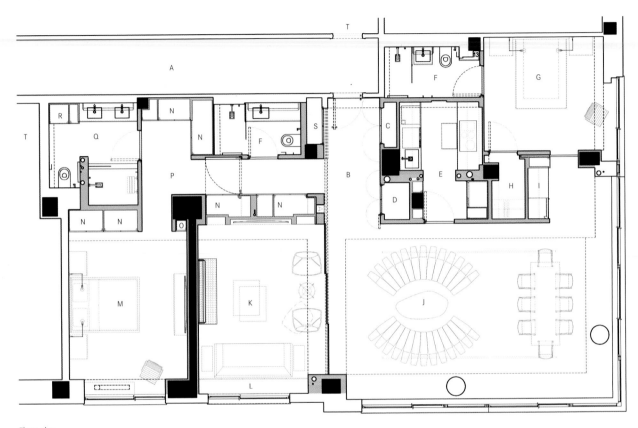

Floor plan

A. Public hall 43rd floor
B. Entry gallery
C. Coats/shoes
D. Laundry closet
E. Kitchen
F. Bathroom
G. Bedroom
H. Closet/exterior
 condenser unit
I. Dry bar/servery
J. Living/dining room

K. Den/flex-bed
L. Ceiling-hung air handlers;
 two-zone central A/C system
M. Master bedroom
N. Closet
O. Ironing board
P. Master bedroom hall
Q. Master bathroom
R. Medicine cabinet
S. A/V closet
T. Adjacent apartment

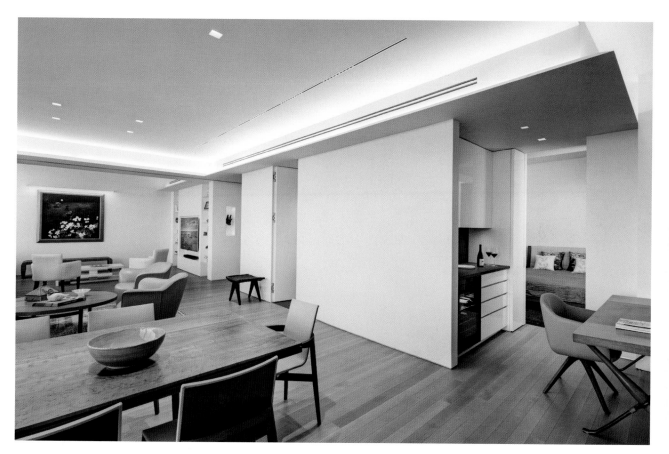

021

The layout is based on an eight-directional axis that guides functional relationships, creating open and clutter-free spaces. An abundance of storage and closets adds to a visually clean, relaxing environment.

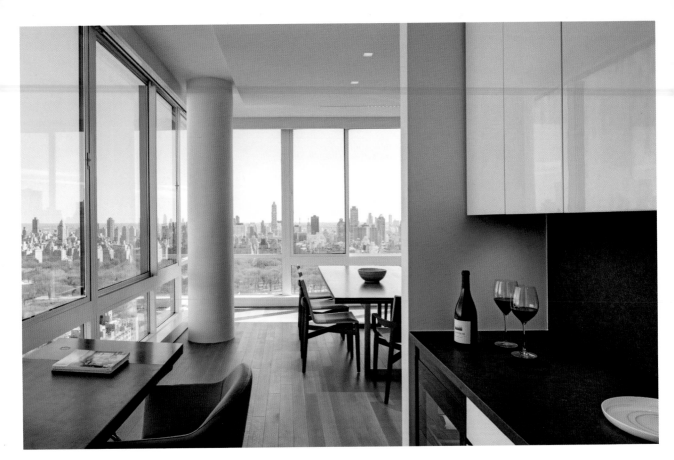

022

Large floor-to-ceiling windows
ensure a maximum amount of
natural daylight, while operable
windows in the right locations
allow for excellent airflow.

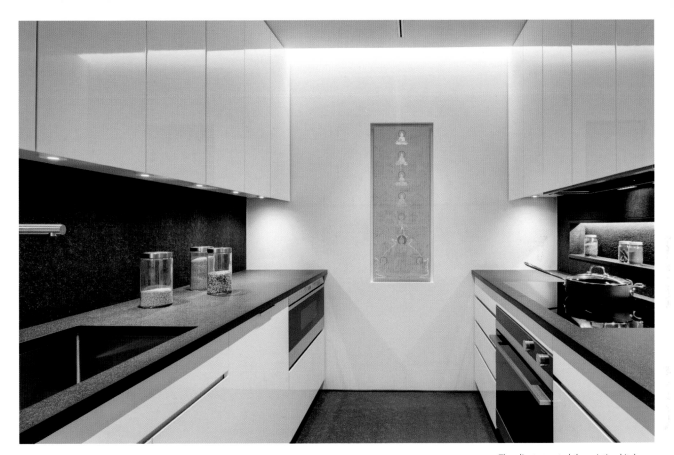

The clients wanted the existing kitchen, open to the center of the main living area, to be relocated and hidden from sight. Preconstructive examining probes located pipes in a building chase with sufficient space to allow for a new, efficient walk-through galley kitchen with direct access to the dining area.

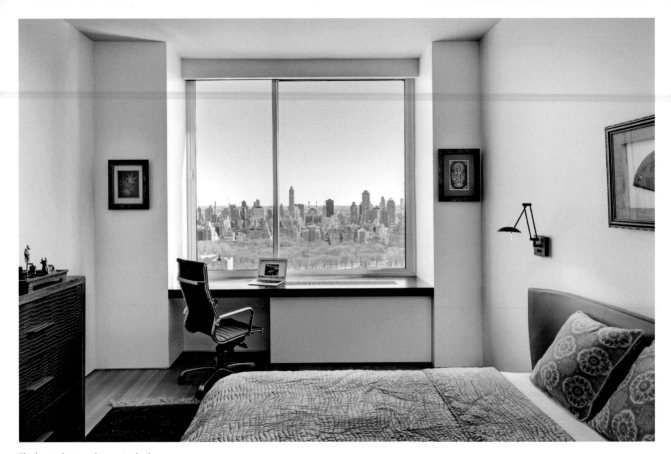

The layout locates the master bedroom
in the southwest quadrant for strength
in love and marriage. A desk placed in
the apartment's career sector faces the
Hudson River, a moving water element
at true north.

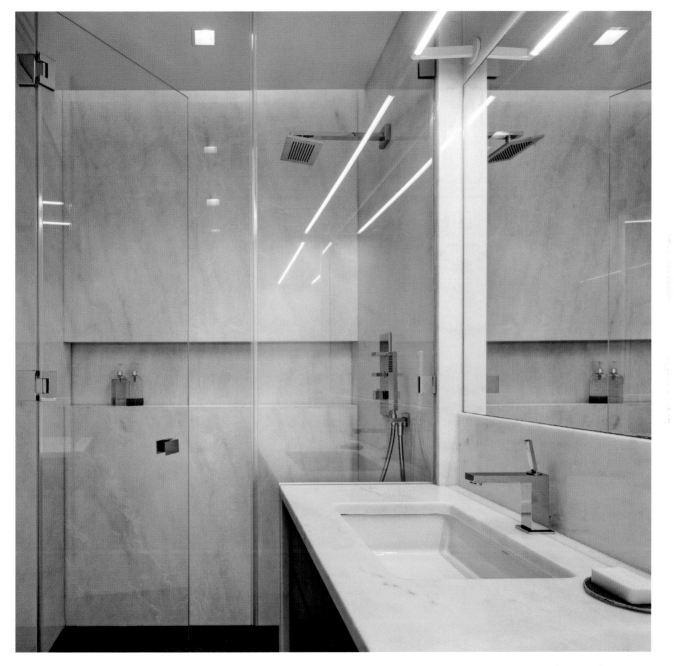

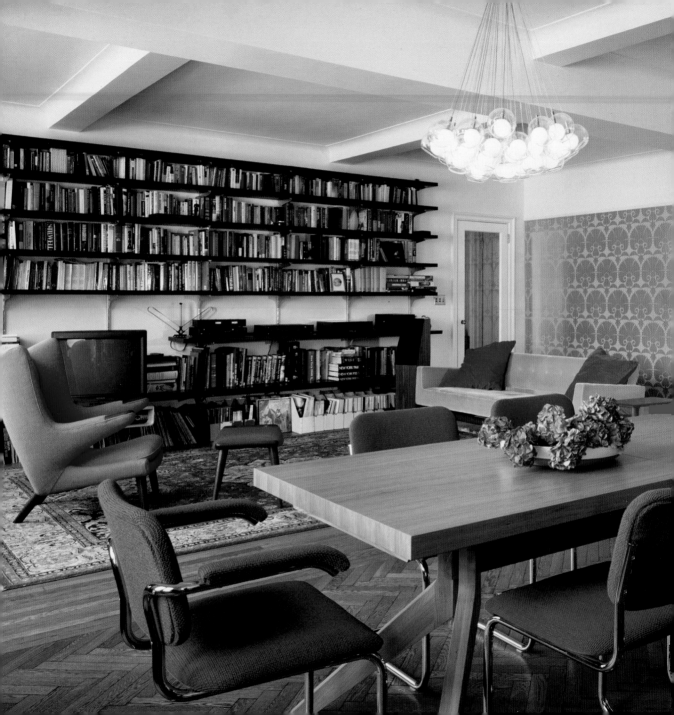

Manhattan Valley Apartment

1,800 sq ft

New York, New York,
United States

Delson or Sherman Architects

Photographs © Catherine Tigue

A tortuous prewar apartment with awkward corners and tight rooms becomes an open loft that subtly highlights its past. The new interior preserves and enhances the building's original features while providing a contemporary living environment. Endless crooked walls were straightened out, and the new configuration creates more usable rooms and improved circulation in general. Vestigial flooring patterns visible in the new space reveal the ghosts of walls removed, celebrating the history of the building.

023

A lively design breathes new life into an over-compartmentalized home, opening up the common areas and concealing all utility rooms in favor of a clearer layout that is as suitable for living as it is for entertaining.

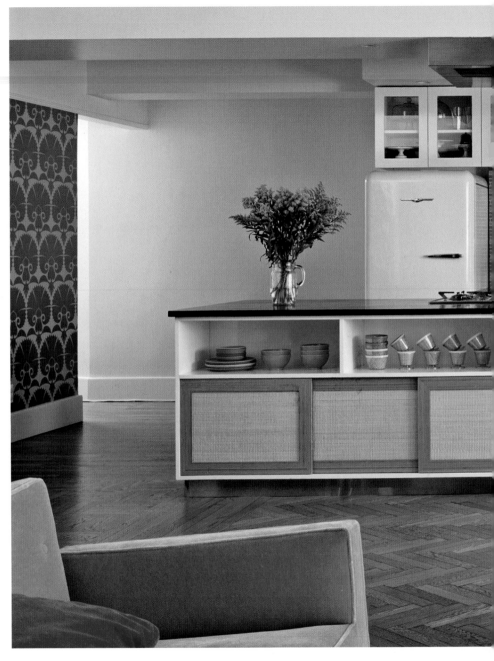

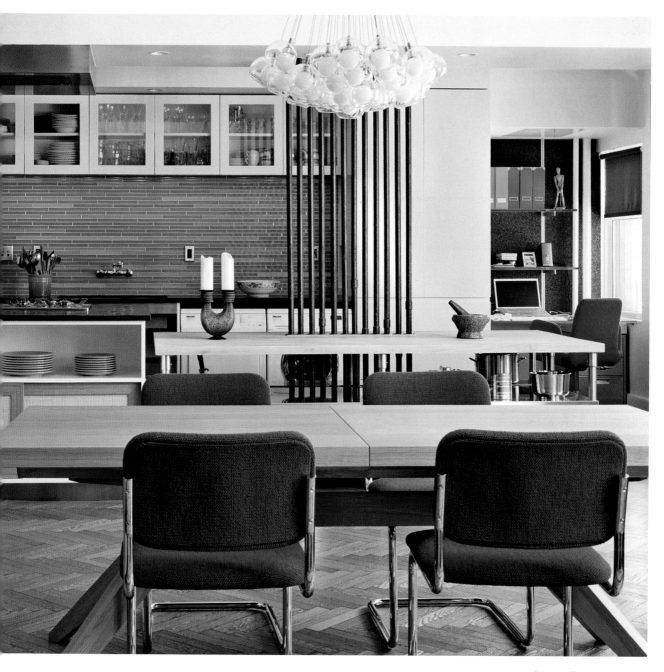

A wall full of gas risers could have thwarted an open kitchen, but instead, the design exposes the pipes, tailoring the island around them, and using them as a decorative screen.

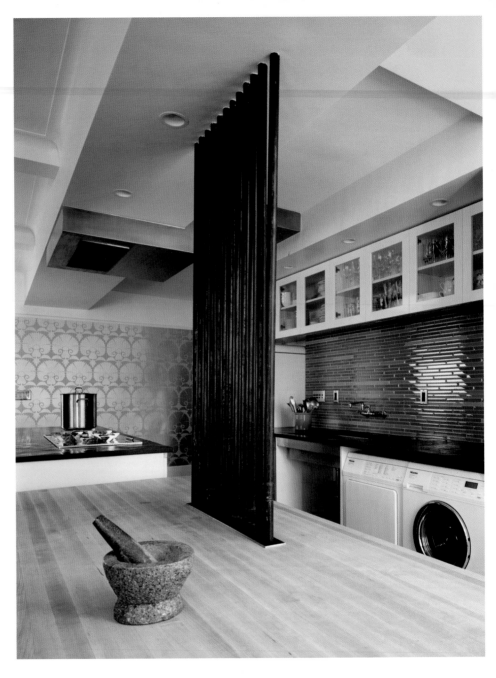

Demolition plan

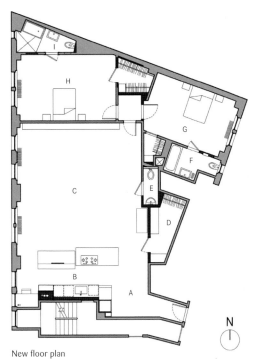

New floor plan

A. Foyer
B. Kitchen
C. Living/dining area
D. Storage
E. Powder room
F. Bathroom
G. Bedroom
H. Master bedroom
I. Master bathroom

N

A crooked hallway was removed, and its space was lent to create usable rooms. Straightening its kinked wall provided extra space for a powder room and storage room.

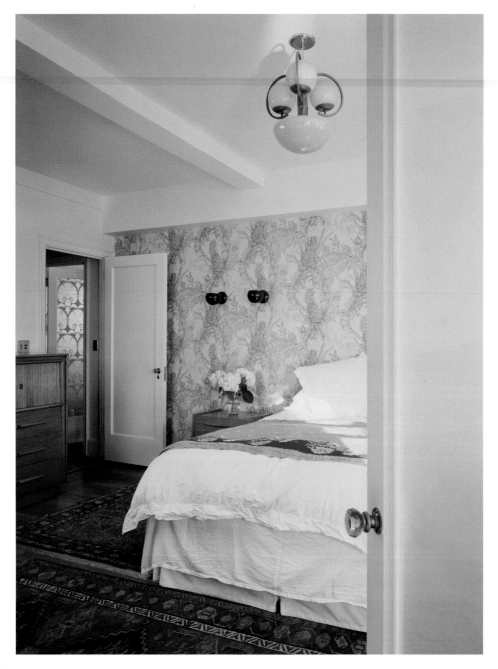

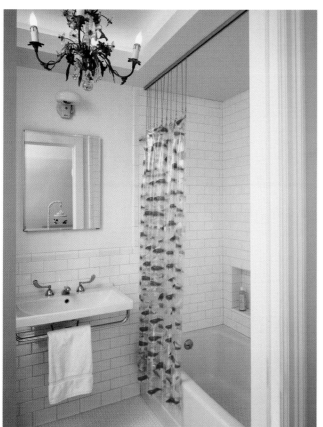

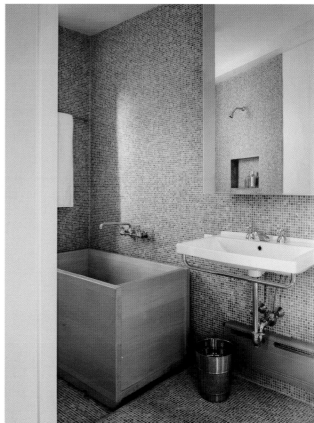

The master suite features a cedar soaking tub that fills to the brim, with a sloped tile floor to drain the runoff.

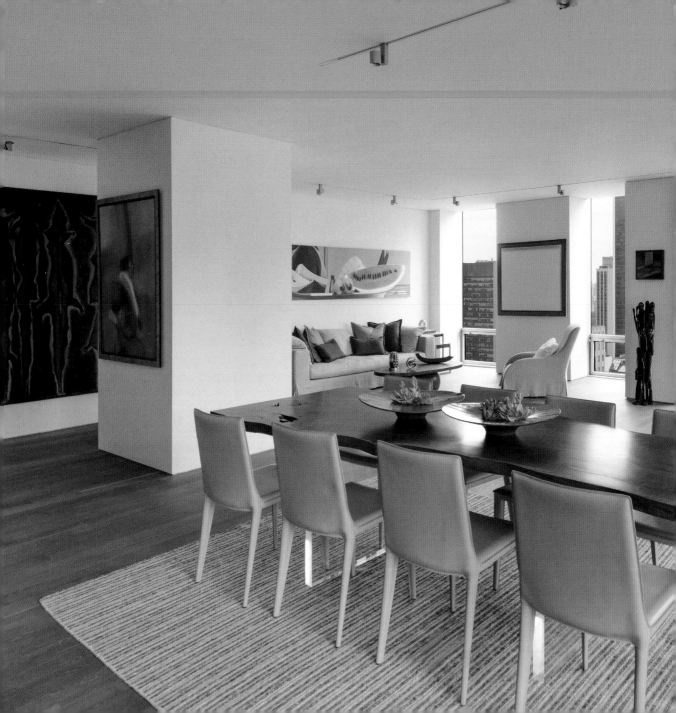

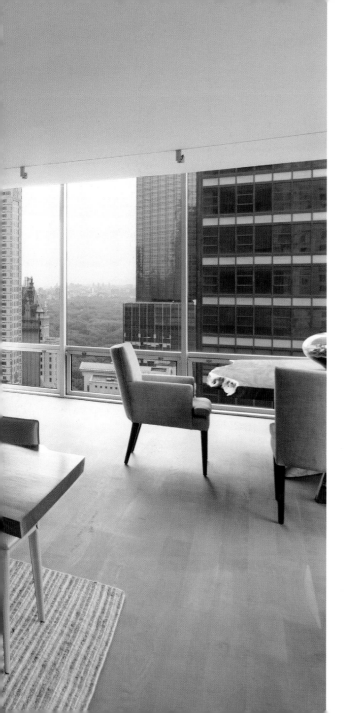

Fifth Avenue Apartment

3,900 sq ft
New York, New York,
United States

Sergio Mercado Design

Photographs © Peter Margonelli

The gut renovation of two apartments combined to become one
takes full advantage of the north- and east-facing views from the
30th floor of a prominent building tower. The combination of
the two apartments was achieved by creating a hallway through
the two. Walls were removed to create an open living, dining,
and kitchen plan. To maintain the open feel throughout and
simultaneously provide the private quarters with privacy, a door
that is the full height and width of the main hallway enables the
master suite to be closed off from the rest of the apartment and
to create an ensuite bedroom/bathroom.

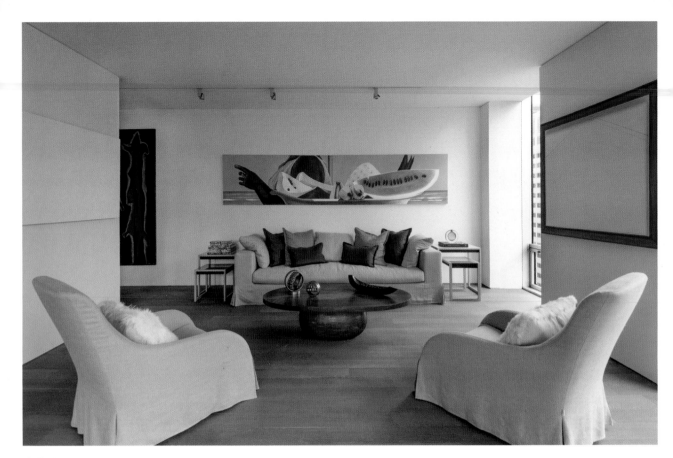

024

The easy flow between spaces and the airy atmosphere are enhanced by a reveal between the base of the walls and the floor. This detail creates a subtle shadow between the two surfaces, producing the impression that the walls are floating, a technique often used in art galleries.

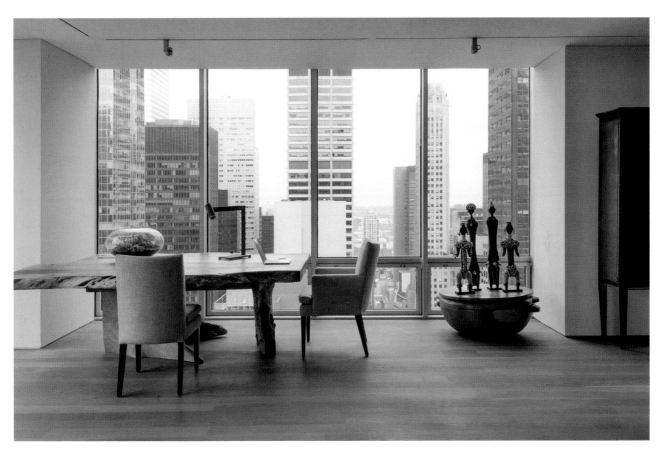

025

The solid wood dining table occupies
a luminous area of the spacious main
room with floor-to-ceiling windows.
The space is strikingly simple, with
no other feature or detail needed
to highlight the panoramic views.

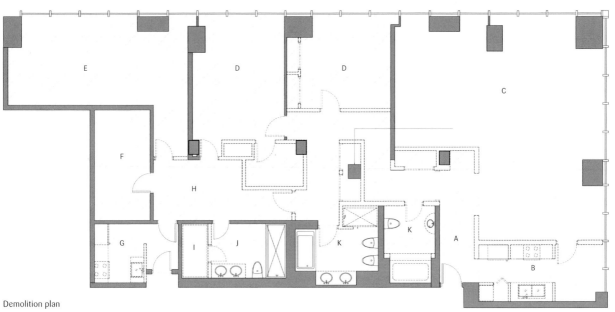

Demolition plan

A. Entry
B. Kitchen
C. Living/dining
 room
D. Bedroom
E. Master bedroom

F. Master closet
G. Kitchen
H. Hall
I. Sauna
J. Master bathroom
K. Bathroom

------- To be removed

▬ To remain

☐ Demo floor

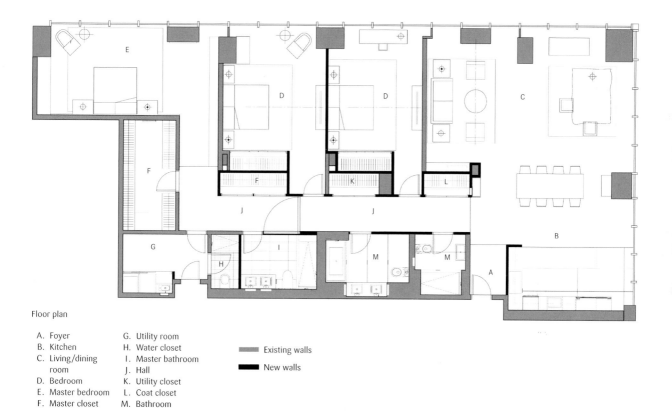

Floor plan

A. Foyer
B. Kitchen
C. Living/dining room
D. Bedroom
E. Master bedroom
F. Master closet
G. Utility room
H. Water closet
I. Master bathroom
J. Hall
K. Utility closet
L. Coat closet
M. Bathroom

Existing walls

New walls

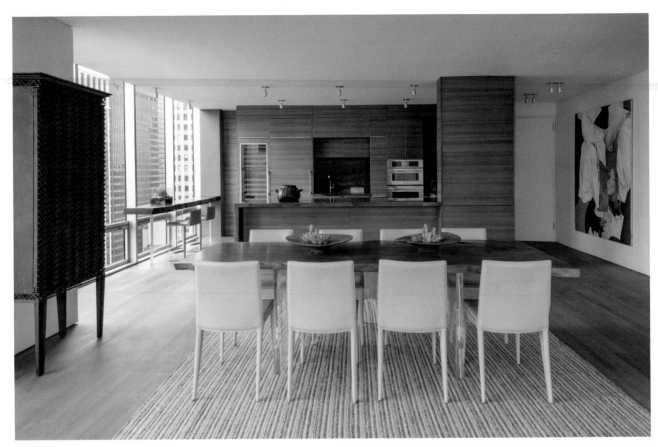

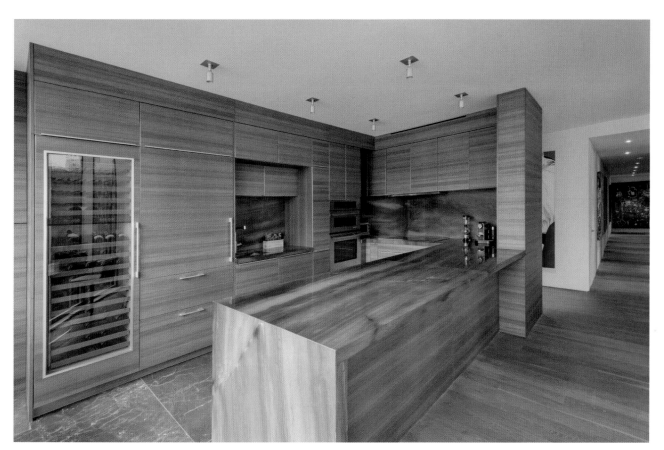

The kitchen features a one-tone marble and wood design, contrasting with the all-white scheme of the rest of the apartment.

With no doorways or baseboard, but rather plain white walls from floor to ceiling, the home has a gallery-like feel with the right lighting.

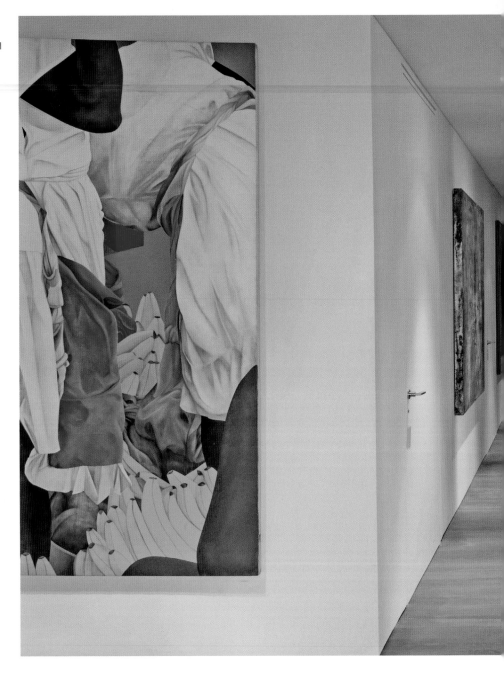

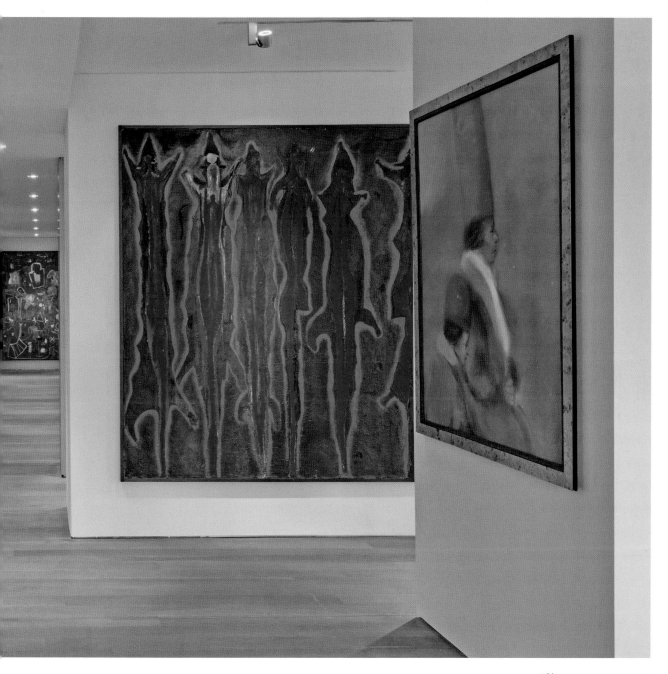

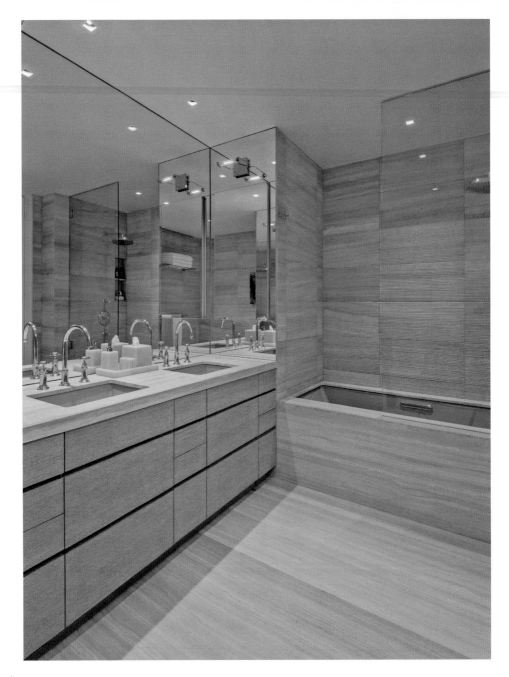

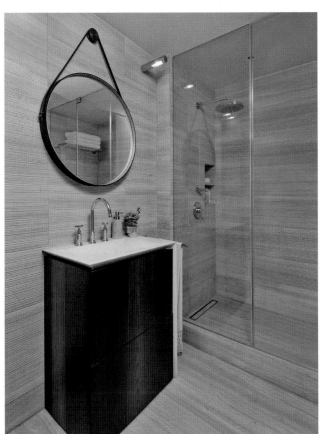

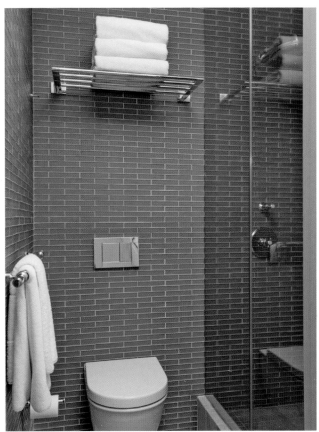

The bathrooms are simple and elegant, with no color or material contrast. The unified look creates a soothing feeling.

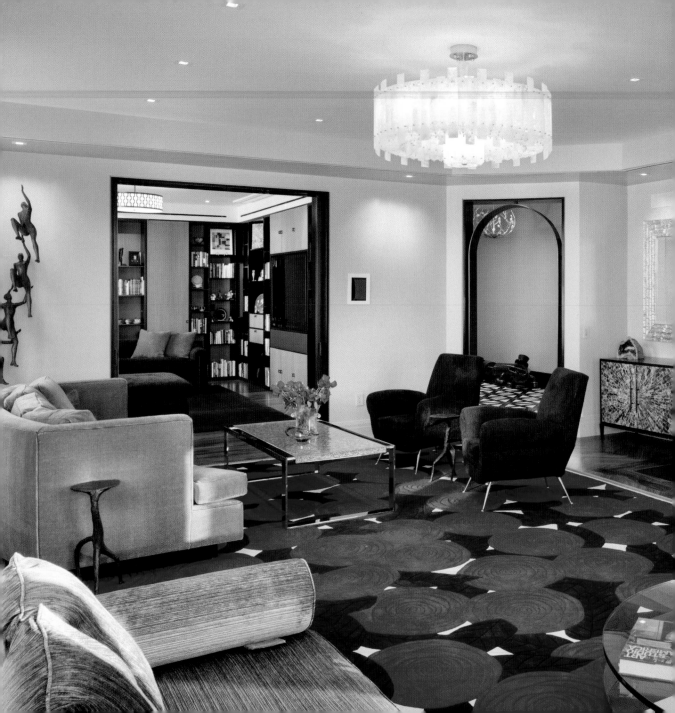

535 WEA

6,700 sq ft

New York, New York,
United States

**Studio ST Architects and John
Barman, interior designer**

Photographs © Bilyana Dimitrova

This full-floor gut renovation creates the perfect urban home,
combining the best of a comfortable suburban house with the
sophistication and convenient location of a city apartment. It
was a collaborative process from day one. Esther Sperber, the
founder of Studio ST Architects, recently published a cover
story in *Lilith* magazine titled "Gender and Genius" that explores
the psychological and architectural aspects of collaborative
creativity. To foster a collaborative design process for this
project, the firm created numerous photo-realistic computer
renderings of each room. This use of renderings as a design
tool rather than as a depiction of the final product supported a
lively dialogue between the architects and clients and sparked
unexpected design possibilities.

The generous foyer, kitchen, dining room, living room, and family room are designed for entertaining. On the other side of the home, the combination of two bedrooms created a large "basement playroom" for the family's three young sons. A service entry was converted into a mudroom.

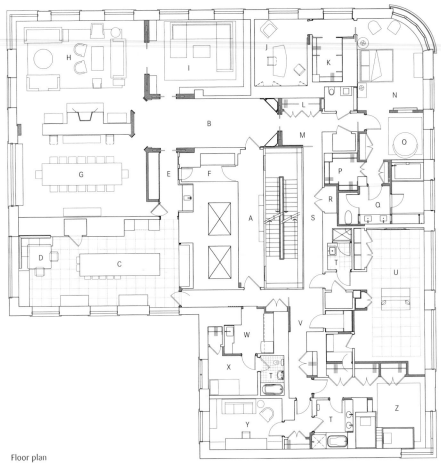

Floor plan

A. Elevator lobby
B. Entry Foyer
C. Kitchen
D. Breakfast nook
E. Pantry
F. Storage/refuse
G. Dining area
H. Living area
I. Library/family room

J. Office
K. His closet
L. Coat closet
M. Vestibule
N. Master bedroom
O. Sitting area
P. Her closet
Q. Master bathroom
R. A/V closet

S. Hall
T. Bathroom
U. Playroom
V. Kids wing
W. Mudroom and laundry
X. Staff bedroom
Y. Scrapbooking
Z. Bedroom

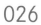

026

The cabinetry that frames openings and doorways from one room to the next give spaces depth. Forced perspective enhances spatial perception.

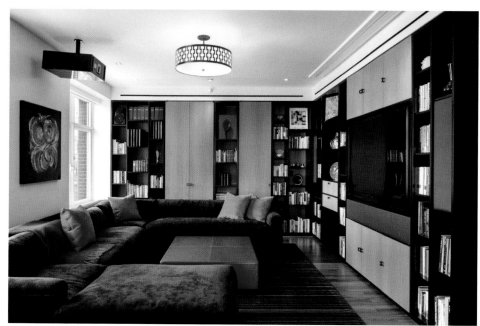

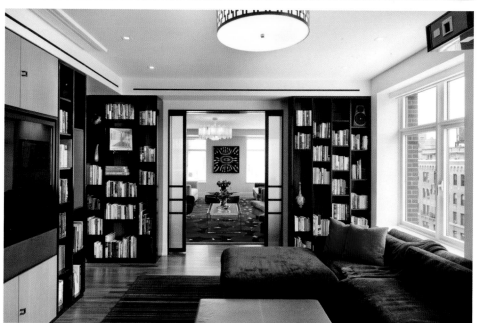

The design conveys a soft opulence that is at once comfortable, beautiful, and functional.

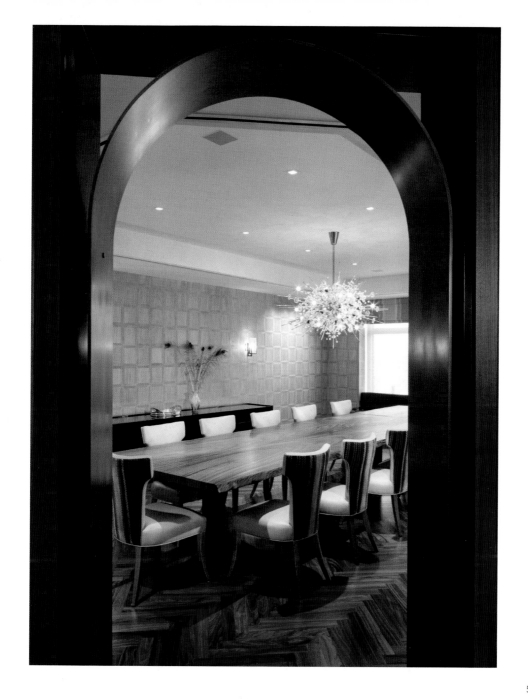

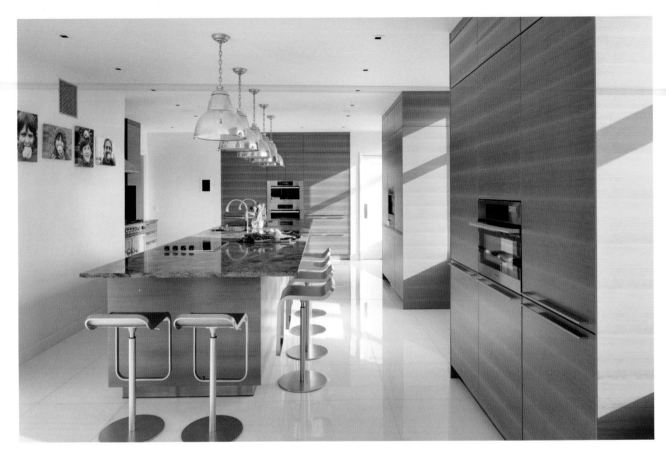

Full-height cabinets make the most of
the wall space between the windows,
providing generous storage space while
creating a rhythm with alternating
wooden and white planes.

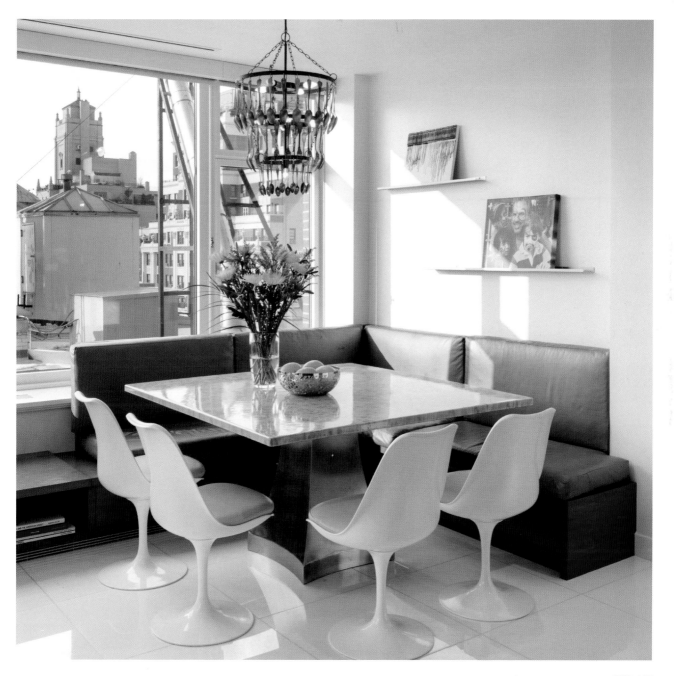

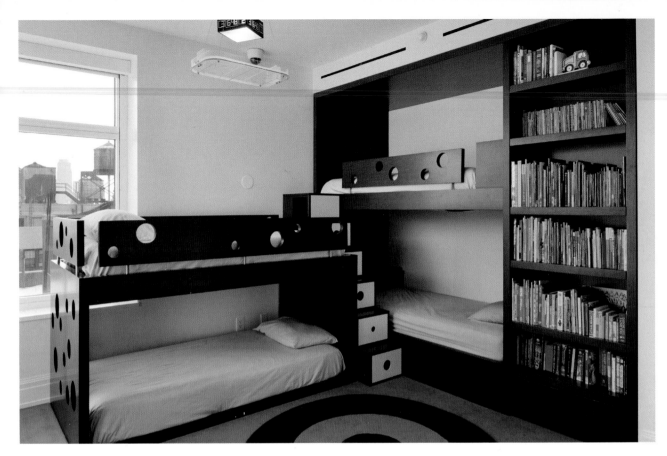

027

Bunk beds are an efficient use
of space and also playful. They
can accommodate other types of
furniture, such as extra seating,
desks, and bookcases.

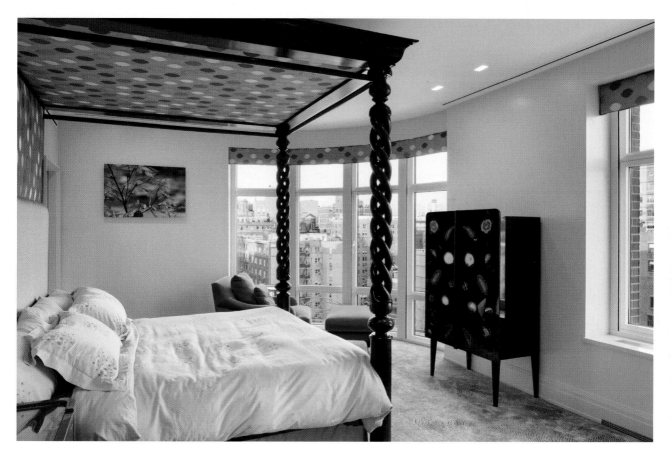

028

Canopy beds take bedroom design to a higher level. They come in any shape and style, and the fabric can be customized to match other fabrics used in the room or chosen as a contrast to add a pop of color and texture.

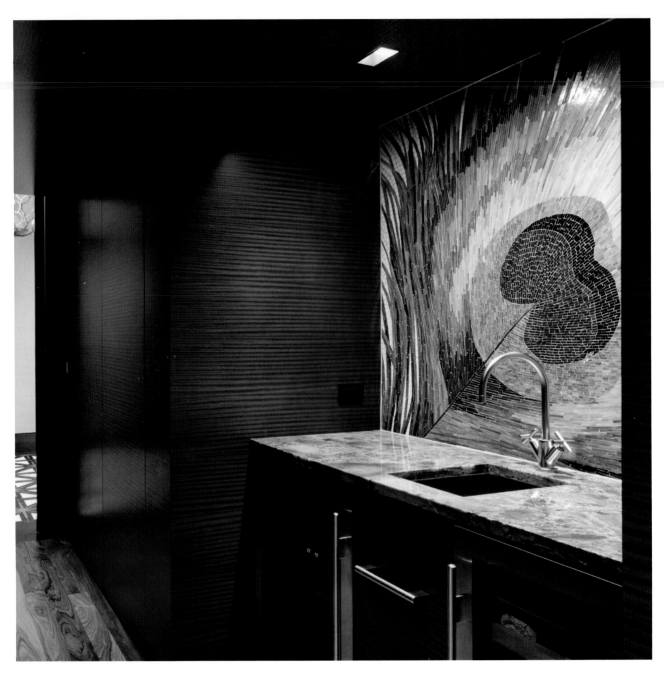

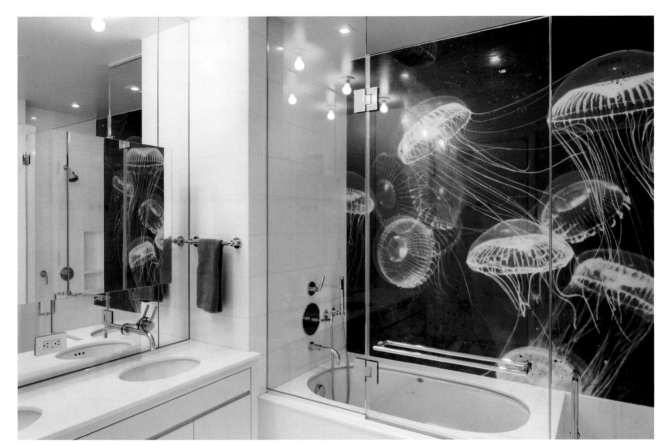

029

Printing technology enables all sorts of images to be transferred onto glass panels. The options are endless, from solid colors to extraordinary pictures that can transport one into a fantasy world within the comfort of the bathroom.

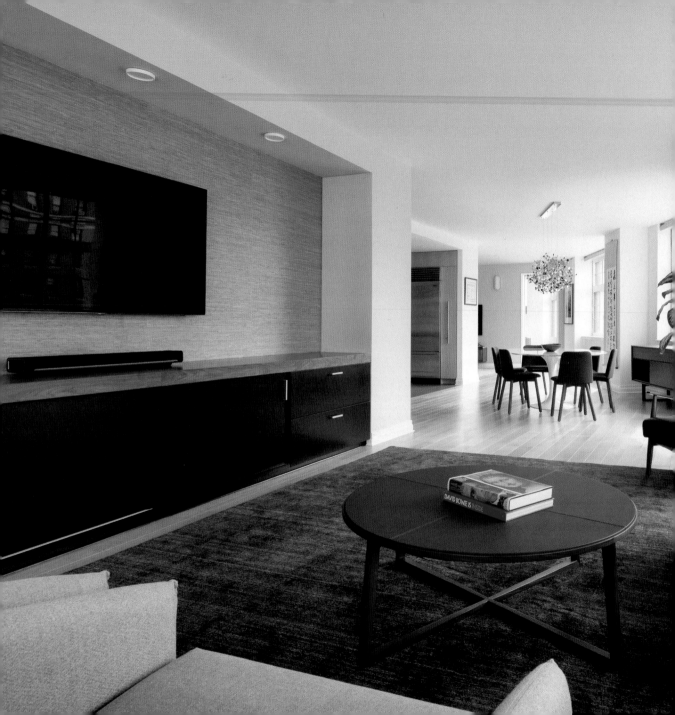

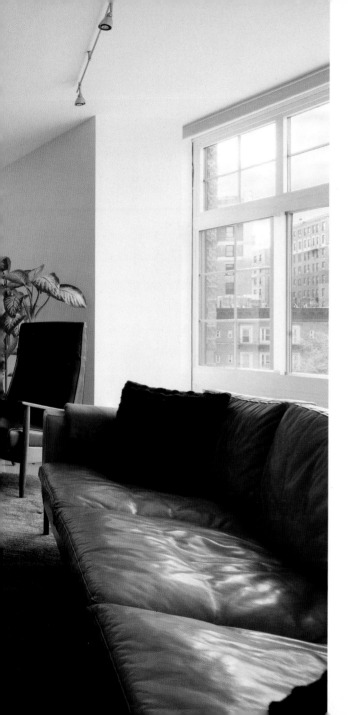

Upper West Side Combination

3,500 sq ft

New York, New York,
United States

Kimoy Studios Architecture

Photographs © Devon Banks
Photography

Combining two apartments—one a three-bedroom, the other
a two-bedroom—creates a modern home for a family of four.
Its floor-to-ceiling windows and a corner location offer views
of its Upper West Side surroundings marked by glamorous
prewar buildings and townhouses. The plan was organized
around a service core containing storage and bathrooms and
an open kitchen, which becomes the heart of the home. The
bedrooms were located to the north of the apartment with the
main open living spaces along the west side. Overall, the design
integrates all the spaces into a grand flowing home that takes in
the incomparable views of the Upper West Side architecture.

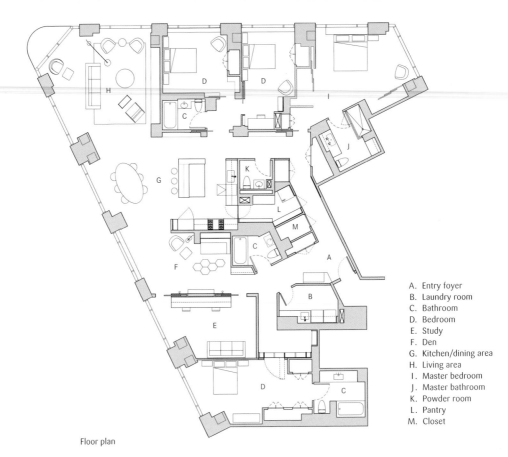

A. Entry foyer
B. Laundry room
C. Bathroom
D. Bedroom
E. Study
F. Den
G. Kitchen/dining area
H. Living area
I. Master bedroom
J. Master bathroom
K. Powder room
L. Pantry
M. Closet

Floor plan

030

Combining adjacent units can be a
creative design and construction
option for upsizing in the city.
Needless to say, it also comes with
the challenge of consolidating utility
infrastructure.

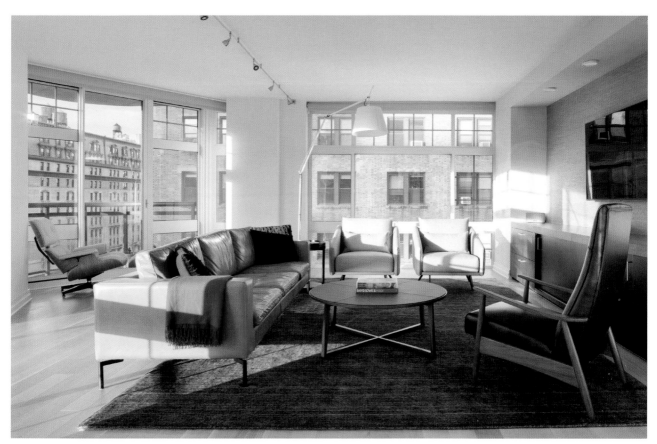

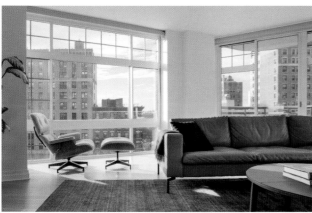

031

Generous open spaces amplify the home's flow, bringing in the views from all sides.

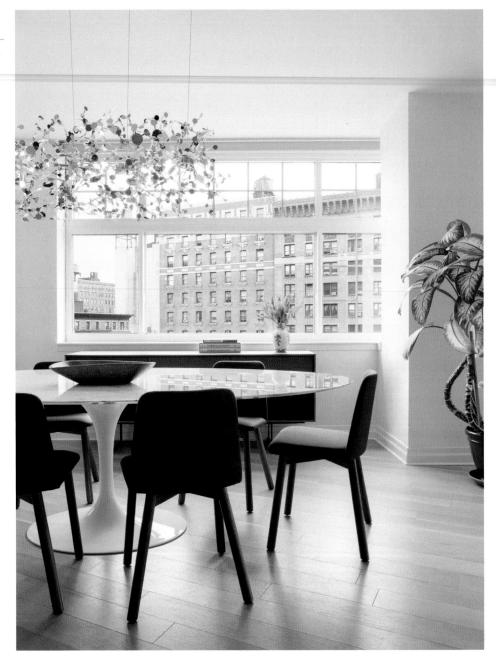

The kitchen is the hub of the home, with separate living spaces for adults and kids to each side.

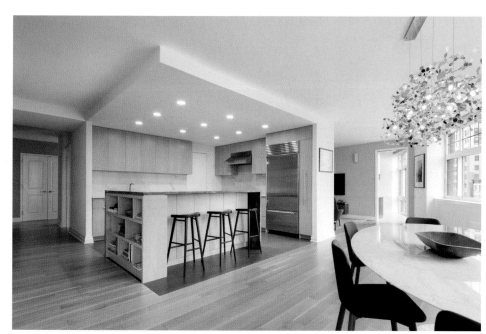

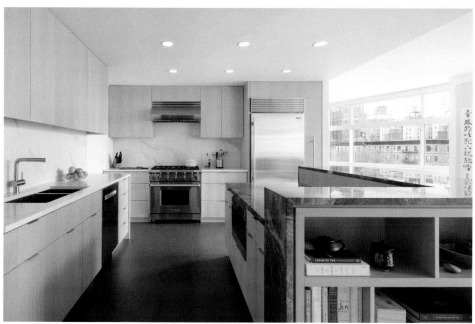

The layout was conceived as a flowing sequence of rooms, and the perimeter of the apartment was left as a continuous plane with no visual barriers that would interfere with the continuity of the layout or obstruct the views.

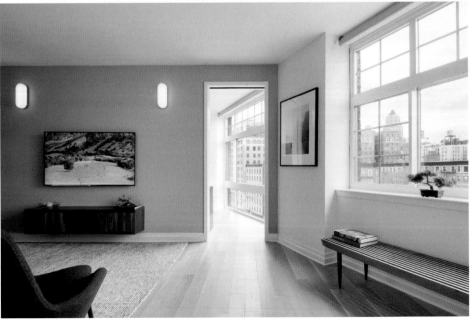

The home is anchored at the south end with a family study and a secret ensuite accessible through a hidden door/bookcase.

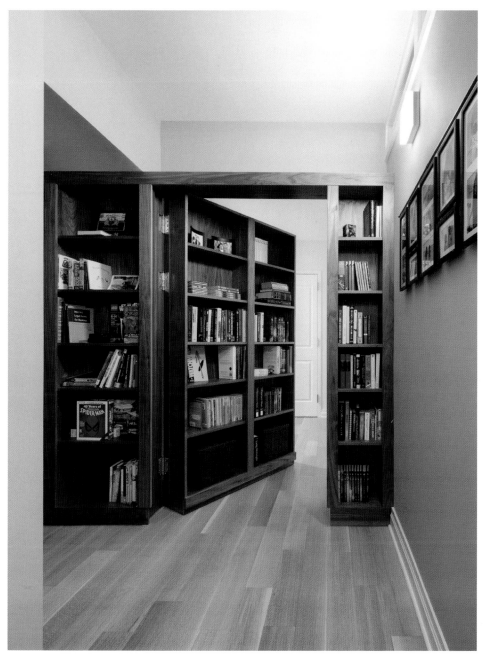

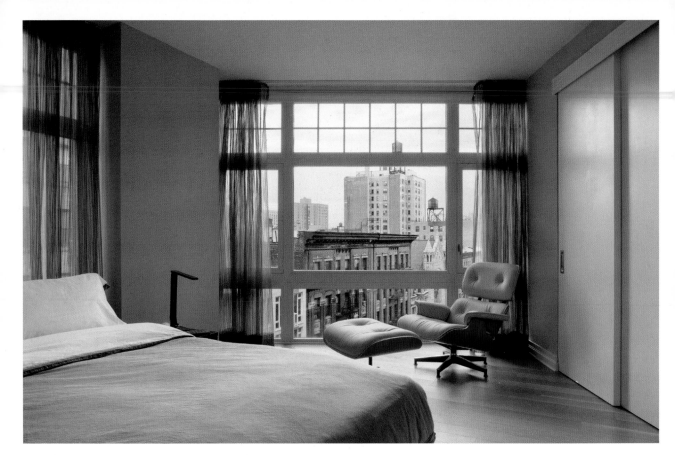

033

The new layout connects the
different spaces within the home,
but the entire home is also
connected, on a greater scale,
to the urban landscape outside.

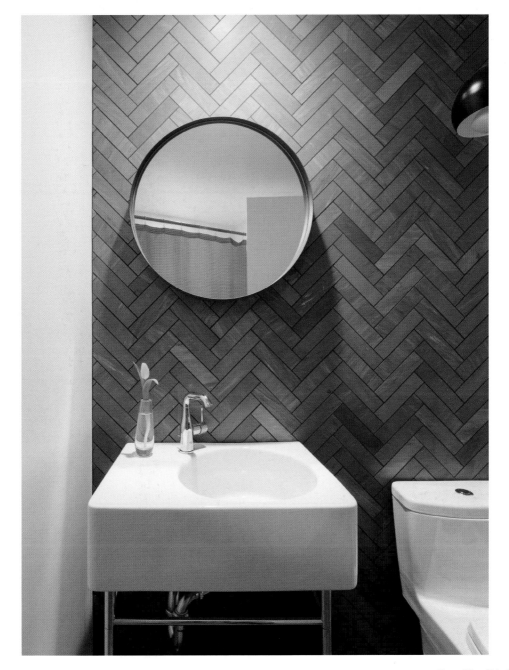

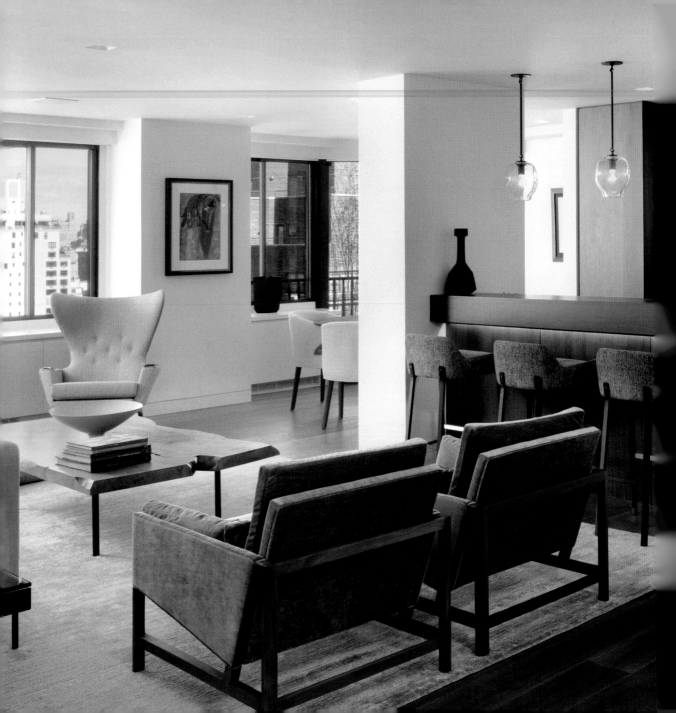

Bayard Residence

2,700 sq ft

New York, New York,
United States

Gne Architecture

Photographs © Peter Dressel

This project posed two distinct and fundamental design challenges. The first was to combine two, two-bedroom apartments into a free-flowing four-bedroom home with a public side for entertaining and a private side for daily living. One end of the apartment contains the living room and serving kitchen while the opposite end has the family room, dining area, and kitchen. The second challenge was adhering to Vastu shastra principles—room locations, bed direction, cooking orientation, entry direction— to promote a place in tune with nature so that the humans inhabiting the space can live a well-balanced and happy life.

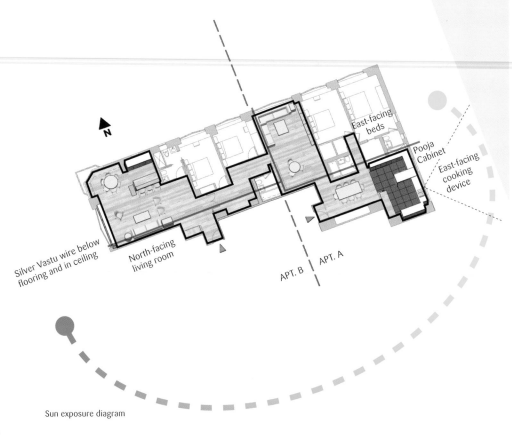

Silver Vastu wire below flooring and in ceiling

North-facing living room

East-facing beds

Pooja Cabinet

East-facing cooking device

APT. B | APT. A

N

Sun exposure diagram

034

Orientation is one of the five Vastu principles that use sun paths to organize the different areas of a home and create harmonious living environments.

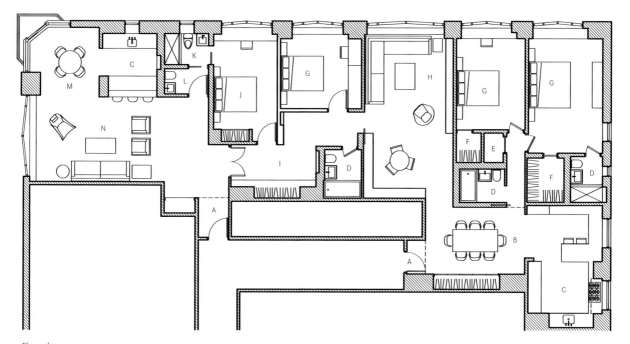

Floor plan

A. Entry
B. Formal dining area
C. Kitchen
D. Bathroom
E. Storage

F. Closet
G. Bedroom
H. Living area
I. Hall
J. Master bedroom

K. Master bathroom
L. Powder room
M. Dining area
N. Family room

035

Vastu shastra, which translates
to "science of architecture," is an
ancient Indian architectural system,
and as such it portrays a deep
understanding of different zones.

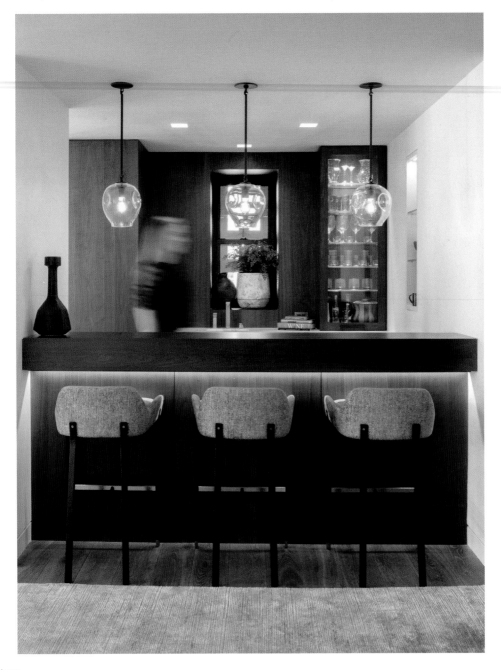

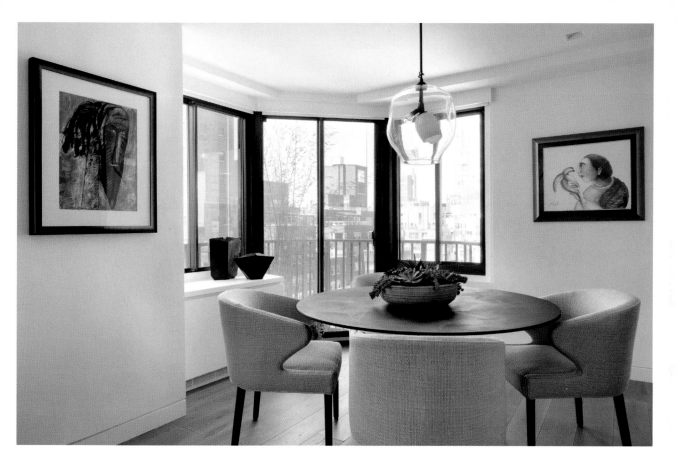

036

The furnishings, a luxurious mixture of modern and contemporary items, create a sophisticated and serene home in the tumult of New York City.

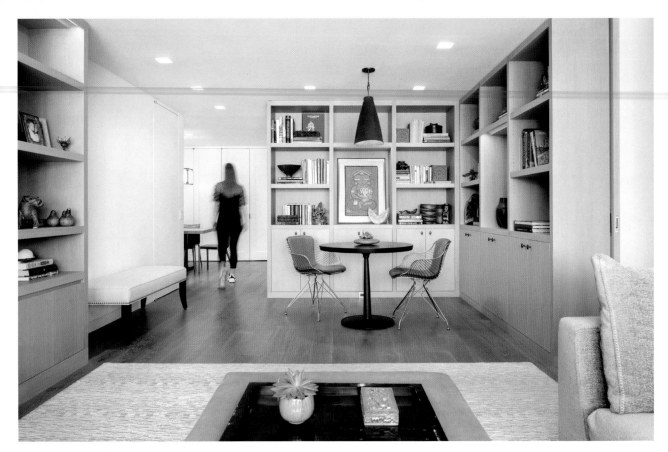

A neutral-toned wood floor weaves its way throughout the premises, tying all areas together.

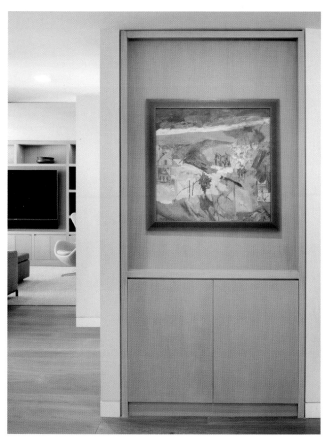

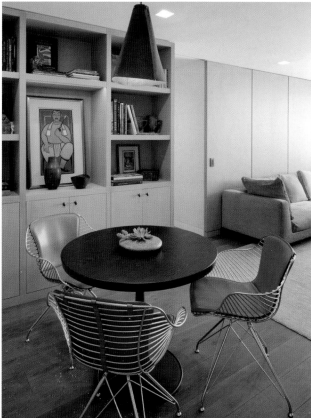

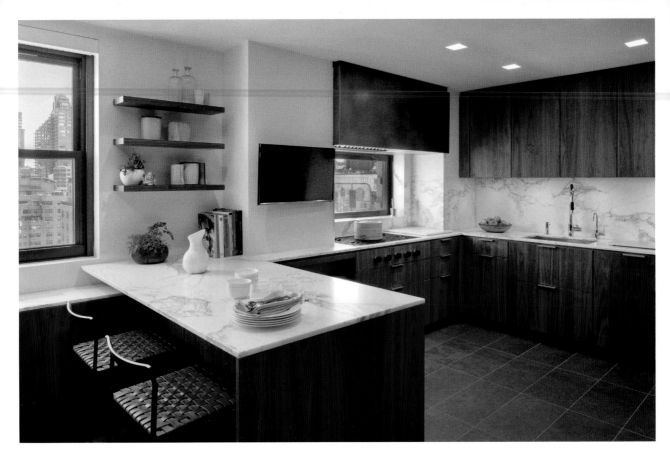

037

Vastu shastra principles integrate
architecture with nature, taking into
account the layout, spatial geometry,
space arrangements, and alignments.

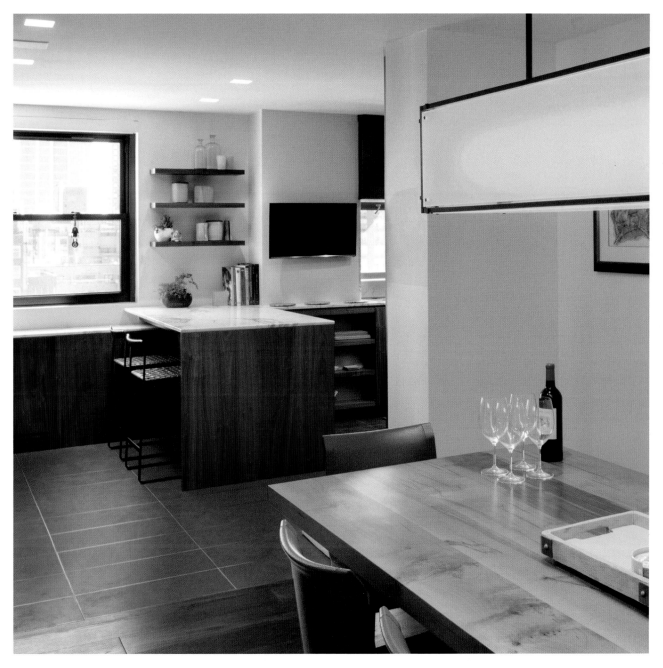

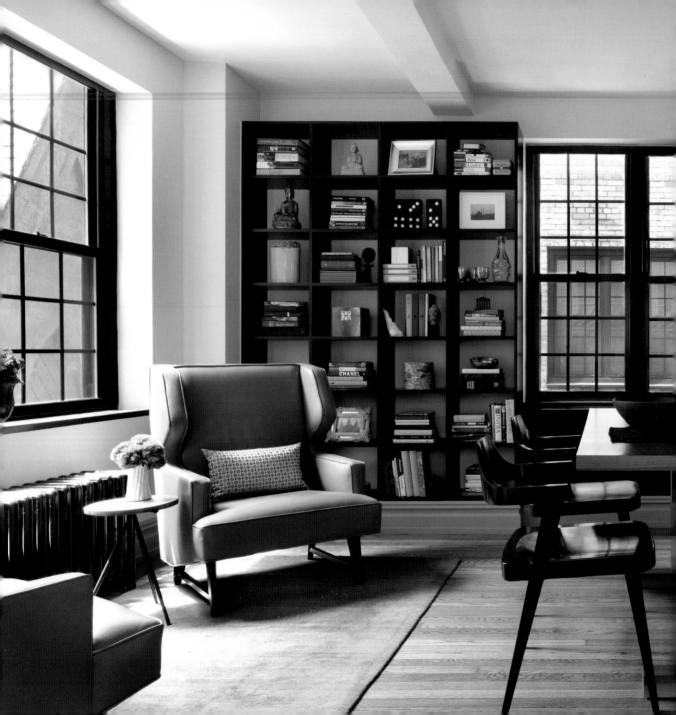

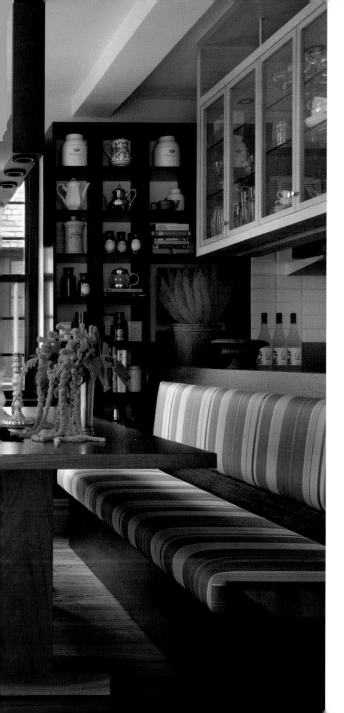

Gramercy Prewar Apartment

1,100 sq ft

New York, United States

**Robert Kaner Interior Design
and Rafael Berkowitz, Architect**

Photographs © Peter Murdock

This project involved the combination of two adjacent apartments in a New York City prewar apartment building. The use of black light fixtures and design elements echoing the traditional window mullions creates a design language that evokes a sense of old New York. This baseline language, which is intended to tie all the spaces together, is then juxtaposed with more modern design elements and furnishings to give each space a unique character. A new fireplace surround, wrapping around from one apartment into the other, was introduced as a focal point to join the two spaces. The kitchen is also conceived as a centerpiece. While it is open to the living and dining zones, it stands out as a separate area through the use of ceramic tiles on its walls, which defines the area.

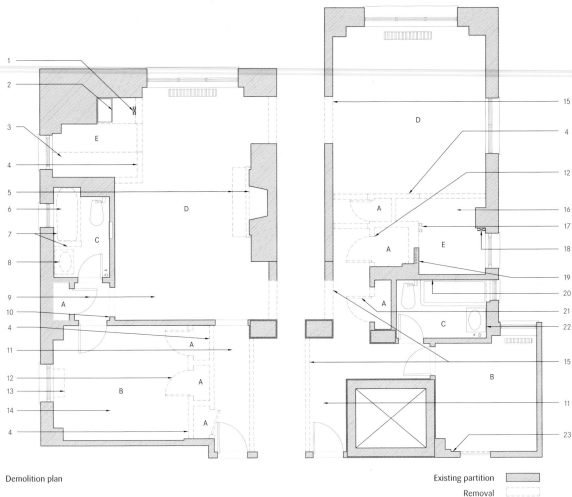

Demolition plan

Existing partition ▨
Removal ⬚

A. Closet
B. Bedroom
C. Bathroom
D. Living area
E. Kitchenette

1. Existing electric panel to be relocated
2. Existing cabinet to remain
3. Remove existing cabinetry, light fixtures, flooring, and appliances
4. Remove non-bearing partition as indicated
5. Remove existing wood mantle, stone hearth, TV, and speakers
6. Remove ceramic tile trim and ceramic tile below
7. Remove existing tub, controls, and partition
8. Remove existing lavatory, medicine cabinet, and light fixture
9. Remove light fixtures and speakers
10. Remove opening frame
11. Remove existing light fixtures
12. Remove doors and frames as indicated

13. Remove radiator cover
14. Remove fan
15. Non-bearing partition between units to be removed as indicated
16. Remove existing flooring, suspended ceiling, and light fixtures
17. Relocate existing box
18. Existing electric panel to remain
19. Existing gas line to remain
20. Remove existing showerhead and control trims
21. Remove door and frame. Save for reuse
22. Remove medicine cabinet, light fixture, and faucet
23. Remove gypsum wall board as indicated

The new layout makes the fireplace that
was once in one of the two apartments
a central feature around which the
common areas are organized.

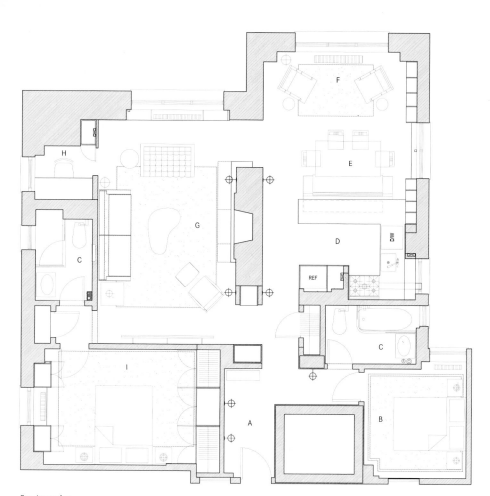

Furniture plan

A. Vestibule
B. Bedroom
C. Bathroom
D. Kitchen
E. Dining area
F. Library
G. Living area
H. Study
I. Master bedroom

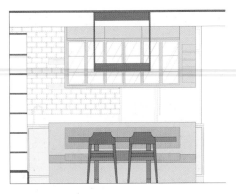

Dining area/kitchen - north elevation

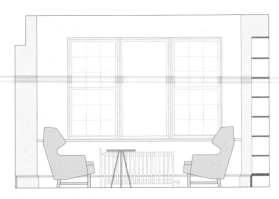

Library - south elevation

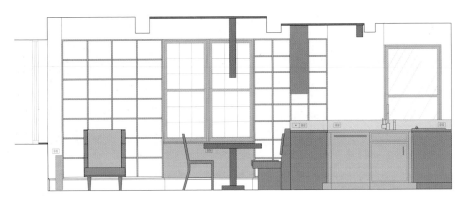

Dining area/kitchen/library - west elevation

The banquette was designed to maximize the use of space. Inspired by the views of a nearby historic church, the banquette also serves as a modern reference to a church pew, engaging with the world below.

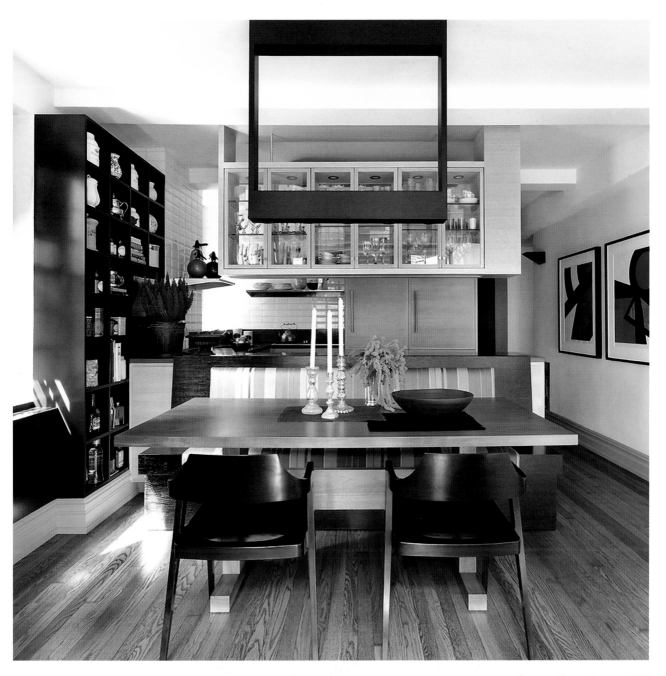

038

Custom cabinetry fits precisely in a particular space, and that means it can borrow design features to help it blend with the home's interior.

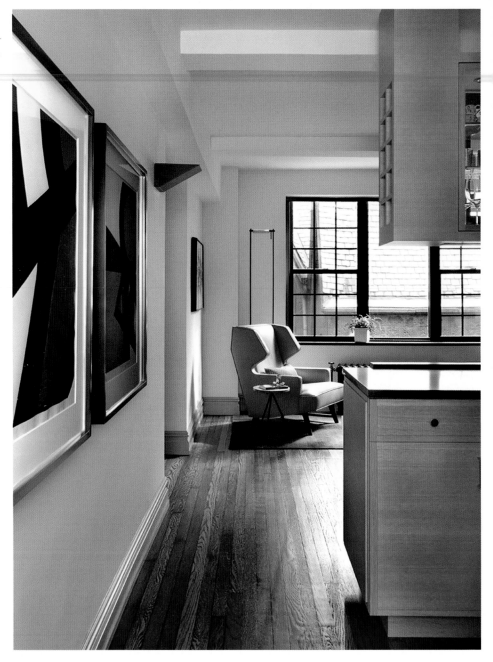

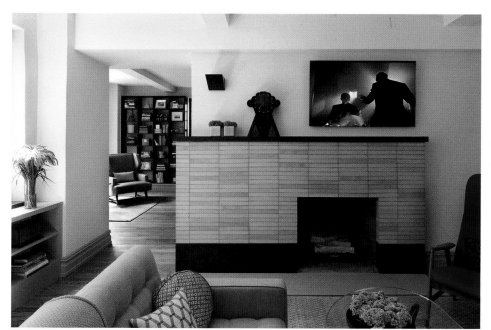

Focal points—like the fireplace—are areas of visual interest around which a hierarchy of design elements will be arranged. The use of balance, scale, color, contrast, alignment, and shape among other design principles will contribute to the creation of a graceful interior.

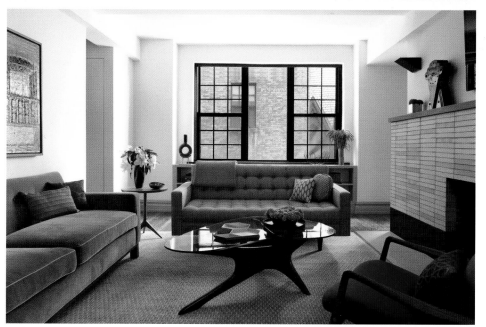

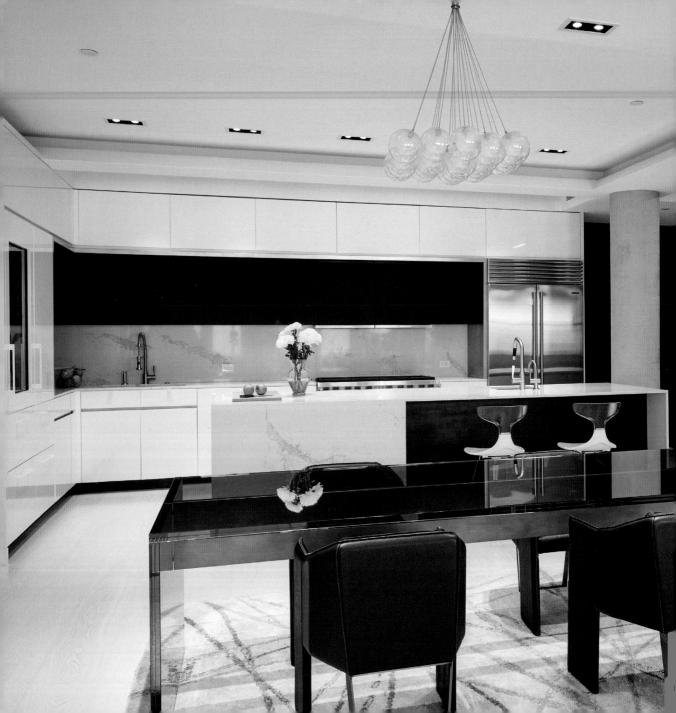

Beach Street Renovation

2,231 sq ft
New York, New York,
United States

studioPPARK

Photographs © Jody Kivort

This once artist-in-residence studio was renovated for traditional
residential use. Converted to condos in the mid 2000s, the space
went mostly unused for the better part of a decade. The loft was
a hollow shell except for recently upgraded building utilities and
existing infrastructure. The clients' renovation plan was subject
to some of the typical open-space challenges and had deep floor
plates with limited natural light and air. The aesthetic of these
spaces drew inspiration from the clients' request to achieve a
tangible feeling of contrast, maintaining an open loft feeling and
offer flexibility in the way it could be used.

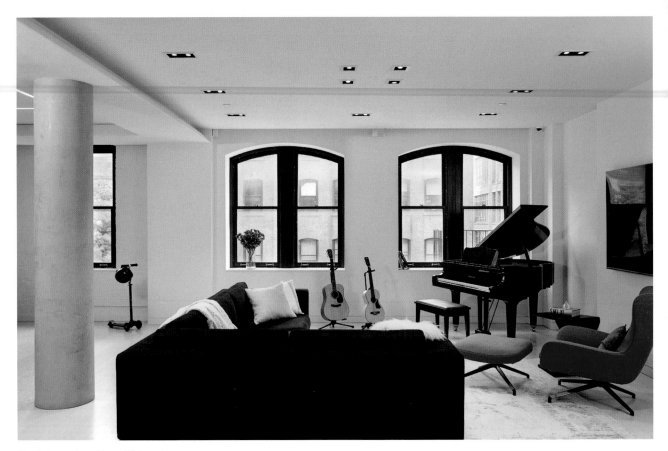

The design explores ideas of light and dark, smooth and textured to create a fairly stark but neutral visual palette in the public spaces against which furnishings could evolve over time.

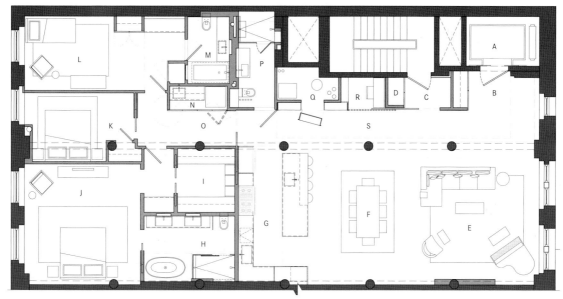

Floor plan

A. Elevator
B. Entry foyer
C. Mud room
D. AV cabinet
E. Living area
F. Dining area
G. Kitchen
H. Master bathroom
I. Master closet
J. Master bedroom
K. Guest bedroom
L. Kid's bedroom
M. Kid's bathroom
N. Laundry closet
O. Hall
P. Guest bathroom
Q. Utility room
R. Office
S. Gallery

040

Private amenities such as the laundry room, guest bathroom, utility room, and mudroom are masked from plain sight. This challenge led to a central spine partition concealing all these functions behind in a linear series of sliding pocketed and swinging trimless doors.

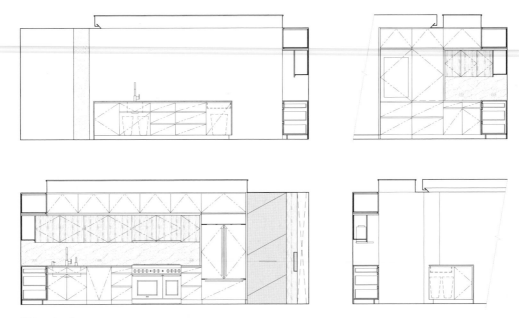

Kitchen elevations

041

The design and detailing evolved
from the original use of the space
as an artist-in-residence studio,
celebrating its history, materials,
and forms.

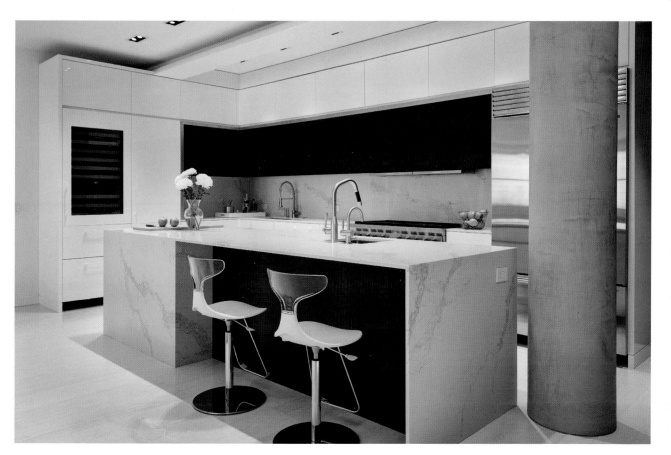

042

The new home was conceived
with a thoughtful and streamlined
approach, including high-quality
materials and full customization.

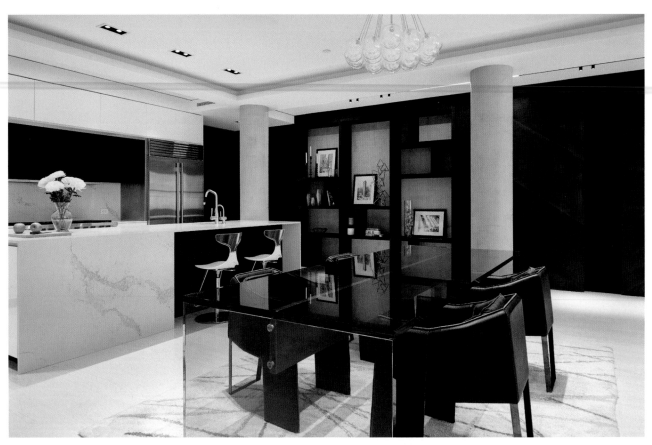

The clients preferred sleek machined materials for living areas. This led to combinations of metals, varied oaks, and concrete in the main space.

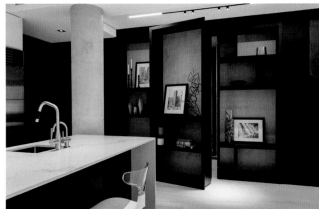

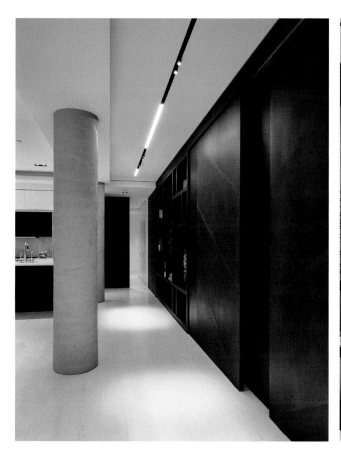

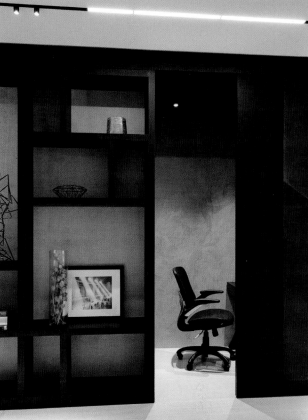

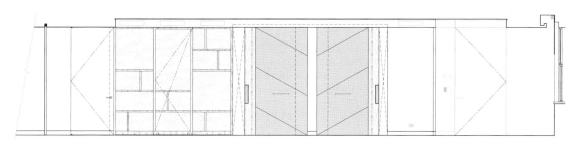

Gallery wall elevation

In contrast with the living spaces, a more sophisticated palette was used in the bedrooms and bathrooms, creating a serene atmosphere.

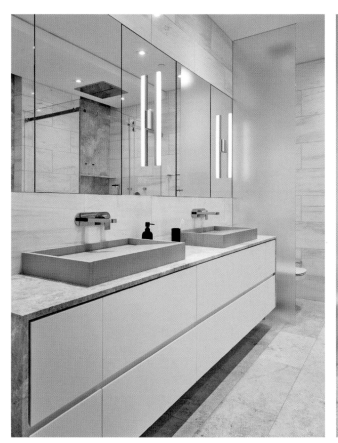
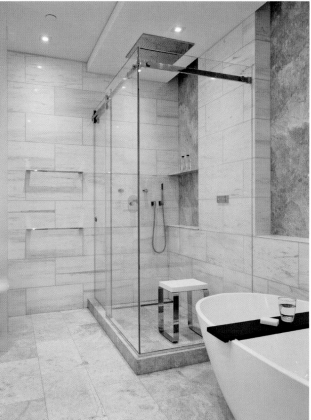

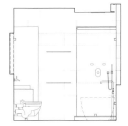

Master bathroom elevations

043

The customization and high level of detail were extended to every room of the home, making its interiors unique and suited to the personality of its residents.

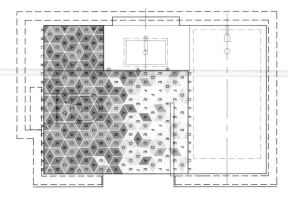

Guest bathroom tile layout

Guest bathroom elevations

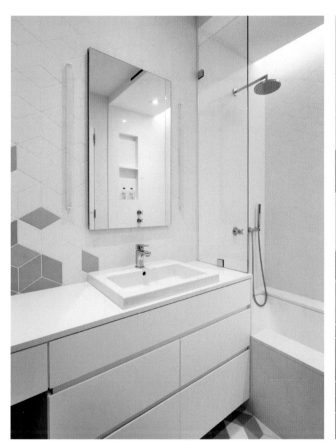
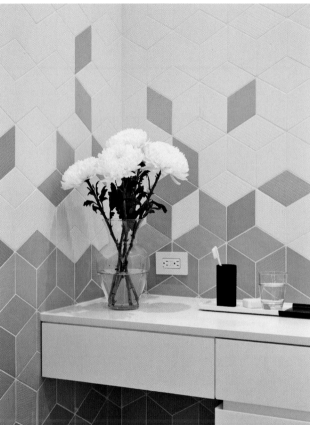

Greenwich Village

1,200 sq ft

New York, New York,
United States

Blythe Design Studio

Photographs © Gregory Kramer

A simple two-bedroom mid-century apartment is transformed into a contemporary, open home. With the new design, the apartment comprises a study/guest room, a separate media space, and a kitchen that is twice as big as the original and opens up to the living room and dining area. Custom translucent walls allow light to pass through and illuminate interior spaces. Bespoke features abound throughout this apartment, detailed with a mix of materials applied in unique ways, seen in walnut doors with steel inlay; room dividers combining textured Lucite, walnut, and blackened steel; custom wood and lacquered cabinetry; and wall treatments that include wallpaper and industrial felt. The result is a crafted aesthetic throughout the home.

The design involved modernizing and
opening up the space by removing
walls and transforming the rooms
through creative design solutions.

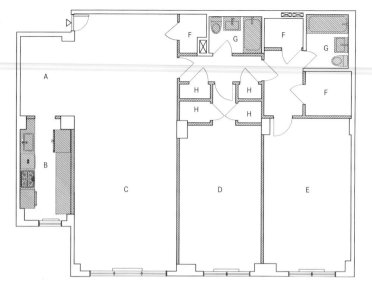

Demolition plan

Walls

Walls, fixtures
for demolition

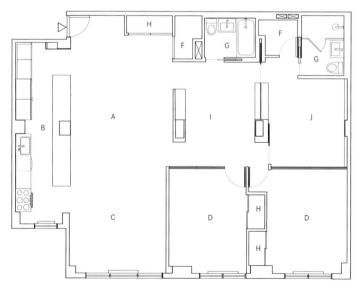

Renovation plan

Walls

New fixtures,
appliances, and
millwork

Partition:
Translucent panels

A. Dining area
B. Kitchen
C. Living area
D. Bedroom
E. Master bedroom
F. Walk-in closet
G. Bathroom
H. Closet
I. Family room
J. Study/guest room

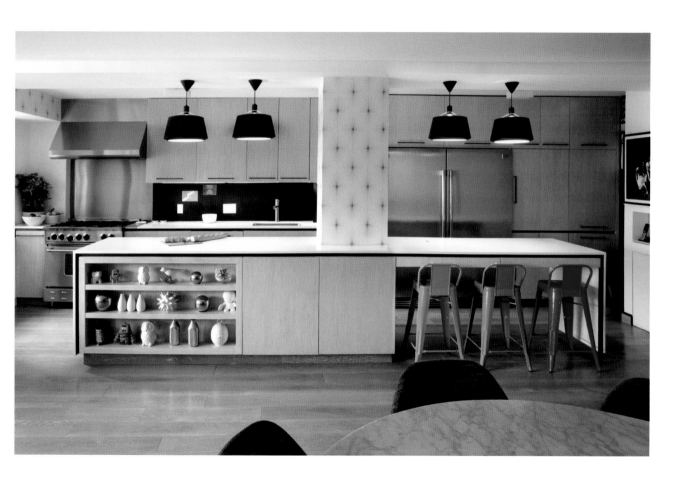

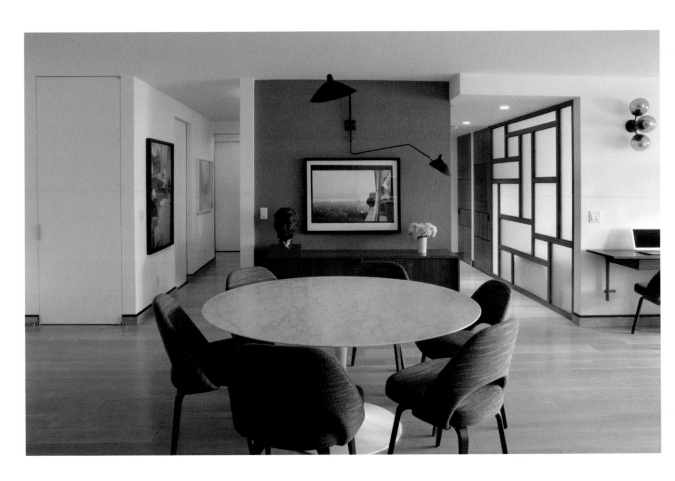

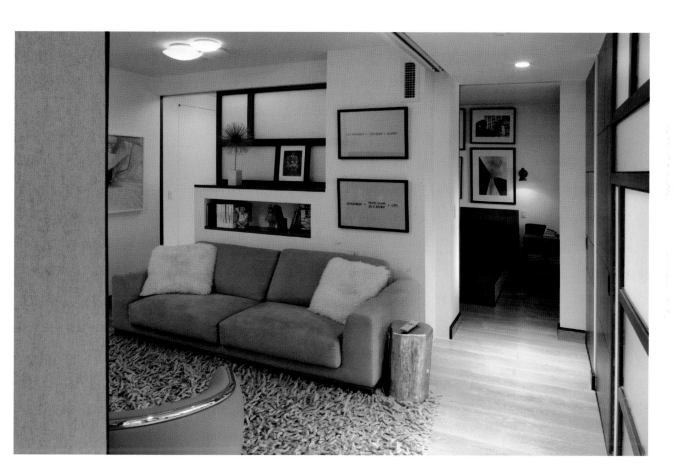

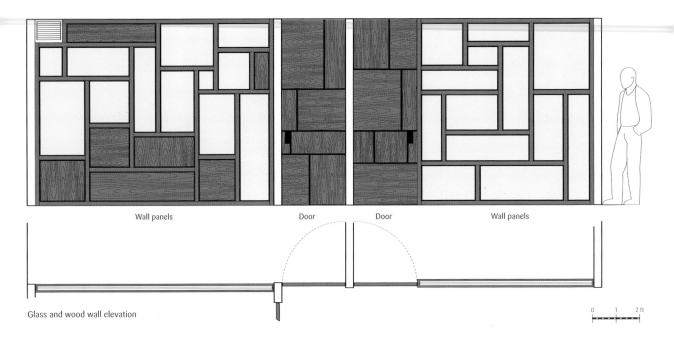

Wall panels Door Door Wall panels

Glass and wood wall elevation

0 1 2 ft

045

In line with the architects' quest to create dynamic, contemporary environments, partitions become artistic room dividers, showcasing bold material combinations.

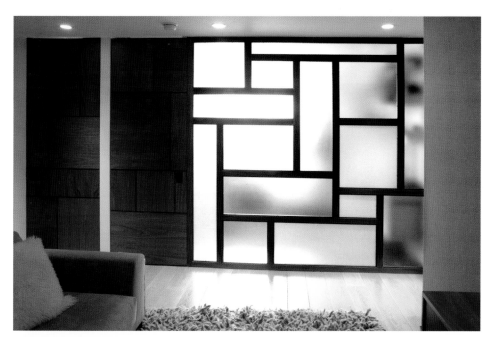

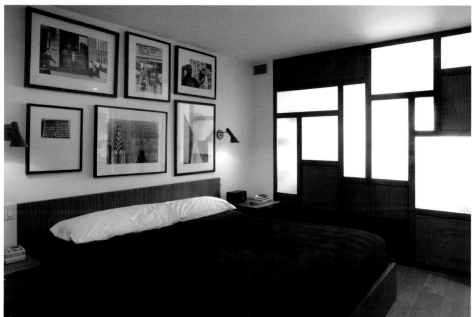

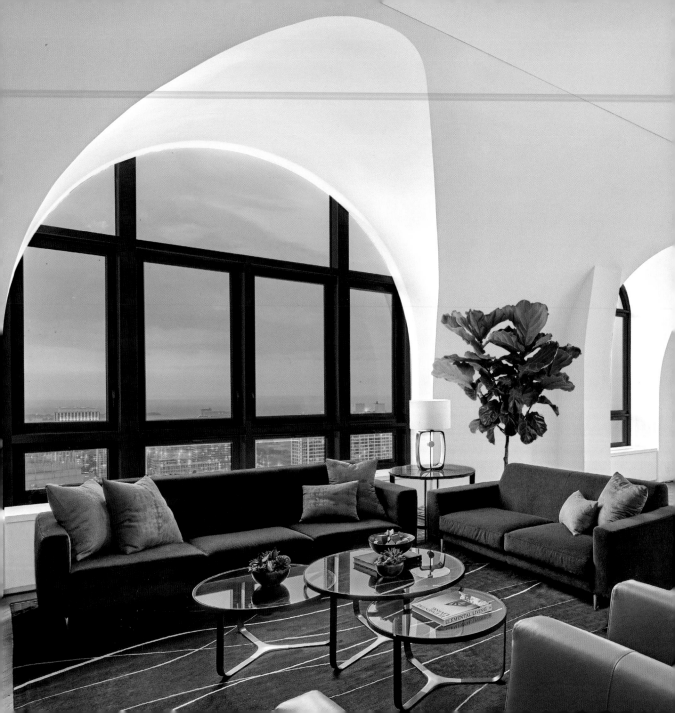

Sky Vault

4,500 sq ft

Chicago, Illinois, United States

dSPACE Studio

Photographs © Tony Soluri

This apartment started as raw space atop a high-rise with a wonderful combination of art and architecture, capturing the stunning views and setting the tone for a contemporary home. The building's mansard roof and arched windows influenced the interior architecture, seen in the striking vault detail in ceilings and doors. This design tempers the impact of thirteen-foot ceilings and offers dramatic space for art. Living areas are located on the perimeter to maximize views. Materials, colors, and lighting were key to creating a harmonious living environment and enhancing the architectural qualities of the apartment.

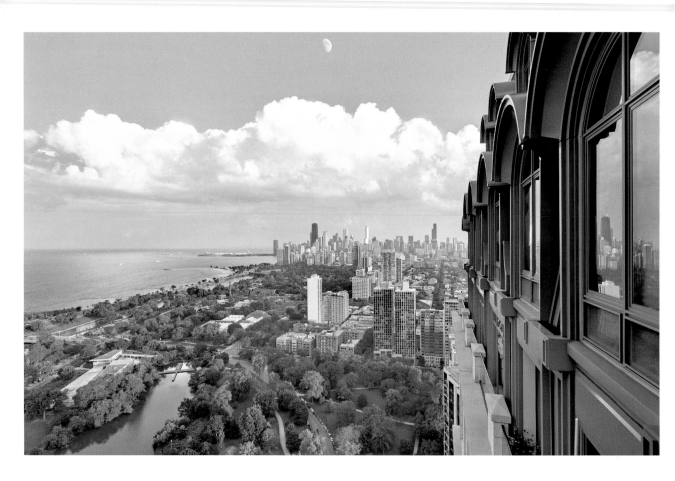

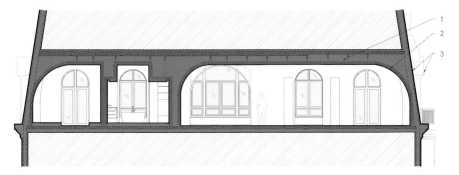

Partial building section through penthouse

Wall section through dormer

1. Mechanical plenum space
2. Suspended curved ceiling with sound isolation
3. Mansard roof and arched window dormers

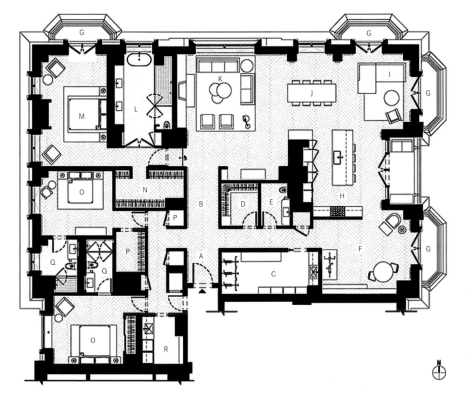

Floor plan

A. Entry
B. Gallery
C. Bike storage
D. Coat closet
E. Powder room
F. Study and exercise
G. Balcony
H. Kitchen
I. Sitting area

J. Dining area
K. Living area
L. Master bathroom
M. Master bedroom
N. Master closet
O. Bedroom
P. Closet
Q. Bathroom
R. Laundry room

046

An edited material palette ensures continuity throughout, while oversize oak flooring reinterprets herringbone and complements the large scale of the space.

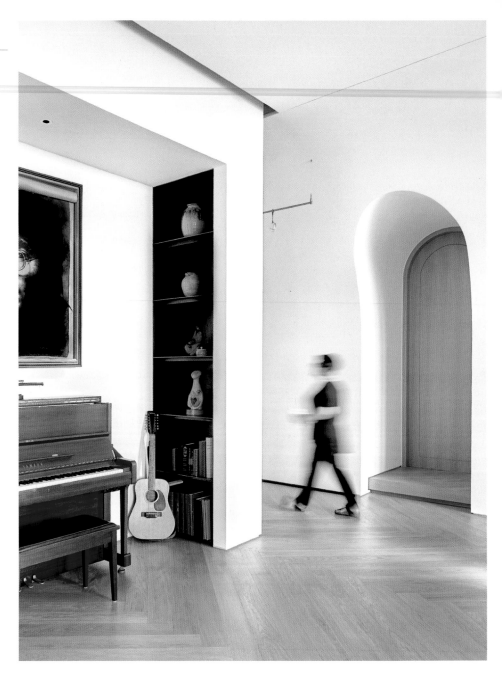

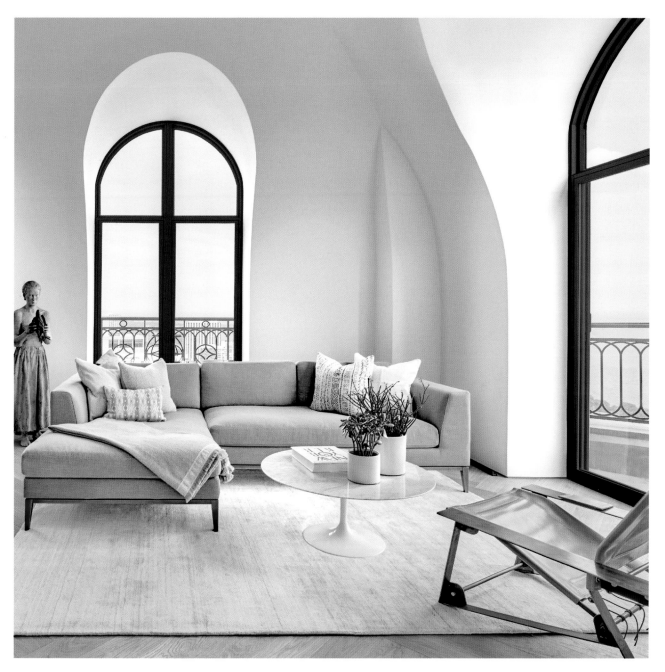

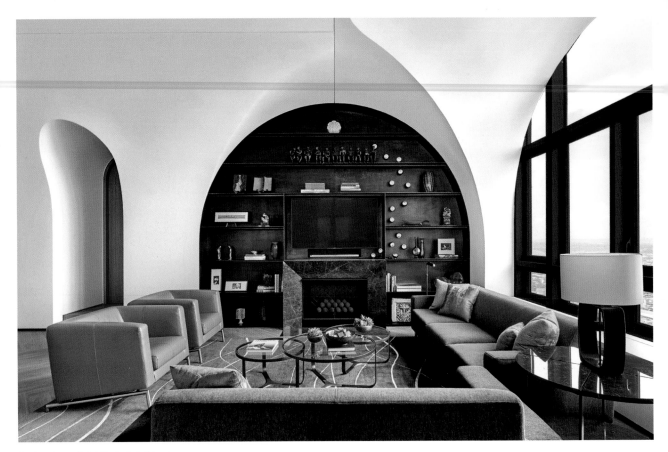

Tracing the vault detail, steel shelving is built in arched niches in the living area (above), surrounding a marble fireplace, and in the study (facing page), making the most of the high ceiling to maximize storage.

047

The furnishings were chosen to complement the architecture of the apartment, challenging the misconception that the architectural context is generally a neutral backdrop to the furnishings.

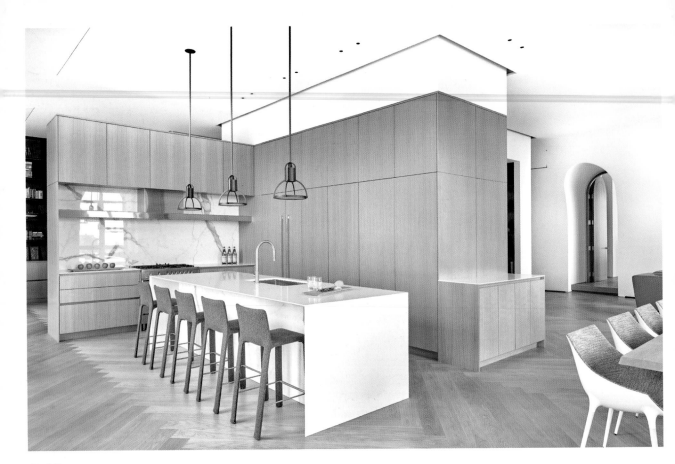

048

The existing concrete structure of
the space was hidden behind the
new cabinetry in the kitchen, which
created continuous structures of
European oak.

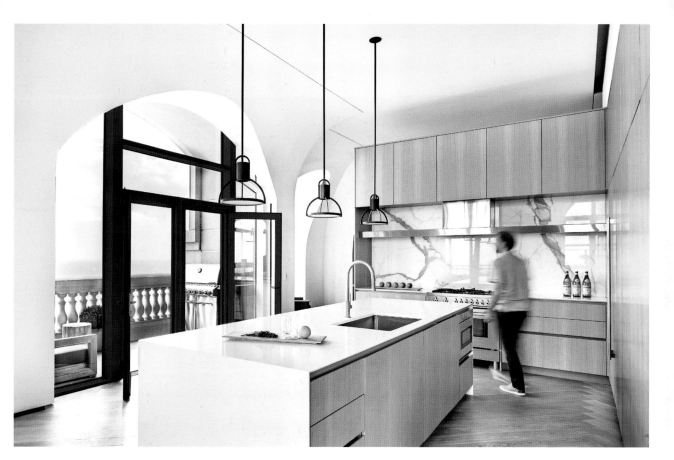

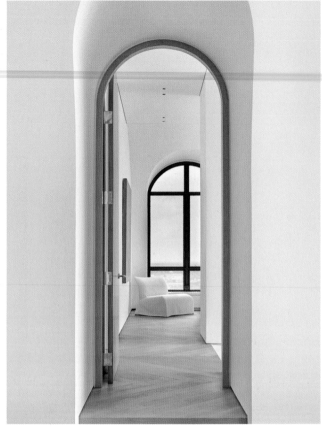

049

A suspended lighting system pairs with cove lighting to draw attention to the arched walls. With no other enhancement but the crisp all-white color scheme, the architecture speaks for itself.

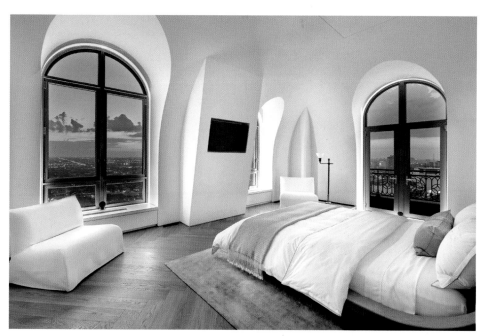

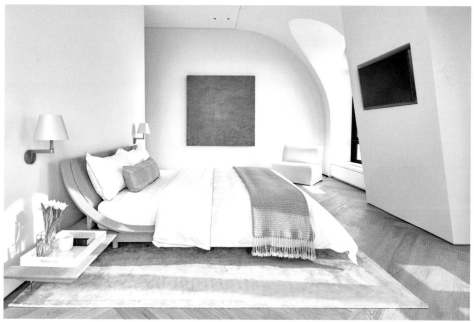

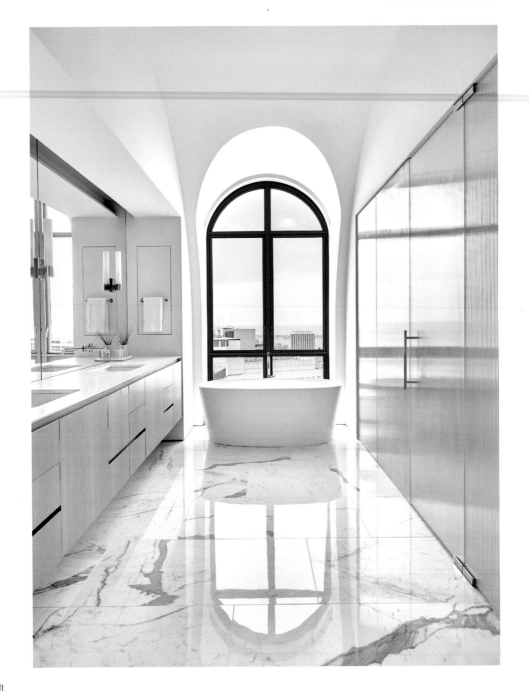

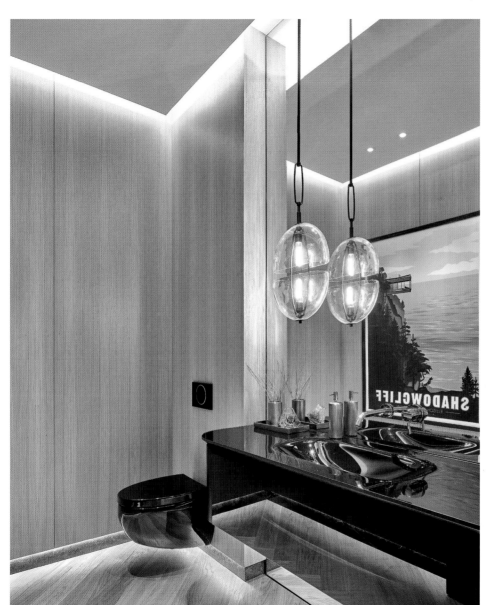

In the powder room, a lit reveal in lieu of a baseboard and a dropped ceiling that doesn't engage with the walls create a floating effect reinforced by the reflective materials and the mirror.

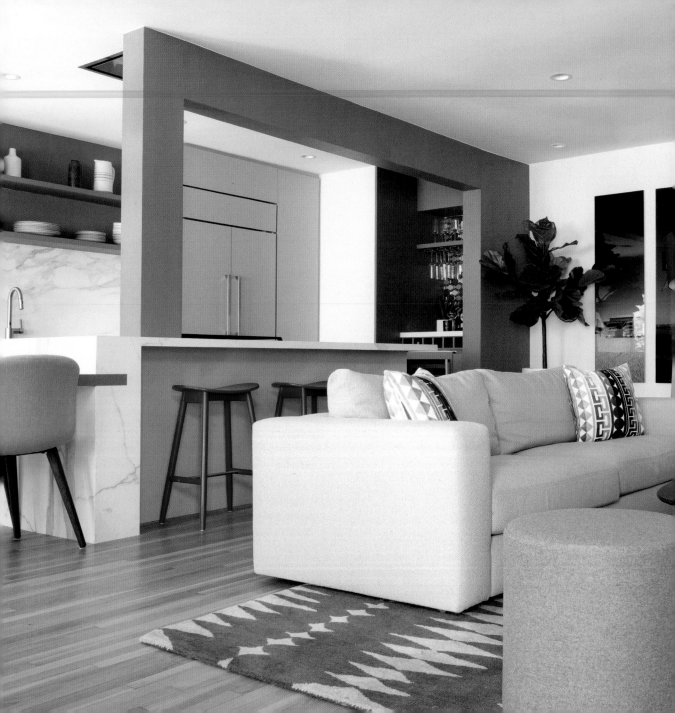

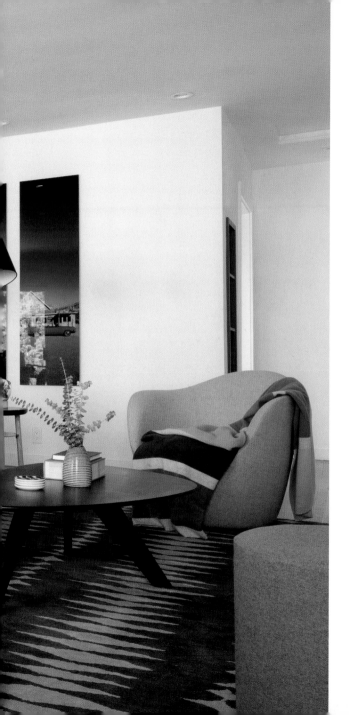

Heavenhurst
Pied-à-Terre

971 sq ft

Los Angeles, California,
United States

22 INTERIORS

Photographs © Annie Meisel

Located in a classic mid-century modern 25-unit building, this apartment has all the charms of West Coast living, including a central courtyard with a pool and hot tub, and views of beautiful palm trees from every room. The owners wanted the unit to be upgraded and opened up, especially the kitchen, which was enclosed and made the living area look small. The priority was to remove the wall separating the kitchen from the living space and reimagine the way a kitchen/dining space could work. Next was the creation of a master suite to make the bathroom private and add a laundry closet. Custom cabinetry and beautiful materials provided the new home with functional clarity and personality.

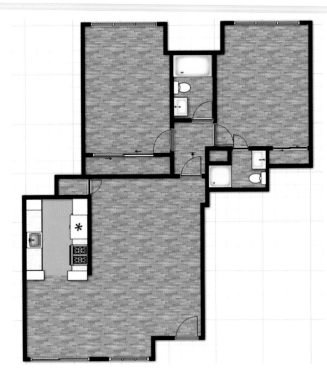

Before renovation floor plan

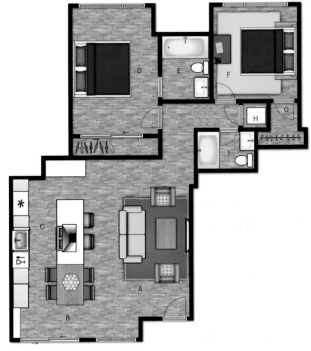

After renovation floor plan

A. Living area
B. Dining area
C. Kitchen
D. Master bedroom
E. Master bathroom

F. Bedroom
G. Walk-in closet
H. Washer/dryer
I. Bathroom

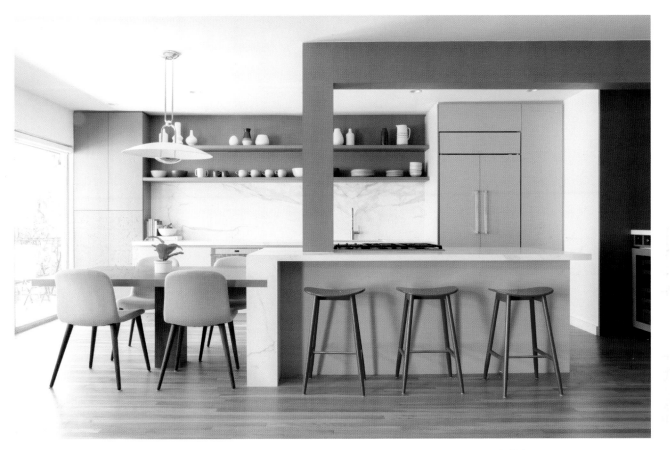

051

The new open kitchen features an island that accommodates informal seating. It extends toward the floor-to-ceiling window to intersect with the dining table, creating a focus for family life and entertaining.

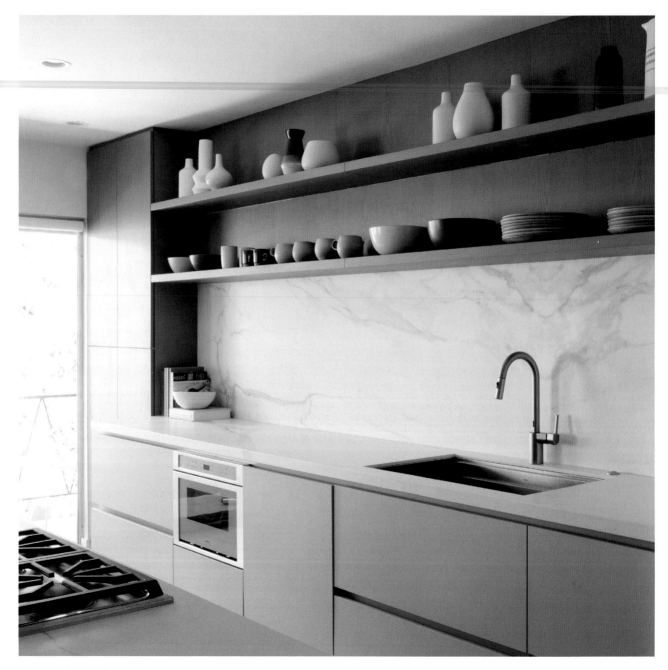

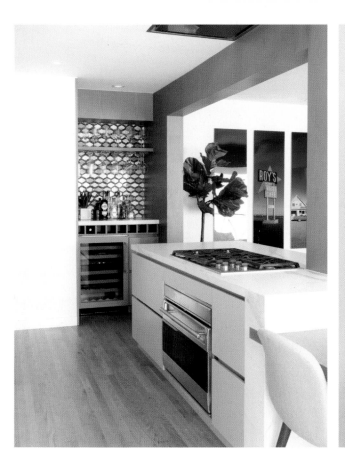

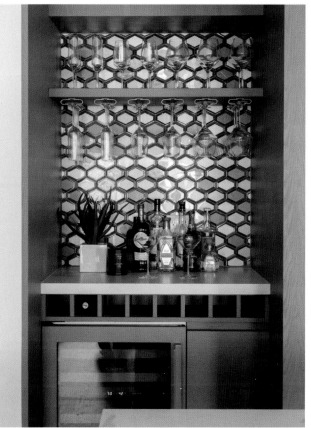

052

The existing beam and columns at the kitchen island are painted a dark shade to set the kitchen off from the living room while linking it with the bar.

053

The considered yet understated decor creates a relaxed living environment and also lets the spaces speak for themselves.

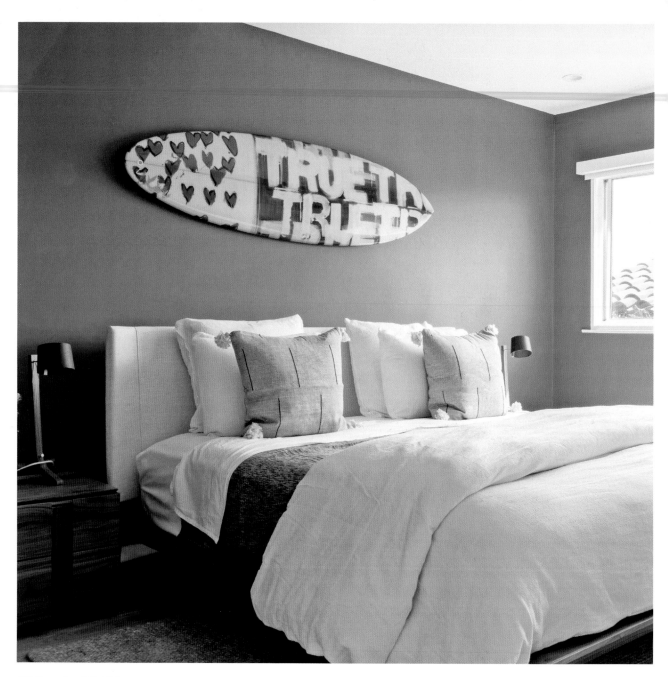

054

The blue theme in the bedroom and the bathrooms is a reference to the West Coast living concept and to the ocean, a perfect way to create a soothing atmosphere.

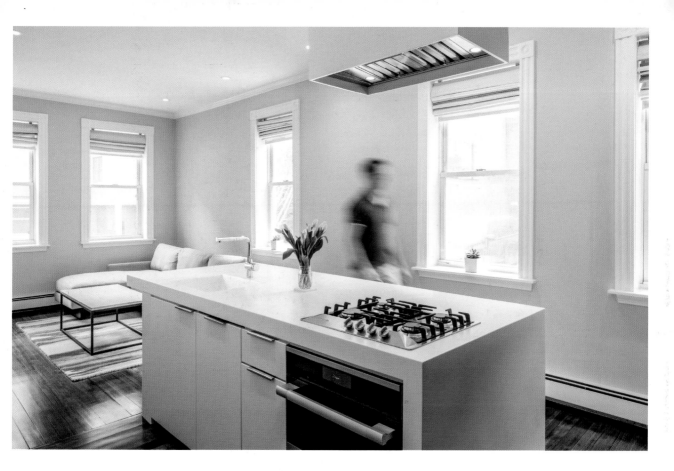

This corner unit, with its high ceilings and interesting detailing, had promising potential. It had been neglected and just needed some attention. The designers focused on making the most of every square inch of the small apartment. They wanted to consolidate storage to free as much space as possible, and they knew it was also critical to allow optimal natural lighting, especially to rooms with no windows such as the bathroom. As a result, the design balances aesthetics and functionality with precise detail, delivering a pleasant living experience in this tiny unit.

Deblois

750 sq ft

Boston, Massachusetts, United States

Bunker Workshop

Photographs © Matt Delphenich

In the kitchen, one of the walls is lined with white cabinetry and a room-choking peninsula is replaced with a flow-friendly island. A new bookcase is a focal point in stark contrast with the overall white color scheme.

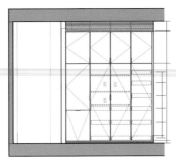

Fridge elevation

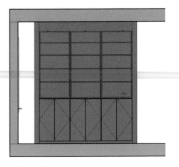

Built-in elevation

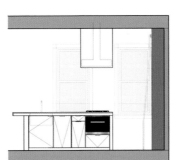

Island elevations

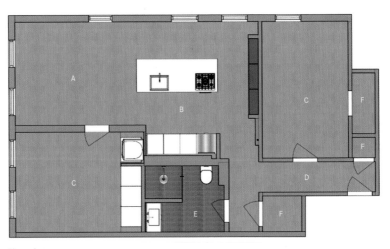

Floor plan

A. Living/
 dining area
B. Kitchen
C. Bedroom
D. Hallway
E. Bathroom
F. Closet

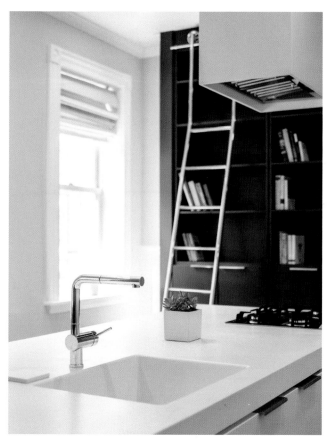

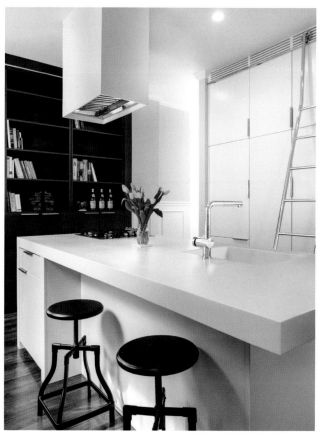

055

Generous and efficient storage is critical to maximizing the usage of limited floor space. Floor-to-ceiling cabinetry takes advantage of the underused space near the ceiling, eliminating clutter atop cabinets.

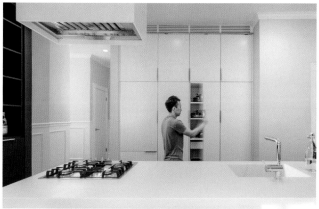

Bedroom closet elevation

Sink elevation

WC elevation

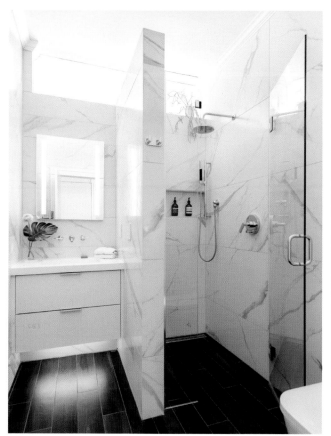

Space was trimmed from an existing bedroom to improve an adjacent bathroom's functionality. Also, the windowless bathroom borrows natural light from the bedroom through a clerestory above a new series of space-saving closets.

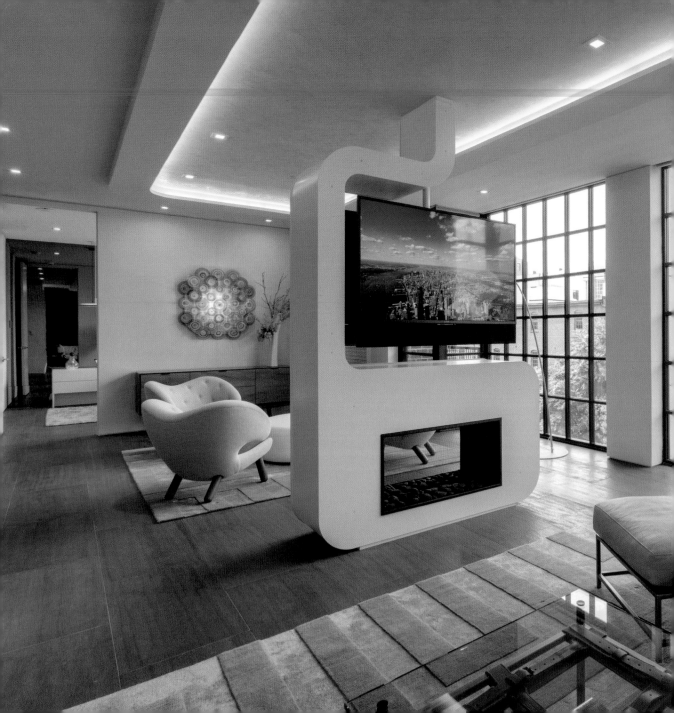

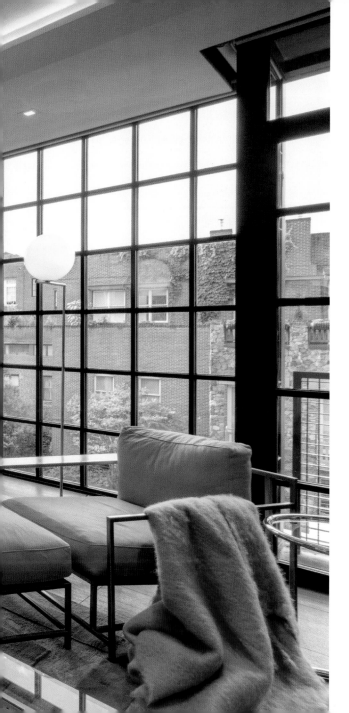

Flat on the Georgetown Canal

1,400 sq ft

Washington, District of
Columbia, United States

FORMA Design

Photographs
© Geoffrey Hodgdon

The clients, a couple who had been living in Baltimore, Maryland, for years, bought this apartment by the Potomac River, with beautiful views of historic Georgetown. The intent was to use it as a weekend getaway to access Washington's cultural events, restaurants, museums, and the Kennedy Center plays and concerts. They approached FORMA to explore how to maximize the potential of the two-bedroom/two-bathroom apartment. The tight dimensions of the apartment guided the design to create an architecture that transformed the space in a way that felt more open and also accommodated the clients' lifestyle and taste.

A wall between the former living room and den was demolished to create an open space for a living area and a lounge. A new double-sided fireplace with a TV facing both areas subtly separates them without compromising the openness of the space.

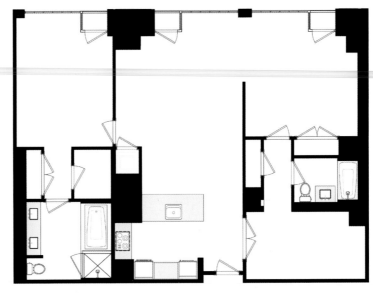

Before renovation floor plan

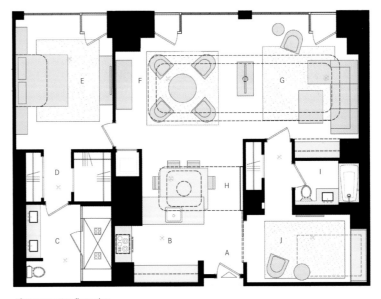

After renovation floor plan

A. Entry
B. Kitchen
C. Master bathroom
D. Master closet
E. Master bedroom
F. Living area
G. Lounge area
H. Dining area
I. Bathroom
J. Office

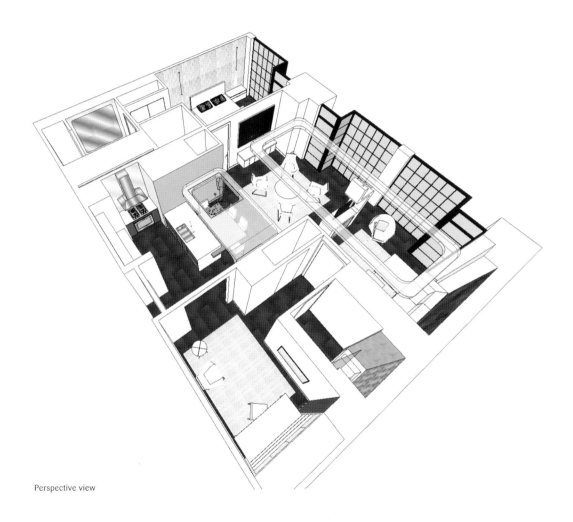

Perspective view

The apartment faces the Georgetown Canal, and has beautiful views of historic Georgetown through floor-to-ceiling windows in the living and lounge areas and in the master bedroom.

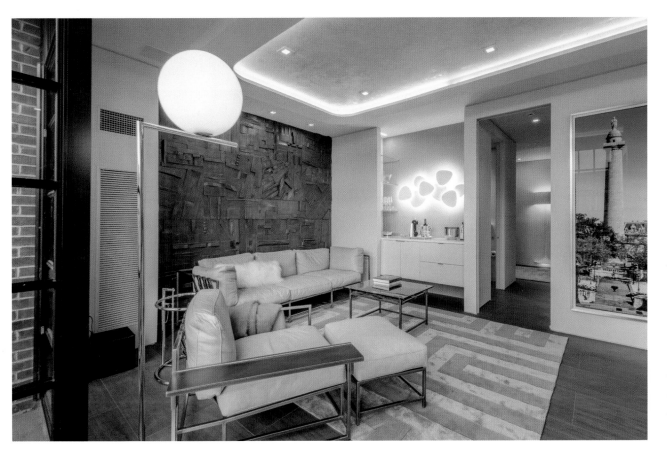

056

Coved ceilings can help define areas in open-plan spaces by highlighting the different zones directly below them. Coved ceilings add character to any room, create a sense of depth, and enhance the perception of a taller ceiling.

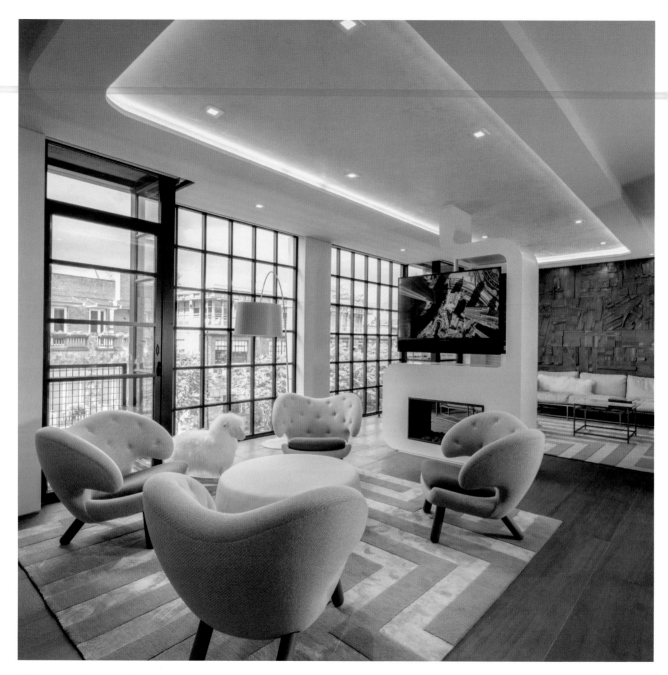

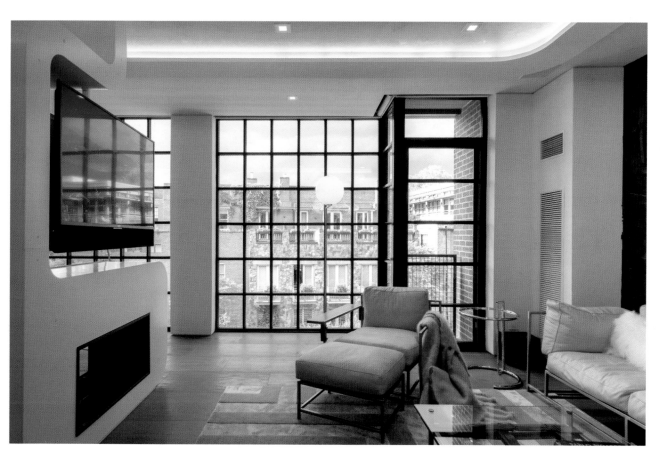

057

A sculptural double-sided fireplace
with a TV facing both the living area
and the lounge area organizes the
common spaces while maintaining
the spatial continuity.

Some of the design's highlights include stone floors with radiant heat, the latest in lighting and AV technology, and a new kitchen and dining area.

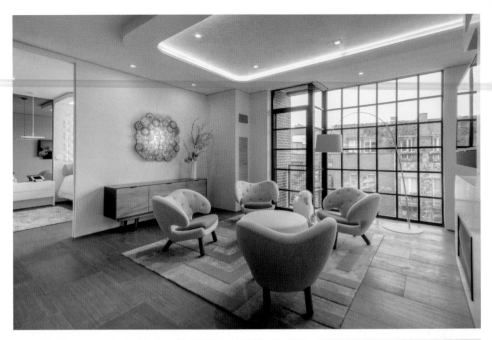

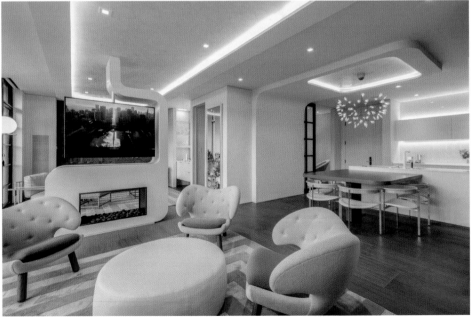

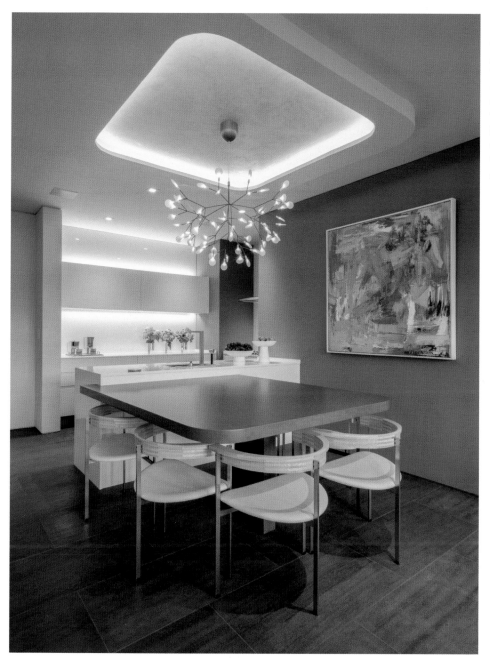

A neutral palette of colors throughout the apartment yields center stage to the owner's collection of contemporary art. The artwork brings color and harmonizes with the selection of mid-century and customized furniture. Cove lighting helps define areas.

The design of the kitchen was adapted to the requirements of a second home, where the owners come to relax and enjoy the active cultural scene of the city. Responding to these requirements, the kitchen is compact, with scaled-down appliances, and open to the living area and lounge.

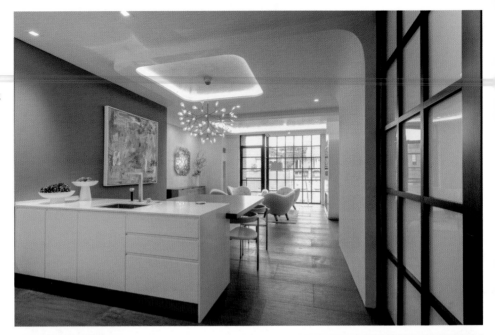

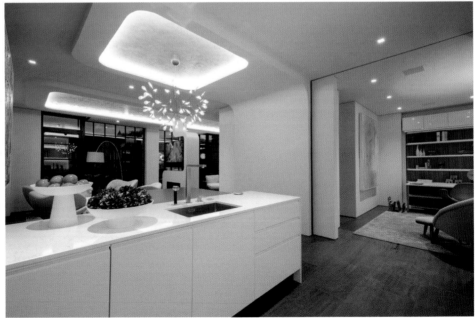

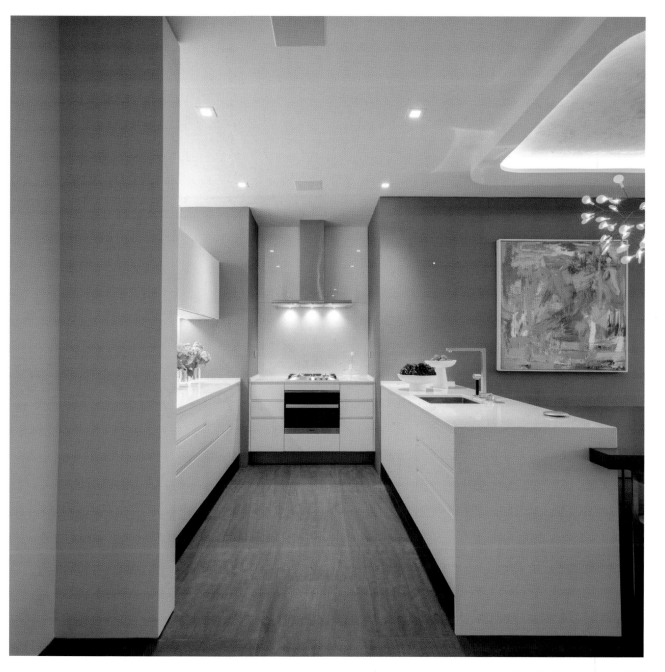

059

Multifunctional furniture allows flexible use of space. Here, the home office doubles as a guest bedroom, with the custom desk and storage system rotating to expose a bed.

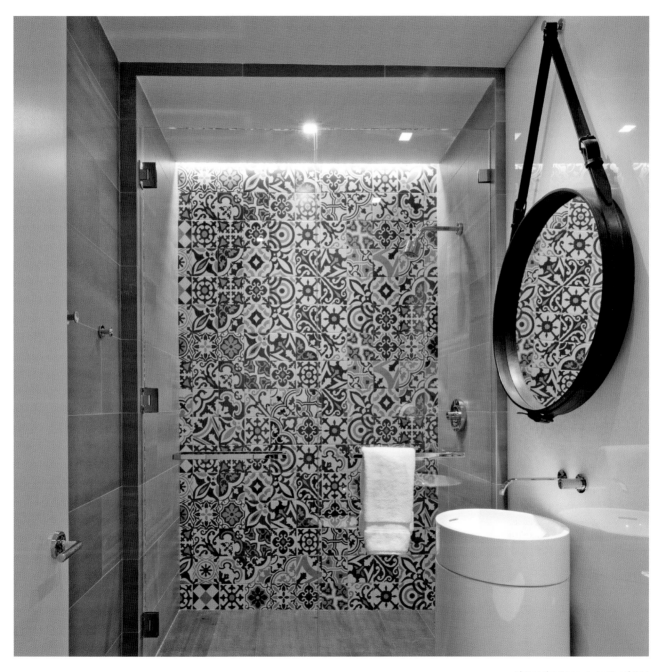

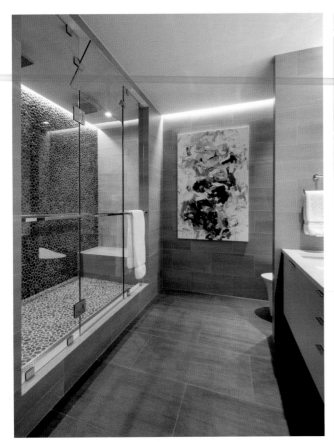

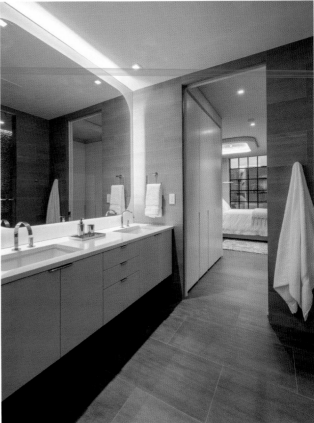

The master bedroom suite features a
leather headboard and smoky mirrors
extending the perception of space. The
master bathroom with a large steam-
bath/shower makes this pied-à-terre
a favorite getaway.

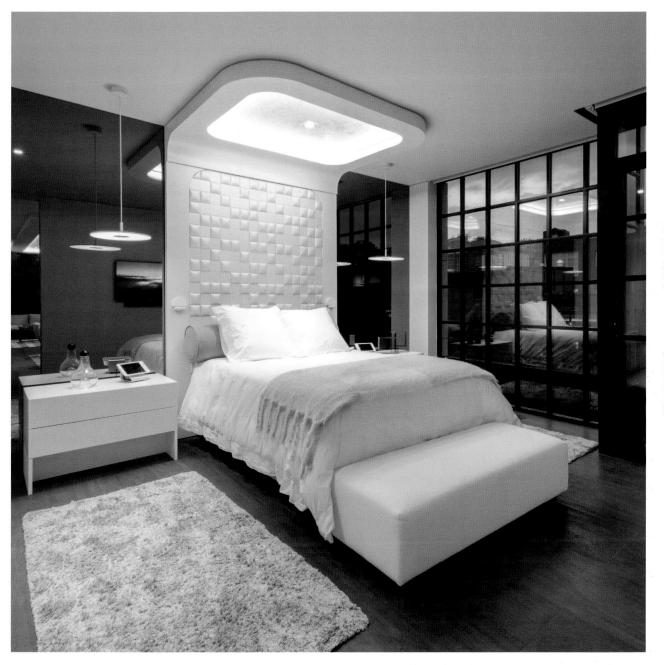

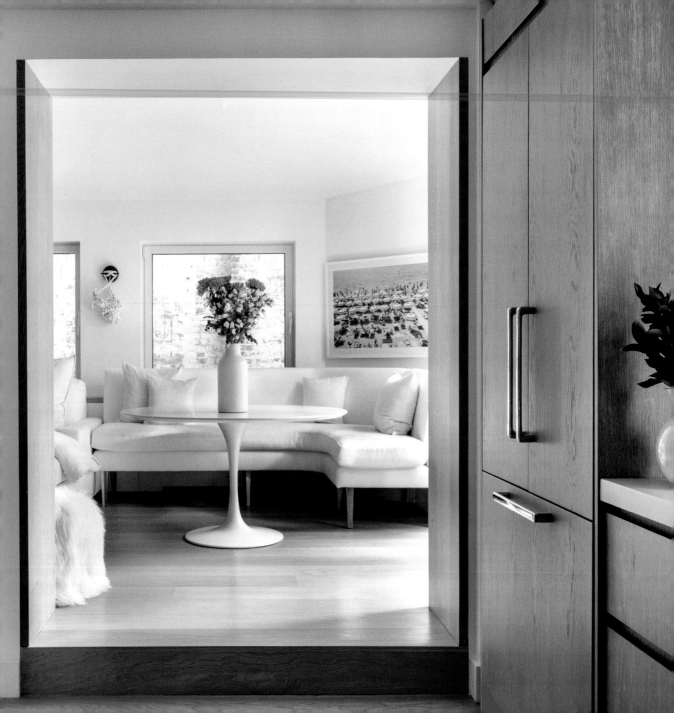

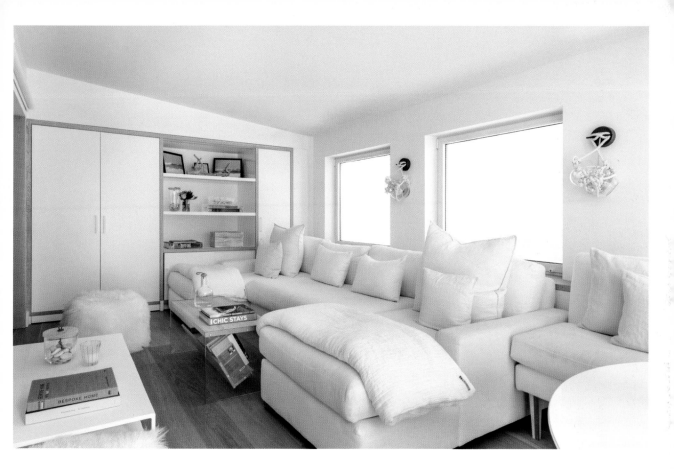

This pied-à-terre with a generous roof terrace overlooking Central Park called for a light and airy feel. The owners, a young family from Palm Beach, Florida, wanted a tranquil and relaxed space, an oasis in the heart of ever-so-busy Manhattan. Taking inspiration from the owner's main home as well as nautical design and yacht interiors, a strategy was developed to create highly customized built-in cabinetry and furniture in the private areas of the apartment —the bedroom suites—while allowing for an open flow and lots of natural light in the public areas. Interior windows and glass sliding doors allow natural light to filter into darker parts of the apartment, such as the master bathroom and the entryway.

Fifth Avenue Pied-à-Terre

1,700 sq ft
New York, New York
United States

Benjamin Andres Architekt/ Opus.AD

Photographs © Regan Wood

060

With windows on three walls,
the apartment is bright and airy.
The open layout promotes fluid
circulation and allows the rooms
with less light to borrow from
adjacent ones.

Floor plan

A. Entry foyer
B. Bedroom
C. TV room
D. Bathroom
E. Washer and dryer
F. Master bedroom
G. Powder room
H. Walk-in closet
I. Master bathroom
J. Kitchen
K. Dining area
L. Living area
M. Outdoor dining
N. Shed
O. Outdoor lounge

061

Separating different areas of a large room without the usual barriers not only brings a sense of spaciousness, but also innovative solutions that will add design appeal. For instance, a step creating a floor level difference can enhance the spatial experience.

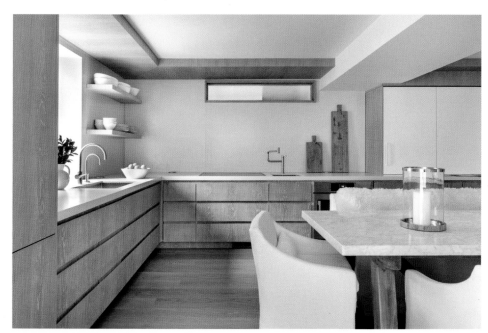

The kitchen is treated as an extension of the living room by using the same cabinet finish as in the rest of the apartment and creating designated cabinet space to conceal all kitchen appliances. The setup is perfect for entertaining as well as weeknight family dinners.

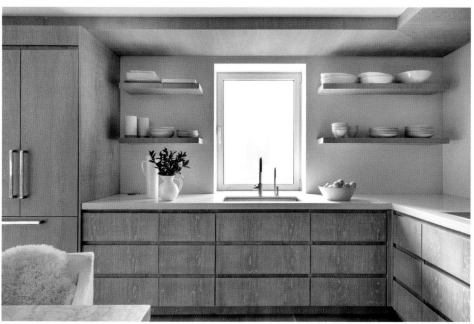

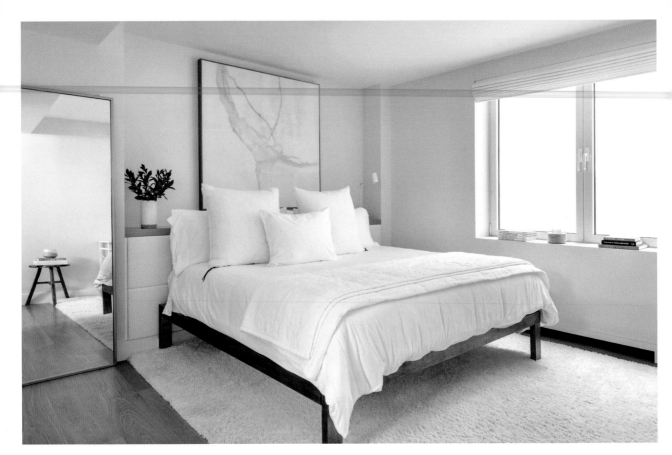

062

The white walls and area rug along with the light wood flooring create a relaxed and soothing atmosphere reminiscent of the Scandinavian design concept hygge.

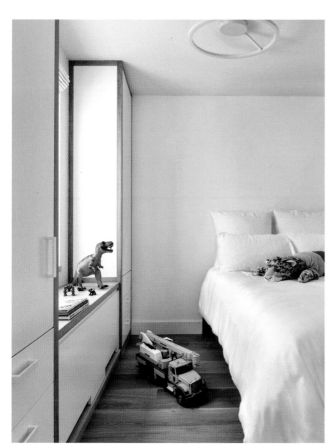

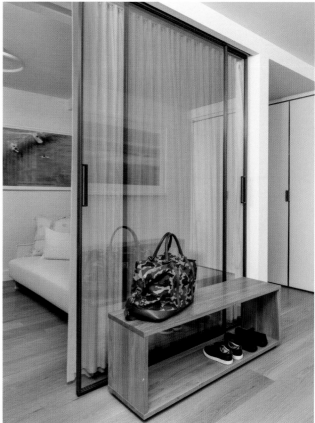

063

Glass sliding doors allow light to reach the entry, the area farthest from any window. They also give the area a sense of openness.

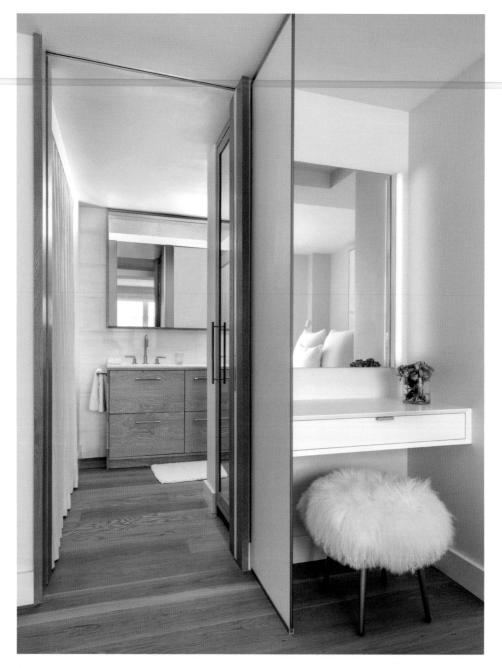

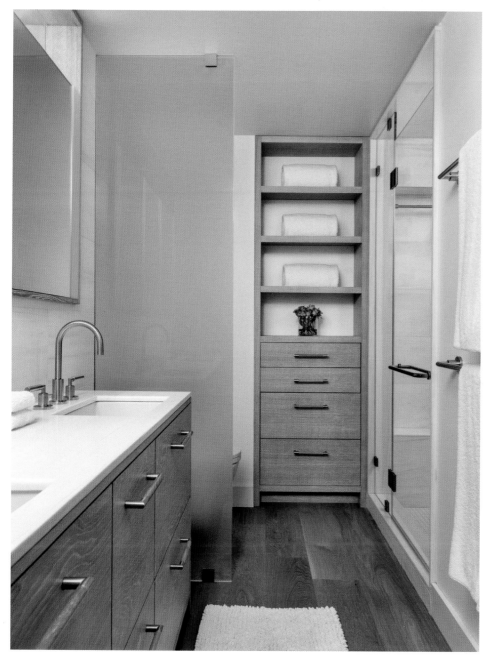

The master bathroom and walk-in closet are infused with the same relaxed atmosphere of the master bedroom.

West Village
Pied-à-Terre

1,525 sq ft
New York, New York,
United States

Lucy Harris

Photographs
© Francesco Bertocci

The interior of this pied-à-terre had character and didn't require any major redesign. New surfaces combine with a tasteful selection of modern classic furniture and contemporary pieces from New York designers Bower, Roll and Hill, and Apparatus. The design focuses on minimal changes for maximum effect and celebrates the modern and timelessness of New York's vibrant culture to create a charming and inviting atmosphere with sophisticated design appeal. Light tones make the apartment bright and airy. Ebony-stained pine flooring and black-painted steel windows add contrast, while pops of color add visual interest and reflect the jovial personality of its young resident.

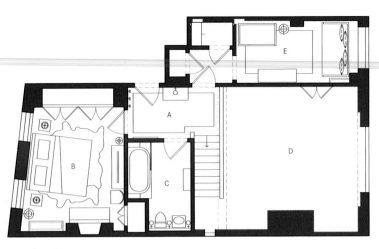

Upper floor plan

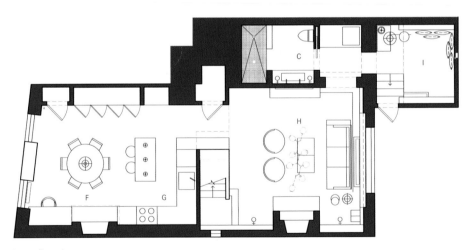

Lower floor plan

A. Entry foyer
B. Master bedroom
C. Bathroom
D. Open to below
E. Nursery

F. Dining area
G. Kitchen
H. Living area
I. Guest bedroom

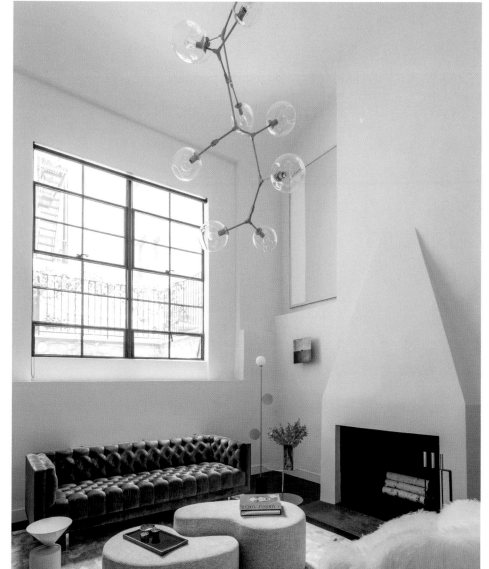

Double-height ceilings create airy interiors. Perhaps the best way to make the most of this prominent architectural feature is to highlight the vertical dimension through other architectural features such as windows or fireplaces, or decorative items like light pendants.

065

The selection of furnishings can highlight the architectural character of the spaces they are in, referencing the stylistic period when they were built.

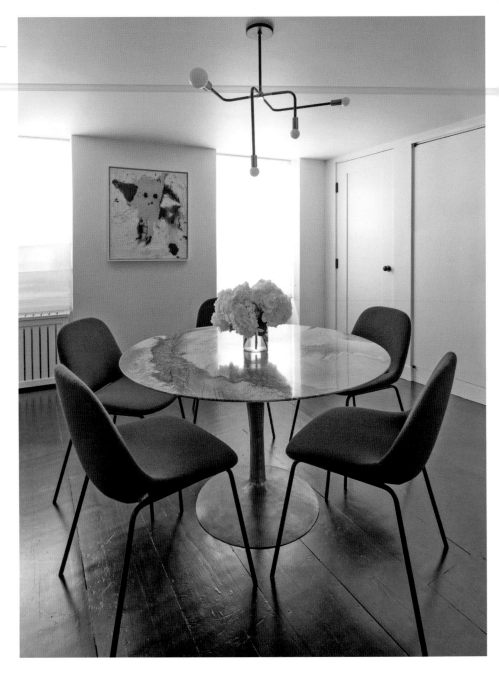

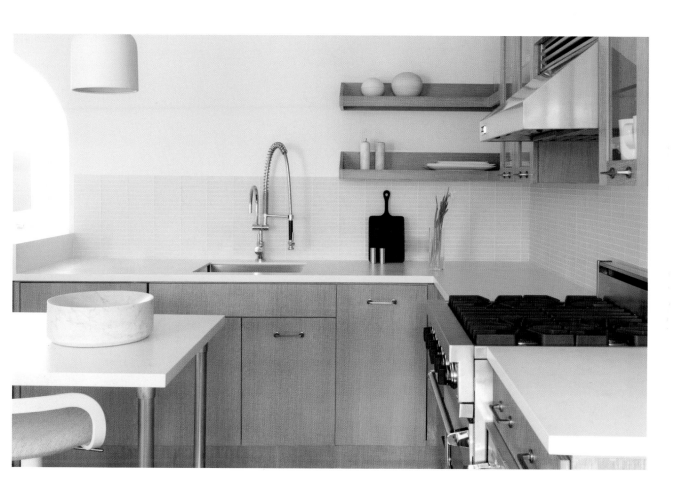

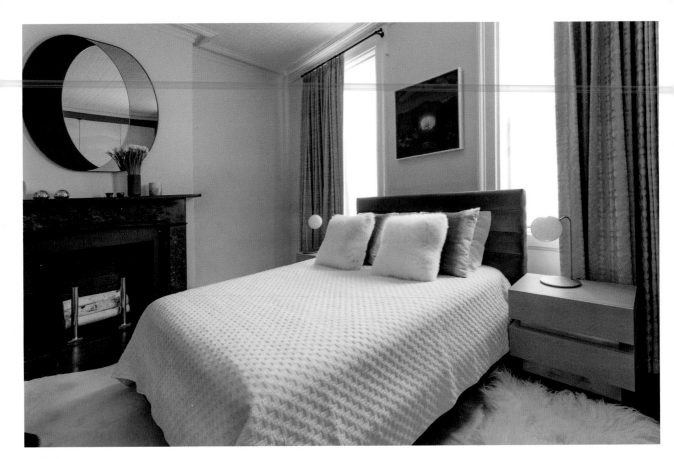

066

A fireplace brings the ultimate
form of cozy and intimacy
into a bedroom while adding
architectural detail and style.

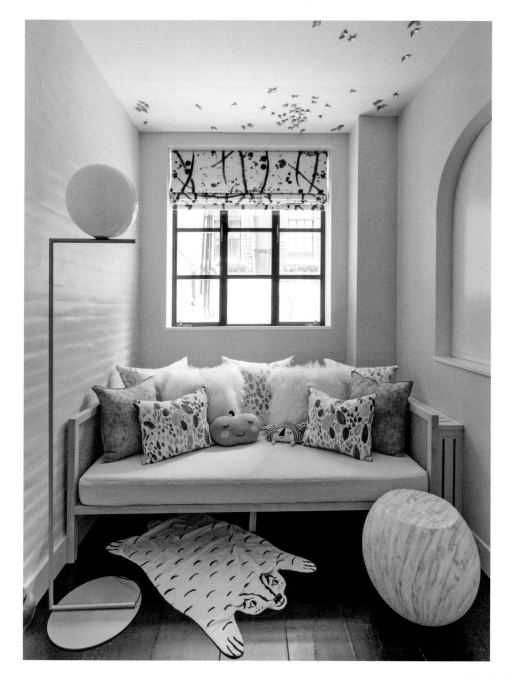

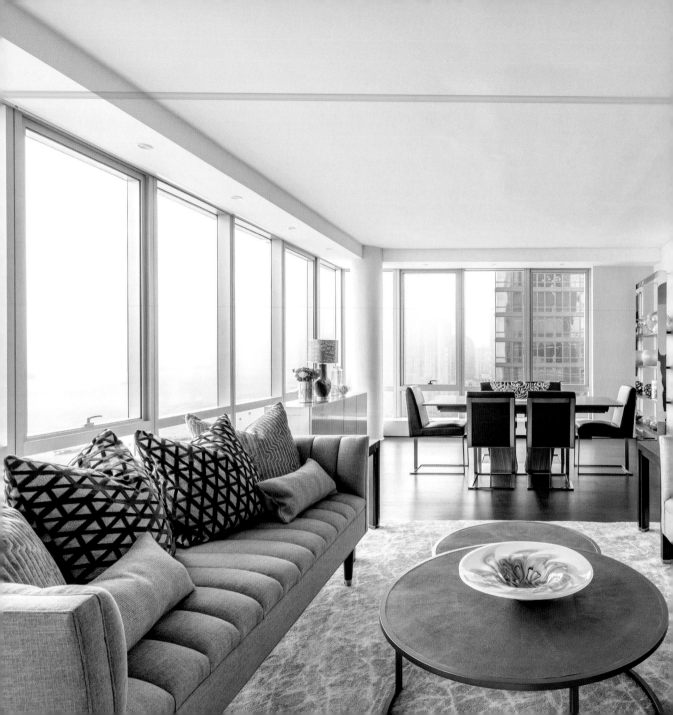

Riverside

3,500 sq ft

New York, New York,
United States

Ward 5 Design

Photographs © Pixy Lau

For this apartment with floor-to-ceiling windows and an open floor plan, a contemporary aesthetic was created to both stand out and blend with sweeping city views. By pairing a variety of surface materials, such as grasscloth and cork wallpapers, brick veneer, and wood beams, the four-bedroom, five-bathroom residence showcases a distinctive modern mix of color and texture. The major common areas are visually connected. Accent colors of ochre in the living room and deep eggplant in the family room complement each other's boldness.

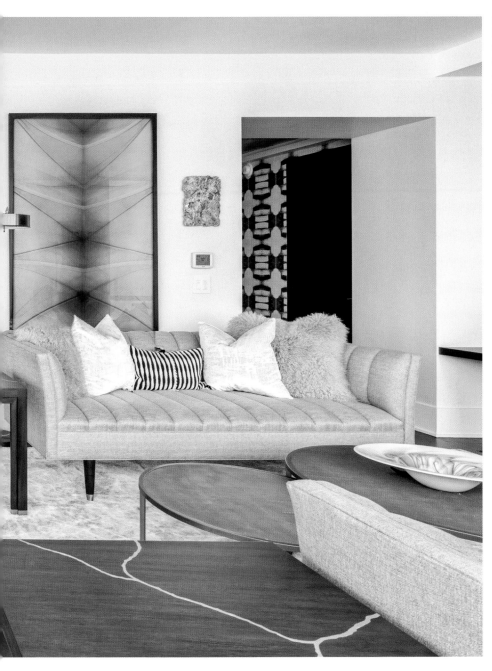

Custom-made sofas are featured in both spaces, one that keeps consistent with light neutrals, the other made of stark black velvet and leather. Mixed metallics were also used in the entry and hallways to create a bold, luxurious look, even in the smallest of spaces.

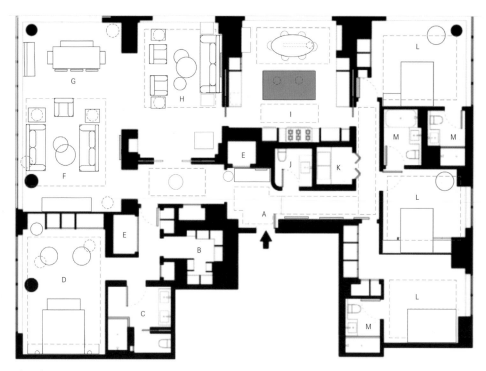

Floor plan

A. Entry foyer
B. Master closet
C. Master bathroom
D. Master bedroom
E. Mechanical
F. Living area
G. Dining area
H. Sitting area
I. Kitchen
J. Powder room
K. Washer/dryer
L. Bedroom
M. Bathroom

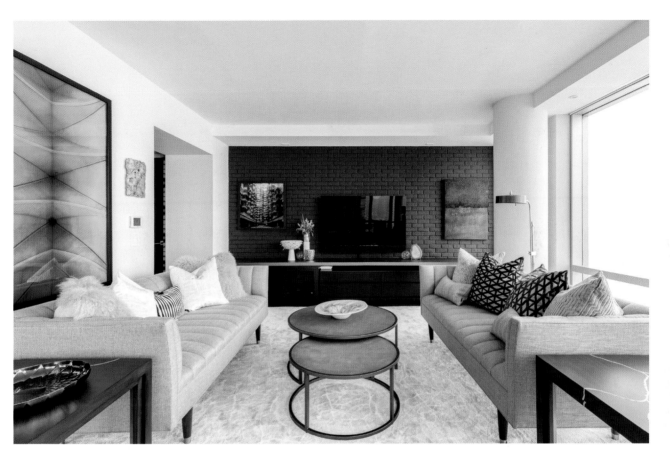

067

Two to three colors sensibly used for surfaces, furnishings, and decorative items will carry the eye throughout a room and keep things visually interesting.

068

Wallpaper is a versatile design material that can greatly change the ambiance of a room. It provides pattern and texture, and the extent of its visual impact is in one's own hands, using it to create an accent wall or to cover all the walls of a room to reflect a unique style.

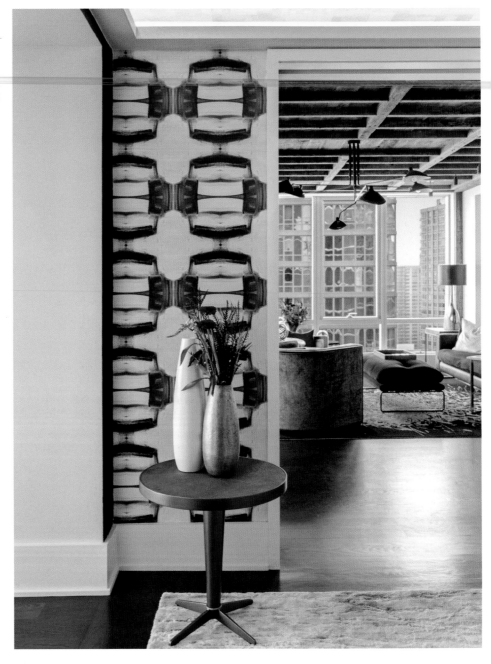

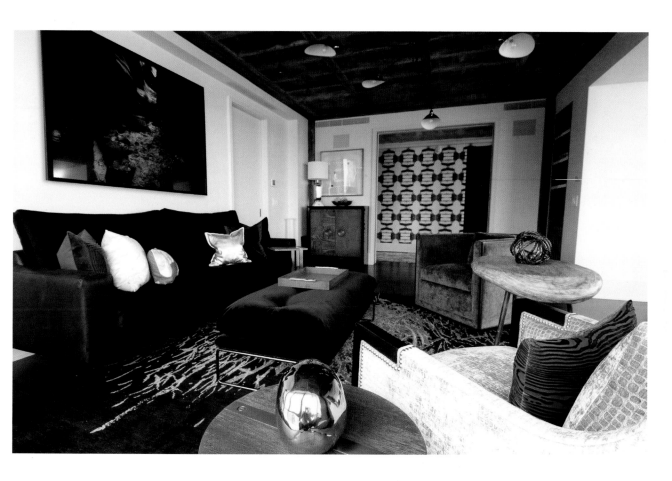

069

Texture is an essential part of any interior design. It can transform a bland room into a unique interior. Blending rough with smooth, visual with tactile will draw attention to any design.

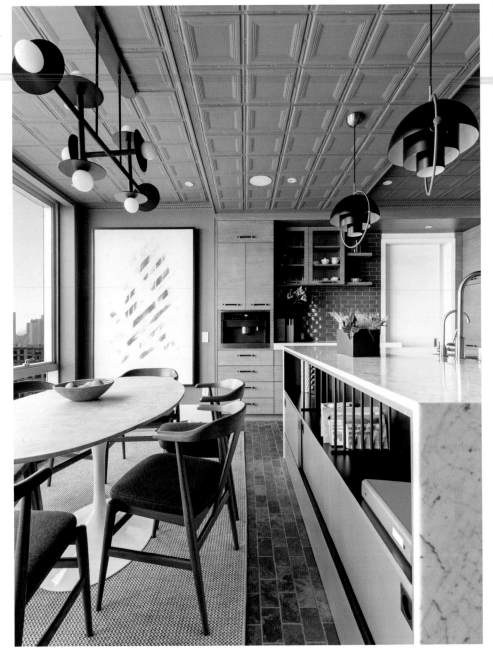

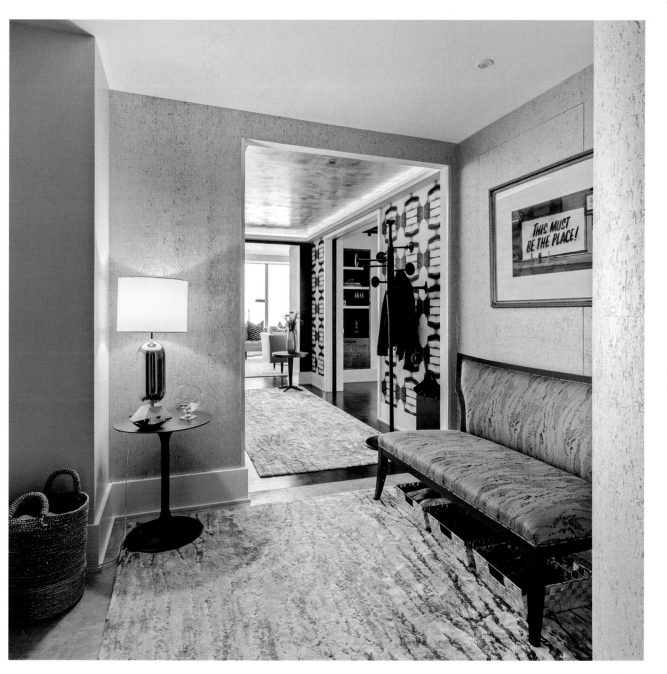

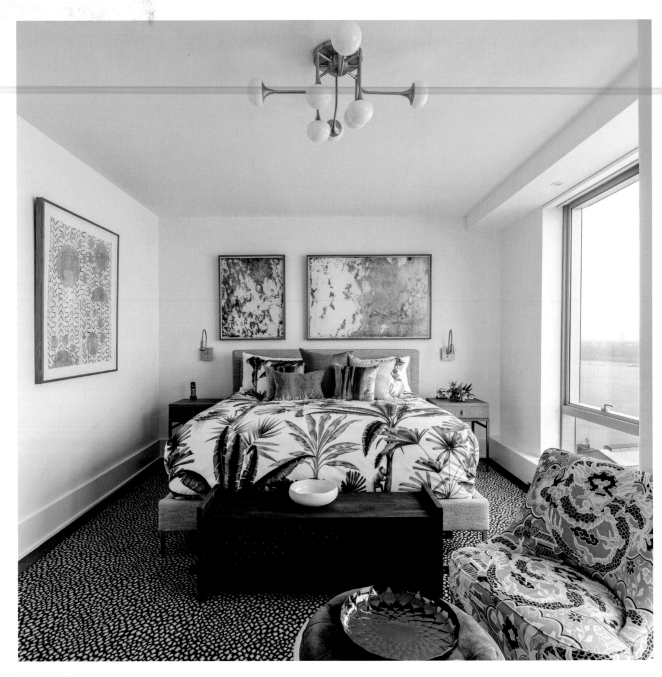

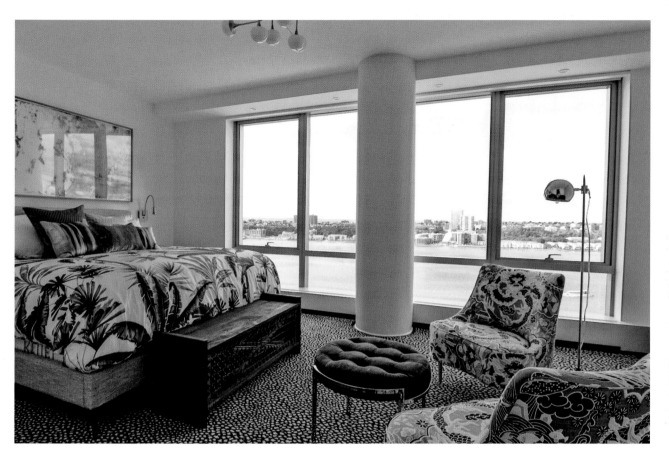

070

Pattern, like color, sets the tone in room decoration. Other than the style, the scale is perhaps the most important aspect of a pattern to take into account. The most prominent pattern can be complemented by others to boost visual appeal.

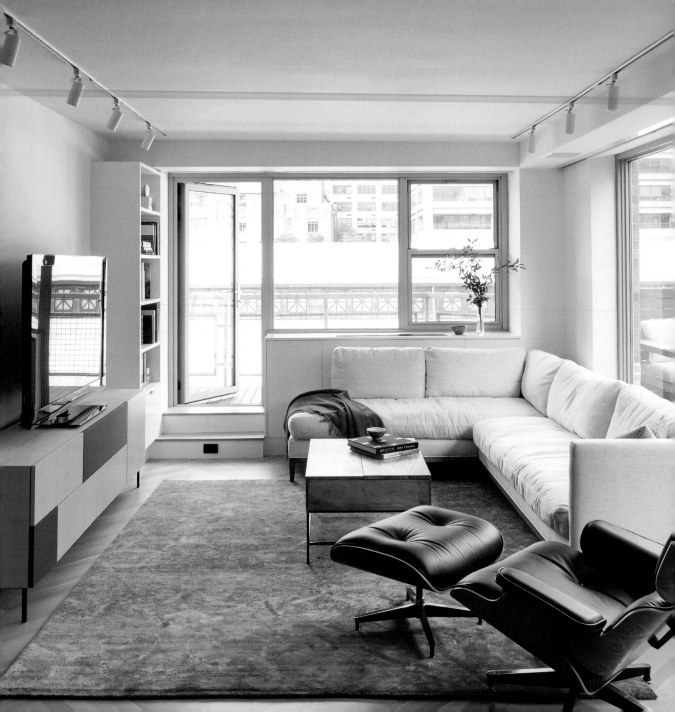

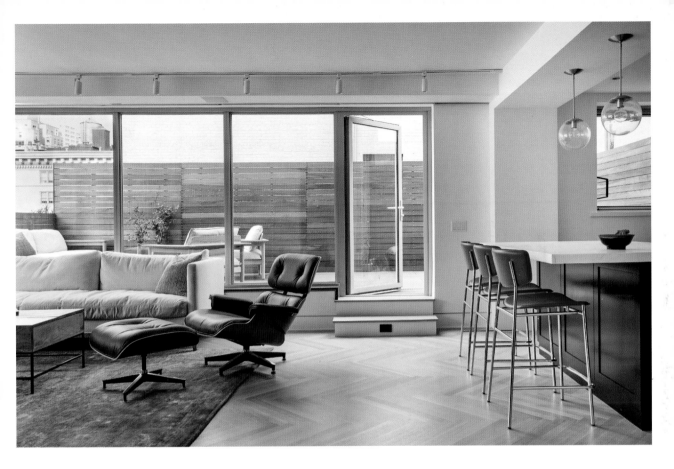

After living in cramped rentals for years, the owners were looking for a modern space where they could still express their personalities. The apartment on the East Side needed a full facelift, which gave them a perfect opportunity to satisfy that desire. Most of all, the 375-square-foot terrace allowed their dog to enjoy the outdoors without a walk to the park. The renovation updated all the finishes and expanded the kitchen into what was the dining room, pushing the dining room into the entry foyer. It also expanded the glazing between the living room and the terrace, blurring the transition between the two.

Armory Apartment

1,050 sq ft

New York, New York, United States

Fowlkes Studio

Photographs © Alison Gootee

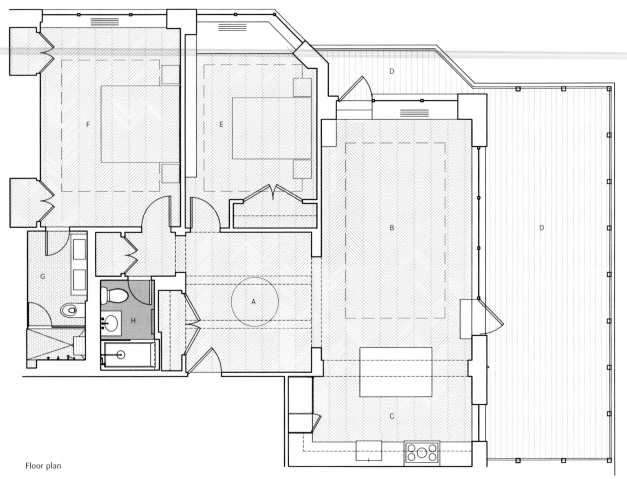

Floor plan

A. Dining area E. Bedroom
B. Living area F. Master bedroom
C. Kitchen G. Master bathroom
D. Terrace H. Bathroom

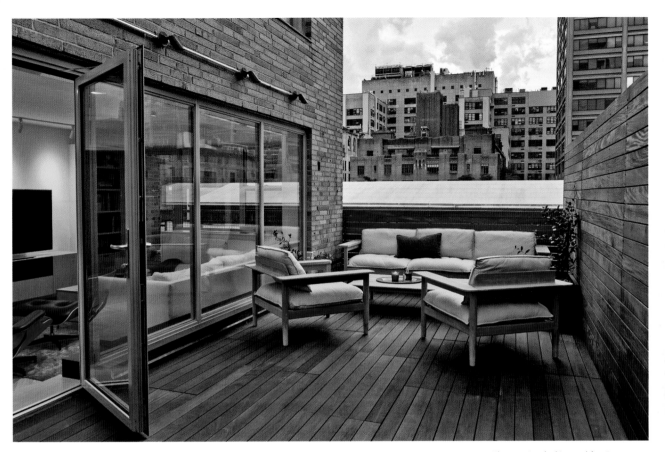

The new Ipe decking and fencing are both refined and rugged and give the terrace the feel of an outdoor room with the same level of finish as the apartment's interior.

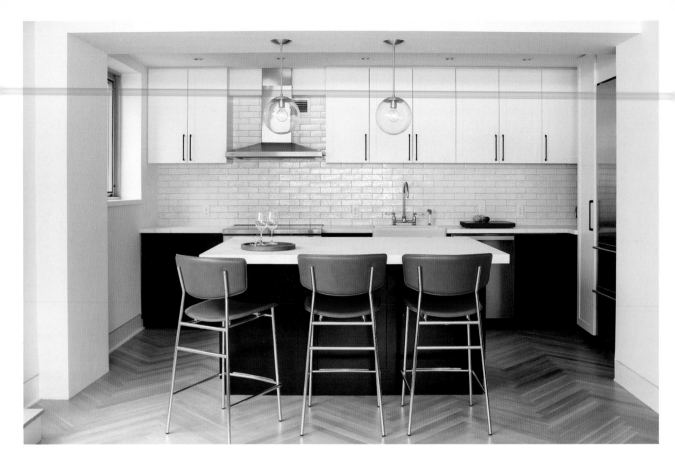

071

Take an accent color from one room to another as the main hue, creating rhythm while maintaining the consistency of the color selection.

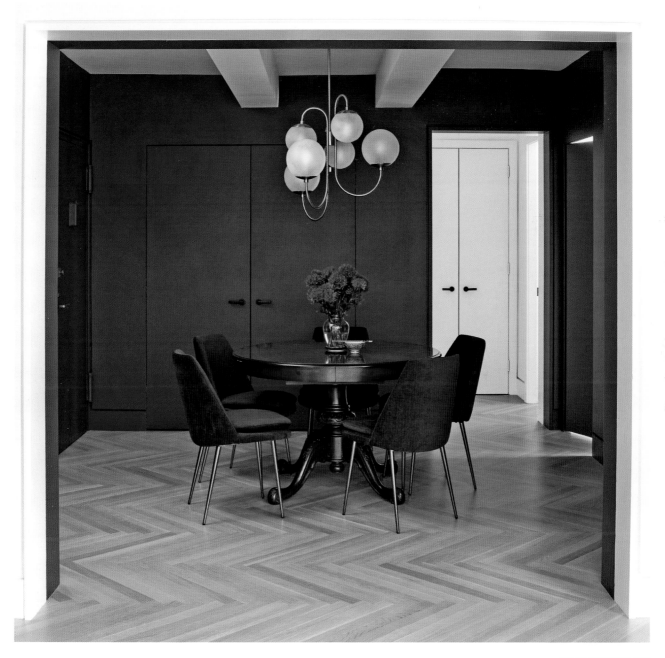

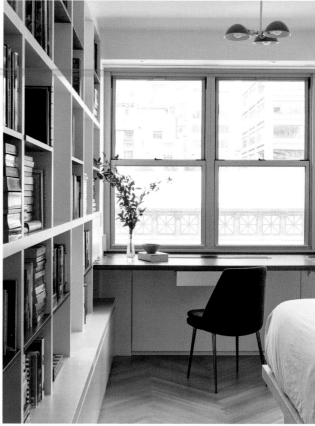

072

White offers a neutral and timeless
backdrop to create spaces where
furnishings and decorative items
take center stage.

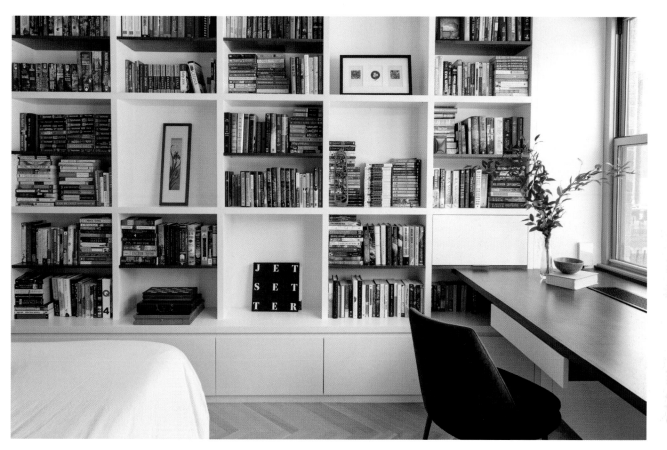

073

Bookshelves bring color and structure to modern spaces in addition to their main function: storage. They can blend with the walls or be featured for maximum effect.

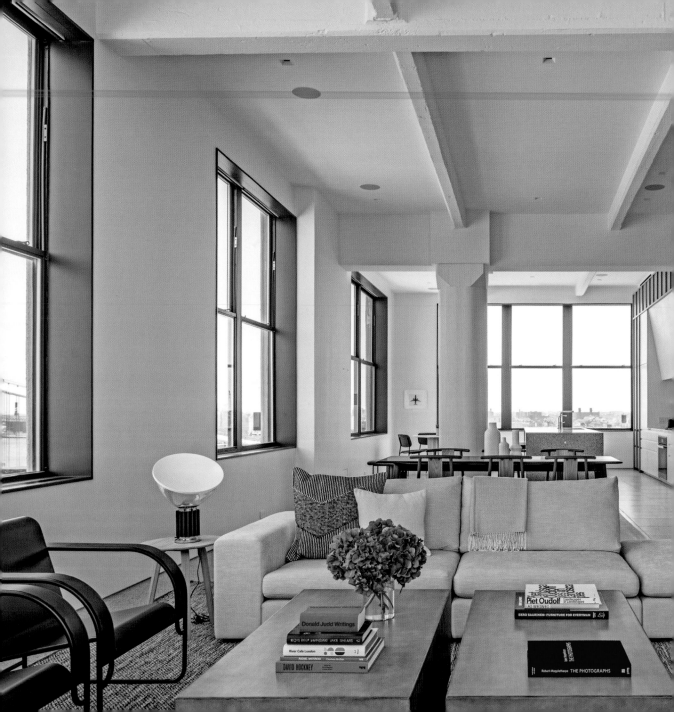

Four Corners Loft

3,200 sq ft

Brooklyn, New York,
United States

Worrell Yeung

Photographs © Alan Tansey

The design of this loft was inspired by the unique panoramic views of Manhattan and Brooklyn. Two distinct volumes become the visual and organizational hub of the loft, allowing each space along the perimeter to take advantage of the expansive four exposures of the New York City skyline beyond. The volumes are materially similar, yet the scale, texture, and pattern of the white oak panels vary to create subtle differentiation and distinct identities. The concrete ceiling and structure of the historical warehouse are exposed and expressed throughout to highlight the rawness and texture of the building, juxtaposed with the warmer materials and pure minimal lines of the new elements.

074

The reuse of existing structures allows for design opportunities that emphasize the distinction between existing and new. This results in an architectural language where the different qualities of old and new are the focus of the design.

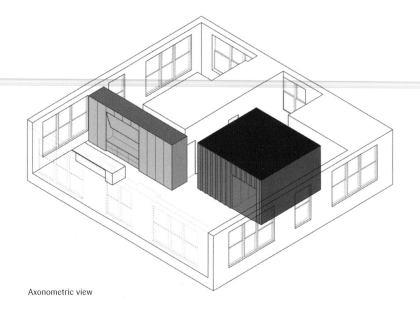

Axonometric view

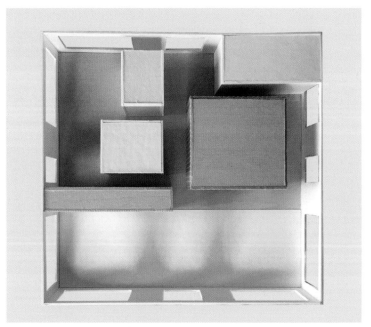

Conceptual model

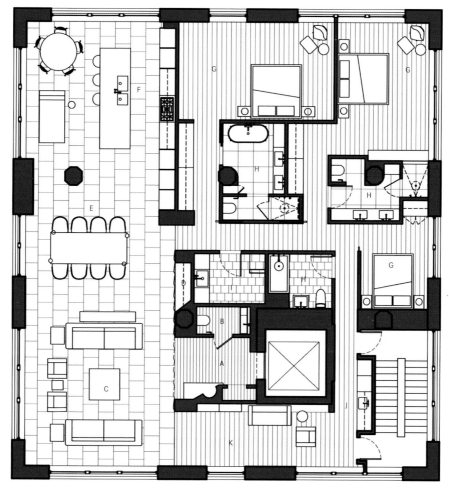

Floor plan

A. Entry foyer G. Bedroom
B. Powder room H. Bathroom
C. Living area I. Laundry room
D. Bar J. Wet bar
E. Dining area K. Library
F. Kitchen

New structures inserted into existing spaces—often referred to as a shell—respond to the concept of a container within another container, creating a powerful design statement.

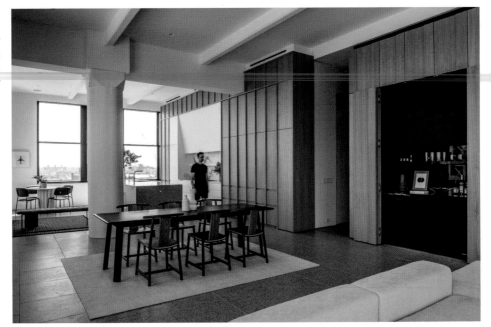

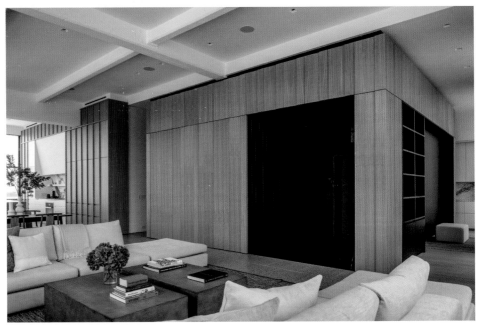

A concrete terrazzo floor and kitchen island accentuate the contrast between the shell and the two wood volumes. The perimeter walls throughout the loft are white, intentionally stark against the dark window frames that help reduce glare while framing the spectacular views.

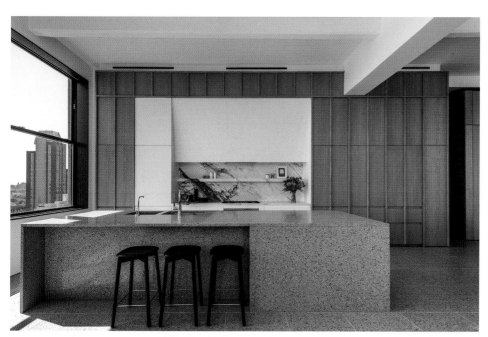

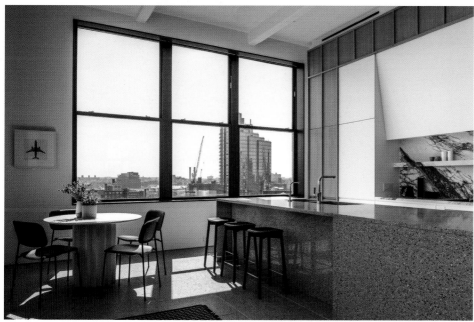

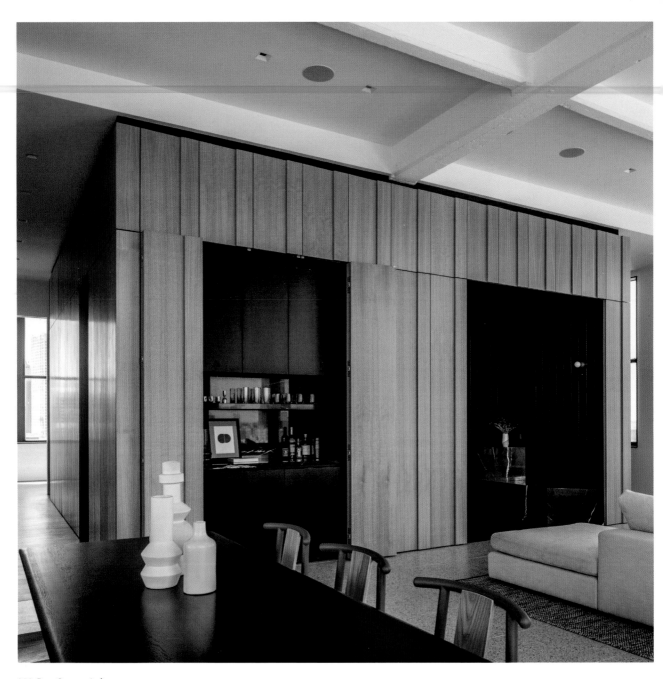

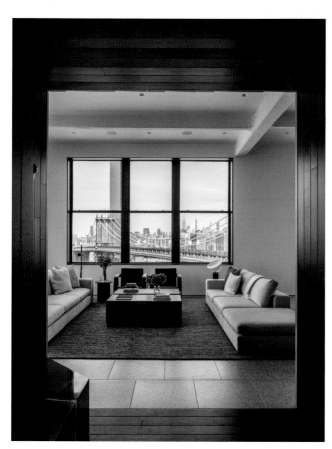

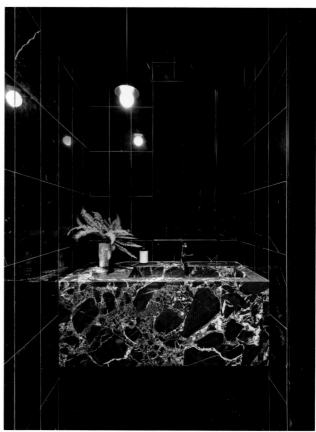

The wood paneling creates a vertical raked pattern. Rooms behind are finished in glossy dark tones that contrast dramatically with the main spaces.

076

The design vocabulary of an interior design project can be established by carrying out the same materials and detailing throughout all the rooms for unity.

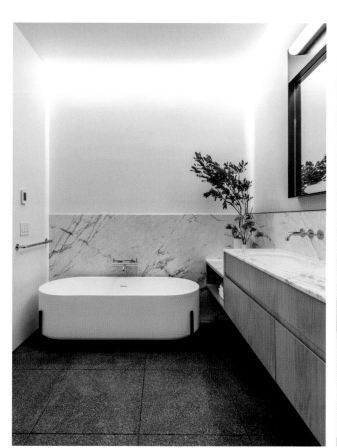

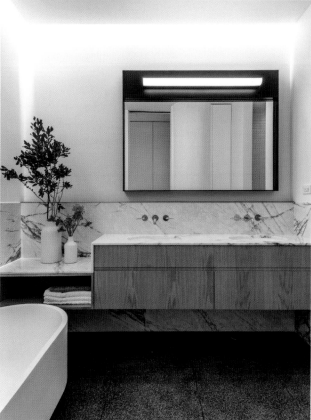

077

Variation in the detailing should respond to the specific requirements of each room.

Chelsea Pied-à-Terre

550 sq ft
New York, New York,
United States

Stadt Architecture

Photographs © David Mitchell

The Chelsea Pied-à-Terre apartment serves as an East Coast home
for a professional couple from Vancouver, British Columbia. Before
the renovation, the postwar layout had a cramped enclosed
kitchen isolated from the windowed living area. To address
the client's desire for a cooking area to be integrated into the
apartment's common areas, the kitchen was enlarged, opened,
and reoriented to take advantage of the living room's daylight.
The client also wanted to bring the lush natural landscape from
southwestern Canada into the design to soften the harshness of
the urban environment. The creation of a living wall was rejected
for practical reasons. This lead to the consideration of more
abstract design solutions that would bring the soothing comfort
and organic feel of nature.

078

Combining the kitchen with the living and dining areas into one big space works well for small apartments. This increases the feeling of spaciousness, improves circulation, and allows for a potential kitchen expansion.

Floor plan

A. Entry
B. Kitchen
C. Dining area
D. Living area
E. Bedroom
F. Walk-in closet
G. Bathroom

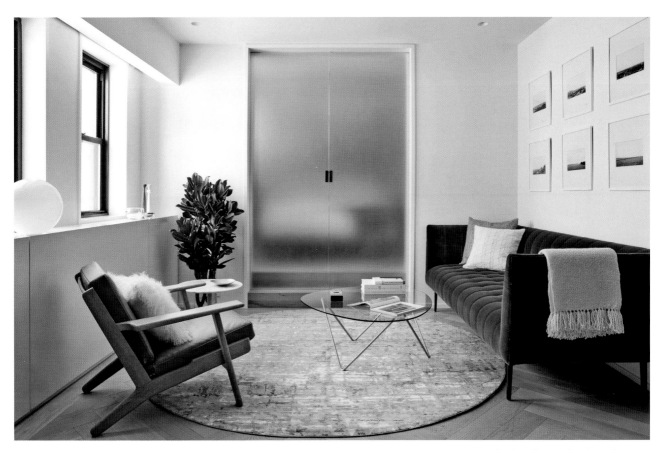

Two large frosted glass doors close, providing a separation between the living area and the bedroom. This separation satisfies privacy needs while still allowing natural light to filter through.

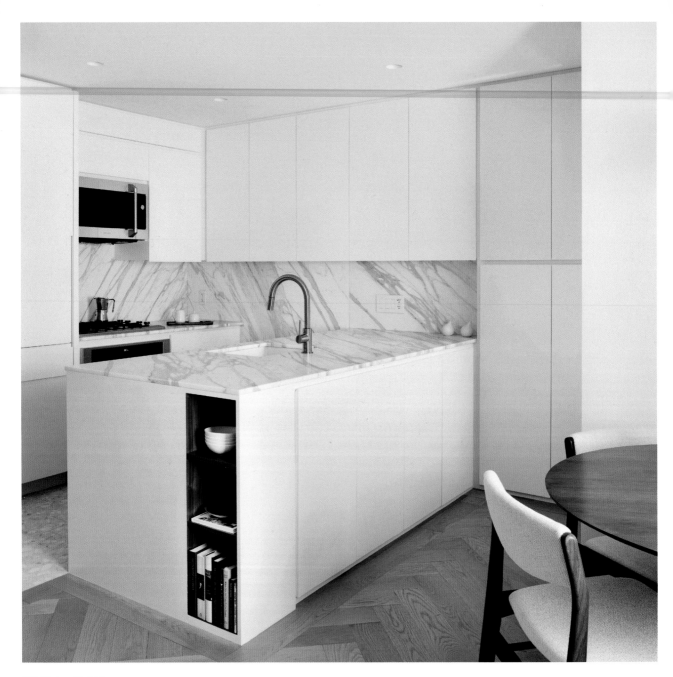

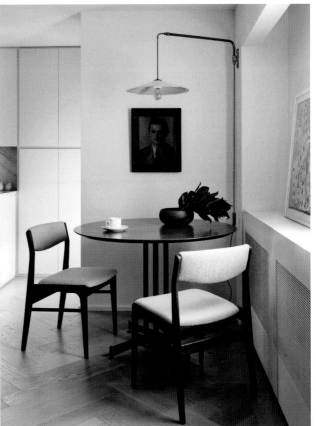

079

When different areas, such as the living room, dining room, and kitchen, share the same space, they can also share the same design language to give a unified approach to decor.

Rendered perspective of the bedroom

080

The gold-leafed ceiling creates
a luminous canopy over the bed
while the green field anchors the
headboard wall. When privacy
is not a concern, the bedroom
becomes a focal point, expanding
the limits of the living area.

Inspirational image for the bedroom design

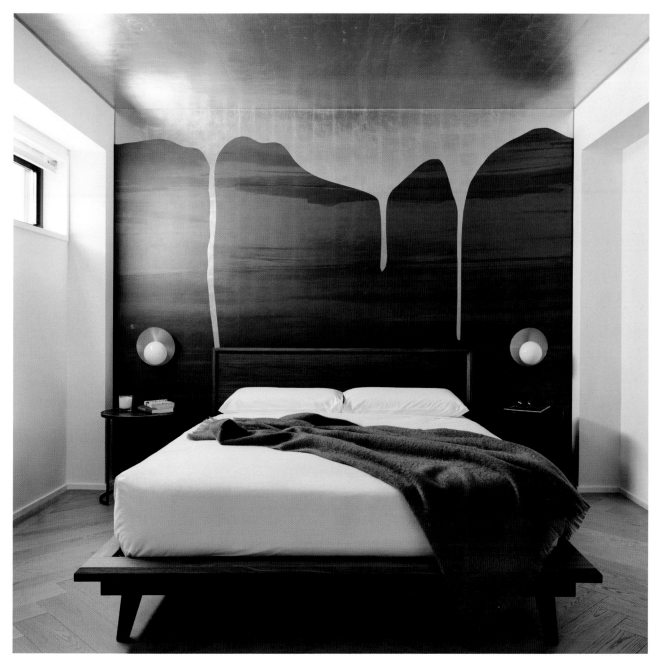

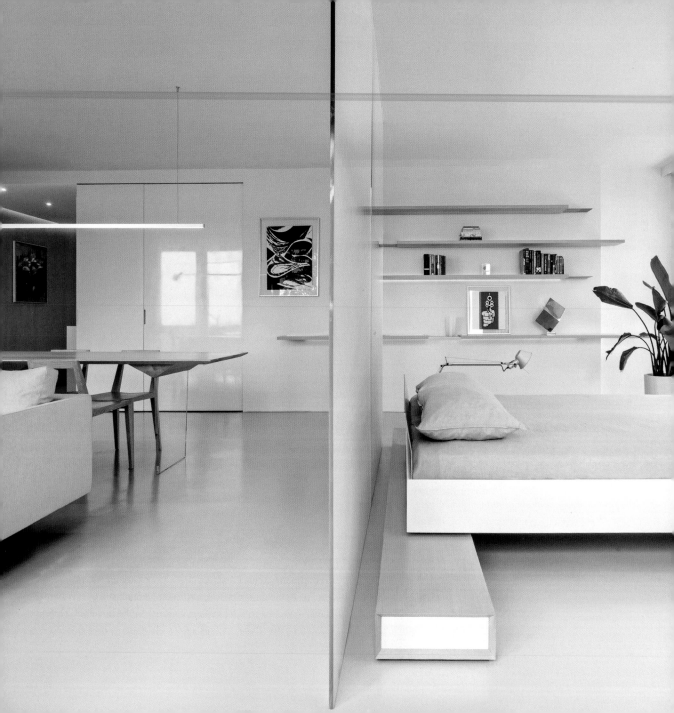

Unit 3E

750 sq ft
Chicago, Illinois, United States

Vladimir Radutny Architects

Photographs © Bill Zbaren

The renovation of this lower-floor apartment began with the clear intent to optimize the views toward the lake from all corners of the unit. The sleeping and living arrangements were reconfigured and separated by a floor-to-ceiling frameless glass panel. While the glass panel provides a clear separation between the two areas, it also offers minimal obstruction, allowing visual continuity. To further maximize the sightlines, the kitchen, bathroom, and storage are lined up against the blank walls. This allowed for the two window walls to be uninterrupted. The furniture also contributes to the creation of a spacious and airy atmosphere. As a result, the design provides efficient functionality while offering a minimalistic aesthetic that pays tribute to the building's architect, Mies van der Rohe, and his influential ideology of less is more.

081

A minimalistic approach in interior design explores seemingly uncomplicated elements that lead to a clean and relaxing atmosphere. It favors functionality, minimal use of materials and colors, and openness for maximum effect.

Conceptual diagram

Space stitching

Ceiling condition

Connections

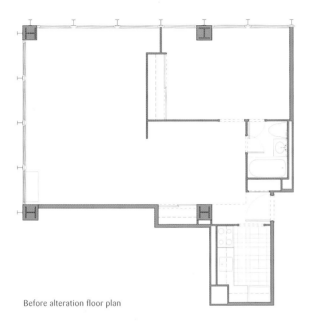

Before alteration floor plan

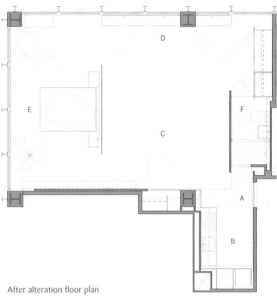

After alteration floor plan

A. Entry D. Living area
B. Kitchen E. Bedroom
C. Dining area F. Bathroom

Abundant storage space is provided
behind a continuous wood-clad wall, while
floating shelves and low profile millwork
add a sense of cohesive stitching between
the various living zones.

082

Minimalist home interiors are more than ultramodern spaces. When examining these creations of the "less is more," we need to value the fantastic functional designs that artfully create a simplified lifestyle.

North elevation

South elevation

East elevation. Bathroom doors closed

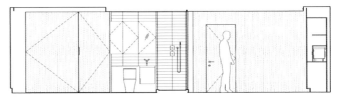

East elevation. Bathroom doors opened

West elevation

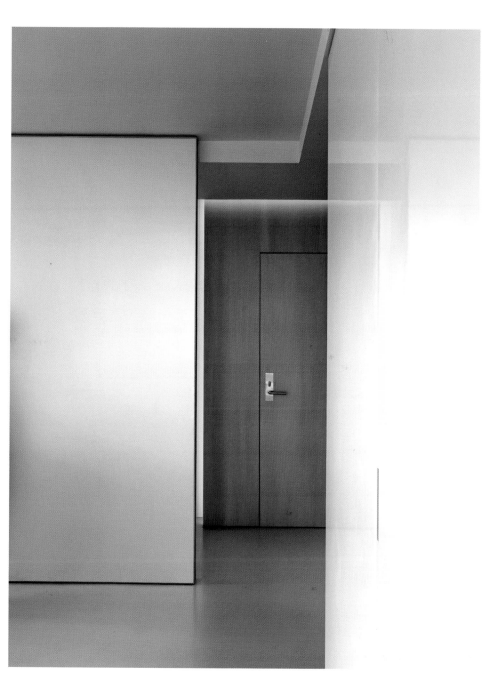

083

The aesthetic appeal of minimalist interiors lies in the way architects and designers achieve extraordinarily beautiful and functional spaces with few elements.

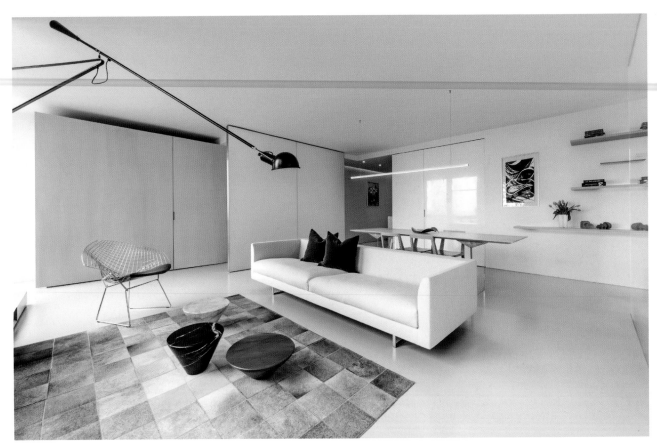

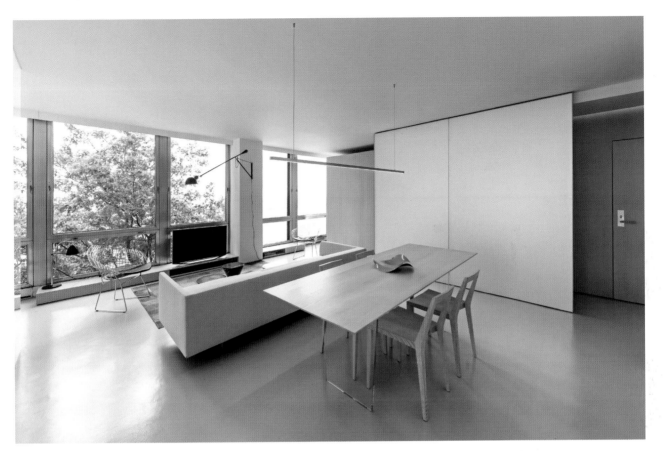

084

In minimalist interiors, the sparsity means that every element—surface, material, finish, color, and piece of furniture—plays a major role in the overall feel. Failing to sensibly curate all these elements can leave a space feeling cold and uninviting.

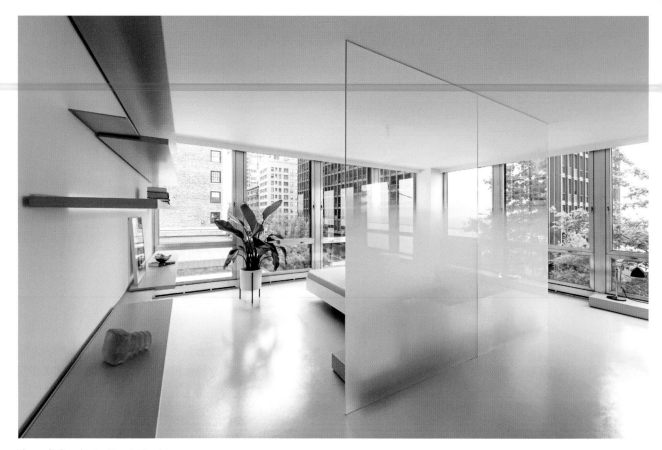

The applied gradient pattern in the glass
adds a subtle sense of privacy within
this fully open plan.

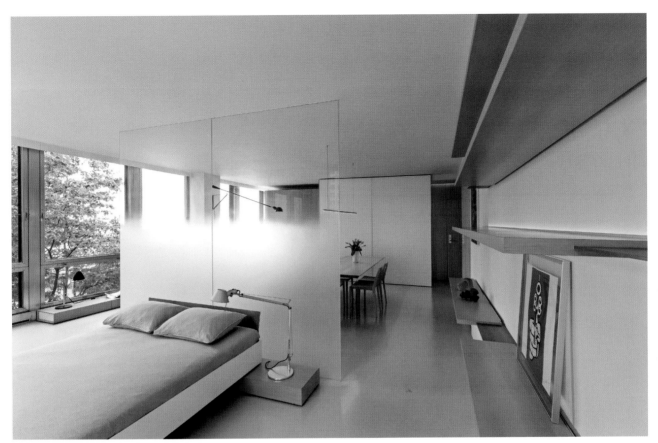

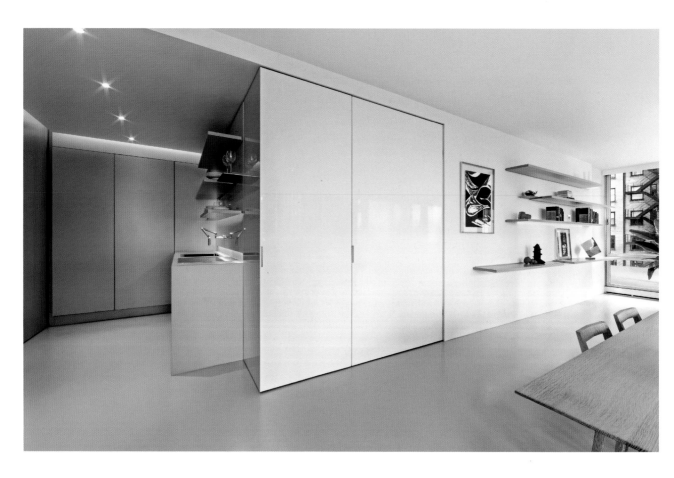

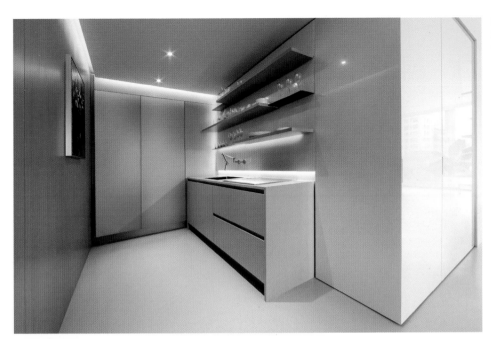

Even the kitchen, far from any light source, benefits from generous natural lighting thanks to the apartment's open plan.

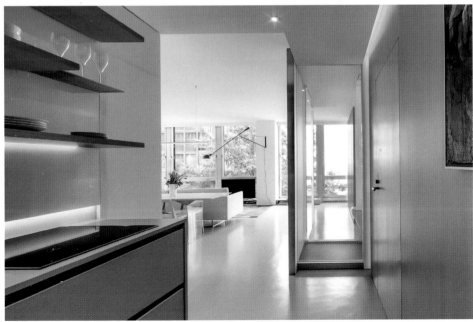

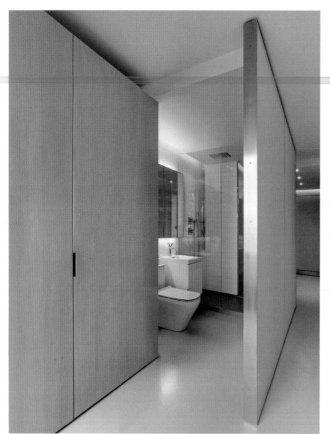
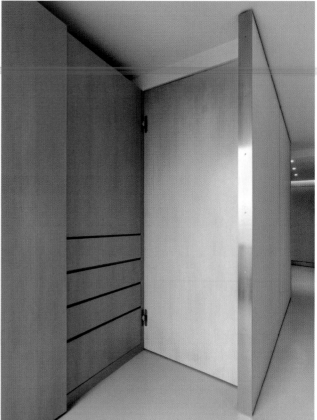

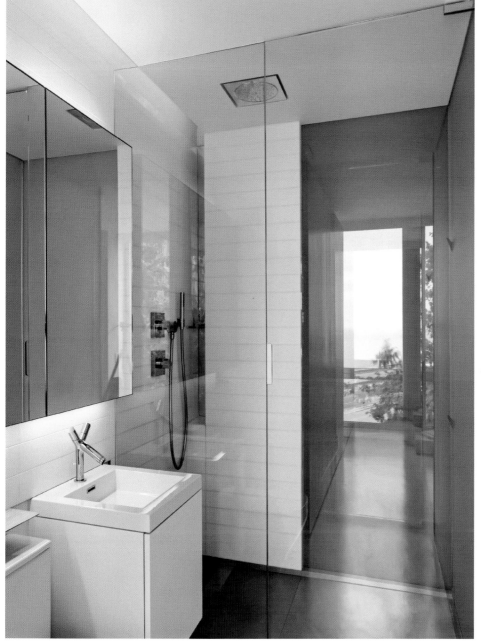

Behind everything that looks effortless and orderly, behind the elegance of simple forms, there is a thoughtful design process, and the result is never achieved randomly.

Williamsburg Schoolhouse

2,000 sq ft

Brooklyn, New York,
United States

White Arrow

Photographs © Thomas
Richter/White Arrow

A utilitarian artist loft was transformed into a glamorous home, rich with period detailing. The timeless backdrop plays off the modern mix of furniture White Arrow designed, customized, and sourced. While the exterior of the former schoolhouse features elements of Romanesque revival and Second Empire styles, the interior was fitted with custom Victorian millwork. Other period elements include salvaged doors, hardware, antique earthenware sinks, and claw-foot tubs. Known as the Historic Schoolhouse, the building was designated a landmark by the Landmarks Preservation Commission in 2013.

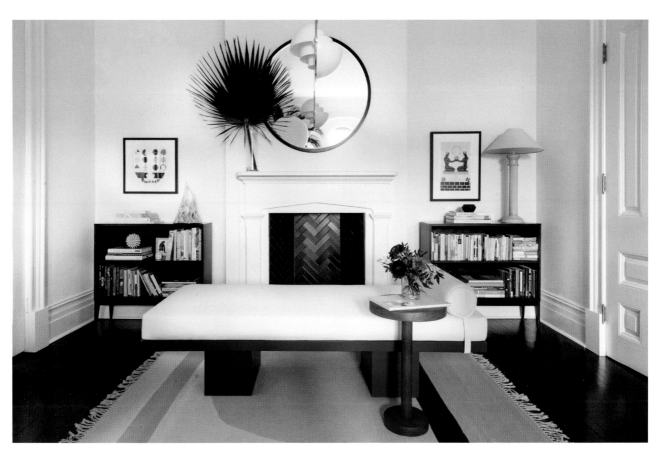

The home features contemporary and classic brands such as Tobia Scarpa, Stilnovo, Yves Klein, Paul McCobb, Milo Baughman, Brendan Ravenhill, and Calico Wallpaper.

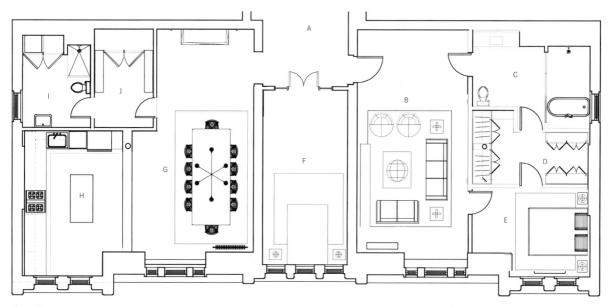

Floor plan

A. Entry
B. Living area
C. Master bathroom
D. Dressing room
E. Master bedroom
F. Guest bedroom
G. Dining room
H. Kitchen
I. Guest bathroom
J. Closet

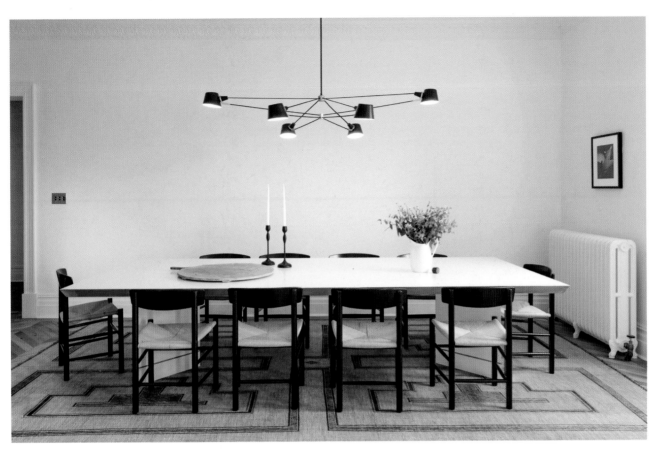

The new design restores the original tin ceiling tiles, celebrating the heritage of the landmarked schoolhouse, and introduces reclaimed North American chestnut on the floors.

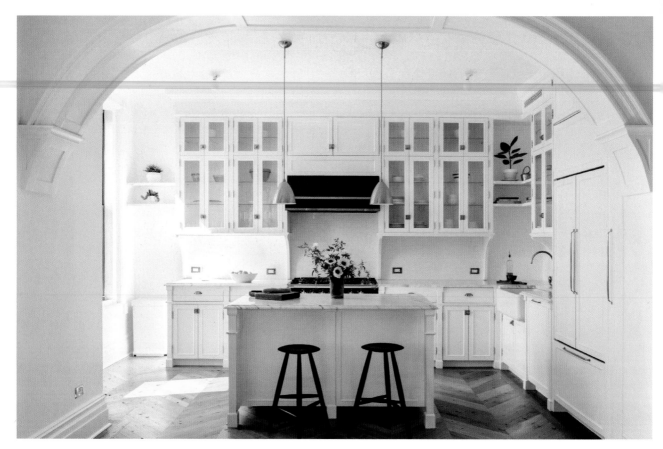

086

The interior design celebrates the historical past of the building while also featuring contemporary elements that raise the old structure to contemporary living standards.

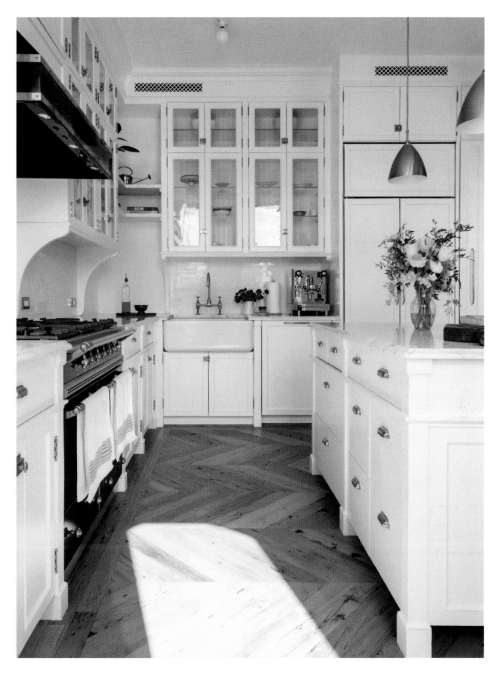

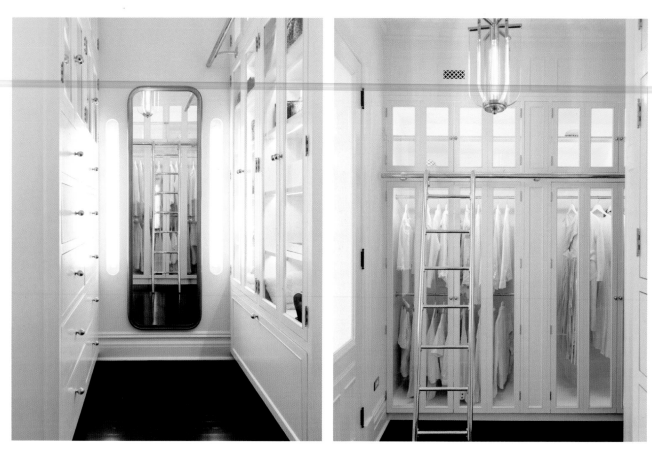

087

The chic dressing room adds a glamorous touch to the eclectic design of the home with glass folding doors and golden details.

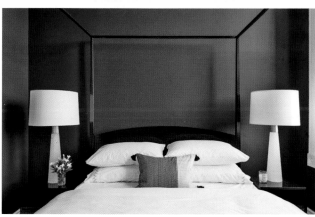

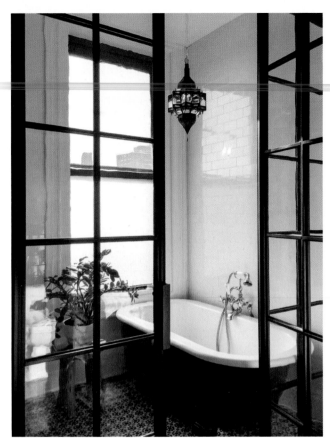

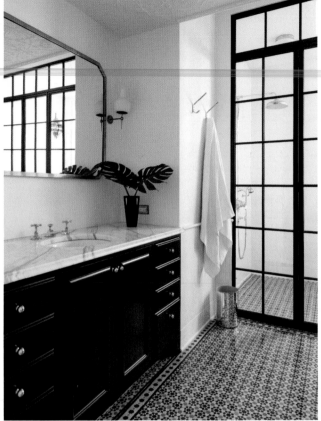

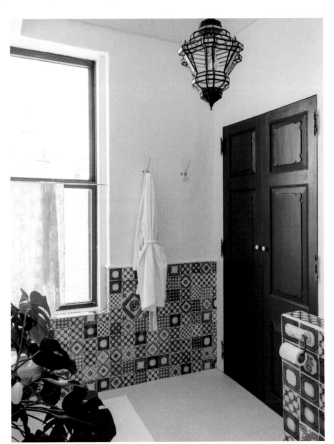
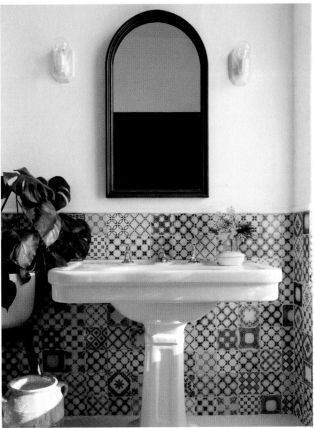

088

The bathrooms feature a rich variety of elements, including a custom-made art deco vanity, Italian vintage light fixtures, and ceramic tiles from Morocco. This eclectic mix takes bathroom decor to a level of artistic endeavor.

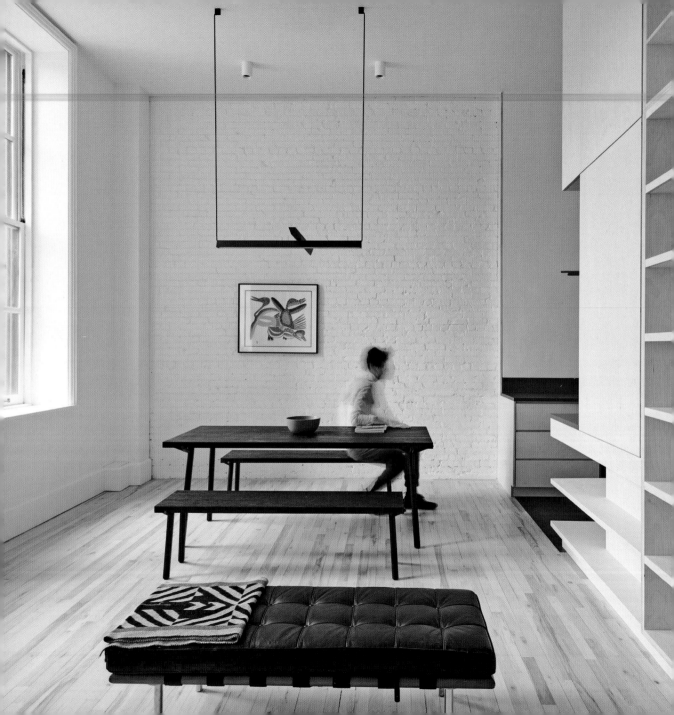

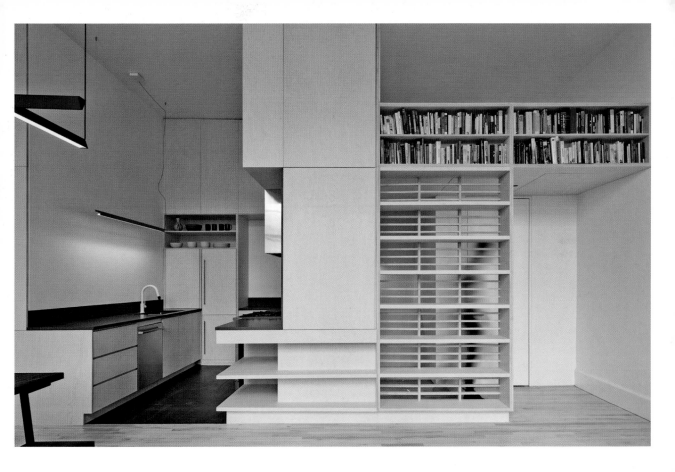

This once heavily partitioned apartment was gutted and dramatically transformed by the insertion of a dynamic armature that generates spatial diversity in the absence of traditional rooms. Unlike typical, static, domestic enclosures, this newly introduced structure is multifunctional, continuous, and able to change scale in order to accommodate occupant use: providing closed storage for the kitchen and living room, countertops for cooking, and open shelving for books. Additionally, the shape's unique and multifaceted composition frames views as one moves through the apartment. As a result, new connections are formed between previously isolated rooms, developing a visually rich experience that adds layers of complexity. The design satisfies spatial and functional requirements, while simultaneously providing a unique character.

Sterling Place

1,200 sq ft

Brooklyn, New York,
United States

L/AND/A

Photographs © Kevin Kundstadt

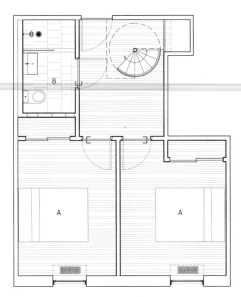

Lower floor plan

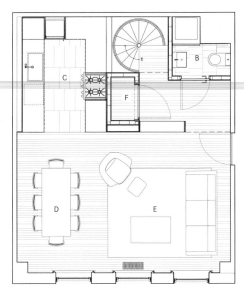

Upper floor plan

A. Bedroom
B. Bathroom
C. Kitchen
D. Dining area
E. Living area
F. Storage

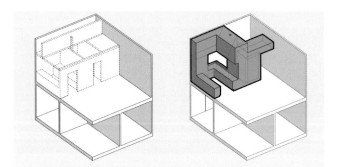

Diagrams

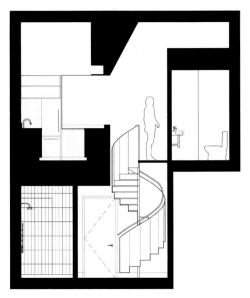

Section

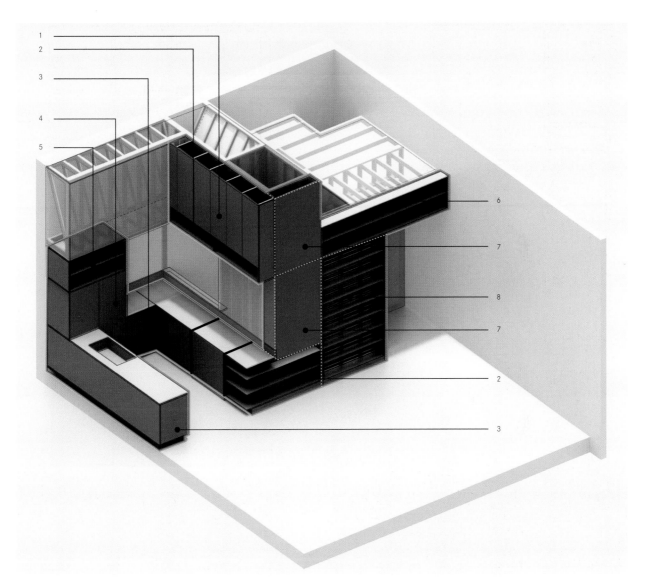

Millwork diagram

1. Cabinets above
2. Open shelving
3. Cabinets and drawers
4. Panel-ready fridge
5. Open shelving above fridge
6. Floating bookshelf
7. Cabinet front
8. Bookshelf with open slatted back

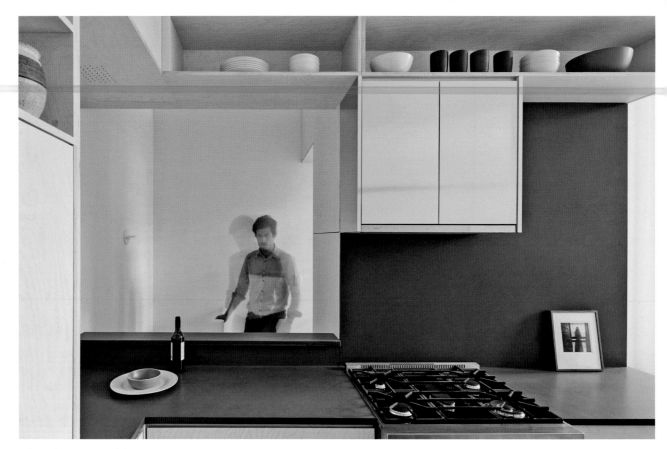

Light reaches every part of the compact apartment thanks to the window between the spiral staircase and the kitchen and the shelves that screen off the hallway from the living area.

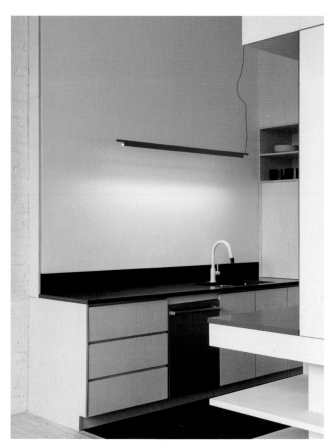
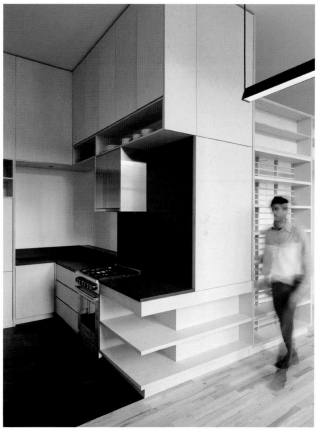

089

A clear distinction between existing and new makes for a strong design statement. In this case, the inserted structure takes center stage, neutralizing the architectural value of the apartment, which becomes a mere container.

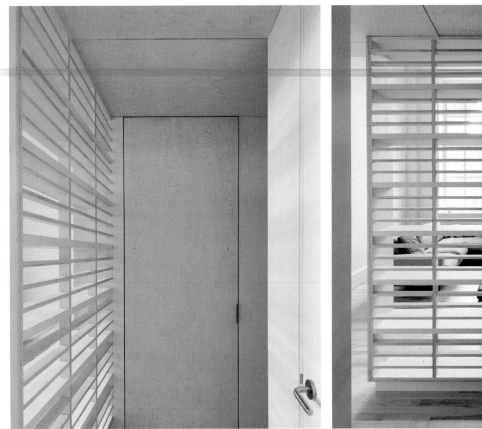

090

Detailing adds soul to an interior design project, and no matter how small these details are, the impact is always great.

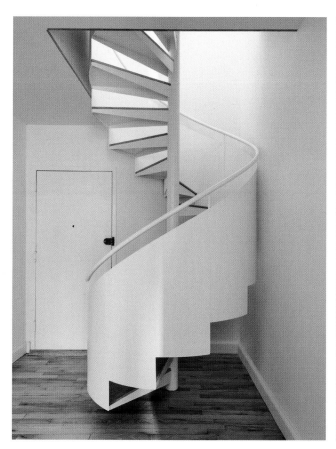

091

The beauty of a custom design piece lies in the careful and precise assembly of elements and materials, defining character and personality.

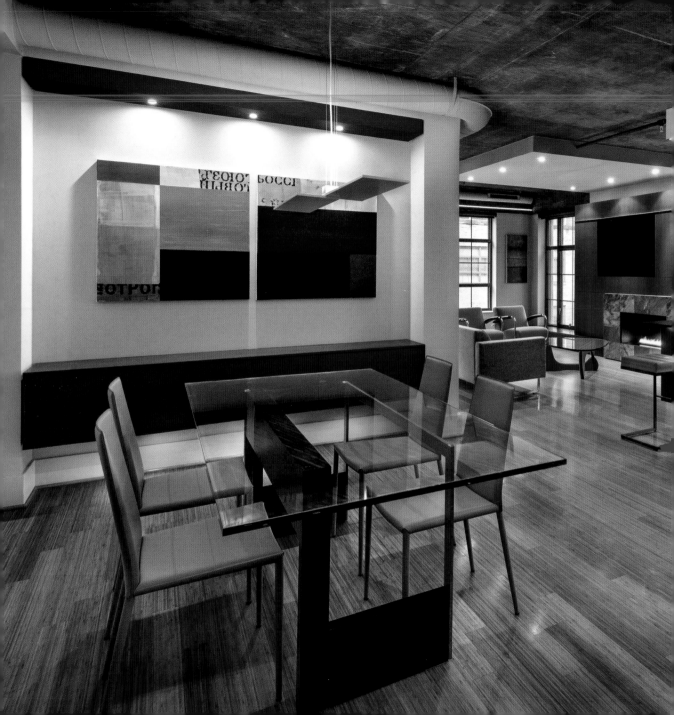

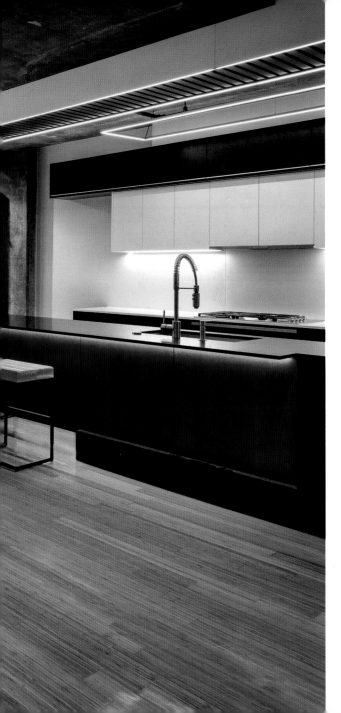

Collage Condo

1,250 sq ft

Washington, District of
Columbia, United States

KUBE architecture

Photographs © Paul Burk
Photography

This condominium renovation is the culmination of a multiphase
project that spanned two years. The firm's partners passed the
project back and forth, each designing a new space, but working
off the previous one. This process resulted in an architectural
collage, where similar materials were utilized and new ones
were introduced in each phase. The spaces overlap and flow from
one to the next while also retaining their own character. The
refined finishes, including wood, glass, and metal, contrast with
the concrete, pipes, and ductwork of the original condo. Energy-
efficient LED lighting is used throughout as "lines of light" floating
as objects or highlighting key defining elements.

Conceptual floor plan

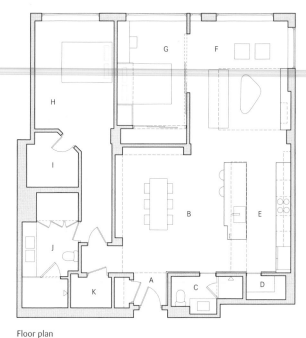

Floor plan

A. Entry
B. Dining area
C. Bathroom
D. Pantry
E. Kitchen
F. Living area
G. Office/Guest bedroom
H. Master bedroom
I. Master closet
J. Master bathroom
K. Closet

092

Different materials were used on
various spatial planes to operate as
a series of distinct layers.

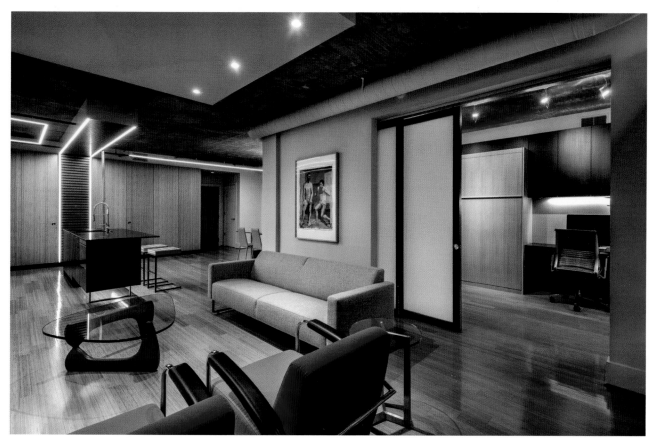

Materials and elements in the foreground
frame others in the distance, to create
an episodic experience as one moves
through the space.

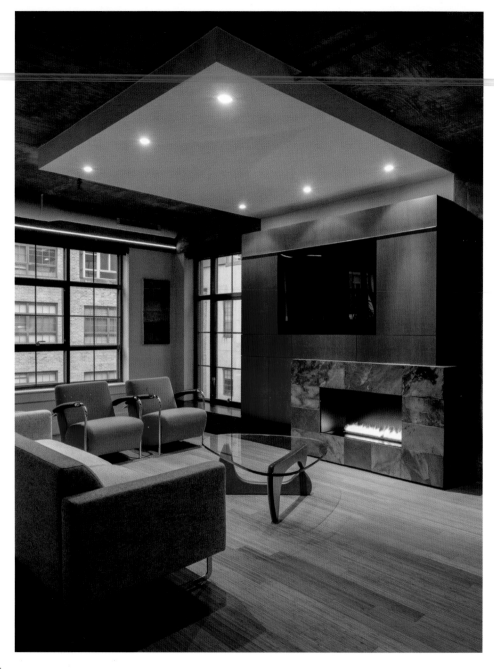

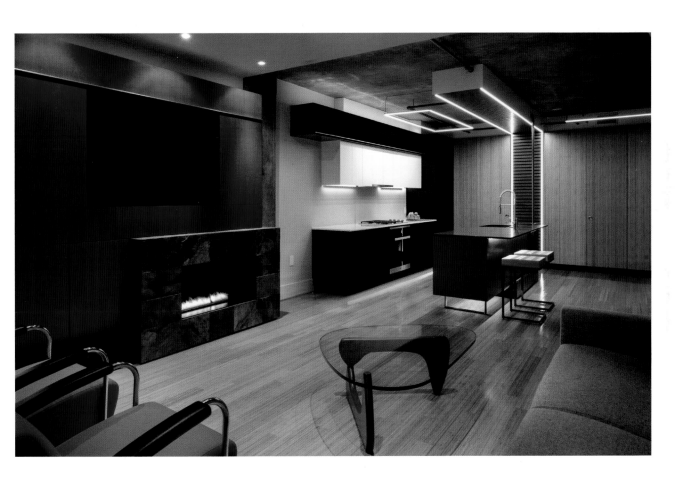

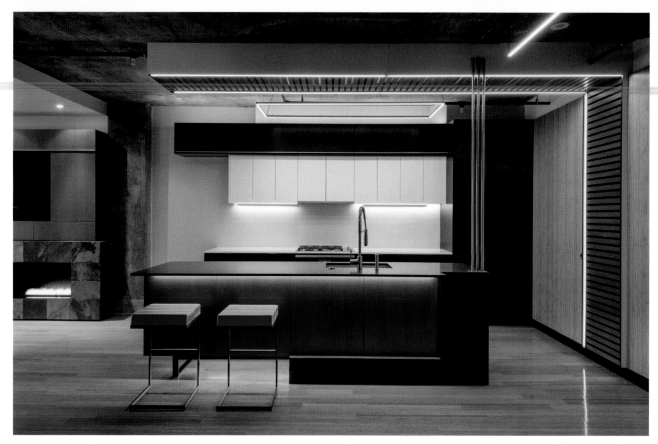

Bamboo flooring and other materials
seem to fold from floor to wall and wall to
ceiling, creating a consistent look.

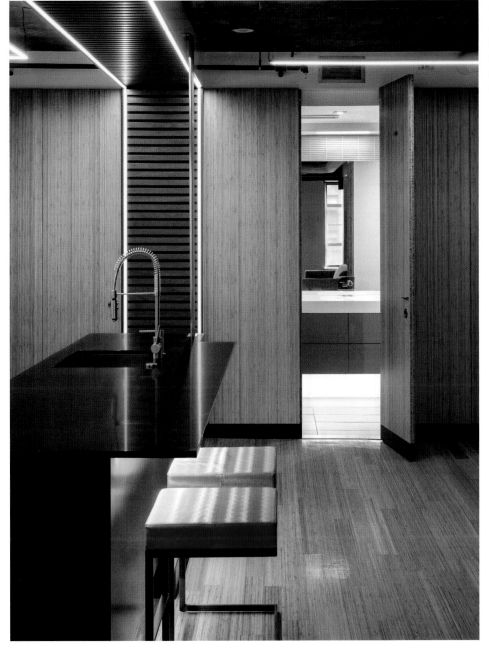

Scale, material, color, light, and rhythm orchestrate the spatial organization of boundaries and connections between spaces.

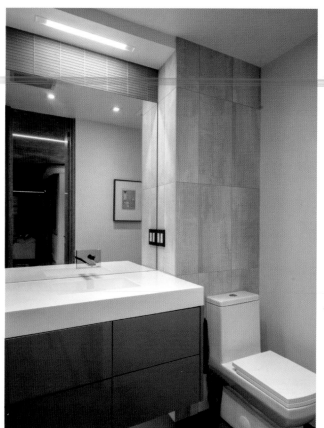

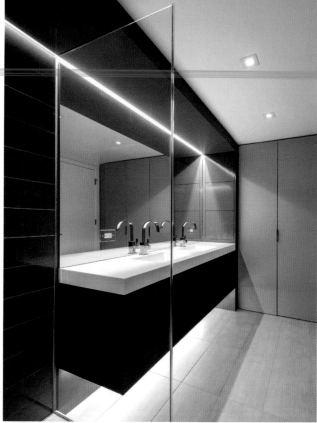

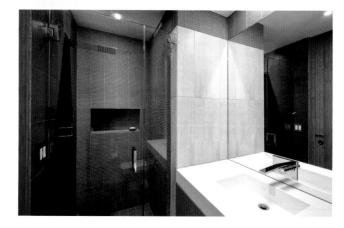

094

Light plays a key role in the way people perceive and understand space, provoking different moods and reactions.

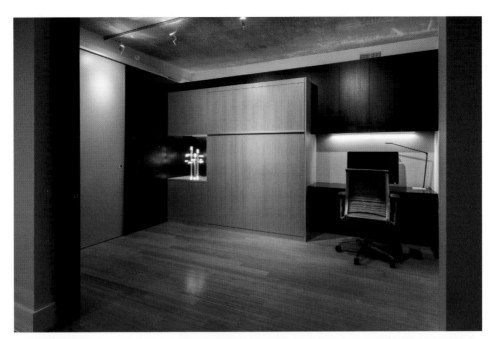

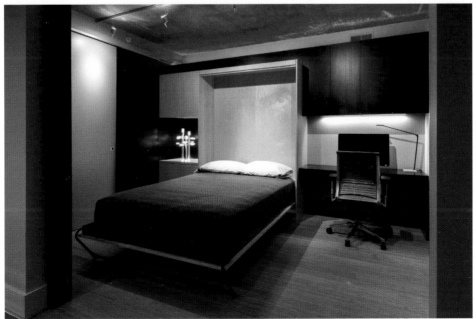

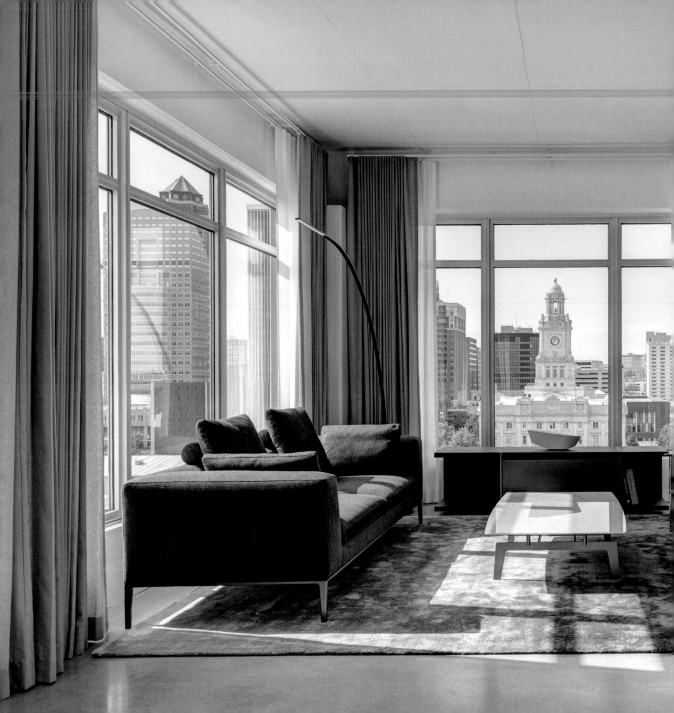

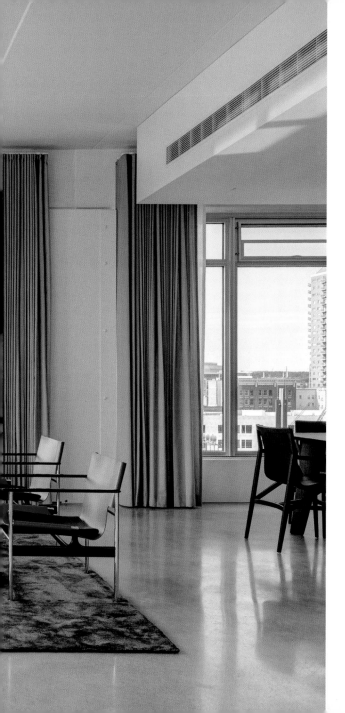

Whiteline Residence

3,900 sq ft

Des Moines, Iowa,
United States

Neumann Monson Architects

Photographs © Cameron
Campbell Integrated Studio

This urban loft, which occupies the top floor of a converted historic warehouse, balances the duality of the clients' public and private lives through processional layout and spatial contrast. The design assigns bright, open social spaces to the perimeter and encloses private areas with dark tones and rich materiality. When you enter the residence, daylight draws you through a compressed, enveloping vestibule and out into the open living area. The airy communal spaces and the master bedroom maximize natural light and the expansive panoramic view. In contrast, support spaces such as the bathrooms and guest bedroom can be found in the interior of the unit, where lowered ceilings enhance experiential intimacy.

Beams, pipes, and ducts are part of a building infrastructure that appear sometimes unexpectedly, when tearing an existing dropped ceiling down or in a warehouse where the cleanliness of the space from exposed conduits and ducts may not be a concern. Because these elements may determine ceiling heights, they should be detected early on in the design phase.

CONCEAL

DELINEATE

ENCLOSE

CONSTRAINTS

Exploded axonometric view

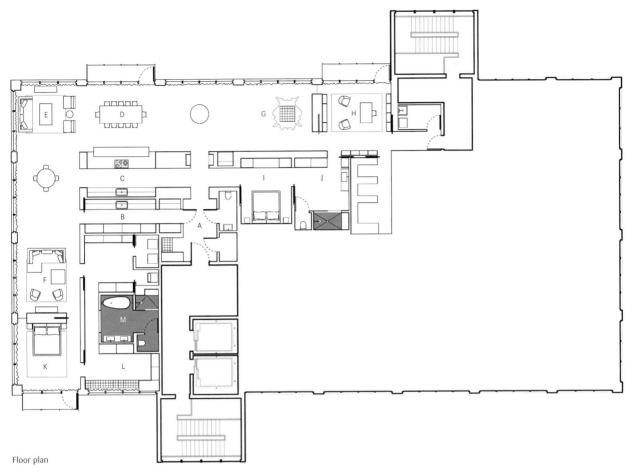

Floor plan

A. Foyer
B. Pantry
C. Kitchen
D. Dining area
E. Living area
F. Sitting area
G. Gallery

H. Study
I. Guest bedroom
J. Guest bathroom
K. Master bedroom
L. Master closet
M. Master bathroom

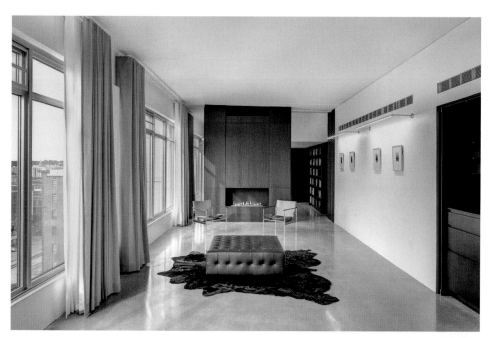

Dark-stained white oak piers cordon off the ends of the sitting area and the gallery to provide enclosure and reserve views for the master bedroom and study.

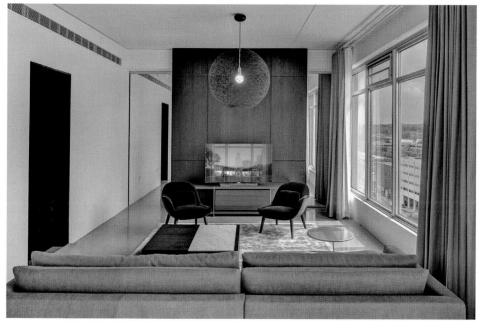

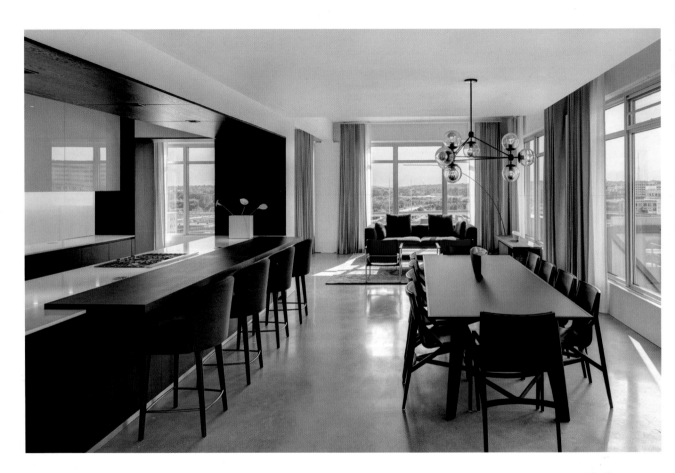

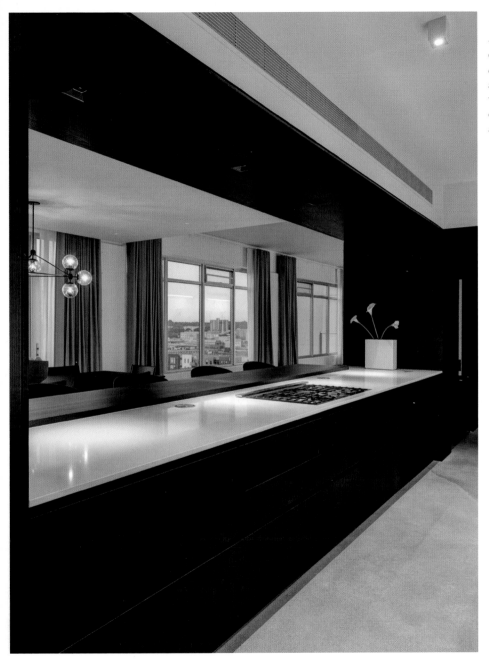

Open kitchens are usually linked to a dining area, whether it is a bar-style arrangement, the traditional dining table, or perhaps a combination of the two, offering flexibility to accommodate different situations.

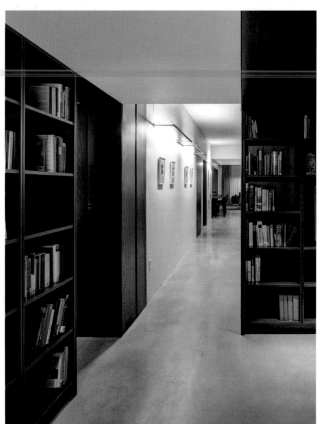
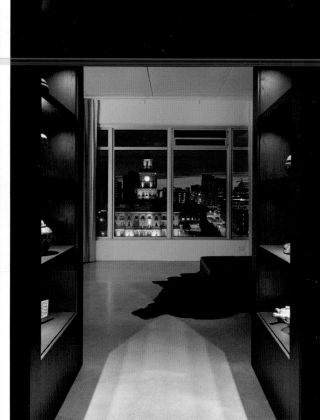

097

Corridors and vestibules can be much more than simple room connectors. They lend to art display, and their walls can be lined with beautiful wood bookshelves or cabinets, lit up for extra effect.

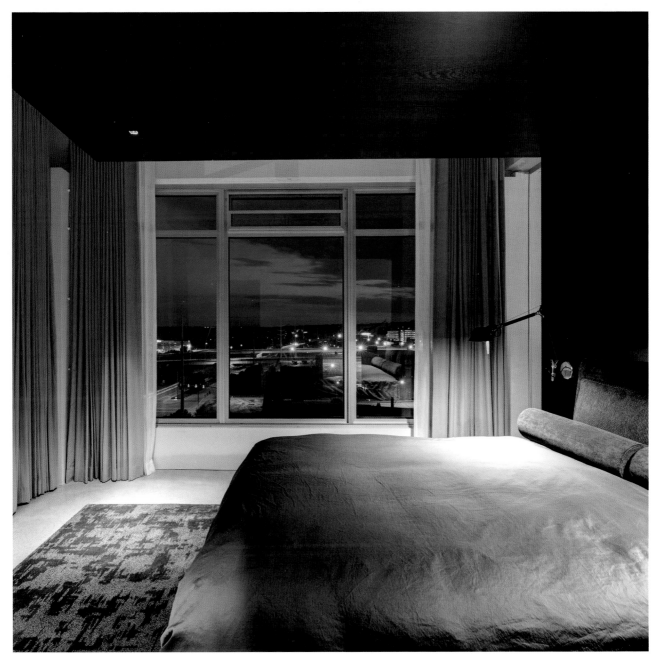

098

The ultimate master bedroom design is one that is directly connected to a private dressing room and bathroom. It provides comfort, pleasure, and efficiency, creating a haven of tranquility and self-indulgence.

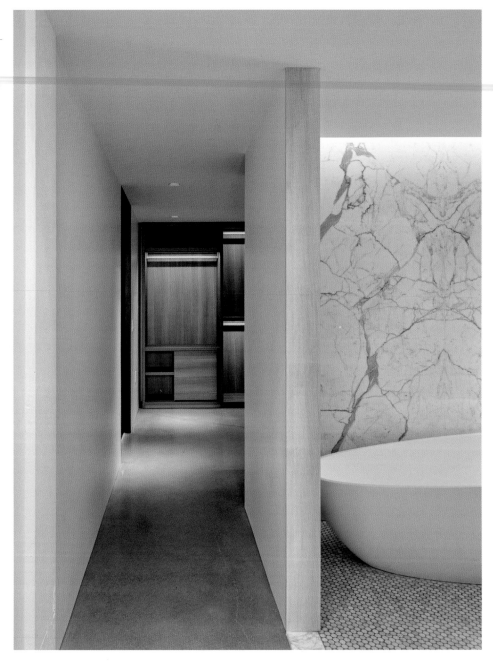

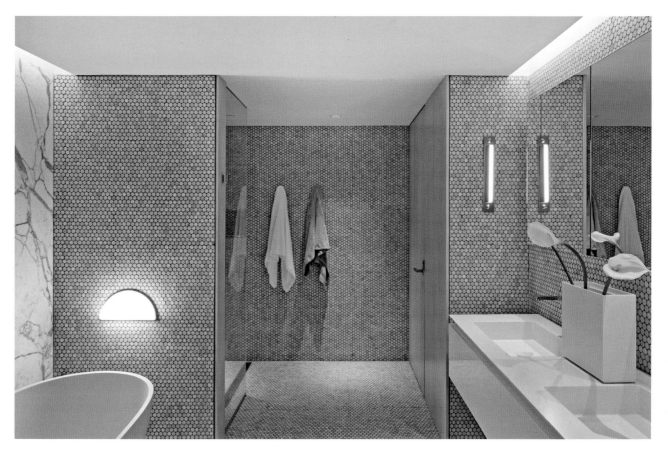

Floors are polished concrete with radiant heat. Bathrooms are finished in marble slabs, marble penny tile, and pickled white oak.

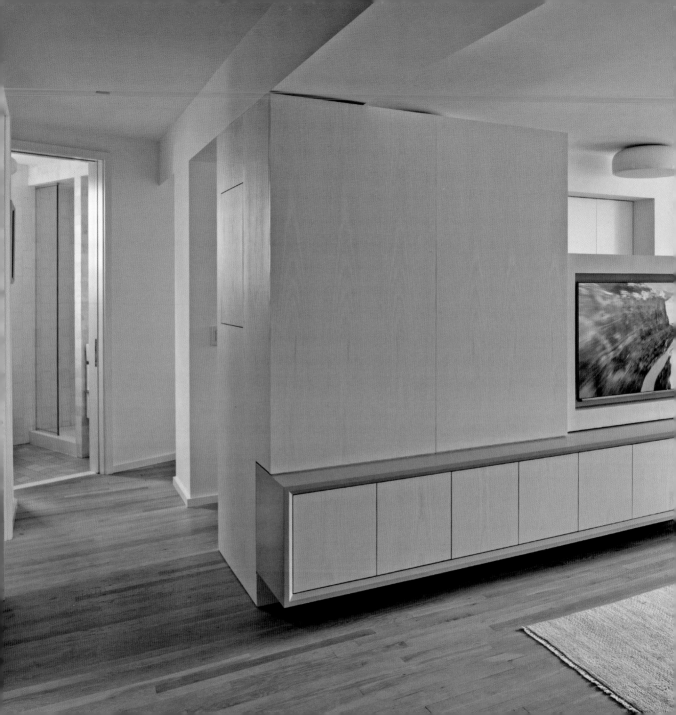

Bank Street Apartment

1,100 sq ft

New York, New York,
United States

Michael K. Chen Architecture

Photographs © Alan Tansey

The thorough reinvention of a generously scaled but awkward postwar West Village apartment features subtly textured materials and carefully detailed custom elements. The new design creates an elegant and informal living environment for a professional couple. The kitchen is shifted to the center of the apartment, creating a separate bar for casual dining and socializing. The living room effortlessly transitions between an open and visually porous state conducive to conversation and socializing, and one that allows the television to be front and center. Concentrating all the solid elements in the center of the apartment liberates the entire perimeter to make the most of natural lighting in the living area and produce a sense of amplitude.

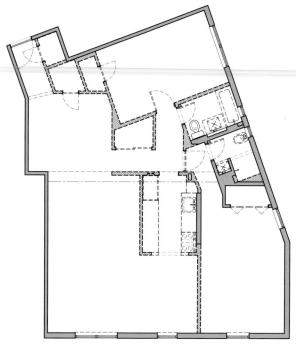

Before renovation floor plan

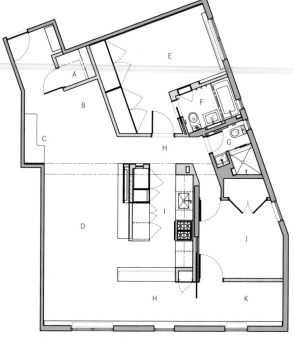

After renovation floor plan

A. Closet
B. Foyer/dining area
C. Bar
D. Living area
E. Master bedroom
F. Master Bathroom
G. Bathroom
H. Hall
I. Kitchen
J. Guest bedroom
K. Study

099

Small apartments work best when the different rooms are opened to each other. When space is the most valuable asset and every square inch counts, the fewer walls, the better. The space that is saved can be put to better use to create much-needed storage space.

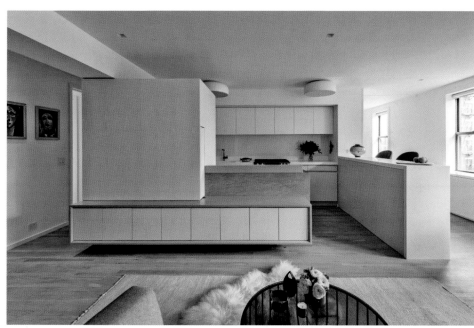

A reconstructed kitchen, anchored by a sturdy block of Vermont marble and bleached ash cabinetry, establishes a functional core that integrates an informal bar and entertaining zone, a generous work area, and a pull-out concealed television.

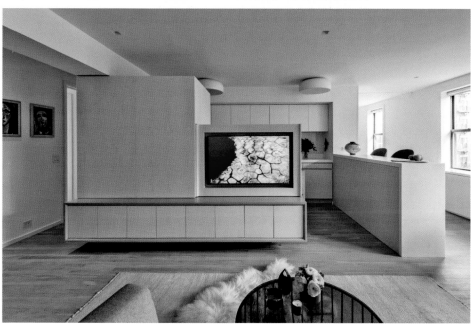

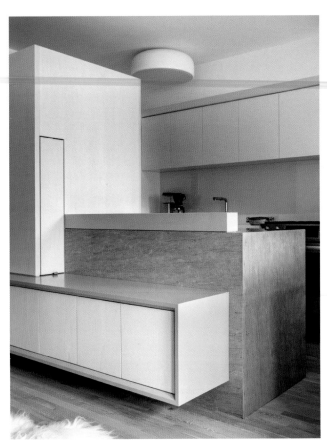
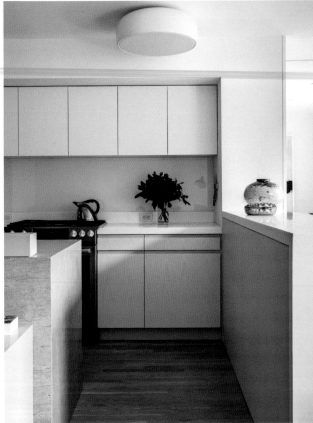

100

Cabinets with recessed finger details
or push latches are alternatives
to traditional pulls and handles to
achieve a clean, easy-to-clean look.

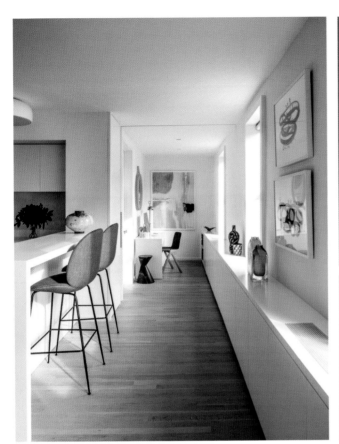

A continuous sill running the width of the apartment provides a location for a rotating gallery display. A home office at one end can be partitioned from the rest of the apartment with an oversized pocket door.

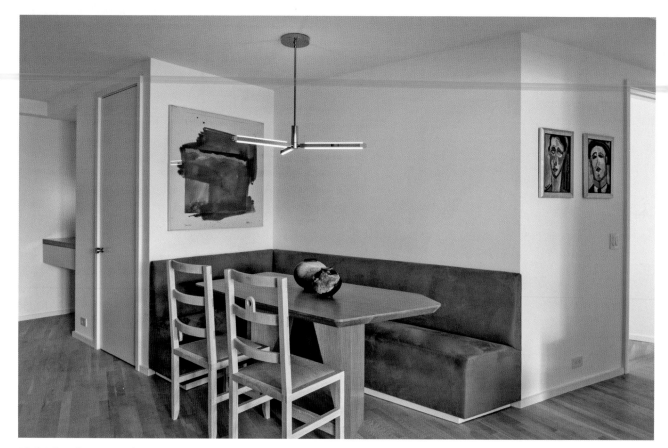

A built-in bar, a banquette, and a custom dining table are inserted into an awkward entrance gallery, converting a leftover space into a generous and gracious entertaining and dining area.

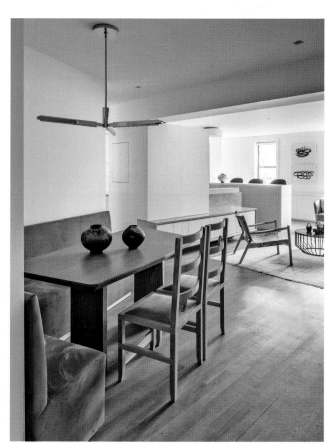

101

Awkwardly shaped spaces can prove tricky for the placement of furniture but not impossible. Some creative thinking, perhaps involving built-ins to reshape these spaces, can produce surprisingly functional areas.

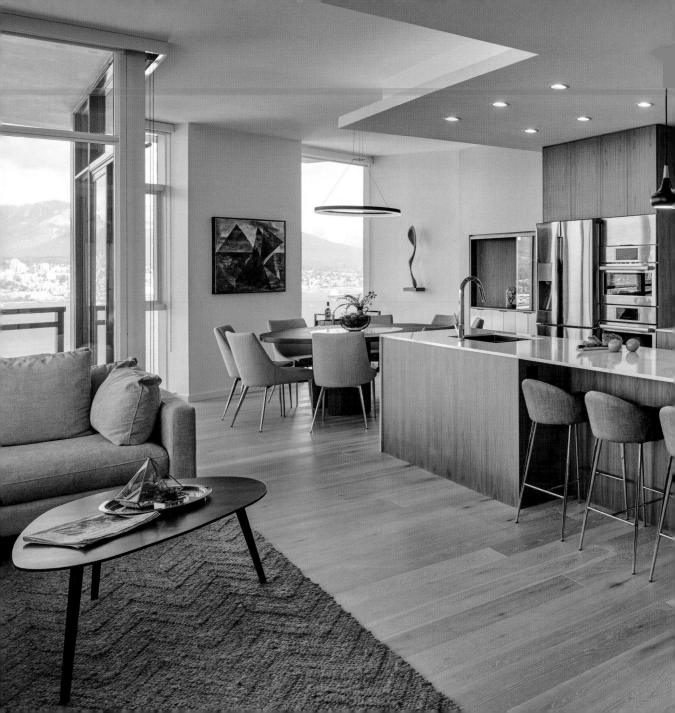

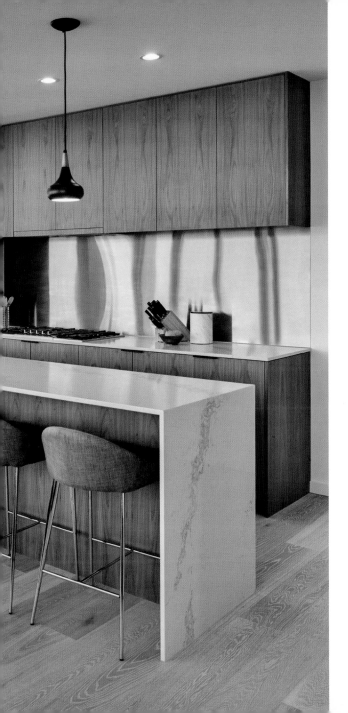

Coal Harbour Apartment

2,150 sq ft

Vancouver, British Columbia,
Canada

Haeccity Studio Architecture

Photographs © Andrew Latreille

The project was devised to create a living space that satisfies the needs of its multigenerational occupants. This guided the design in determining the personality, nature, and atmosphere of the project, resulting in a mix of spaces that could be broken into smaller private areas or connected to create a large communal space. The design was also inspired by the clients' traveling lifestyle—they spend time between Vancouver and Hong Kong. Generous storage was a top requirement. Making the most of the stunning views was another. Materials and colors were selected to help create a space where all the members of the family feel comfortable.

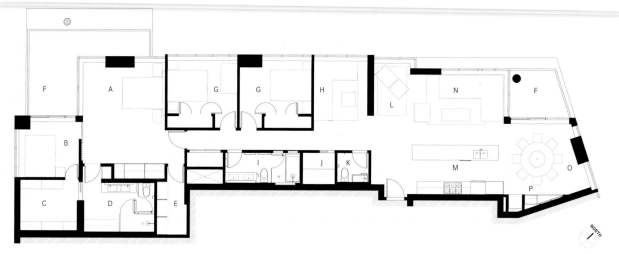

Floor plan

A. Master bedroom
B. Second master bedroom
C. Walk-in closet
D. Master ensuite
E. Storage

F. Deck
G. Bedroom
H. Flex media room
I. Family bathroom
J. Laundry room
K. Powder room

L. Reading nook
M. Kitchen
N. Living room
O. Dining room
P. Wine niche

The design and location of the living, dining, and kitchen areas were determined by the dining table, which was custom-made to accommodate eight people.

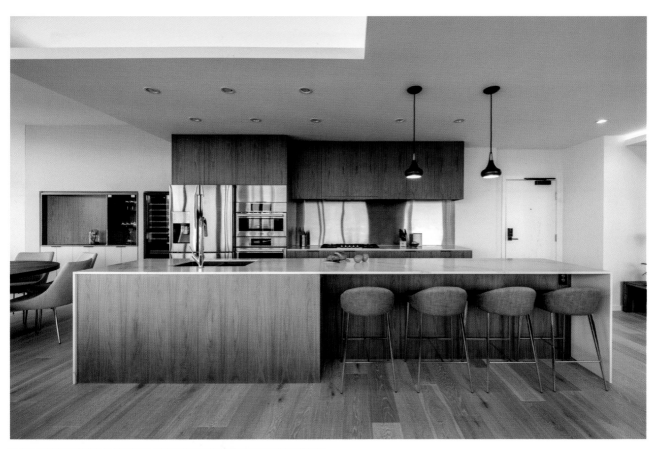

102

If space allows it, kitchen islands can be designed to accommodate some extra seating, ideal for weekend breakfast for the whole family and also suitable for informal meals.

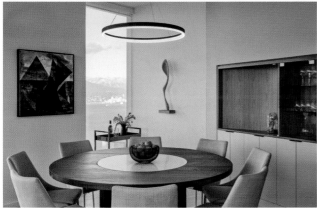

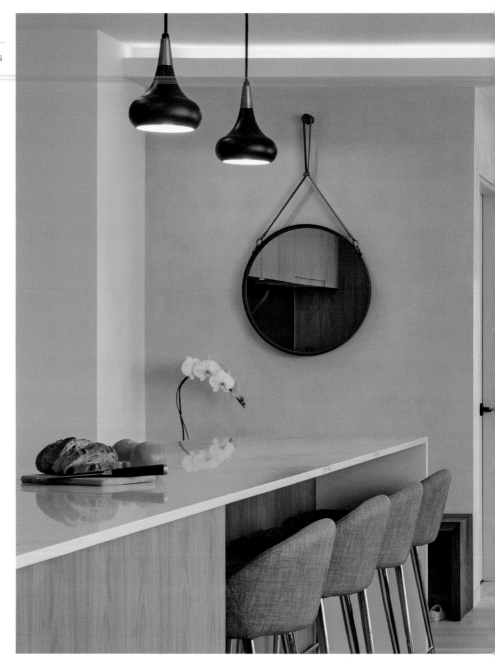

103

Minimizing partitions and doorways promotes room-to-room flow, creates a sense of spaciousness, and maximizes usable floor area.

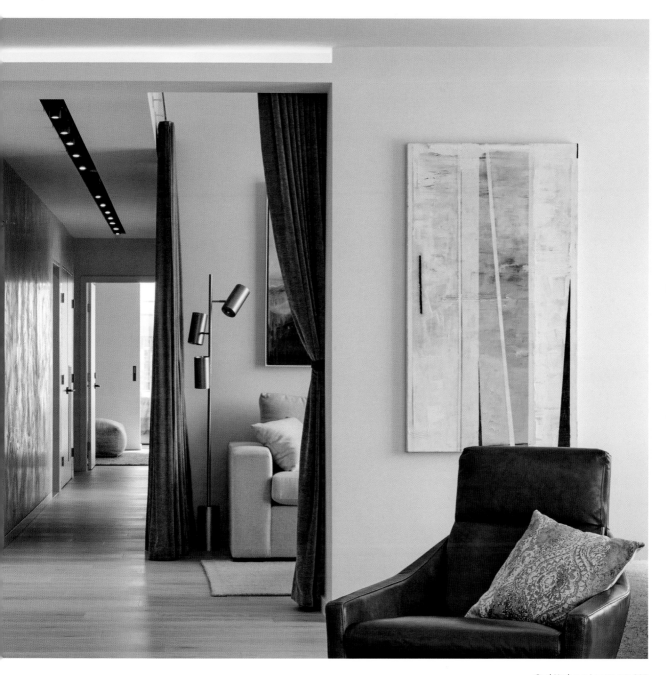

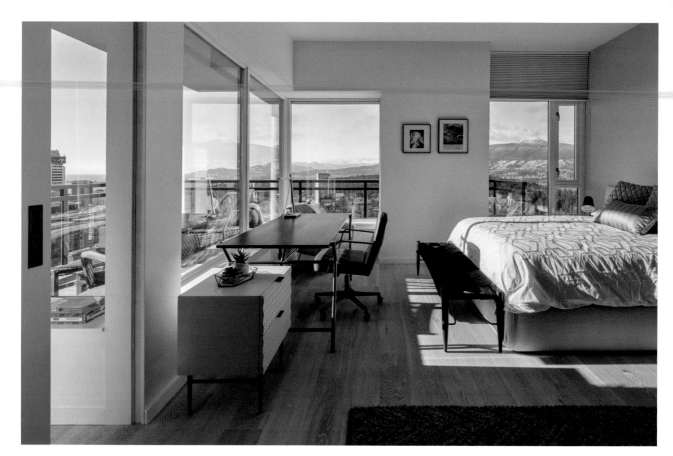

104

Corner windows are atypical
fenestration models because they
greatly influence the structural
design of buildings. They are more
expensive than regular windows but
add valuable design appeal, especially
when they are facing great views.

The master suite feels airy and spacious, making the most of the space available. The bedroom, bathroom, and walk-in closet are connected to each other or can be sectioned off for privacy.

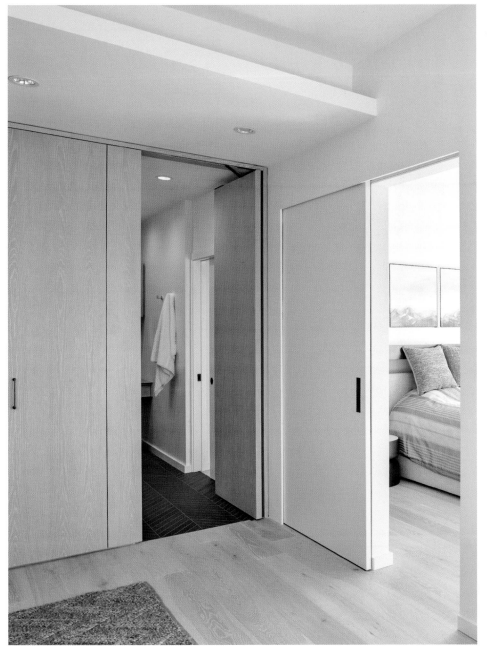

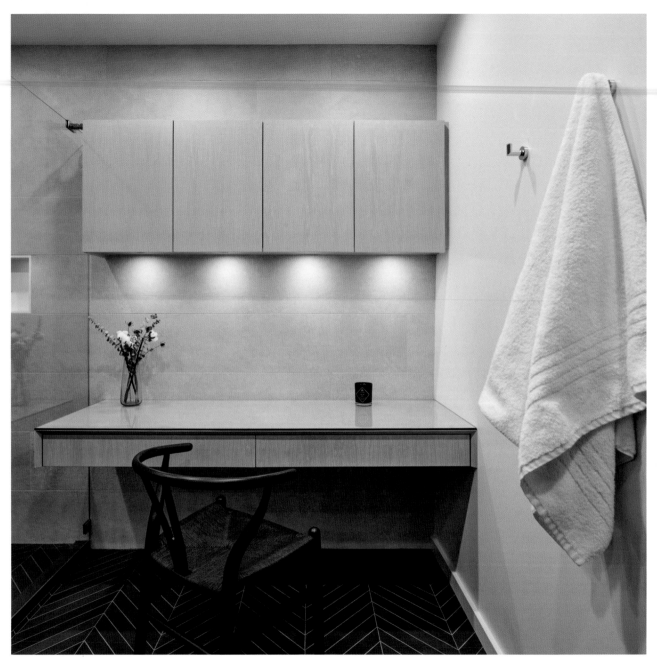

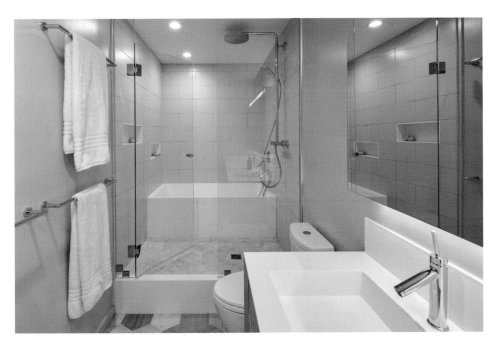

The renovation also improved the layout of the bathrooms, which didn't use space efficiently and were dark and uninviting.

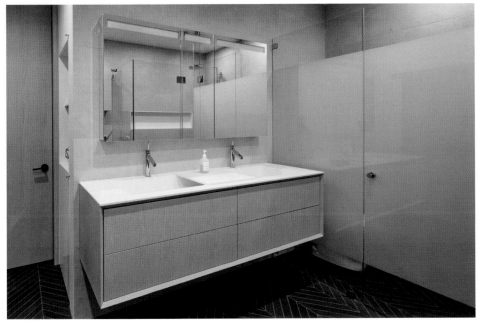

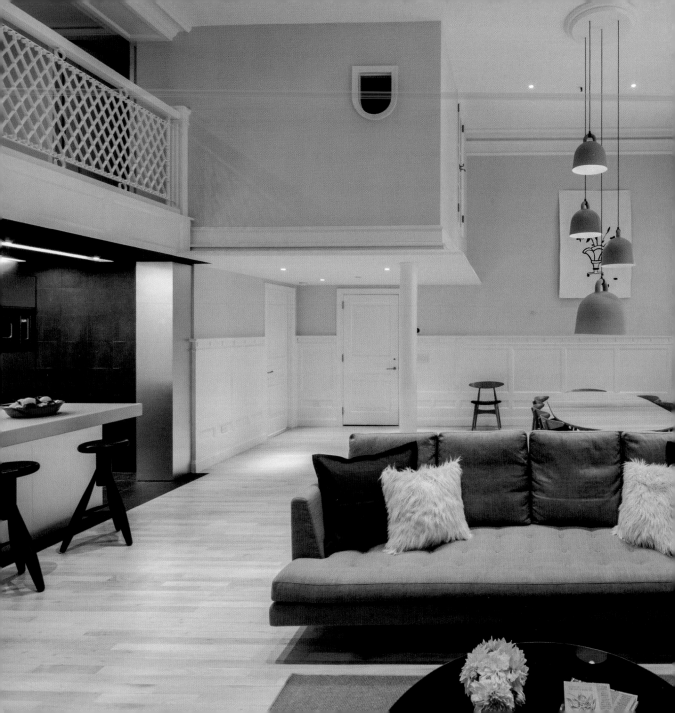

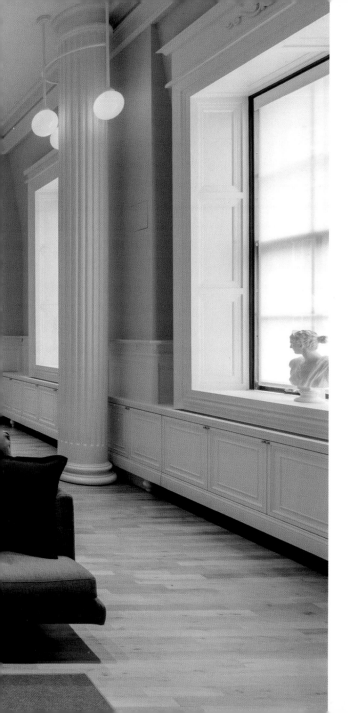

Wormhole Loft

1,700 sq ft

New York, New York,
United States

Dash Marshall

Photographs © Jason
Lewis Photography

Wormhole occupies a historic structure and creates a world with futuristic elements within a world: new inside old, dark is inside of bright, minimal is inside of maximal. The Wormhole Loft is defined by a complete change of style and form, morphing into an environment of striking contrast, where old and new coexist within clearly defined boundaries. While the two are intrinsically connected, they each maintain their different qualities, neither overpowering the other. Lighting and material use play an important role in giving the new living space unique character. Everything seen in this project is new, though some of it looks old. The design team carefully studied the building's exterior and other constructions from the same period to reproduce interior details that match the building's Second Empire style.

The wormhole appears as a narrow dark space containing the kitchen and a passage between the entry foyer and the living area.

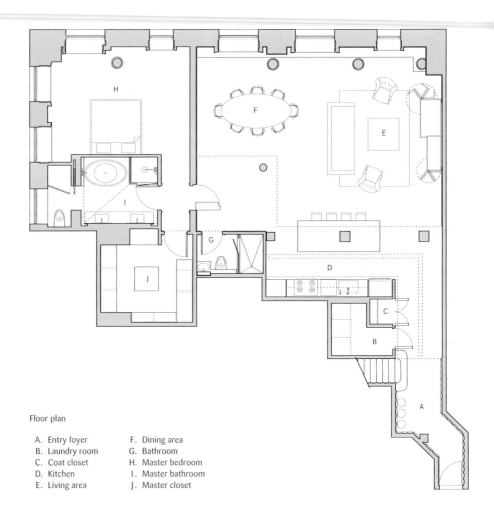

Floor plan

A. Entry foyer
B. Laundry room
C. Coat closet
D. Kitchen
E. Living area

F. Dining area
G. Bathroom
H. Master bedroom
I. Master bathroom
J. Master closet

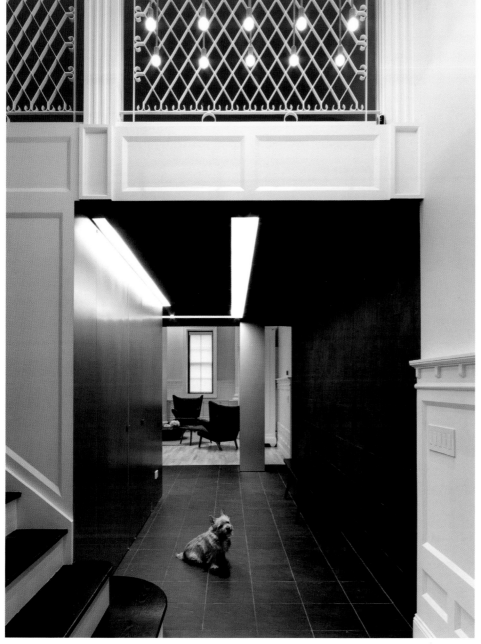

Different colors used in the same space produce different visual effects that influence our perception of space. A simple example is that light colors make spaces look larger and dark colors make them look smaller.

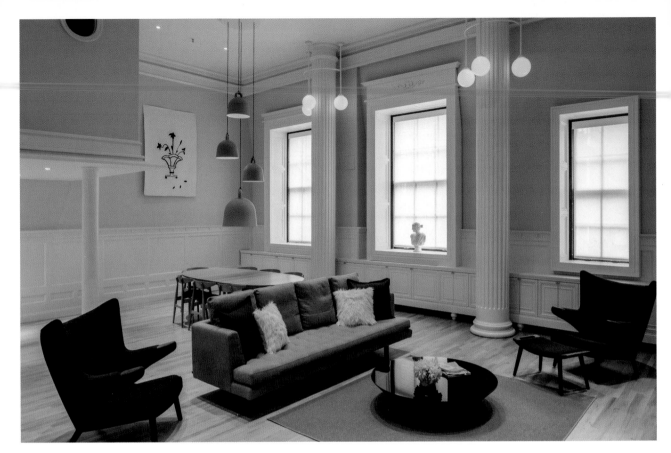

107

Architectural detailing can transform
a nondescript room into a space full
of character, showcasing design and
craftsmanship.

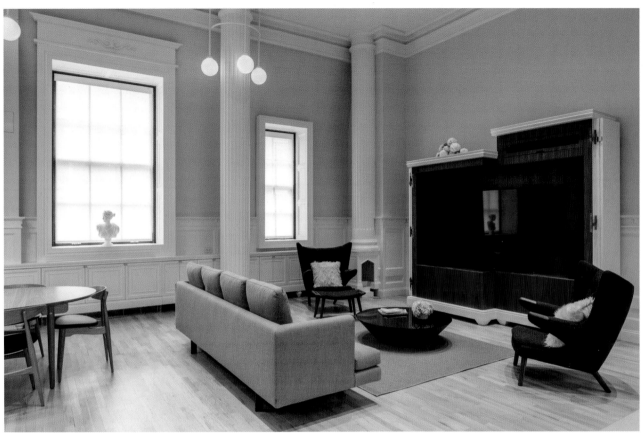

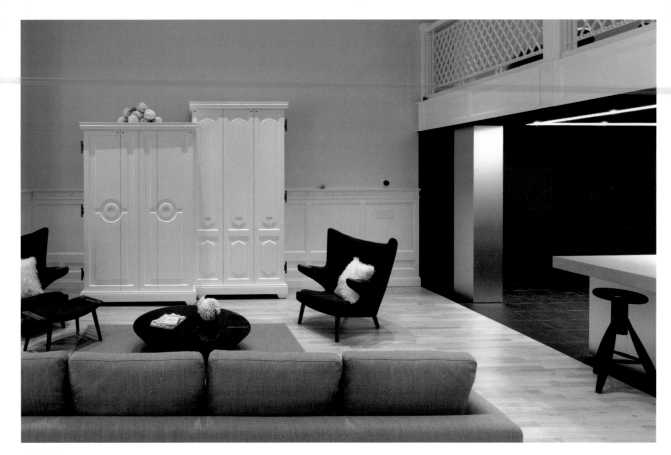

108

A color contrast, such as black and white, can emphasize spatial differences. For instance, in the passageway, or wormhole, the walls are clad in natural black slate and the ceiling is painted black, making the space feel even more narrow next to the bright white double-height room.

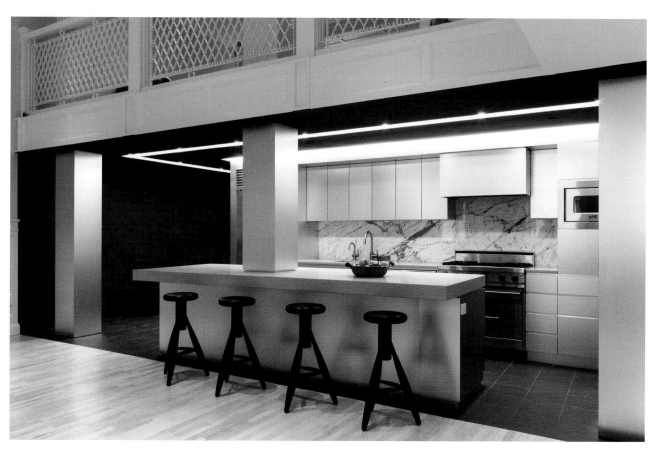

Lighting and material use play an important role in providing the new living space with unique character.

The master bathroom also showcases the spatial qualities of the wormhole, the dark atmosphere expressing a feeling of being in a subterranean space.

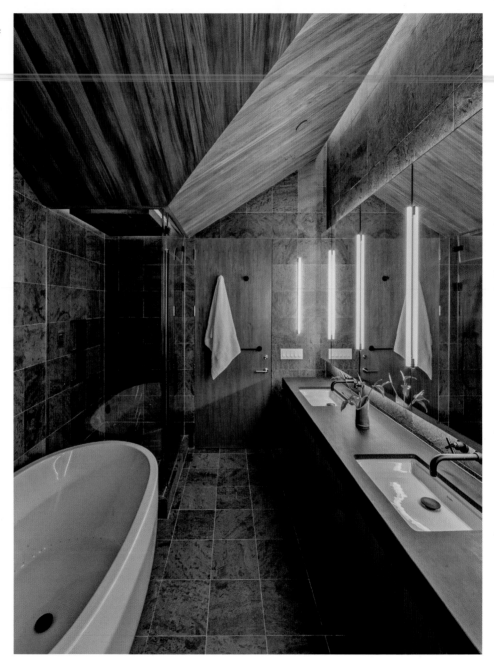

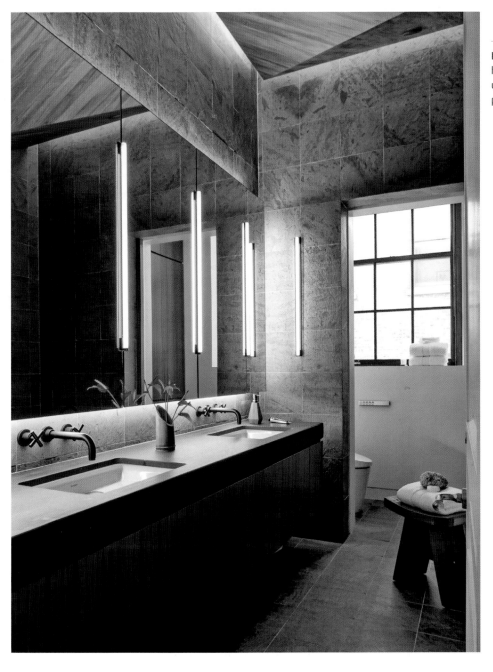

Light—whether natural or artificial—
has an aesthetic quality that can be
used to maximize the full expressive
potential of forms and materials.

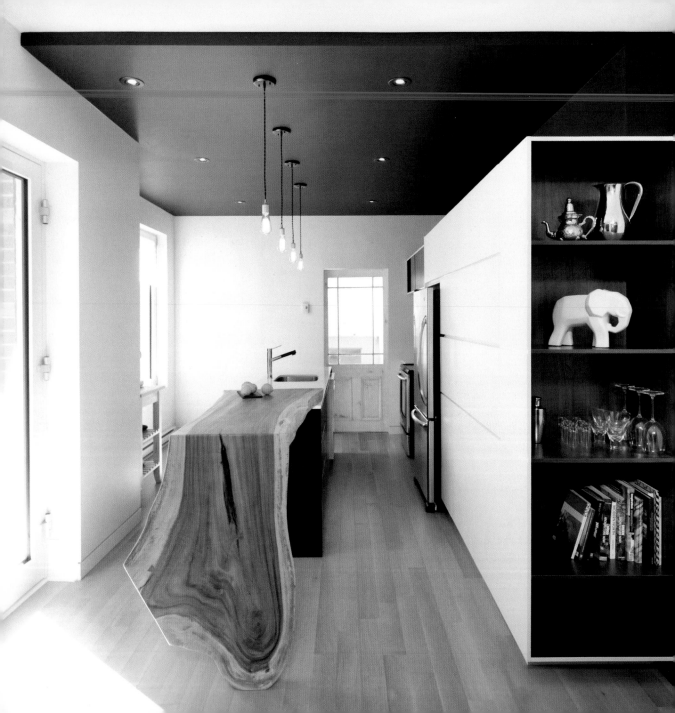

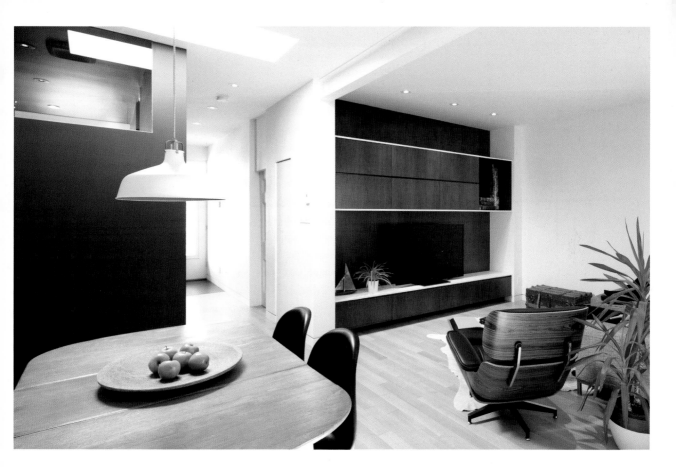

The Bourdages-Cloutier Residence is a renovation project where the design concept developed around the duality between stage and backstage. It is from this analogy that the interior of this apartment took shape. Mostly functional, the backstage area contains the mechanics used to set up the show. They are both charged and austere. For its part, the stage takes on the appearance of an empty space where objects are meticulously placed and where the aesthetics vary according to the elements found there. The architectural interpretation of the relationship between stage and backstage is transposed into the notion of served/servant spaces developed in the middle of the 20th century by the architect Louis Khan.

Bourdages-Cloutier Residence

950 sq ft

Montreal, Quebec, Canada

ADHOC Architectes

Photographs
© Alexandre Guillbault

Axonometric view

The concretization of the served/servant
notions gave rise to the black ribbon that
runs across the apartment and wraps the
backstage spaces, from the entrance to
the bathroom, ending in the kitchen.

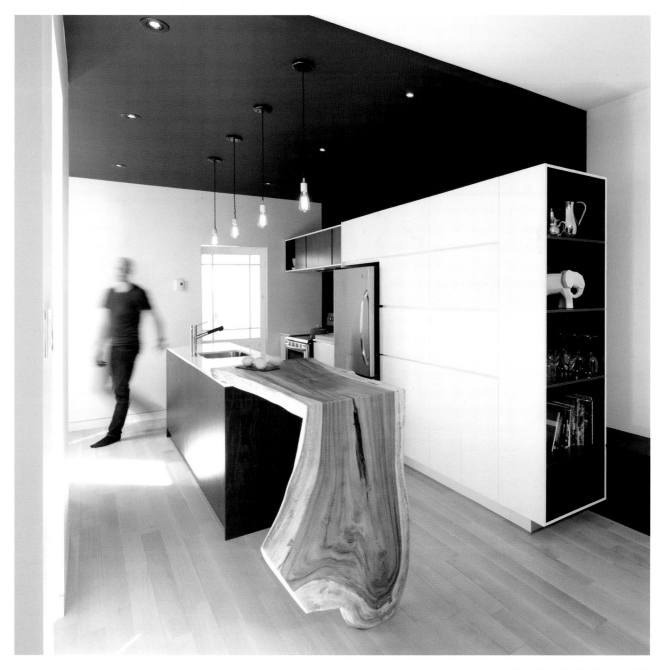

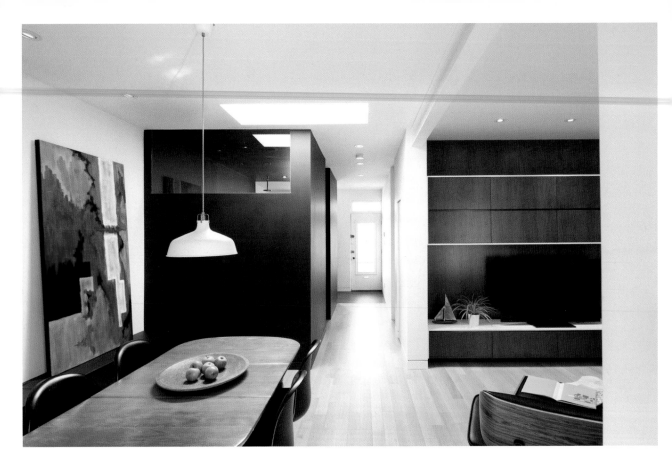

110

Skylights provide natural lighting
to areas where light from windows
can't reach.

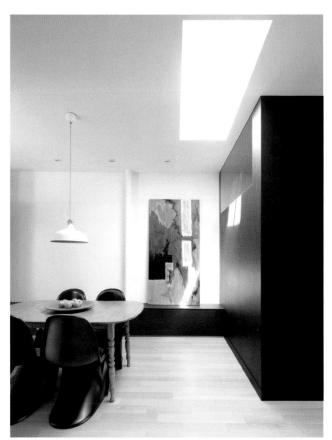

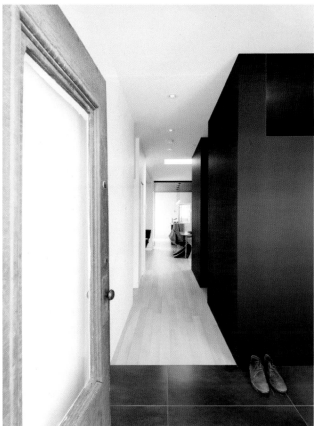

The rest of the space is soberly painted, finished in different natural textures. The visual identity of this design is characterized by the black and white contrast and the use of materials both raw and sophisticated.

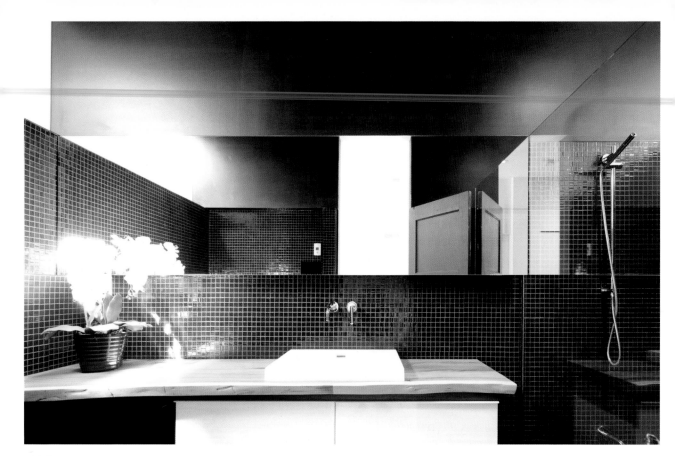

111

Mosaic tile is perfect for wall coverings, whether accent walls, small wall sections, wainscot, backsplashes, tub surrounds, or shower. Combined with another finish, it adds a pop of color and texture, but when it is used as the only finish, it gives the room a distinct uniform look.

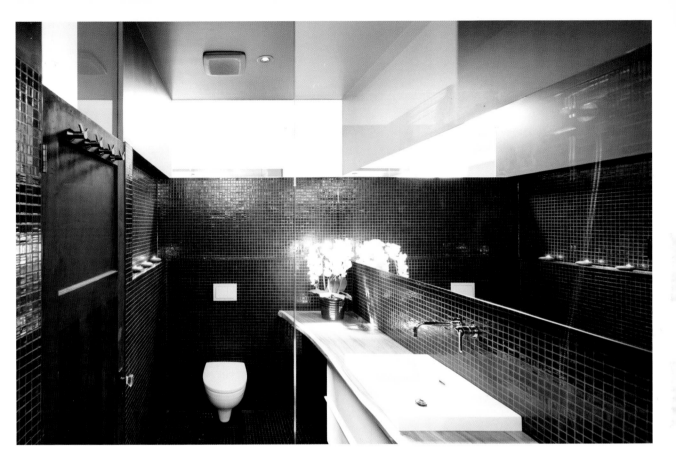

112

Glossy black mosaic tile creates
a sophisticated and dramatic look
that, inevitably, makes one think of
formal evening wear.

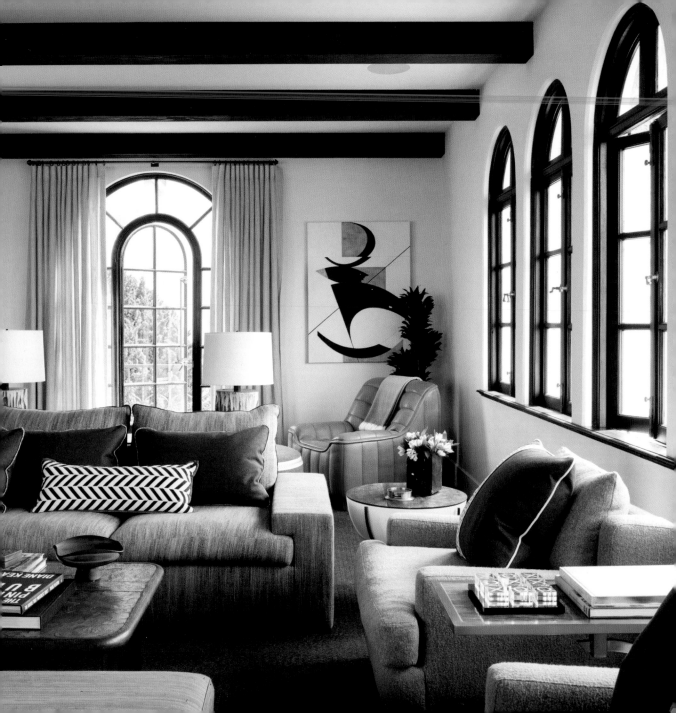

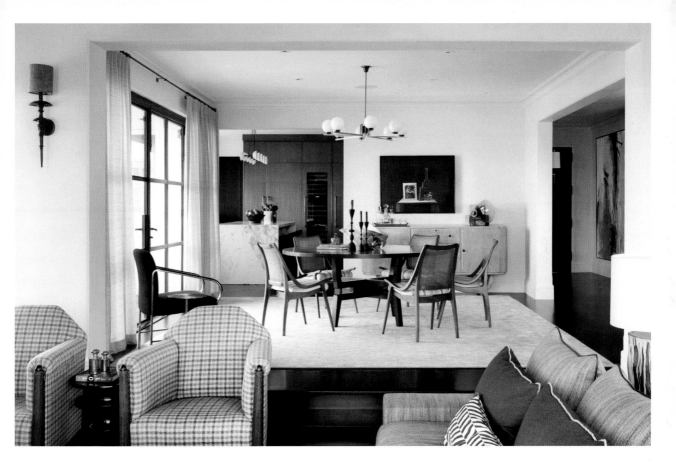

For a bachelor in Russian Hill, Sutro Architects gutted the top apartment of a three-unit building to provide a blank canvas for designer Jay Jeffers. The home, which sits atop one of San Francisco's most desirable neighborhoods, reflects the cool, comfortable, and elegant vibe of the owner with a modern emphasis. Using a mix of vintage pieces, interesting textured textiles, and pops of dark-colored accents, Jay's design complements the home's original beauty, including its arched, stained glass windows.

Bachelor Pad in Russian Hill

2,850 sq ft

San Francisco, California, United States

Jay Jeffers and Sutro Architects

Photographs © Matthew Millman

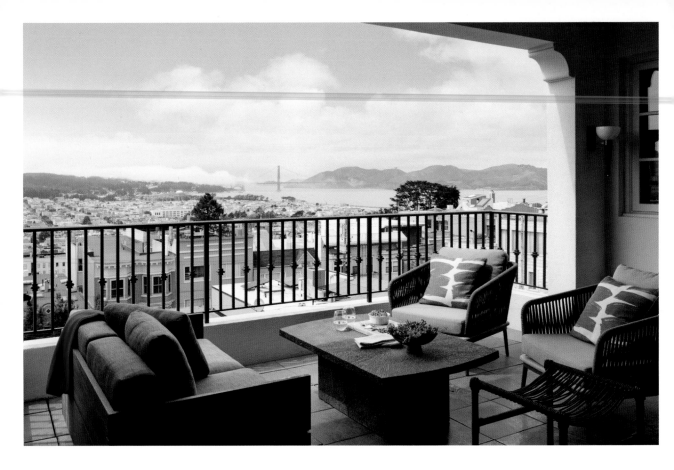

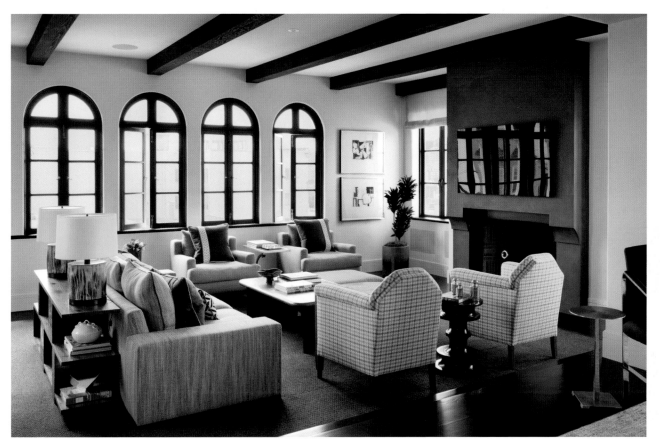

Ideal for entertaining, the expansive great room features open beam ceilings, luminous arched windows, and plenty of seating with lounge chairs by Lawson-Fenning in Pierre Frey fabric and a Dmitriy sofa in Stroheim fabric that encircle the plaster fireplace, painted black to disguise the mounted television.

113

The arched windows and doorways
are emphasized with a dark stain that
contrasts with the light walls and
harmonizes with the wood flooring.
This simple yet effective design
gesture is aimed at preserving the
original character of the structure.

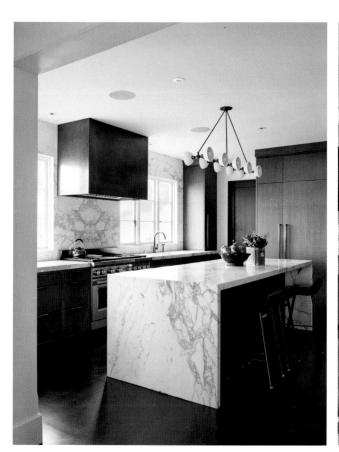

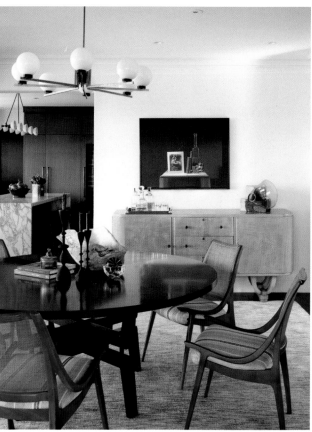

The kitchen features an Apparatus chandelier, and subtle navy leather stools were selected to tuck under the stunning white and gray marble island centerpiece.

A console behind the sofa breaks up the spacious room and partitions the sitting areas while still allowing the spaces to remain connected and conversational.

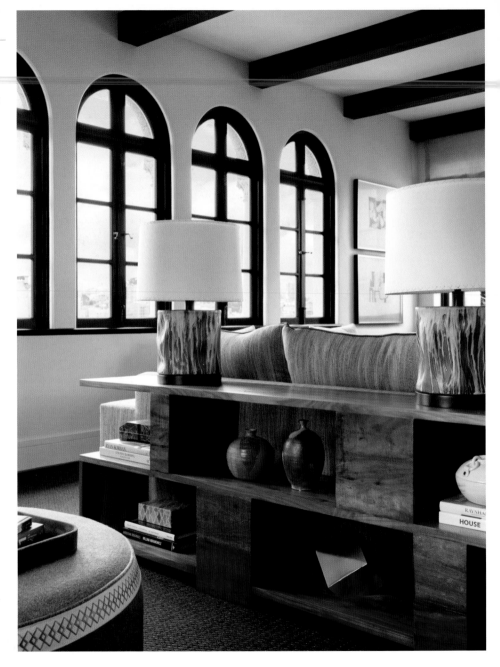

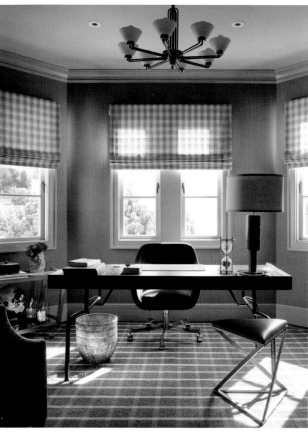

The masculine office centers around a McGuire desk flanked by a sculptural Lee Industries stool and a paw-footed Ironies armchair in Osborne & Little fabric.

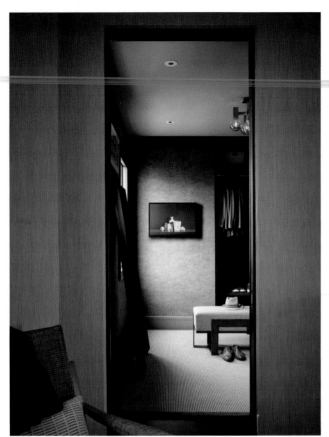

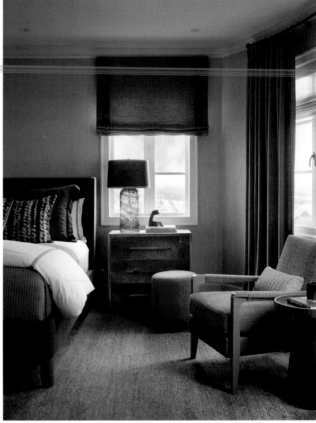

115

Wallpaper and carpet add cozy
warmth to any bedroom. The two
combined can set the tone of room
decor. Color, pattern, and texture
are key.

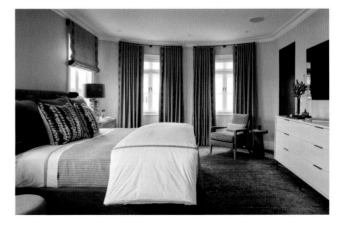

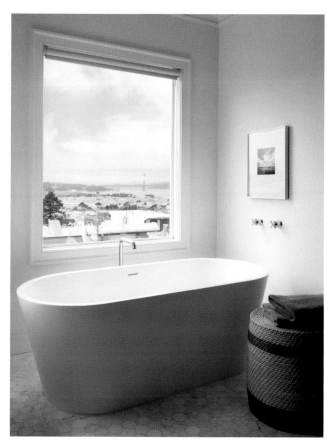

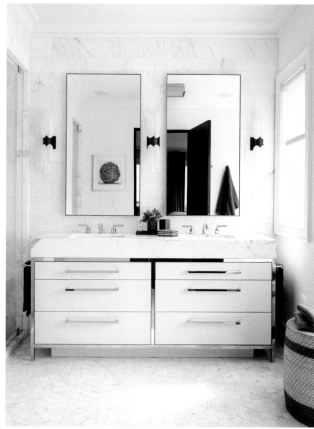

116

Just as wallpaper and carpeting set the mood for a bedroom, natural stone and ceramic tile do the same for a bathroom. Marbles, ceramic tiles, glass, and stainless steel are popular material selections for creating a spa-like room in the comfort of one's home.

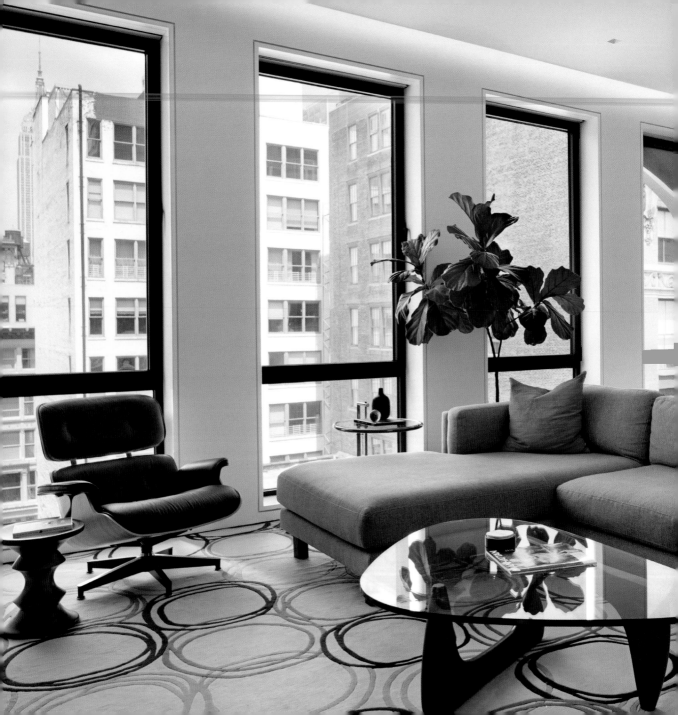

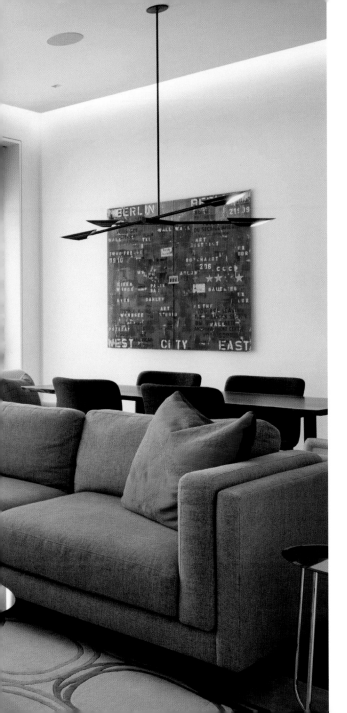

USQ Residence

1,500 sq ft

New York, New York,
United States

StudioLAB

Photographs
© Amanda Kirkpatrick

The renovation of a 1920s apartment focuses on simplicity and functionality while highlighting original features such as the large windows. An unusually high ceiling provides the apartment with a loft-like character. The apartment is bright already and inviting without splurging on unnecessary design gestures that would obscure the clarity of the plan. Mid-century modern furnishings and touches of industrial detailing play off the overall minimalistic design and add warmth. With plenty of new comfortable spaces, the apartment is suitable for living and for entertaining.

Kitchen elevation

Living area elevation facing north

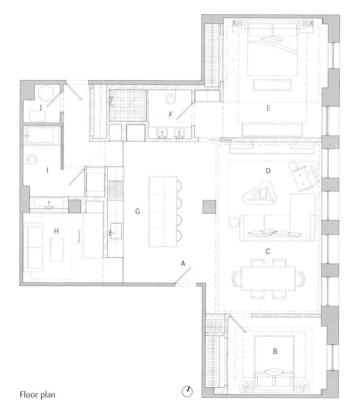

Floor plan

A. Entry
B. Bedroom
C. Dining area
D. Living area
E. Master bedroom
F. Master bathroom
G. Kitchen
H. Office
I. Bathroom
J. Utility room

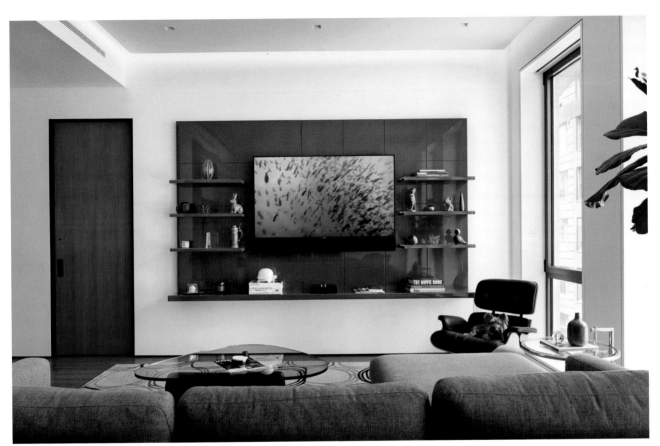

A single large floating ceiling with perimeter cove lighting was built over the living and dining area to accentuate the extra ceiling height. The ceiling also serves to hide LED recessed lighting, speakers, and sprinkler heads.

Custom teak veneer doors are wrapped with blackened steel door jambs, and a blackened steel base reveal matches the tall aluminum windows.

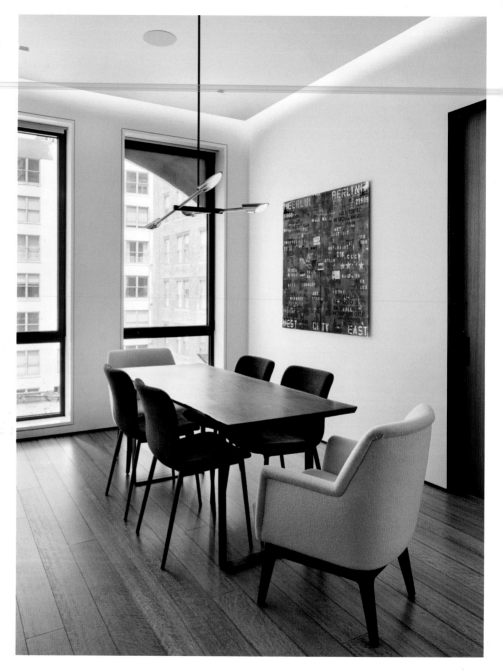

The overall design was conceived to highlight the effortless connection between spaces. In the kitchen, custom pivot doors were built to look like part of the kitchen cabinetry, and the gray-washed rift and quartered white oak flooring throughout unifies the entire apartment.

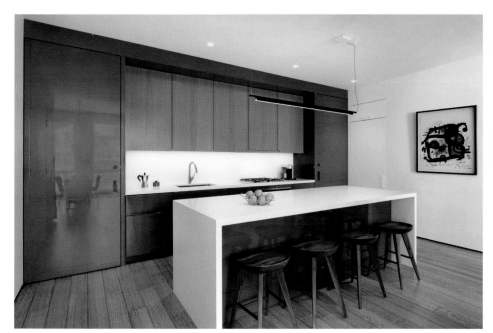

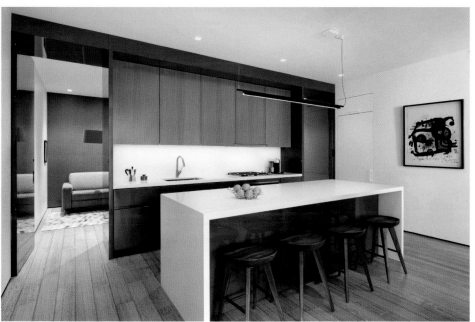

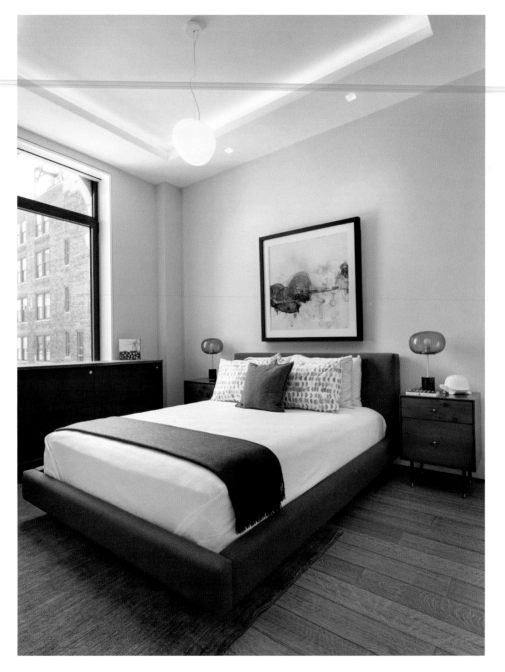

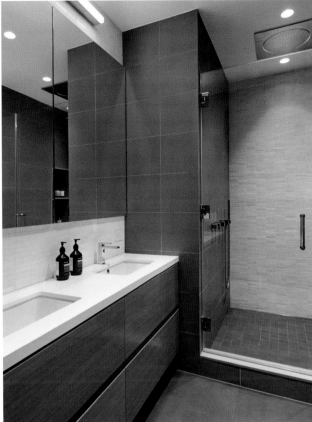

118

In line with the simple design of the public spaces, the bathrooms feature clean lines and harmonious material and finish combinations to create an inviting atmosphere.

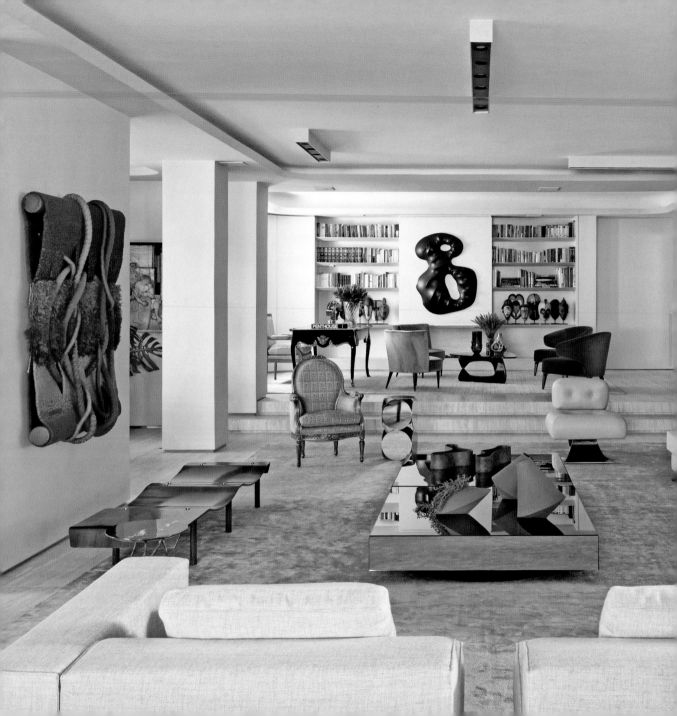

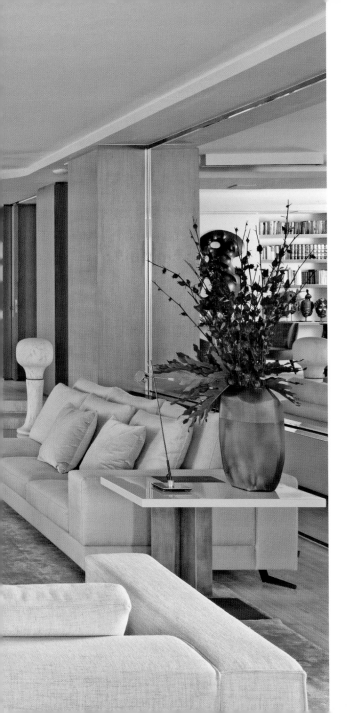

Artur Ramos Apartment

5,380 sq ft
São Paulo, Brazil

Diego Revollo Arquitetura
Photographs © Alain Brugier

A young couple with children gave carte blanche to the design office of Diego Revollo for the complete overhaul of a 35-year-old apartment. The new design satisfies contemporary spatial and functional living requirements while making the most of the potential that the apartment's original structure offered. The perimeter walls and some interior partitions presented distinctive curved forms that influenced the design concept. The renovation opens up the plan, improving the circulation pathways and the connection between the different rooms, as well as bringing as much natural light as possible to the interior of the apartment.

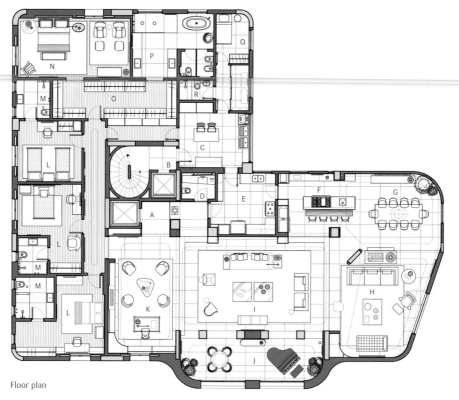

Floor plan

A. Main entry
B. Service entry
C. Back kitchen
D. Powder room
E. Kitchen
F. Gourmet kitchen

G. Dining area
H. Home Theater
I. Living area
J. Indoor garden
K. Office
L. Bedroom

M. Bathroom
N. Master bedroom
O. Dressing room
P. Master bathroom
Q. Maid's bedroom
R. Maid's bathroom

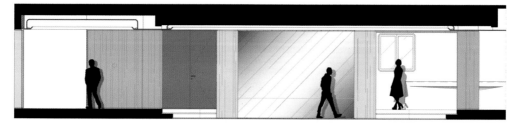

Partial elevation living area, facing the main entry and the gourmet kitchen

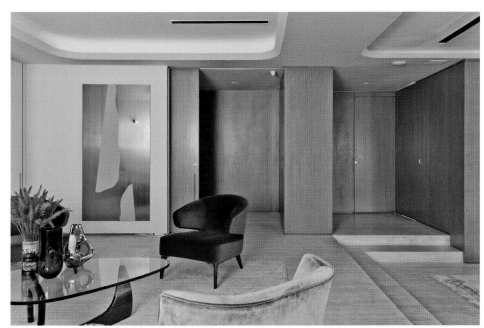

With the new configuration, the apartment exudes spaciousness and airiness. A sparse but tasteful selection of furnishings and artwork of different styles and periods creates a unique living environment.

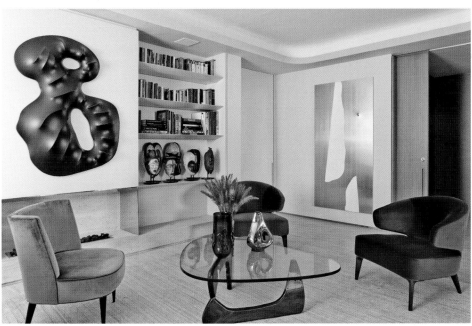

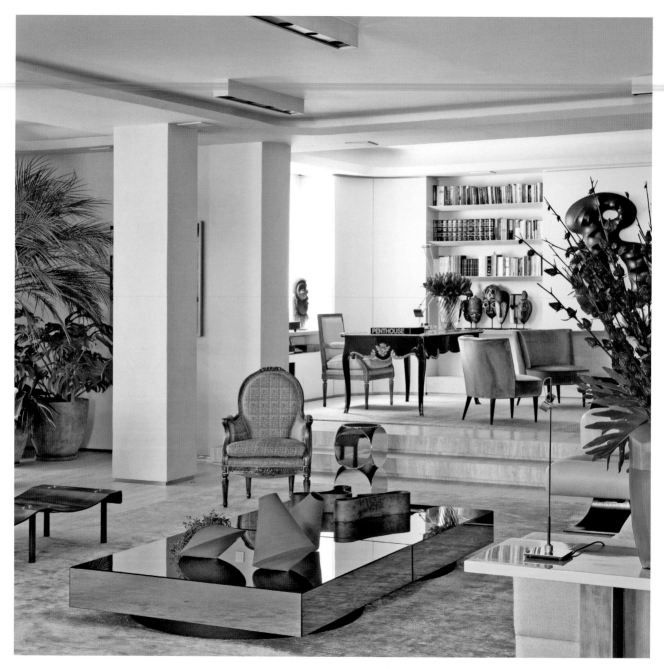

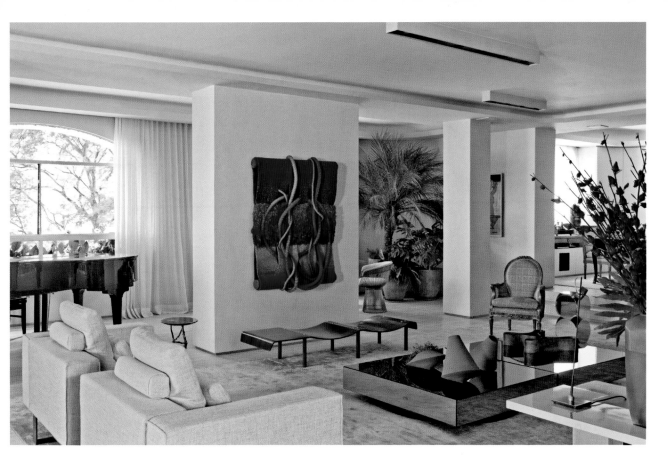

119

Organic shapes generally soften
the rigidity of overly geometric
space, bringing natural, flowing,
and calming qualities.

Open spaces offer spatial continuity from one area to another without obstructions. Still, different areas need to be demarcated. Columns and built-ins are design solutions that are often used to frame different areas.

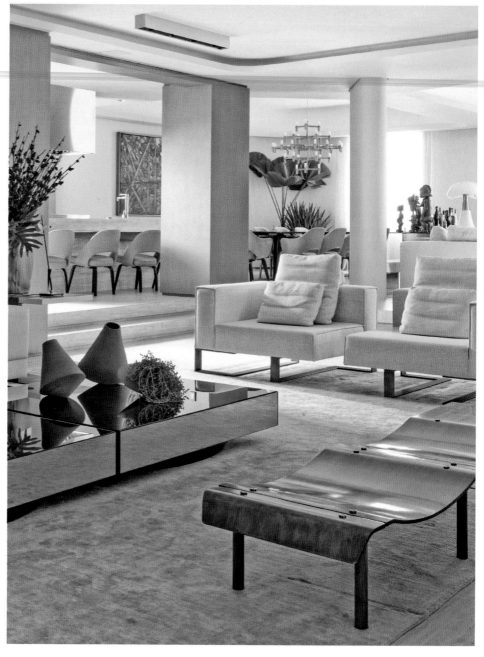

The travertine stone flooring and kitchen island add texture and warmth to this section of the apartment, complementing the light tones of the walls and cabinetry and the stainless steel appliances.

Creating graceful transitions between areas of different use that share the same space is nothing short of a challenge. The result can be as permanent as a floor height difference or as temporary as using area rugs to define different zones.

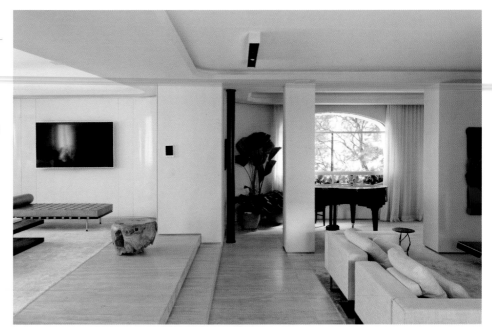

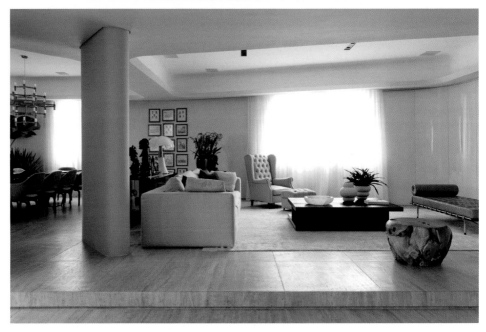

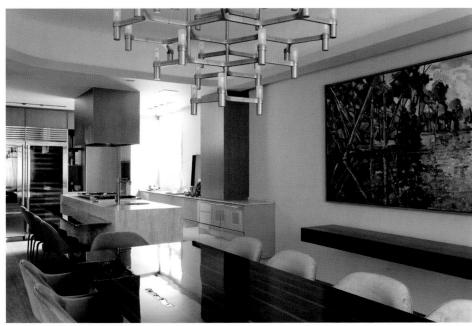

Saarinen's executive armchairs, a Crown Major chandelier manufactured by Nemo, and Ricardo Dias Ramos wall painting make for an elegant formal dining area.

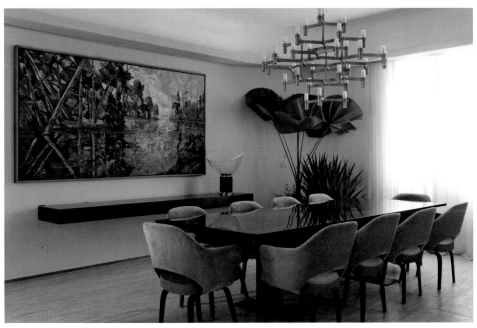

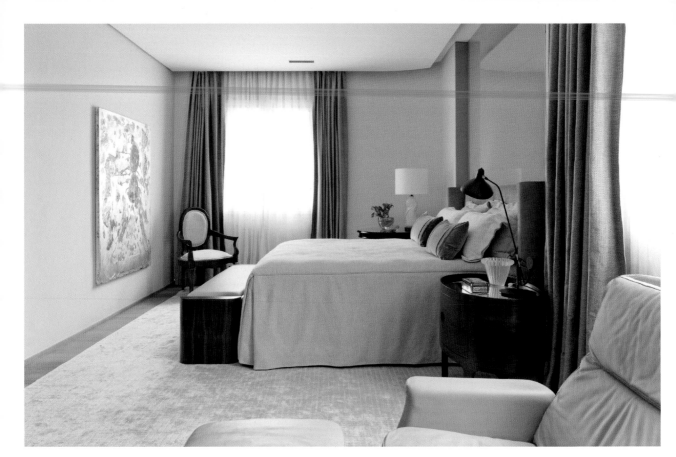

122

Dropped ceilings give any room
a stylish touch. Aside from their
aesthetic qualities, they are also
functional. The space between an
existing ceiling and a new dropped
ceiling can be used to hide wires,
pipes, lighting, and ventilation
systems discreetly.

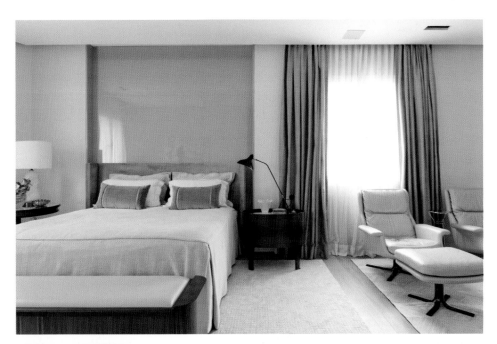

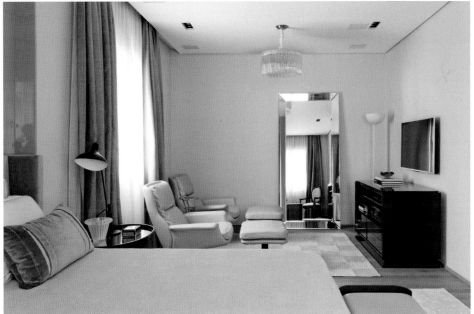

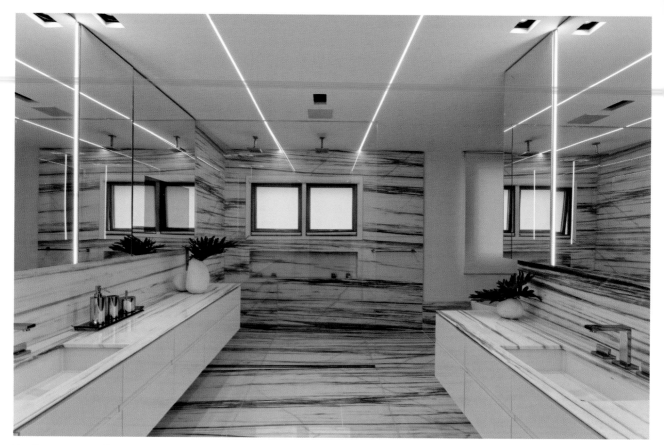

The almost symmetrical layout of the
master bathroom is enhanced by the large
mirrors. To achieve this visual effect,
Diego Revollo finished the floor and
walls in striated white marble and used
recessed LED lighting ceiling strips, which
accentuate the linearity of the vanities.

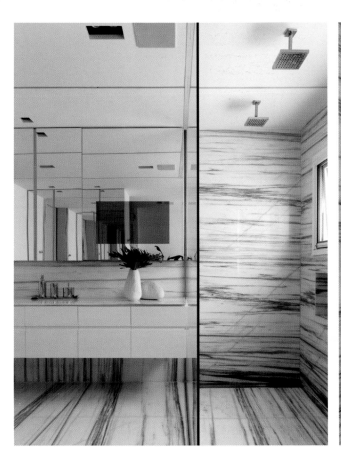

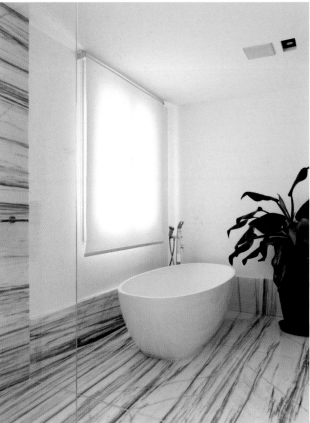

123

Showcasing a very veiny marble is perhaps all that's needed to give a bathroom a unique and elegant touch. Plumbing fixtures should be simple and understated so as not to conflict with the marble surfaces.

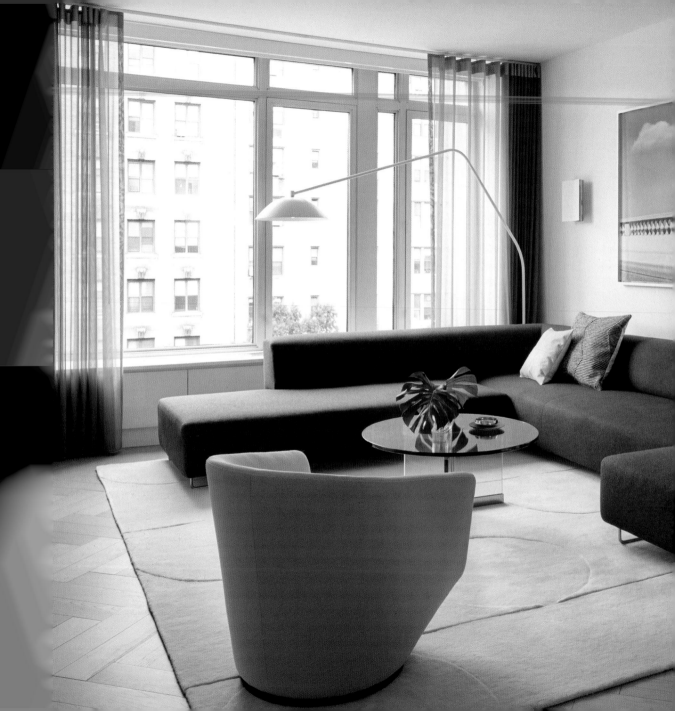

Upper West Side Renovation

2,300 sq ft

New York, New York,
United States

Frederick Tang Architecture

Photographs © Gieves Anderson

The gut renovation and combination of two residential condominium units provide a family with three children with much desired additional space. The renovation affords a separate wing for the children, which includes a media room, study area, bathroom, and laundry. Other key additions include entertaining areas and a home office. The design laces sophistication with bold color accents and a sense of playfulness, reflecting a hybrid of the couple's different sensibilities: tasteful simplicity meets bold and colorful vision. New furniture and materials, along with a range of custom built-ins designed by the architects, reflect this synthesis.

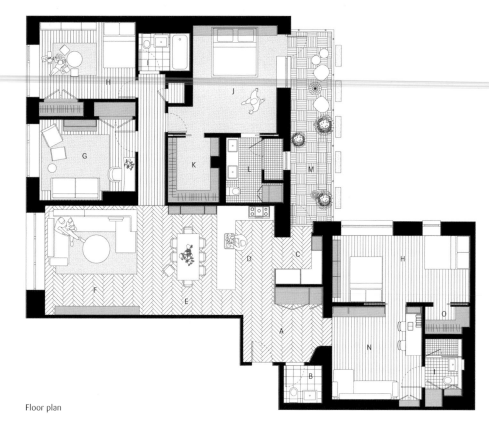

Floor plan

A. Entry foyer
B. Powder room
C. Pantry
D. Kitchen
E. Dining area
F. Living area
G. Sitting area
H. Kids' room
I. Bathroom
J. Master bedroom
K. Walk-in closet
L. Master bathroom
M. Terrace
N. Kids' study room
O. Closet

124

Combining two adjacent units
to create a dream home doesn't
come without challenges. The first
is to ensure that the result is a
convenient and functional layout
as this project by Frederick Tang
Architecture demonstrates.

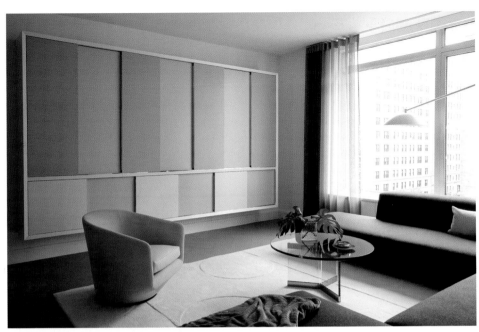

A custom wall cabinet gives many storage options. Two ecru and soft gray millwork sliding panels and brass hardware reveal and conceal the TV, family pictures, and a book collection, adding visual interest to the living area.

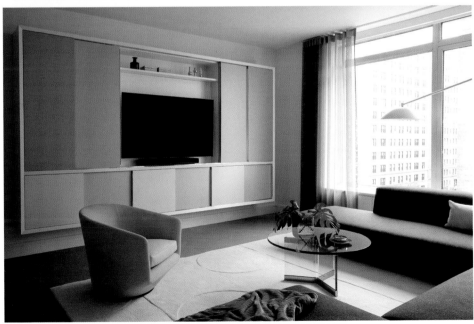

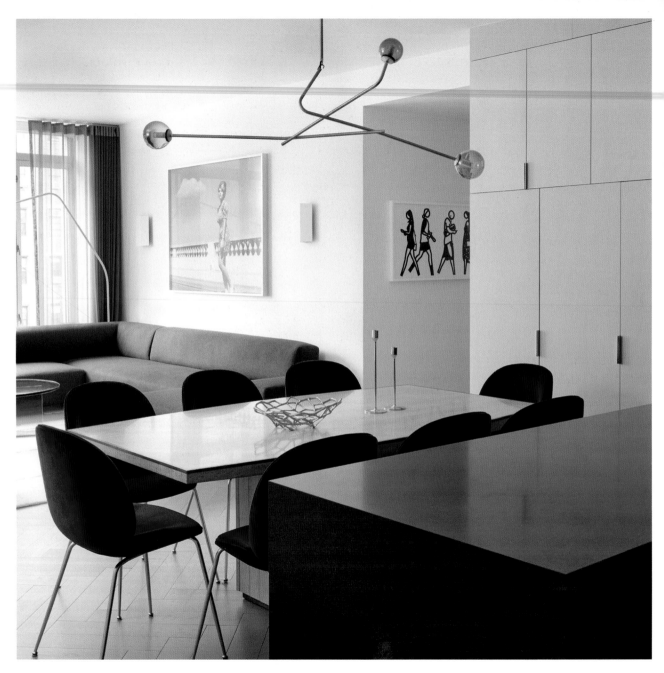

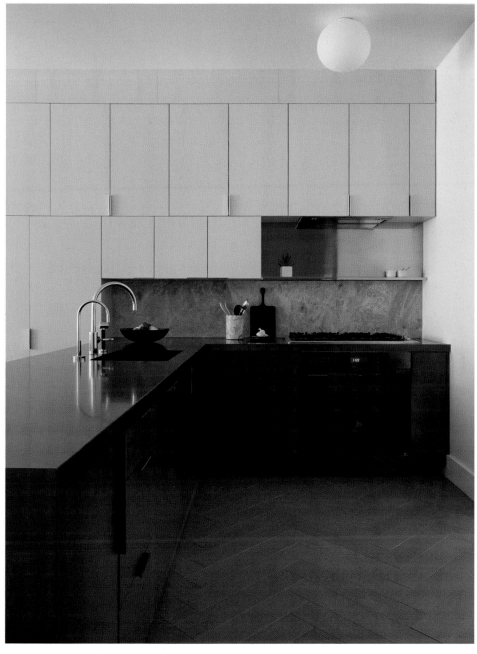

Opening up the kitchen and joining it to the living and dining areas to create one continuous functional area responds to a contemporary lifestyle where the kitchen becomes the heart of the home and often the epicenter of social interaction.

In the main entry foyer, an archway formed by two curving wall and ceiling planes finished in a warm gray venetian plaster connects the boys' wing with the rest of the apartment. This expressive opening conceals the building's structural and mechanical ductwork.

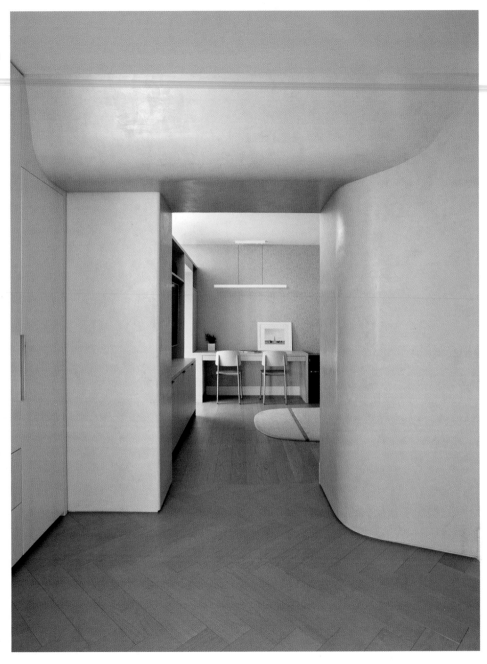

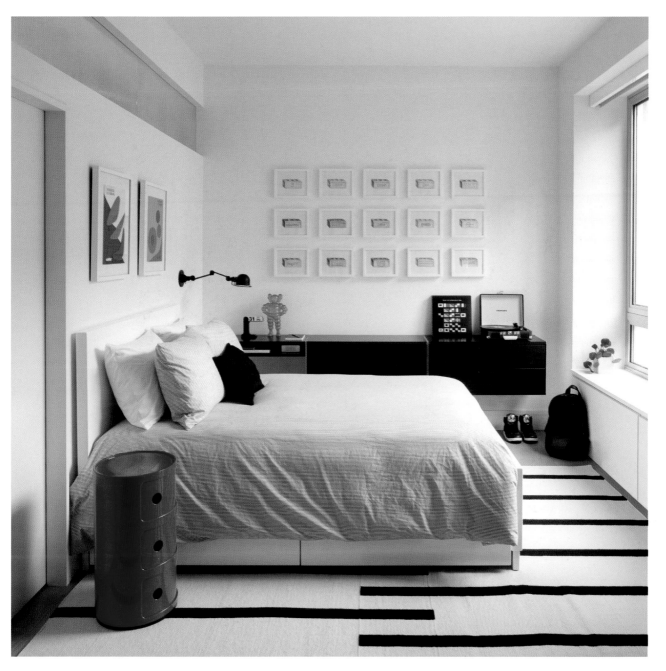

126

Bold color accents add a sense of
playfulness and give rooms a distinct
look. In kids' bedroom design, the
use of color can support a theme
related to a special interest, creating
a unique and personal environment.

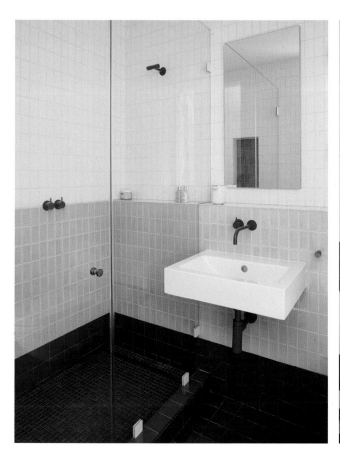

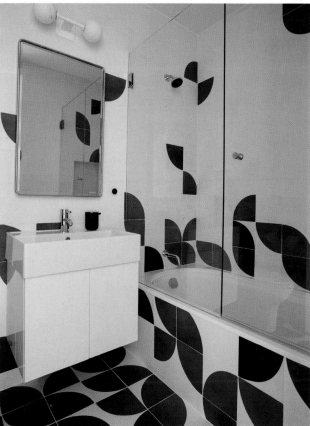

In the guest bathroom, which is also shared by the boys, a rain of tiles featuring graphic shapes balances elegance and whimsy.

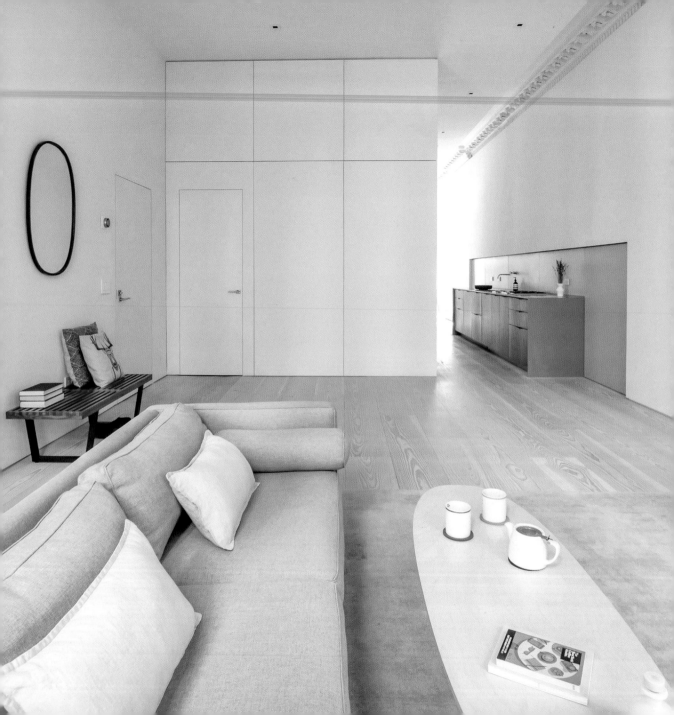

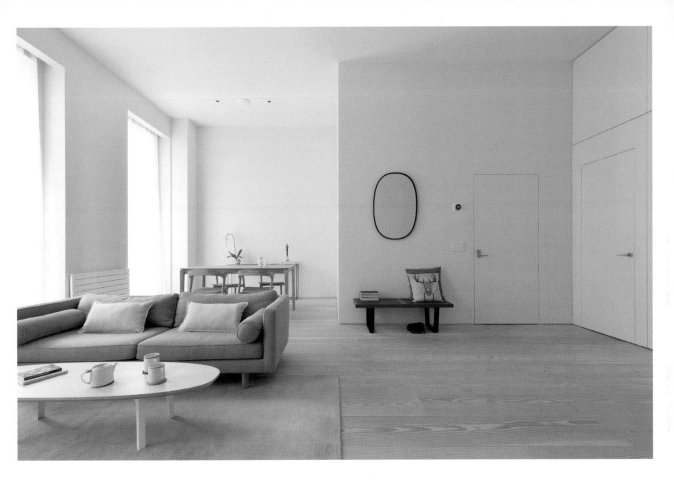

With tinted white walls, natural plank floors, and uncomplicated furnishings, this flat becomes a retreat from the clamor of New York's streets. The renovation expanded the single-bedroom apartment, which was the rear half of the building's third floor, to occupy the entire floor. Challenged with designing a sanctuary within a tourist center of New York, the designers found their inspiration in Scandinavian and Japanese aesthetics. The design maintains the 12-foot-high ceilings and original crown molding dating back to 1846 to preserve the apartment's original character while adding new features that improve its functionality. The all-white scheme emphasizes spatial continuity throughout the apartment, combining functional and aesthetic requirements.

Sumu Residence

1,200 sq ft

New York, New York,
United States

Echo Design + Architecture

Photographs
© Echo Design + Architecture

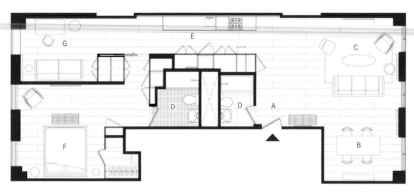

Floor plan

A. Entry E. Kitchen
B. Dining area F. Bedroom
C. Living area G. Office
D. Bathroom

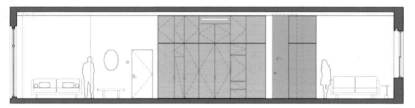

Longitudinal section

Cross section

A service core provides the spaces around it with functional amenities and generous storage. Its location against a blank interior wall allows the rest of the apartment to be as open as privacy permits along the window walls.

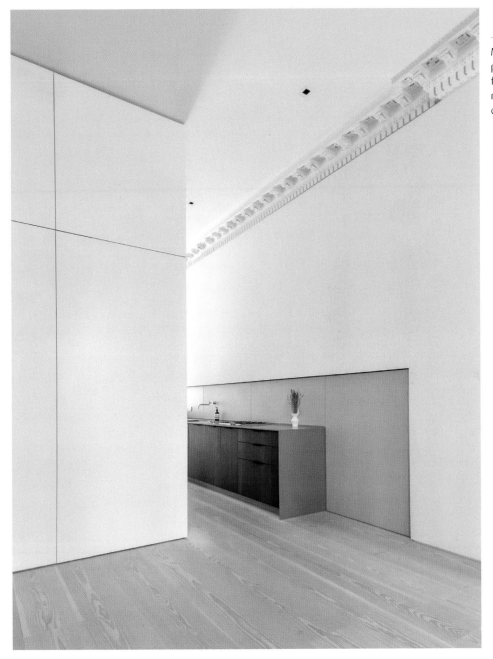

Moldings, ceiling roses, cornicing, paneling, and trim are architectural features in period homes that can make a dramatic backdrop to contemporary remodels.

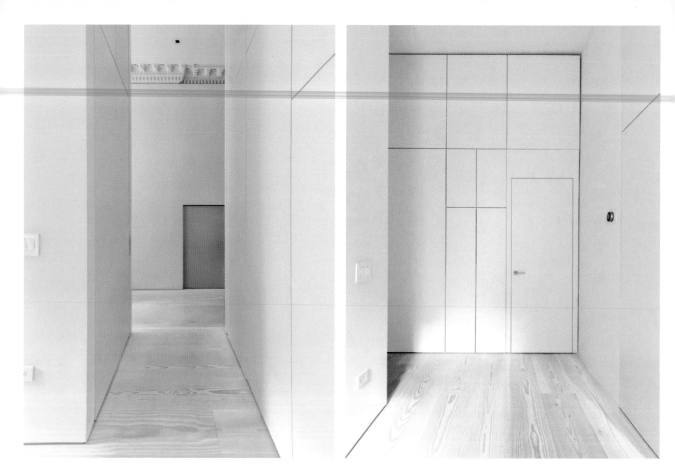

128

The central core is clad in white
panels with recessed pulls. The
simple design allows the architectural
detailing to be subtly expressed.

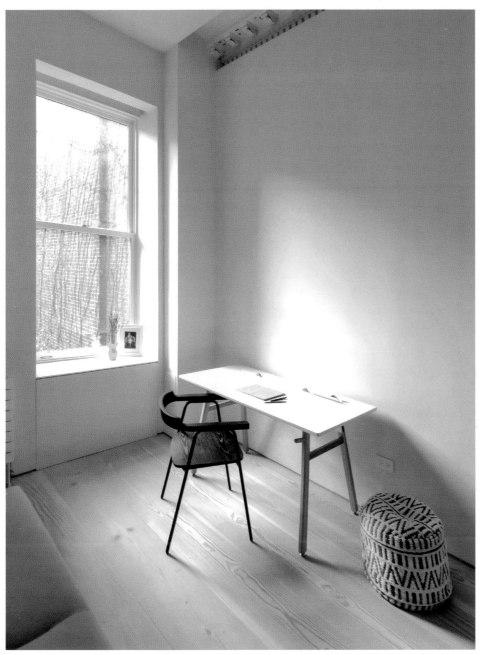

The selection of materials and furnishings combines with the use of natural lighting to emphasize a sense of amplitude and create an airy and serene atmosphere.

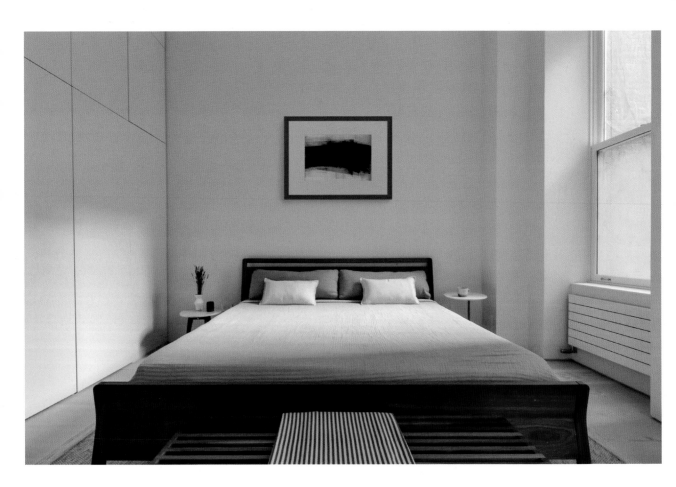

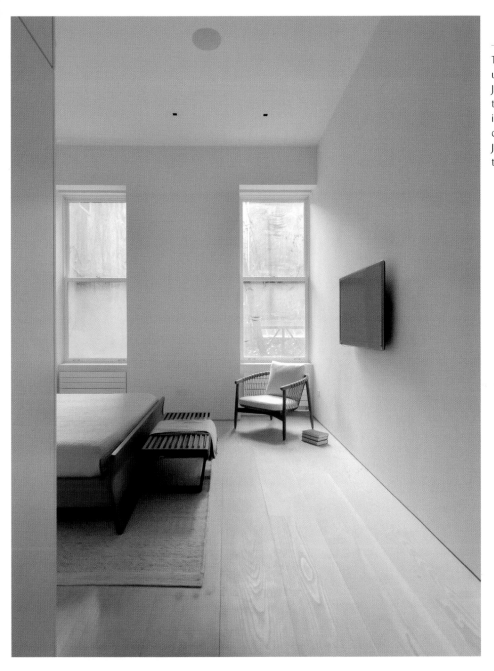

The neutral tones and sober use of space that characterizes Japanese design harmonizes with the relaxed style of Scandinavian interiors, demonstrating a stylistic connection between the traditional Japanese wabi-sabi aesthetic and the Scandinavian hygge culture.

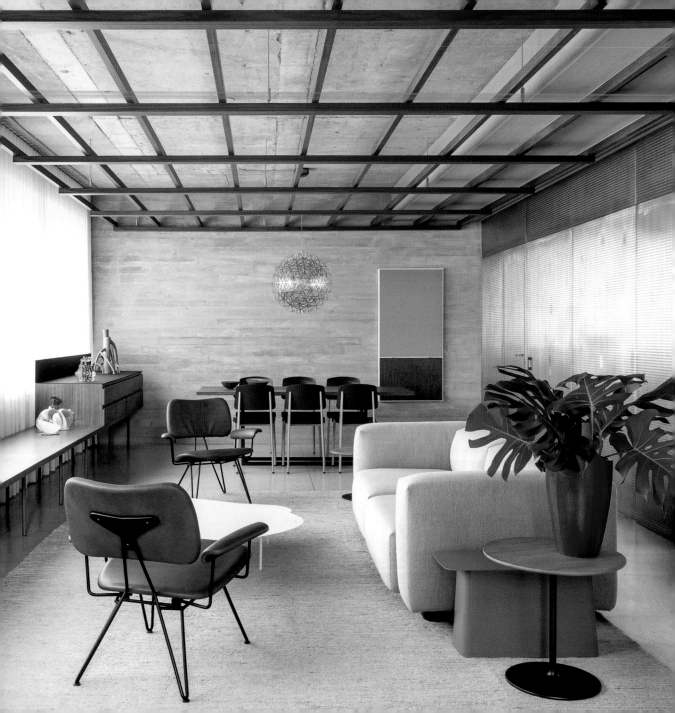

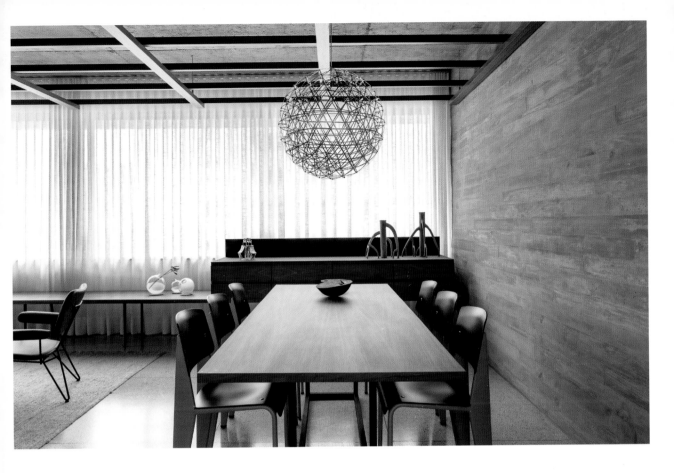

The SC Apartment was designed as a pied-à-terre for an art and design collector, a place for hosting gatherings with friends. The most prominent design feature is the wood ceiling trellis that adds warmth to the otherwise raw space. The Granilite flooring, a mixture of concrete and aggregate, echoes the existing concrete structure that was left exposed. In contrast with the roughness of the wood and concrete, a sleek stainless steel and opaque acrylic wall separates the living and dining area from a central core containing the entry, the kitchen, the powder room, and access to the private quarters. The use of these materials is nonetheless downplayed to accommodate an extensive art collection, including works by Osgemeos, Jesús Rafael Soto, Ken Russell, and Mauro Perucchetti.

SC Apartment

1,160 sq ft

São Paulo, Brazil

Pascali Semerdjian Arquitetos

Photographs © Ricardo Bassetti

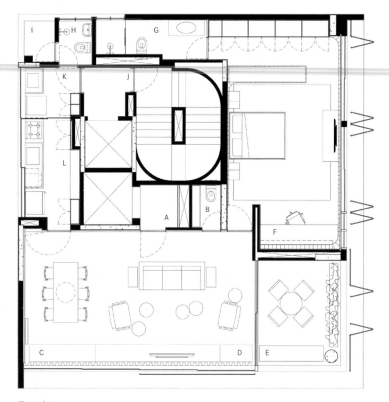

Floor plan

A. Entry hall
B. Powder room
C. Dining area
D. Living area
E. Balcony
F. Master bedroom
G. Master bathroom
H. Bathroom
I. Service balcony
J. Service Hall
K. Laundry room
L. Kitchen

With ribbon windows on two walls and a corner balcony, the apartment is airy and bright. Pascali Semerdjian Arquitetos took full advantage of this asset, providing fully open spaces for the main room and the bedroom.

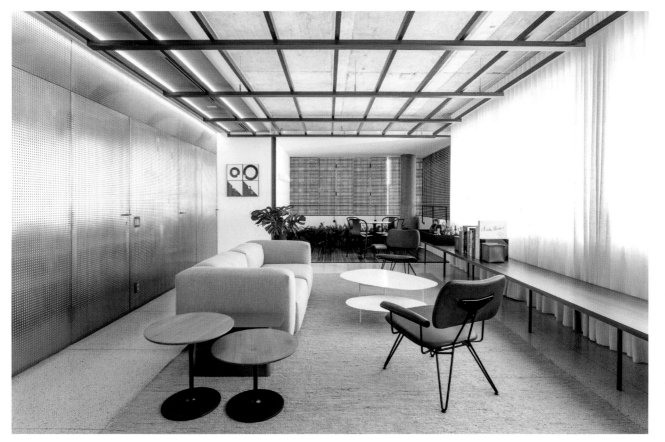

130

The wood structure suspended
from the ceiling supplies indirect
lighting for the living area to
provide a well-lit and comfortable
atmosphere at sunset.

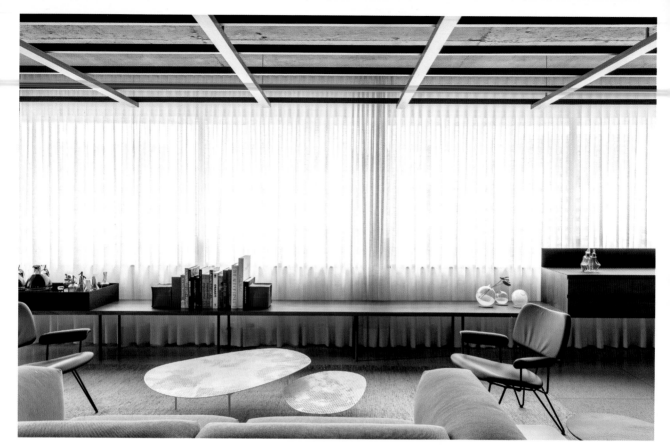

The custom-made wood sideboard in front of the ribbon windows serves as a bar and dining counter. Its low and long design helps define the area and accentuates its elongated proportions.

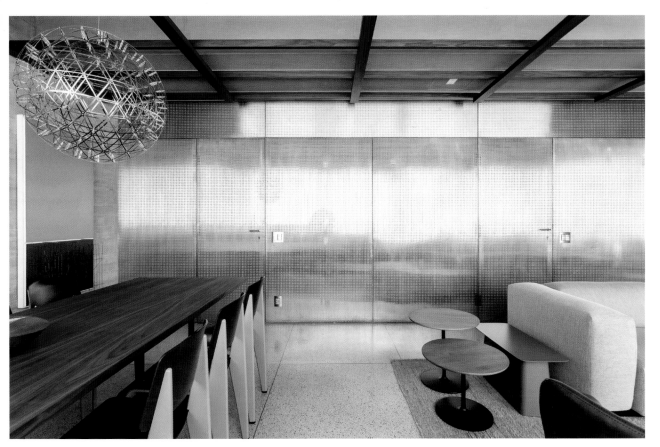

131

Texture in interior design can provide
rooms with depth and visual appeal.
The key is to find the right balance
between items with coarse textures
and others with subtle textures.

The master bedroom is a large room containing a bed, a dressing area, and an office. A wooden wall emphasizes the connection between these three areas, integrating the headboard, the closet, and the office desk.

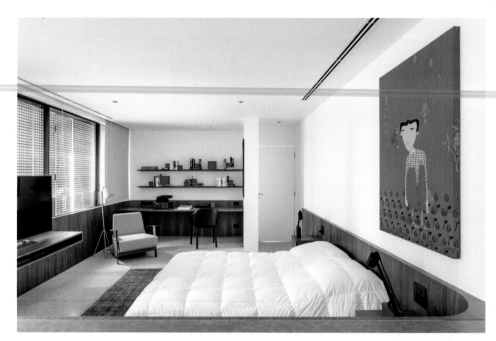

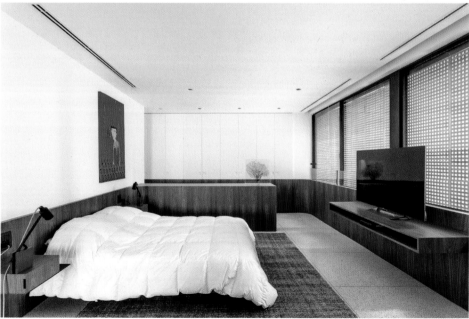

An all-white color scheme is ideal for bathrooms, creating a clean and fresh look. Adding an element of color and texture won't necessarily disrupt this look and will add a touch of sophistication, like this walnut vanity.

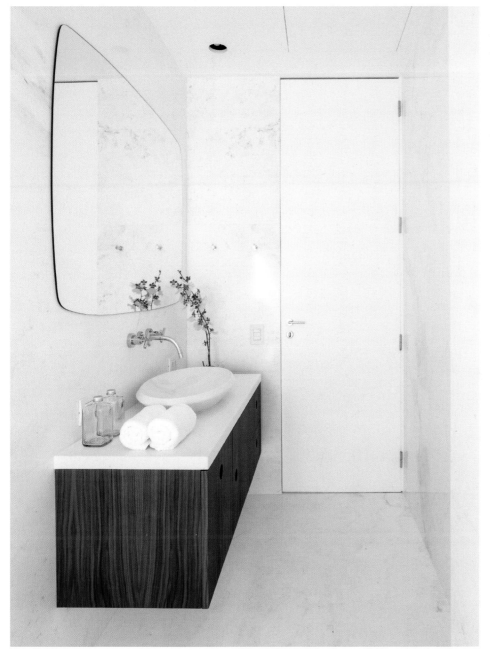

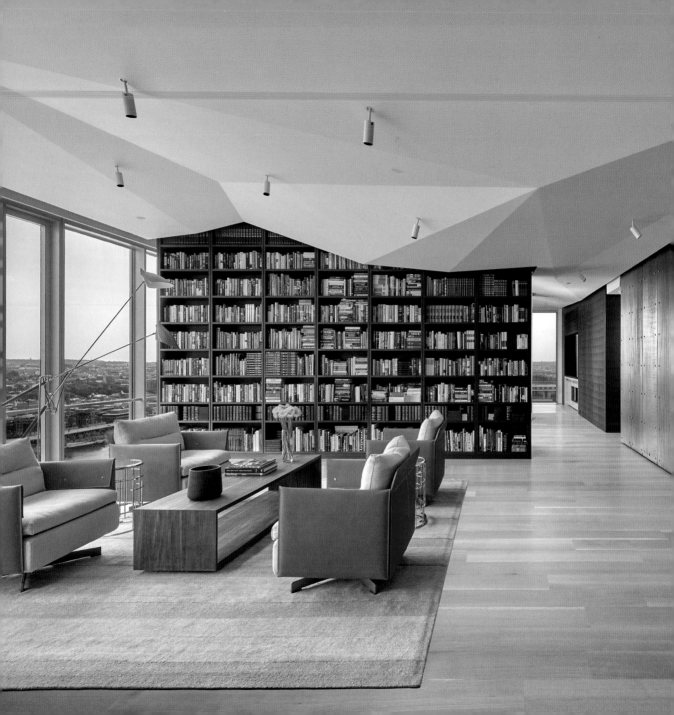

Waterview Condominium

4,800 sq ft

Rosslyn, Virginia, United States

Robert M. Gurney Architect

Photographs
© Anice Hoachlander,
Judy Davis, Maxwell MacKenzie

This project involved the renovation of a condominium on the 30th floor of the Waterview, a luxury high-rise building designed by Pei Cobb Freed & Partners in 2008. Located along the Potomac River, the building yields unequaled panoramic views of Washington DC and beyond. Maximizing these views was the primary goal. This required a design strategy that involved concealing a highly intruding building infrastructure—including roof drains, fire suppression systems, plumbing lines, and ductwork—that often was revealed in unexpected locations, where ceiling height dropped as low as eight feet above the finished floor. To work with the varying heights, an origami-inspired composition of ceiling planes accommodates the differing elevations of the infrastructure, maximizing ceiling height, especially along the ten-foot-high floor-to-ceiling, uninterrupted curtain wall.

Open plans offer great design benefits. With no partitions sectioning the space, they maximize the use of space and optimize natural lighting. From a social standpoint, they encourage interaction, creating the perfect environment for entertaining.

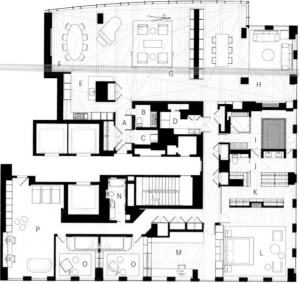

After renovation floor plan

A. Entry foyer
B. Powder room
C. Mechanical room
D. Laundry room
E. Kitchen
F. Dining area
G. Living area
H. Media room
I. Spa room
J. Master bathroom
K. Dressing area
L. Master bedroom
M. Office
N. Bathroom
O. Bedroom
P. Study

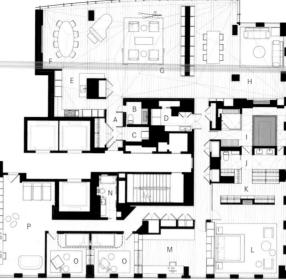

Before renovation floor plan

before FLOOR PLAN

0' 5' 10' 15'

Axonometric view

Materials for the project are carefully considered and selected, ultimately producing a palette of materials that are rich and refined, juxtaposed to others that are raw and austere.

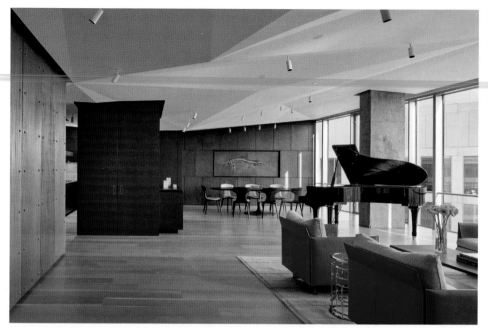

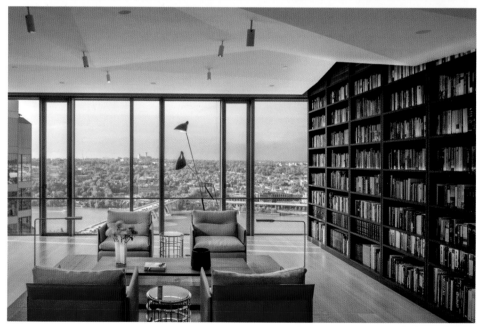

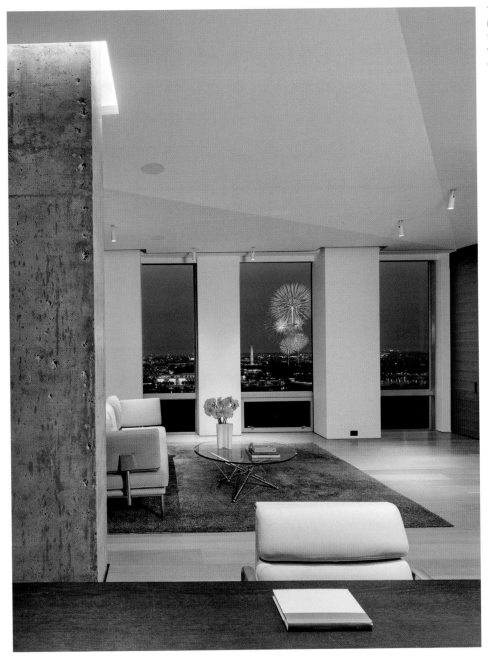

The concrete columns remain exposed, intended to read as objects in space. The folded ceiling plane never engages the walls, columns, or millwork components, creating a floating effect.

Spaces are defined by planes of wenge
or rift-sawn white oak to modulate the
open floor plan. The defining, central
utility core is armored with steel panels.

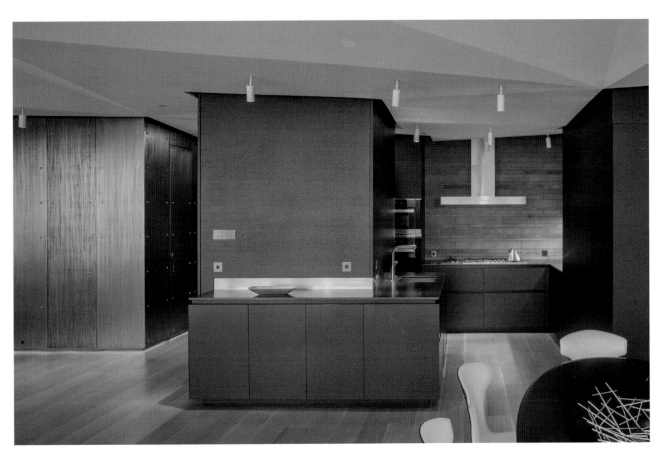

134

Open plan designs can use different materials to demarcate separate areas and give them a distinct look.

135

The consistent use of materials throughout an interior eases the transition from one room to the next, ensuring a coherent and powerful design language.

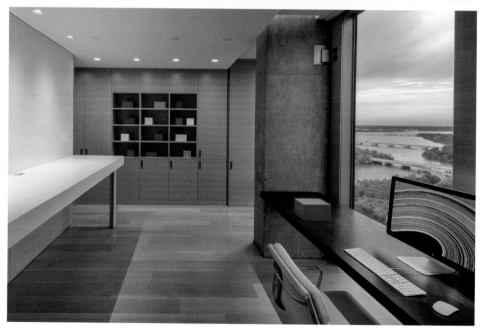

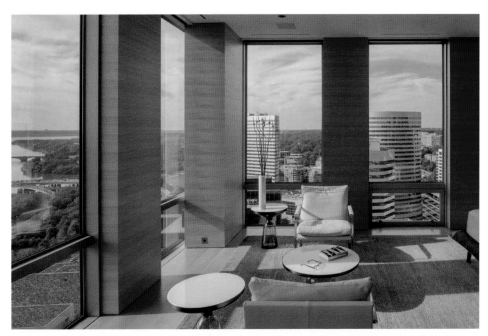

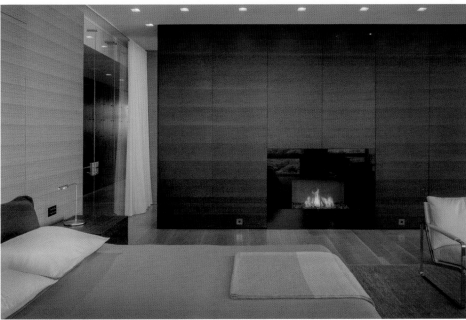

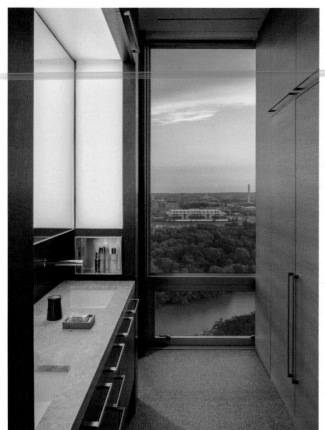

A large, Japanese soaking tub is central to a monastic spa room. Honed absolute black granite and vertical grain western red cedar walls combine with flamed impala black flooring to provide a calm, quiet backdrop to the city views beyond.

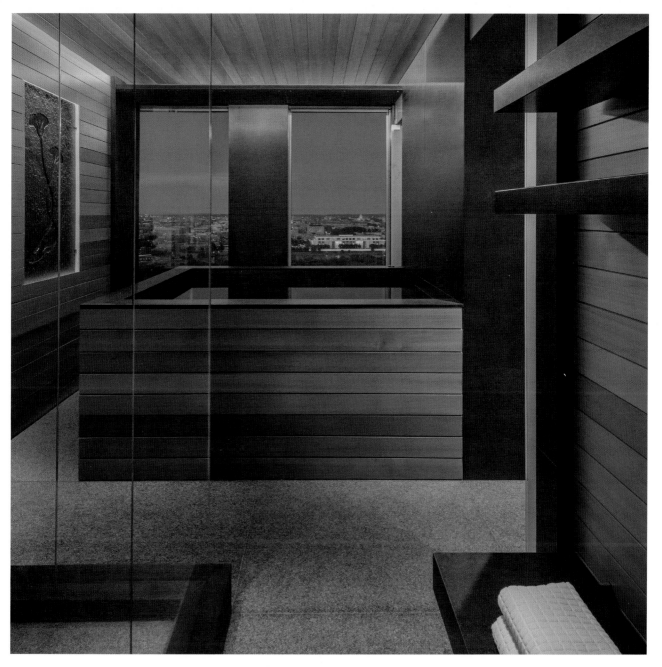

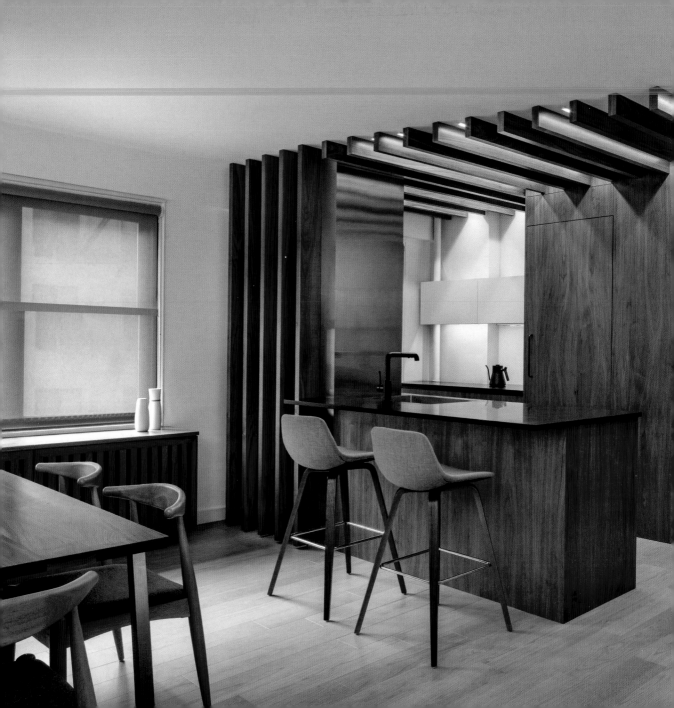

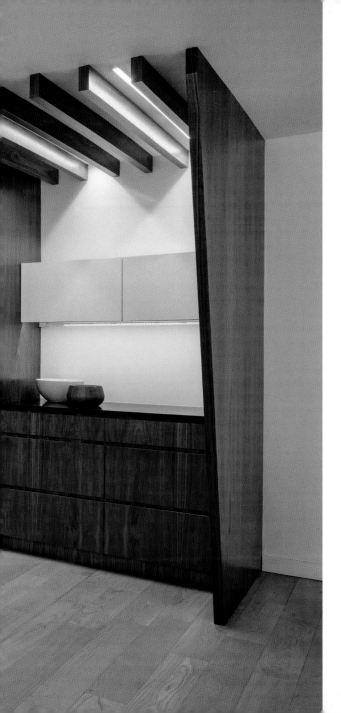

Modern Nostalgia

650 sq ft

New York, New York,
United States

Andrew Mikhael Architect

Photographs © Brad Dickson

What started with a concern about the lighting possibilities of
a New York City apartment with a concrete ceiling evolved to a
discussion on how to design a dream home that would suit the
client's desire to work from home and his interest in cooking
and baking. It soon became clear that the kitchen could be
the focus of the design, engaging the rest of the apartment
while integrating an original lighting solution. The owner's
childhood memories of the walnut-paneled dining area of his
grandmother's apartment in Manhattan served as inspiration,
guiding the material aspect of the design and providing the
apartment with a distinct and evocative aesthetic.

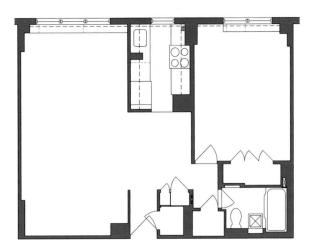

Before renovation floor plan

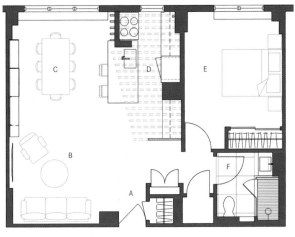

After renovation floor plan

A. Entry D. Kitchen
B. Living area E. Bedroom
C. Dining area F. Bathroom

The apartment was cleared of all the
molding, and the existing flooring was
replaced with wide plank white oak. This
new blank canvas allowed the focus of
the design to turn to the creation of the
client's dream kitchen.

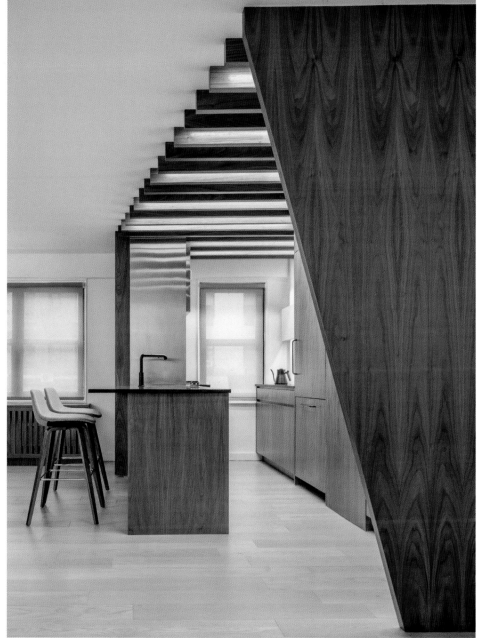

The kitchen is open to the living room and diagonally wrapped in a three-dimensional walnut veneer. The arrangement of appliances was reconfigured to create an open and functional layout. The range is tucked away in the corner, and the fridge was moved next to a structural column so both could be clad harmoniously in the same wood veneer.

Between the slats, linear LEDs provide efficient task lighting, addressing the client's concern about lighting possibilities in a New York City apartment with a slab ceiling.

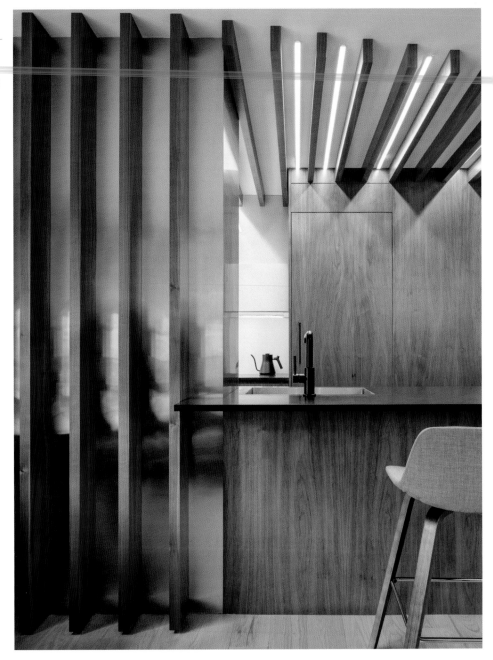

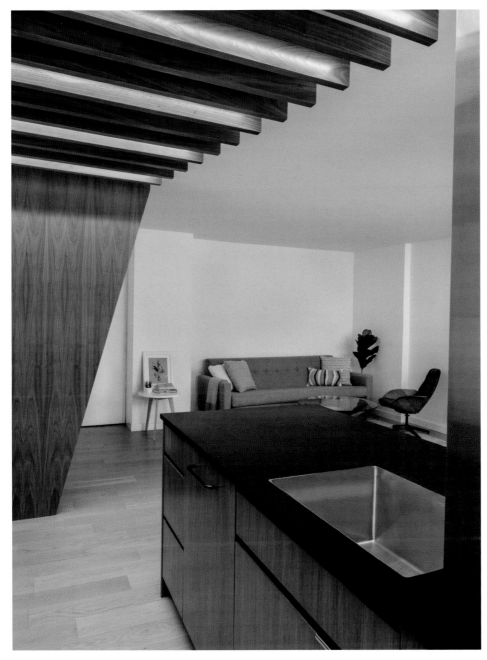

An angled sheath of wood faces the entryway. Along the ceiling 2x4 wood slats widen till they reach the far end and pour down a stainless steel wall.

The bathroom was also reconfigured with luxury finishes—Artistic Tile stone walls and floors, Vola faucet, accent lighting by Rich Brilliant Willing—while maintaining a modest overall budget. Teak decking in the shower gives a warm touch underfoot. Overall the bathroom emotes a masculine and sophisticated feel.

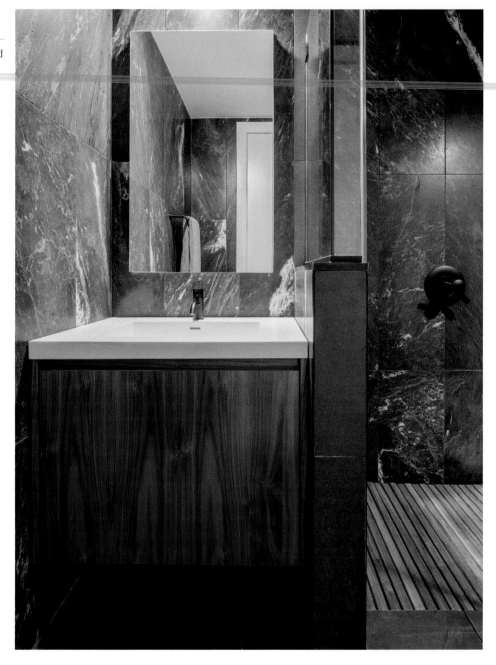

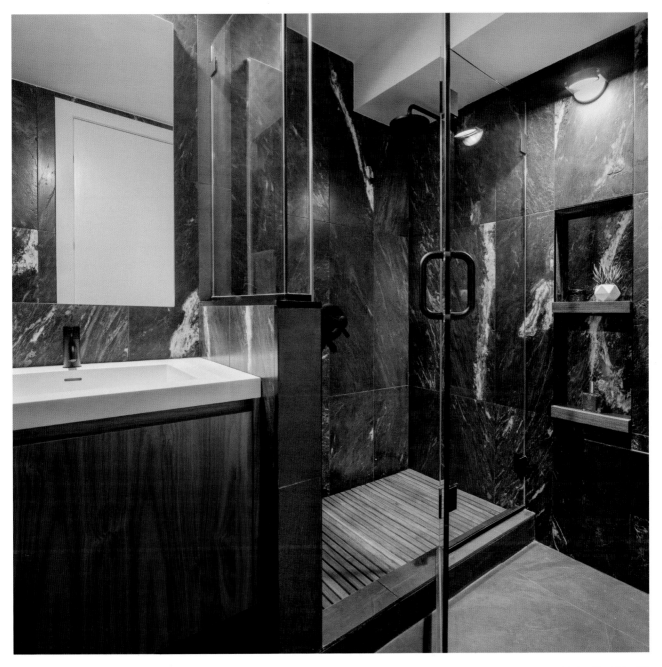

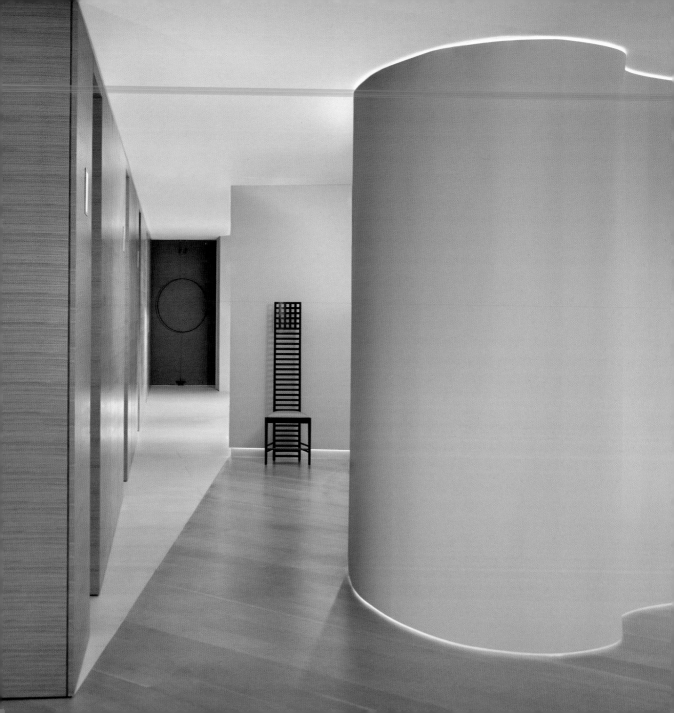

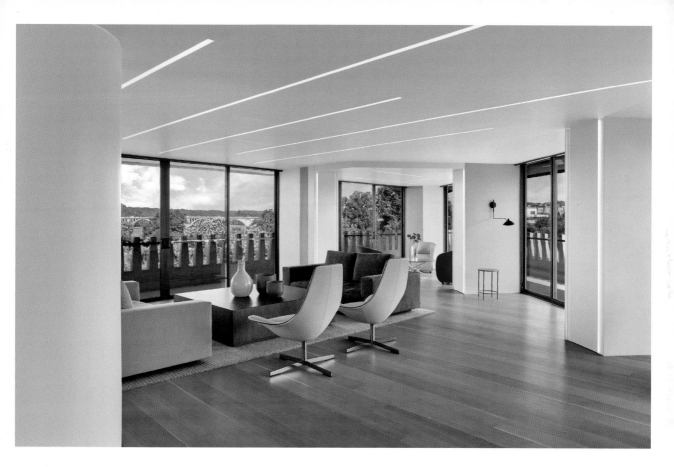

This corner unit is located on the fifth floor of the Watergate West Building, one of the five buildings forming the iconic Watergate complex. Situated on ten acres overlooking the Potomac River, the complex was designed by Italian architect Luigi Moretti and built between 1963 and 1972. The apartment is comprised of two units that had previously been combined with minimal alterations. Spaces remained compartmentalized with ceiling heights typically 8 feet 4 inches and lower. These less than optimal conditions are offset by views into the treetops and toward the Potomac River and the landmark Francis Scott Key Bridge. The interior was gutted down to the plumbing, electrical, and mechanical infrastructure and then reconfigured with a formal clarity, providing open living spaces with river view orientation.

Watergate 502

3,720 sq ft

Washington, District of Columbia, United States

Robert M. Gurney Architect

Photographs
© Anice Hoachlander

Planar walls and millwork elements combine to organize and define spaces. In contrast, a centrally located curving volume is designed to accommodate plumbing and electrical infrastructure that could not be moved.

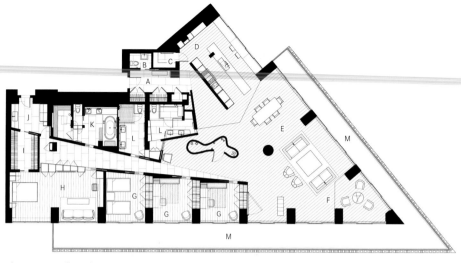

After renovation floor plan

A. Entry foyer
B. Powder room
C. Pantry
D. Kitchen
E. Dining area
F. Living area
G. Bedroom
H. Master bedroom
I. Dressing area
J. Laundry room
K. Master bathroom
L. Bathroom
M. Terrace

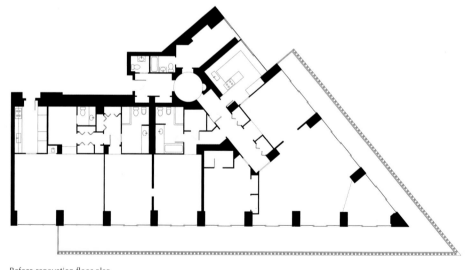

Before renovation floor plan

A sequence of planes can be used to create pathways and organize space while establishing an architectural language through color and materials.

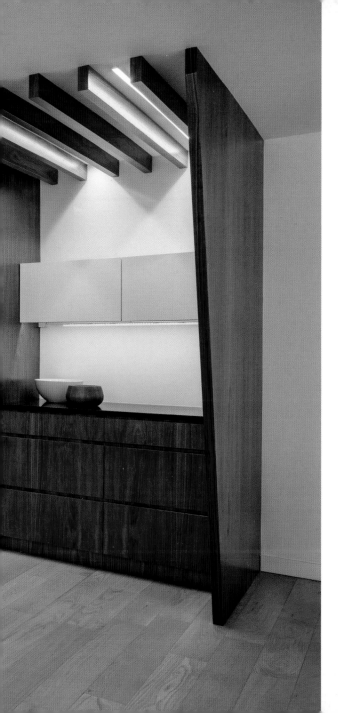

Modern Nostalgia

650 sq ft

New York, New York,
United States

Andrew Mikhael Architect

Photographs © Brad Dickson

What started with a concern about the lighting possibilities of a New York City apartment with a concrete ceiling evolved to a discussion on how to design a dream home that would suit the client's desire to work from home and his interest in cooking and baking. It soon became clear that the kitchen could be the focus of the design, engaging the rest of the apartment while integrating an original lighting solution. The owner's childhood memories of the walnut-paneled dining area of his grandmother's apartment in Manhattan served as inspiration, guiding the material aspect of the design and providing the apartment with a distinct and evocative aesthetic.

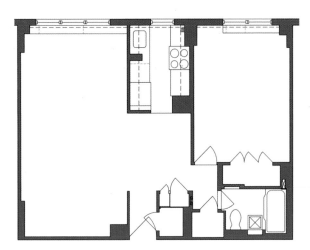

Before renovation floor plan

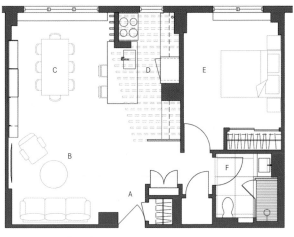

After renovation floor plan

A. Entry D. Kitchen
B. Living area E. Bedroom
C. Dining area F. Bathroom

The apartment was cleared of all the molding, and the existing flooring was replaced with wide plank white oak. This new blank canvas allowed the focus of the design to turn to the creation of the client's dream kitchen.

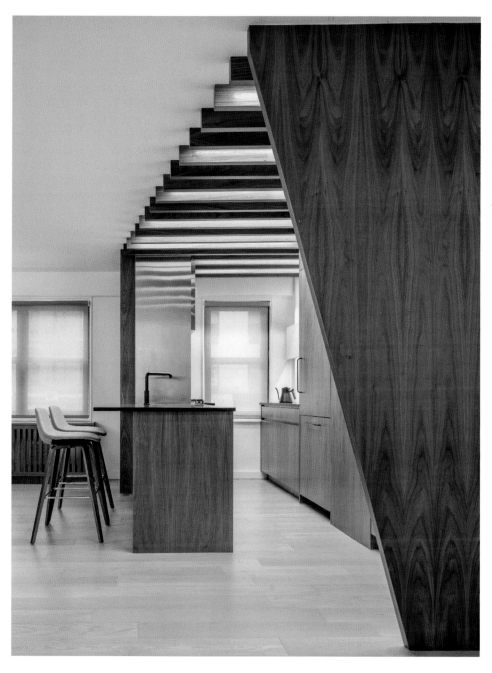

The kitchen is open to the living room and diagonally wrapped in a three-dimensional walnut veneer. The arrangement of appliances was reconfigured to create an open and functional layout. The range is tucked away in the corner, and the fridge was moved next to a structural column so both could be clad harmoniously in the same wood veneer.

Between the slats, linear LEDs provide efficient task lighting, addressing the client's concern about lighting possibilities in a New York City apartment with a slab ceiling.

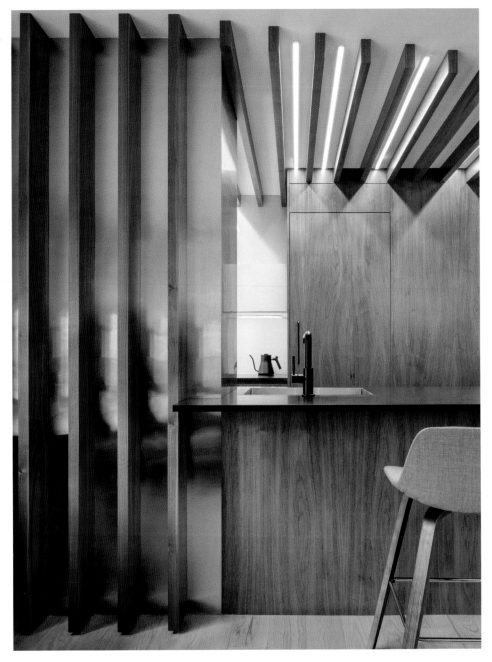

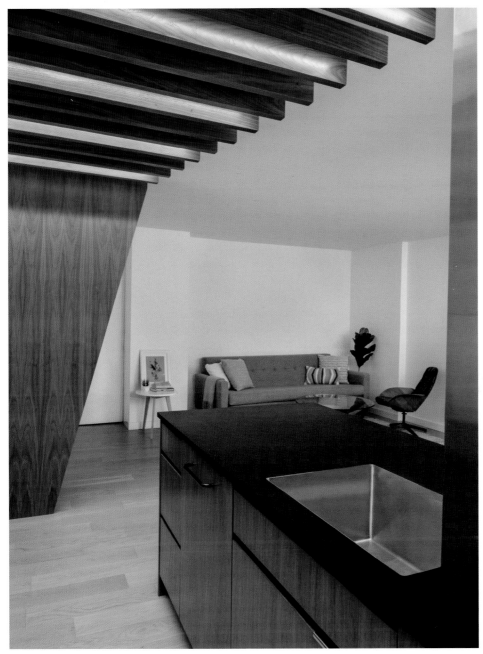

An angled sheath of wood faces the entryway. Along the ceiling 2x4 wood slats widen till they reach the far end and pour down a stainless steel wall.

The bathroom was also reconfigured with luxury finishes—Artistic Tile stone walls and floors, Vola faucet, accent lighting by Rich Brilliant Willing—while maintaining a modest overall budget. Teak decking in the shower gives a warm touch underfoot. Overall the bathroom emotes a masculine and sophisticated feel.

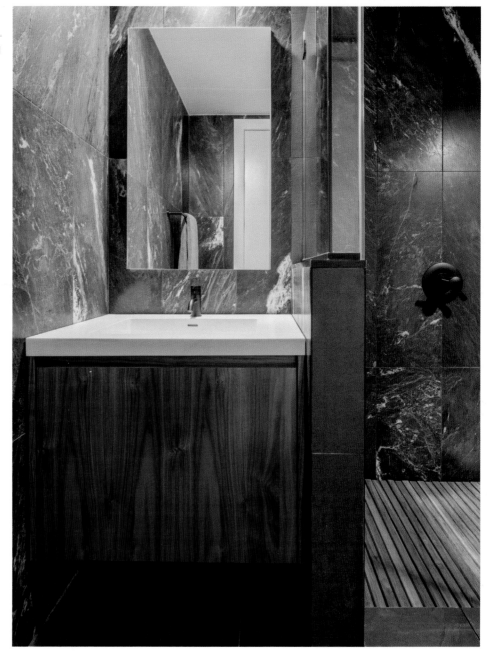

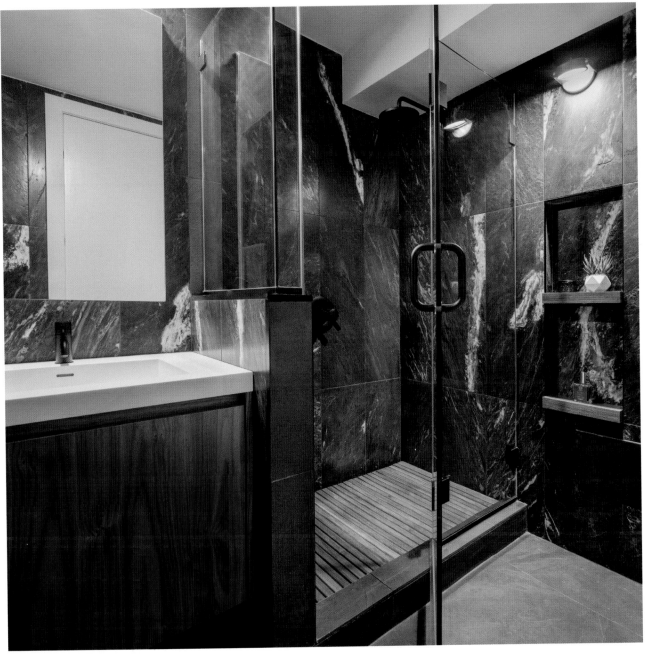

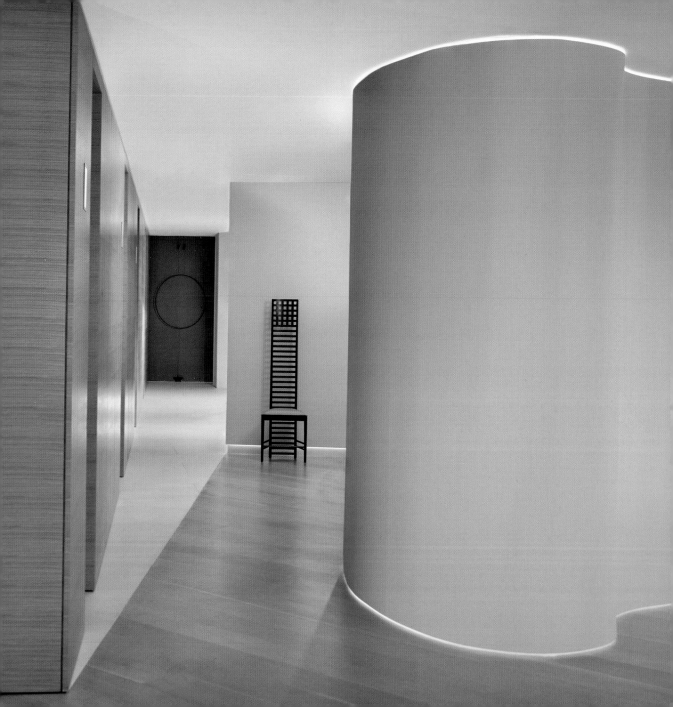

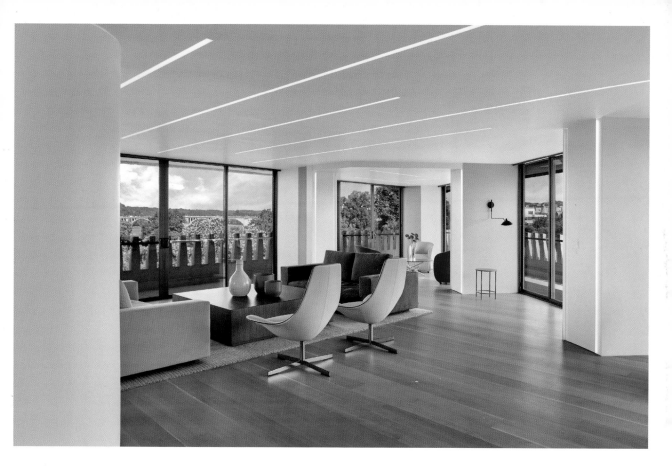

This corner unit is located on the fifth floor of the Watergate West Building, one of the five buildings forming the iconic Watergate complex. Situated on ten acres overlooking the Potomac River, the complex was designed by Italian architect Luigi Moretti and built between 1963 and 1972. The apartment is comprised of two units that had previously been combined with minimal alterations. Spaces remained compartmentalized with ceiling heights typically 8 feet 4 inches and lower. These less than optimal conditions are offset by views into the treetops and toward the Potomac River and the landmark Francis Scott Key Bridge. The interior was gutted down to the plumbing, electrical, and mechanical infrastructure and then reconfigured with a formal clarity, providing open living spaces with river view orientation.

Watergate 502

3,720 sq ft

Washington, District of Columbia, United States

Robert M. Gurney Architect

Photographs
© Anice Hoachlander

Planar walls and millwork elements combine to organize and define spaces. In contrast, a centrally located curving volume is designed to accommodate plumbing and electrical infrastructure that could not be moved.

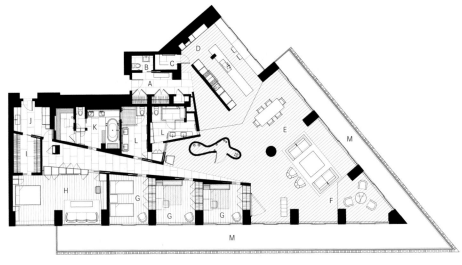

After renovation floor plan

A. Entry foyer
B. Powder room
C. Pantry
D. Kitchen
E. Dining area
F. Living area
G. Bedroom
H. Master bedroom
I. Dressing area
J. Laundry room
K. Master bathroom
L. Bathroom
M. Terrace

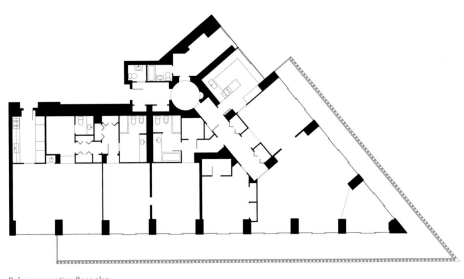

Before renovation floor plan

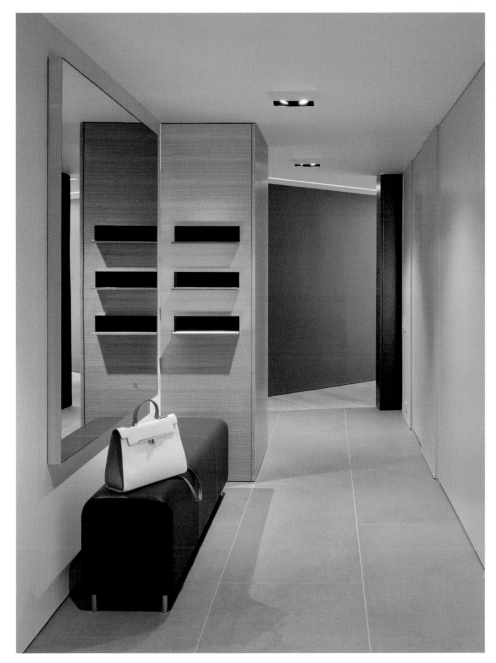

A sequence of planes can be used to create pathways and organize space while establishing an architectural language through color and materials.

The architecture is intended to enhance the spatial experience and the views while minimizing the presence of the existing low ceiling. Forms and textures unify and diversify spatial qualities.

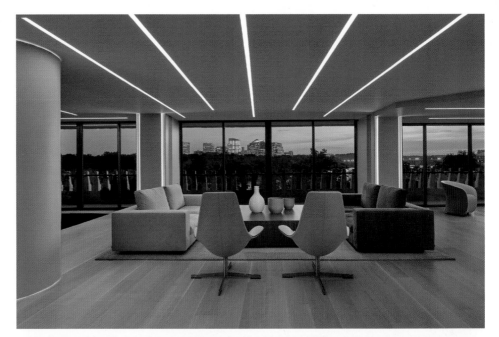

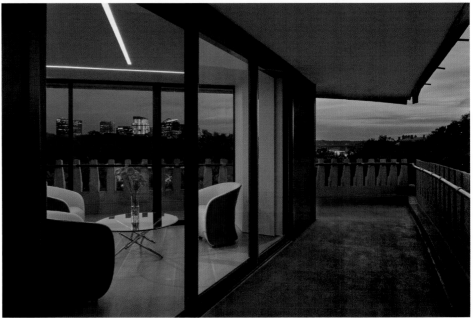

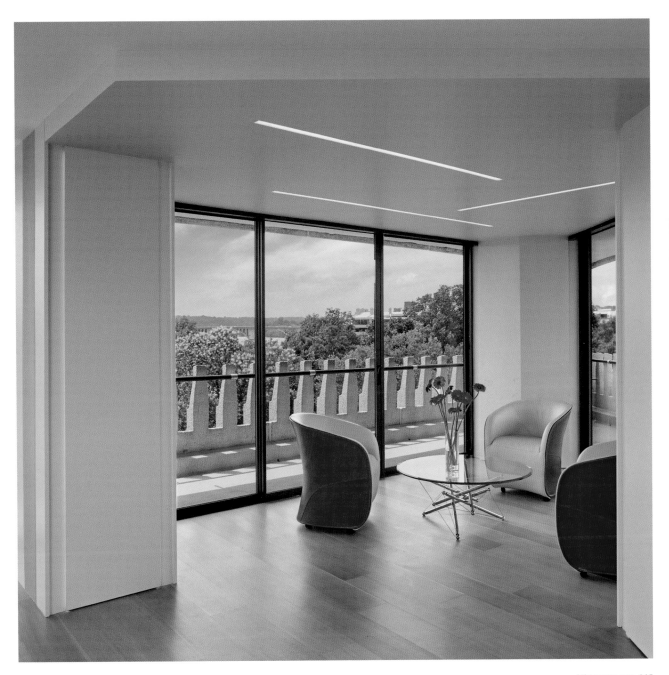

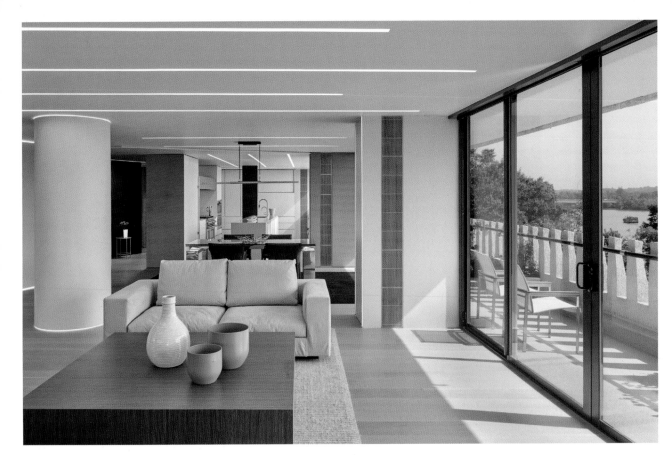

140

Views and natural lighting increase the value of spaces, making them more desirable to potential occupants. Architecture and interior design provide the framework to enhance these assets.

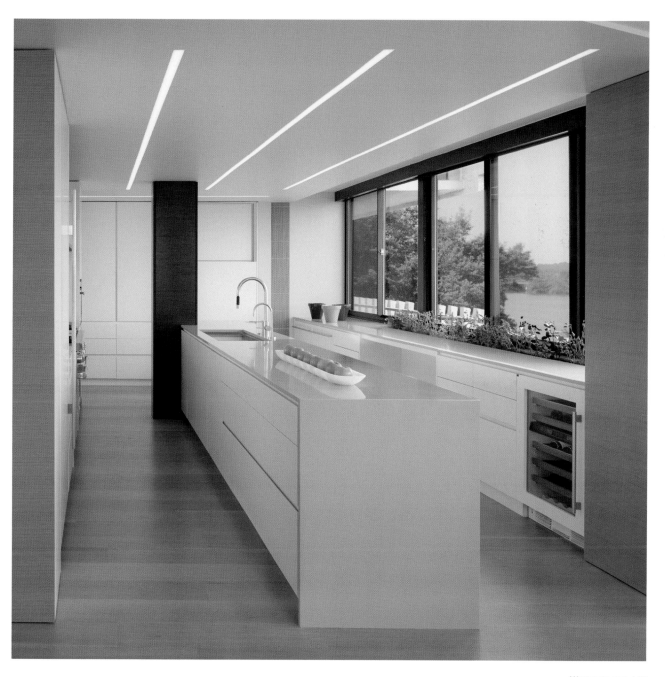

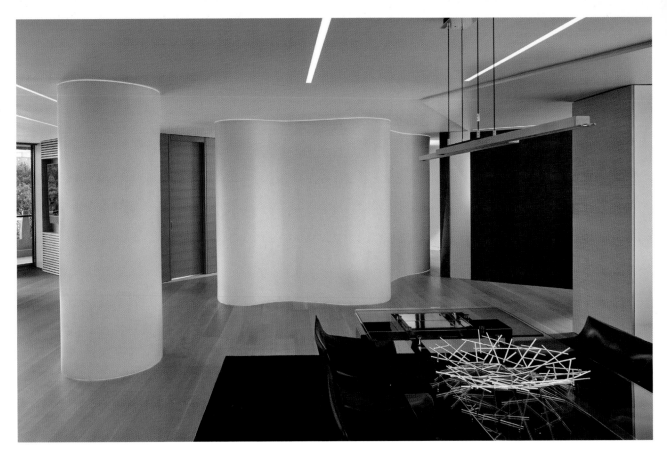

The material palette is intended to be subtle and refined. Detailing is minimal and crisp. Rift-sawn white oak flooring becomes the stage for similar white oak cabinetry and wall paneling. White lacquered and dark-stained oak cabinetry and millwork complete the look.

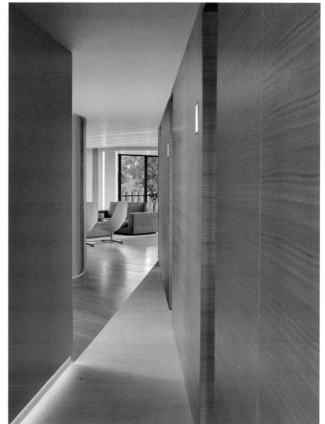

141

Colors and materials used minimally allow form and space to take center stage and contribute to design clarity. They also offer a neutral backdrop for displaying furnishings and artwork.

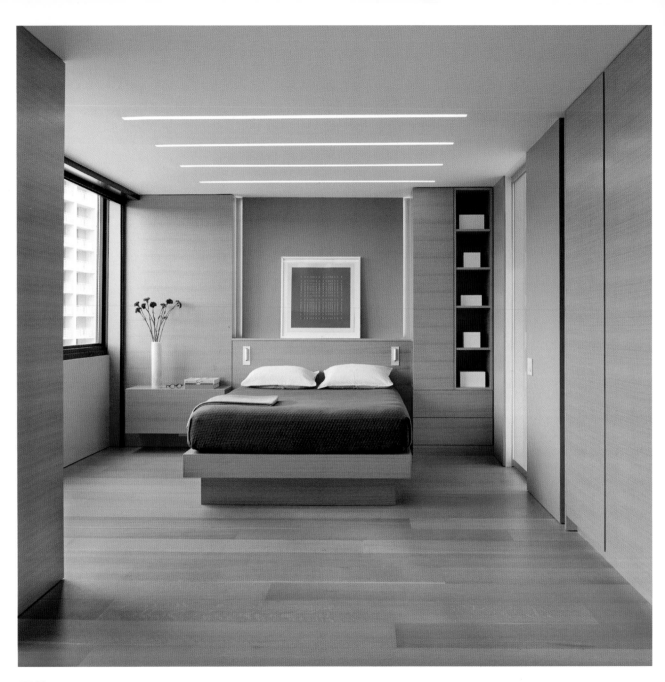

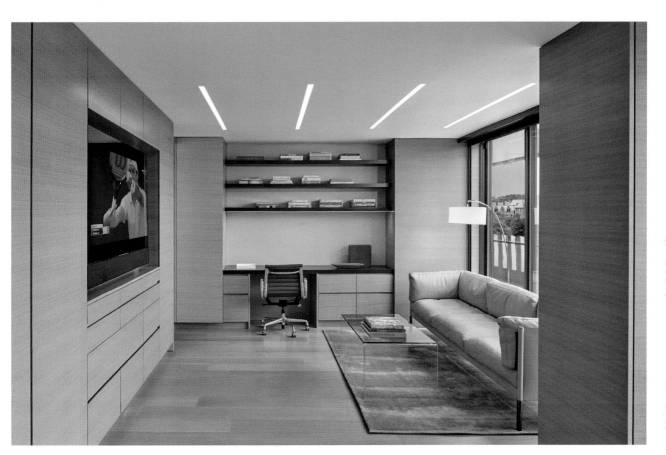

142

Large rooms can be designed to
accommodate areas with different
functions, allowing flexible use
of space yet maintaining spatial
continuity.

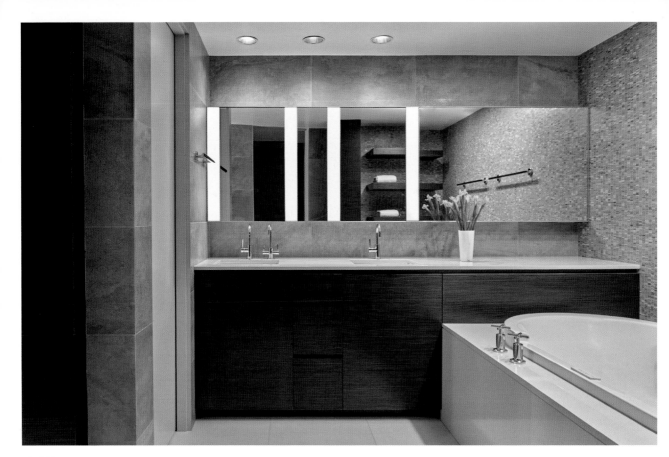

143

Stylish materials can add a
sophisticated touch to bathrooms,
creating the atmosphere of a spa
in the comfort of a home.

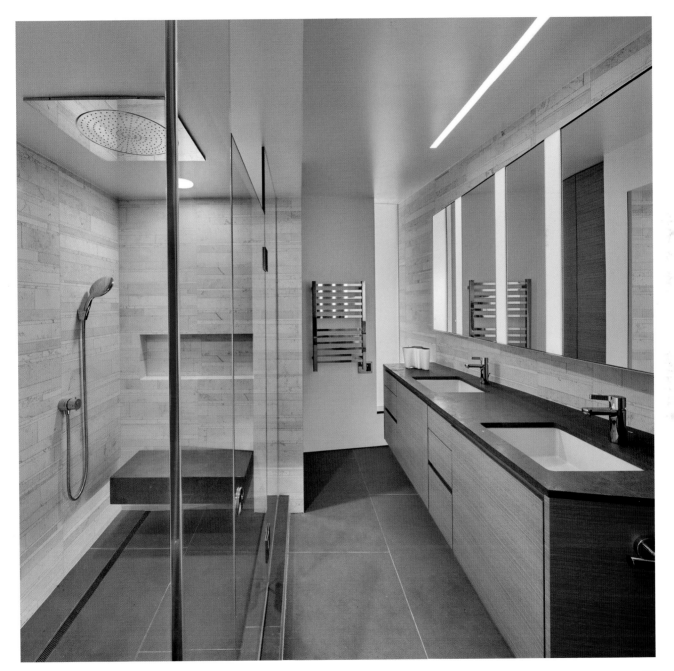

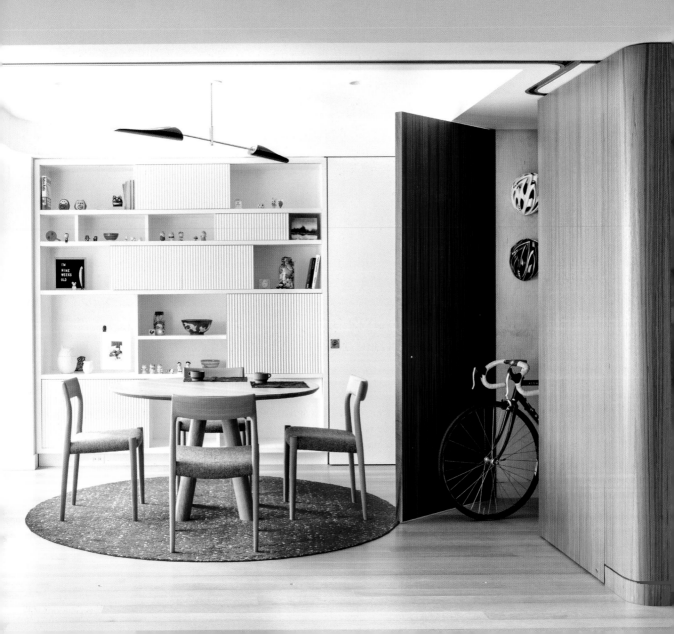

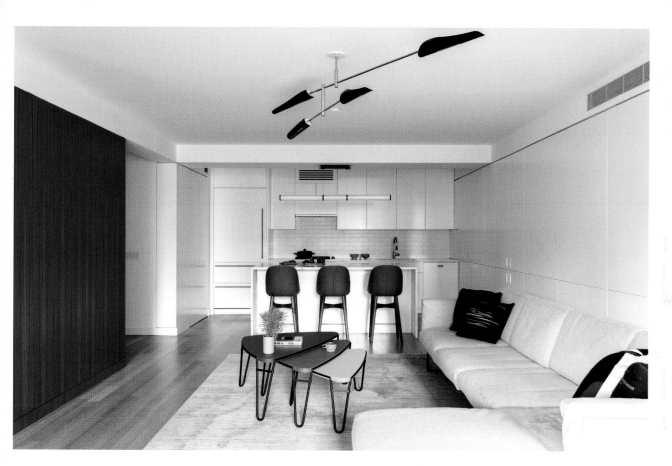

The design of the apartment is structured around the core idea of opening up the living space as much as possible while still maintaining the ability to separate part of the main room to create a guest room/nursery. The client was single during the design phase of the project but wanted to allow for these possibilities. This was accomplished through a main design element, a multiplex "teak cube." After the apartment was completed, the client married and had a daughter. The design adapted with them, going from an open plan of a bachelor to a subdivided space separated by folding teak panels, which are pulled from the teak cube.

Highline Residence

1,300 sq ft
New York, New York,
United States

Pulltab Design

Photographs © Fran Parente

144

A structural column and building electrical risers are hidden in the teak cube, creating a continuous open space around it, free of obstructions.

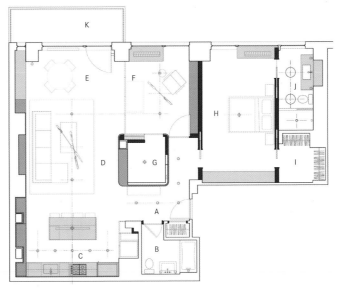

Floor plan with nursery

A. Entry
B. Bathroom
C. Kitchen
D. Living area
E. Dining area
F. Nursery
G. Teak cube/
 walk-in closet
H. Master bedroom
I. Closet
J. Master bathroom
K. Terrace

Floor plan without nursery

A. Entry
B. Bathroom
C. Kitchen
D. Living area
F. Teak cube/
 walk-in closet
E. Dining area
G. Master bedroom
H. Closet
I. Master bathroom
J. Terrace

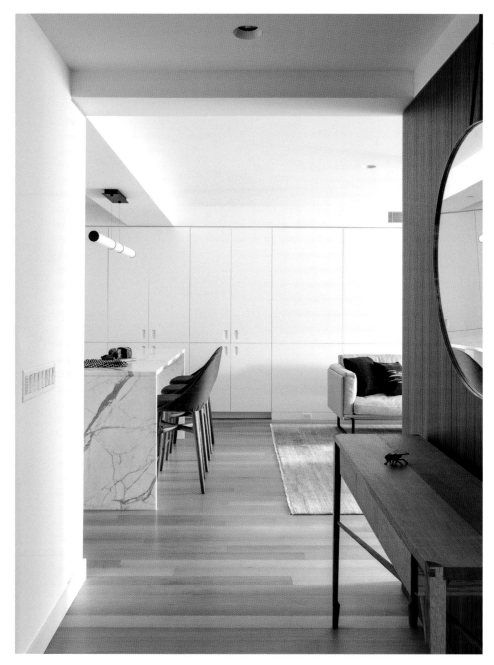

Circulation was designed to be fluid, so one space would connect with the next seamlessly.

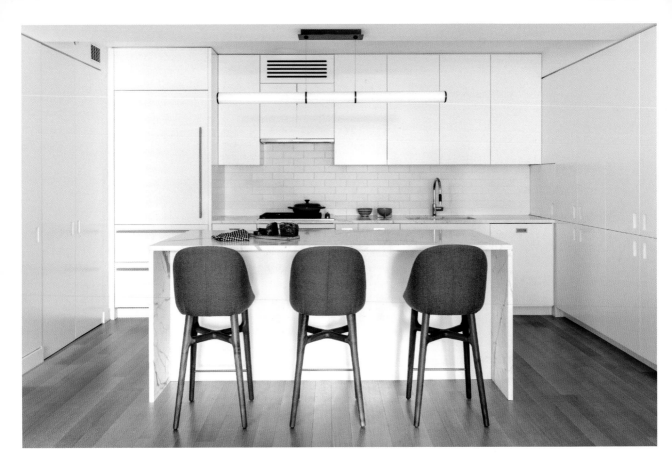

The renovated apartment is clean
and reductive in its detailing, with
significant millwork storage added
throughout the apartment.

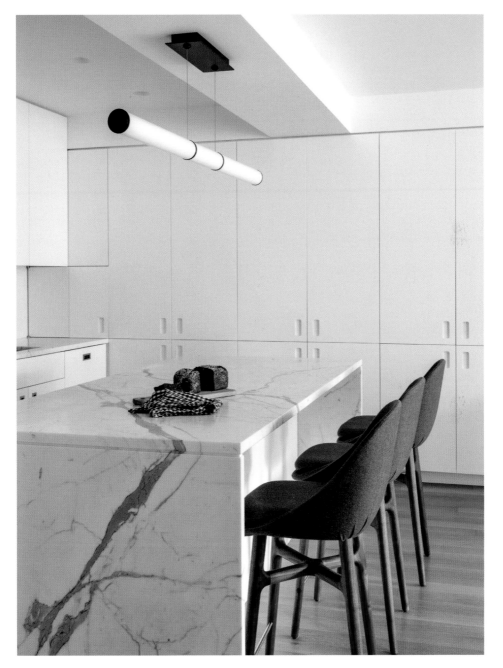

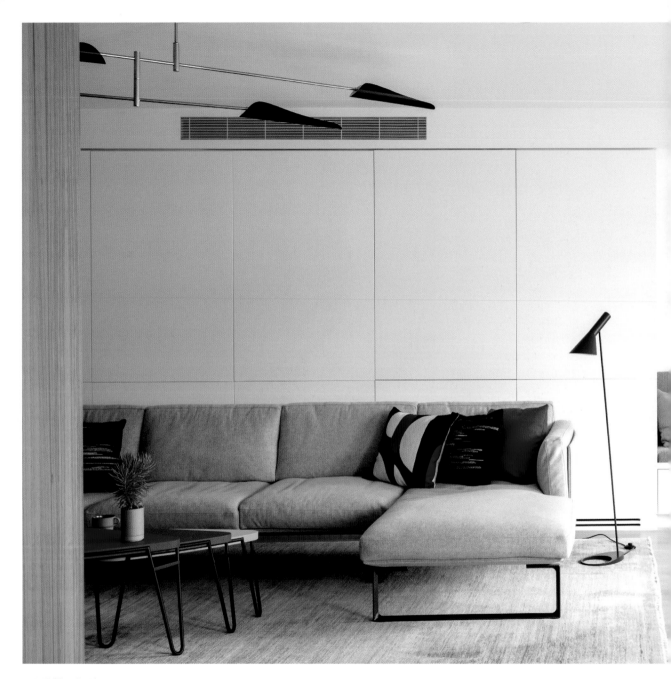

Walls frame spaces rather than contain them and create sight lines that make the home feel larger.

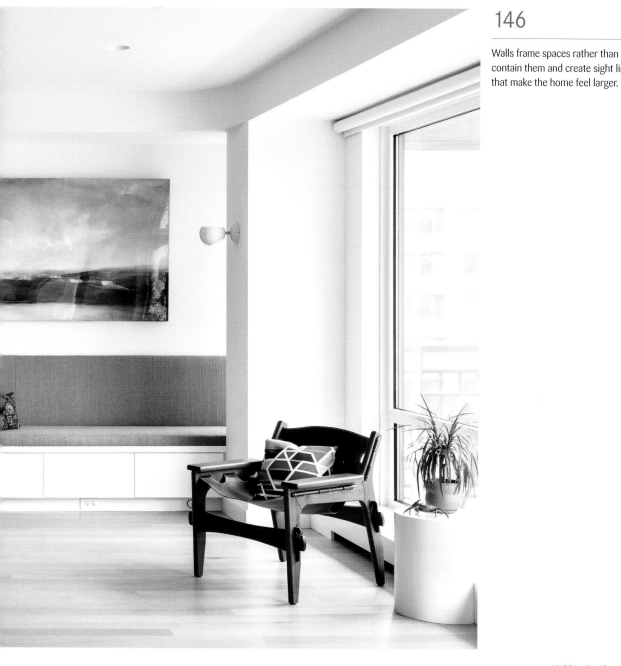

An original second bedroom was opened to the living area but can still become a separate space through the use of millwork panels concealed as part of the teak cube.

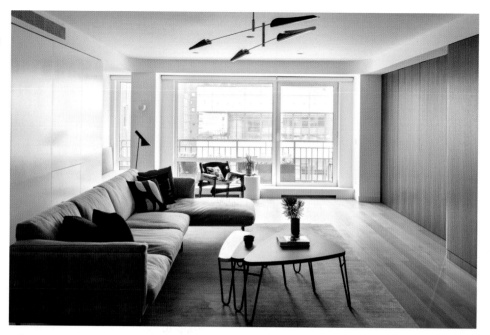

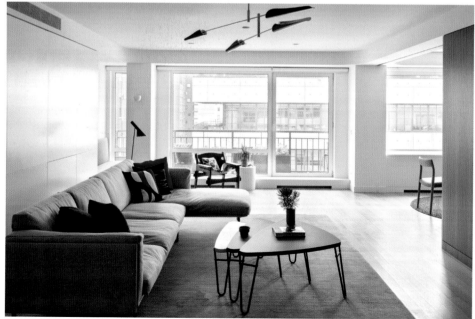

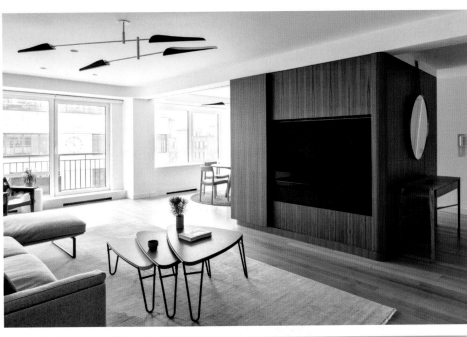

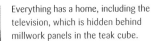

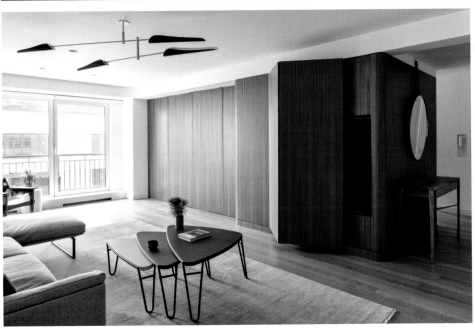

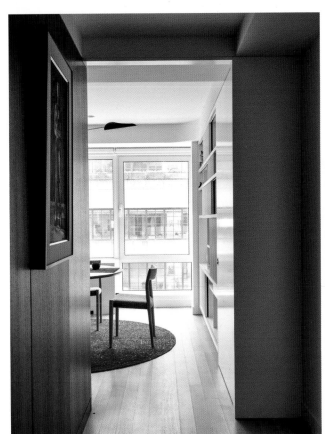
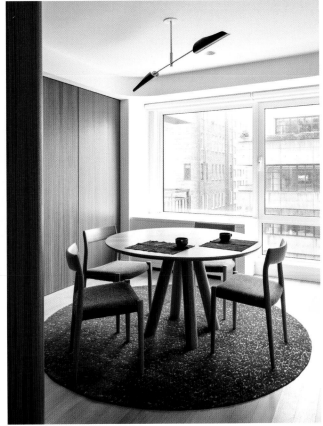

147

The teak cube organizes the space, creating narrow passages that funnel out into open spaces such as the dining area. The dining table is located near the windows, creating an open and naturally lit space for eating and working.

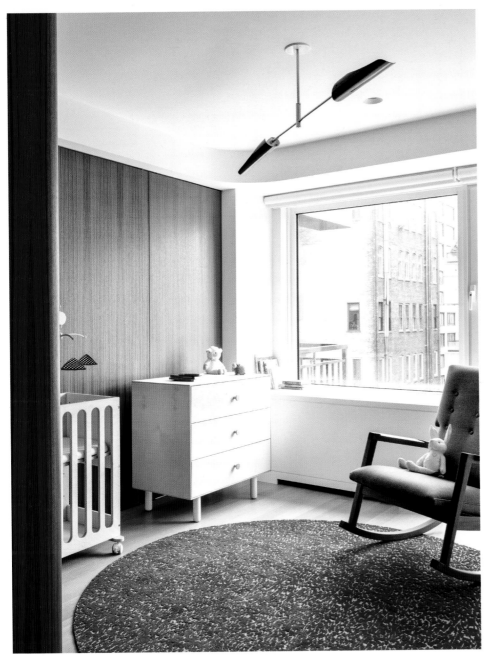

The dining area was seamlessly
converted into a nursery, adapting
to the client's life transition.

A bright and open space was created through the use of a tailored palette of modernist materials. The bed and nightstand—from BDDW—are a combination of American black walnut and claro walnut, highlighted with accents of brass. The storage cabinet—from USM Haller—is enameled steel and chrome.

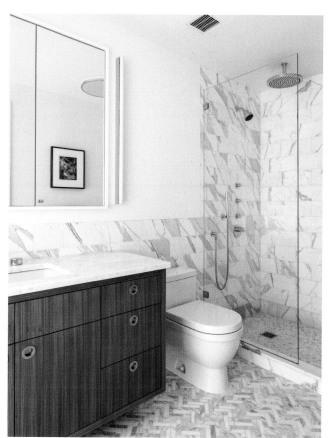

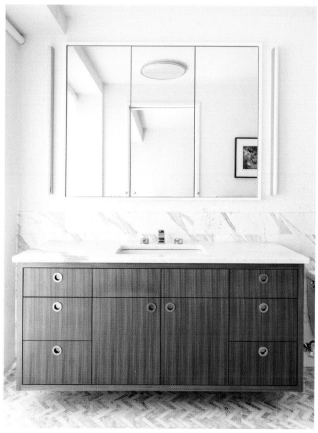

The master bathroom has floor and walls tiled in honed statuary marble. The vanity is American black walnut with a statuary marble top.

Igloos of the Canadian North inspired the design of this compact residence. Just as the snowy white structures are accessed through a compressed entry, a central corridor in a storage and bed loft separates the small apartment's entrance, bathroom, and office from the living, dining, and kitchen areas deeper inside. Along each side of the corridor, flat-paneled doors conceal two five-foot closets, laundry, a drying closet, a fridge, and pantries. Overhead, a Japanese-style loft bed provides privacy for sleeping. What seems counterintuitive—using extensive millwork and larger furnishings, such as the USM Haller cabinet—actually makes the space feel larger.

The Igloo Loft

583 sq ft

Vancouver, British Columbia, Canada

Falken Reynolds Interiors

Photographs © Chad Falkenberg

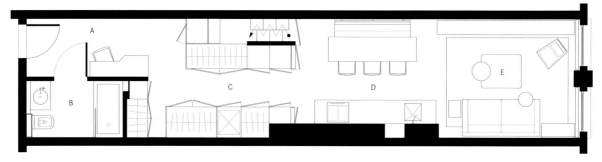

Main level floor plan

Loft floor plan

A. Entry foyer/office
B. Bathroom
C. Hallway/utilities/closet/
 access to loft
D. Dining area/kitchen
E. Living area
F. Loft

Before the renovation, the kitchen had a
large bulkhead and overhead cabinetry
that made the space feel confined.

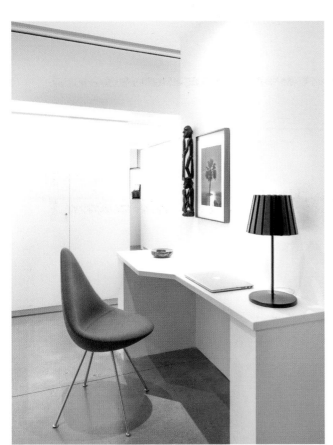

148

All-white color schemes brighten up spaces, making them look larger than they are. The right lighting—which is reflected on the white surfaces—also contributes to achieving this effect.

Minimalist detailing including integrated pulls, matte textured Fenix paneled doors, and a wall-mounted Vola faucet creates an understated kitchen design, so the dining area turns into the focus. An opening in the wall becomes an appliance niche backed by blue granite.

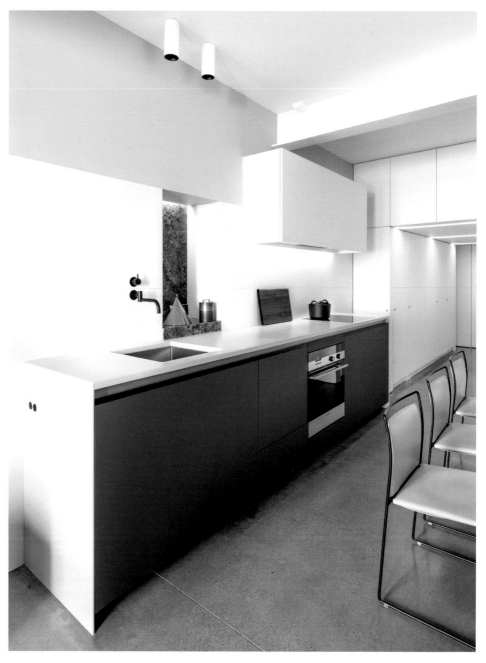

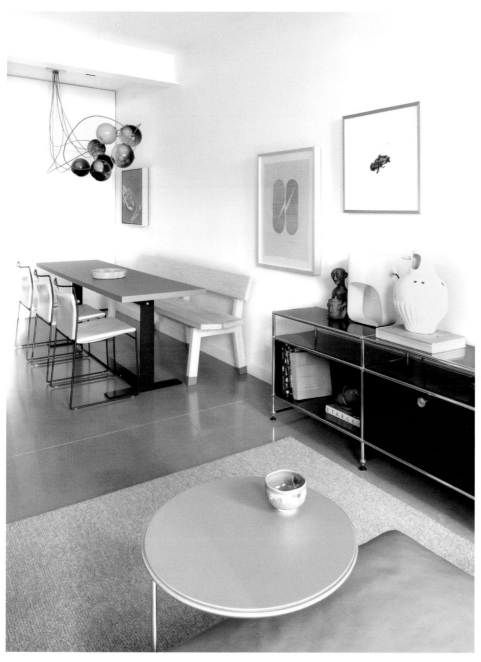

A sweeping Bocci 28.7 copper fixture creates movement in the rectilinear room and solves the problem of an immovable junction box.

Generous and efficient storage
space contributes to clutter-free
living environments, enhancing the
spatial experience, and promoting
a calm atmosphere.

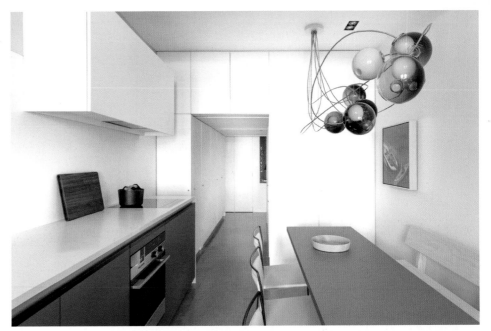

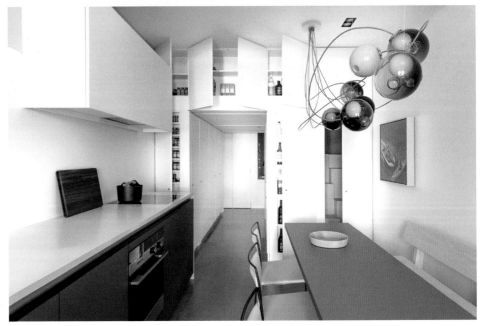

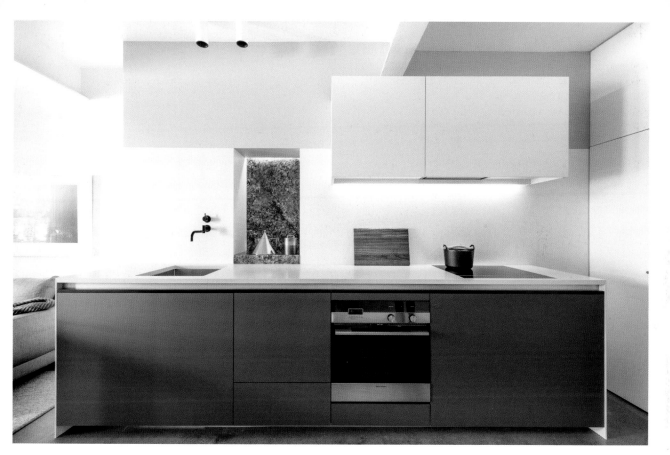

150

Concealing appliances behind cabinet fronts is a great design solution for small open kitchens, making them look organized and neat from any angle.

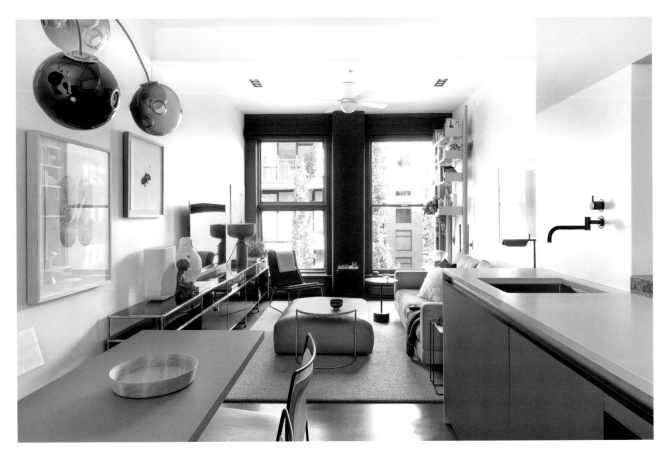

The narrow corridor funnels out into
a spacious living area. Brightened by
natural light, the living room has a
comfortable, cozy feel that contrasts
with the minimalistic aesthetic of the
entry and the kitchen.

DIRECTORY

ADHOC architectes
Montreal, Quebec, Canada
adhoc-architectes.com

Andrew Mikhael Architect
New York, New York, United States
andrewmikhael.com

Atelier SUWA
Montreal, Quebec, Canada
s-uwa.ca

Axis Mundi Design
New York, New York, United States
axismundi.com

BAAO Architects
Brooklyn, New York, United States
baaostudio.com

Ben Walker Architects
Ainslie, ACT, Australia
benwalkerarchitects.com.au

Benjamin Andres Architekt
Jersey City, New Jersey, United States
benjaminandres.com

Blythe Design Studio
Brooklyn, New York, United States
blythedesignstudio.com

**BoND/Noam Dvir and
Daniel Rauchwerger**
New York, New York, United States
bureaund.com

Bourgeois / Lechasseur Architectes
Quebec City, Quebec, Canada
bourgeoislechasseur.com

Bunker Workshop
Philadelphia, Pennsylvania, United States
bunkerworkshop.com

Coletivo Arquitetos
São Paulo, Brazil
coletivoarquitetos.com

Dash Marshall
Brooklyn, New York, and Detroit,
Michigan; United States
dashmarshall.com

DELSON or SHERMAN ARCHITECTS
Brooklyn, New York, United States
delsonsherman.com

Diego Revollo Arquitetura
São Paulo, Brazil
diegorevollo.com.br

dSPACE Studio
Chicago, Illinois, United States
dspacestudio.com

Echo Design + Architecture
New York, New York, United States
echoda.com

Falken Reynolds Interiors
Vancouver, British Columbia, Canada
falkenreynolds.com

FORMA Design
Washington, District of Columbia, United
States
formaonline.com

Fowlkes Studio
Washington, District of Columbia, United
States
fowlkesstudio.com

Frederick Tang Architecture
Brooklyn, New York, United States
fredericktang.com

gne Architecture
New York, New York, United States
gnearchitecture.com

Haeccity Studio Architecture
Vancouver, British Columbia, Canada
haeccity.com

Jay Jeffers
San Francisco, California, United States
jayjeffers.com

KUBE Architecture
Washington, District of Columbia, United States
kube-arch.com

L/AND/A
Brooklyn, New York, Unites States
landa-arch.com

Lilian H. Weinreich Architects
New York, New York, United States
weinreich-architects.com

Lucy Harris
New York, New York, United States
lucyharrisstudio.com

MKCA // Michael K Chen Architecture
New York, New York, United States
mkca.com

Neumann Monson Architects
Iowa City, Iowa, United States
neumannmonson.com

OPUS-AD
Long Island City, New York, United States
archinect.com/opus-ad.com

Pascali Semerdjian Arquitetos
São Paulo, Brazil
psarquitetos.com

Pulltab Design
New York, New York, United States
pulltabdesign.com

Robert Gurney Architect
Washington, District of Columbia, United States
robertgurneyarchitect.com

Robert Kaner Interior Design
New York, New York, United States
kanerid.com

Sergio Mercado Design
New York, New York, United States
sergiomercadodesign.com

Stadt Architecture
New York, New York, United States
stadtarchitecture.com

StudioLAB
New York, New York, United States
studiolabdesign.com

studioPPARK
New York, New York, United States
studioppark.com

Studio ST Architects
New York, New York, United States
studio-st.com

Sutro Architects
San Francisco and Healdsburg, California, United States
sutroarchitects.com

22 INTERIORS
Los Angeles, California, United States
22interiors.com

Vladimir Radutny Architects
Chicago, Illinois, United States
radutny.com

Ward 5 Design
Astoria, New York, United States
ward5design.com

White Arrow
Brooklyn, New York, United States
thewhitearrow.com

Worrell Yeung Architecture
New York, New York, Unioted States
worrellyeung.com